IN A NEW LIGHT

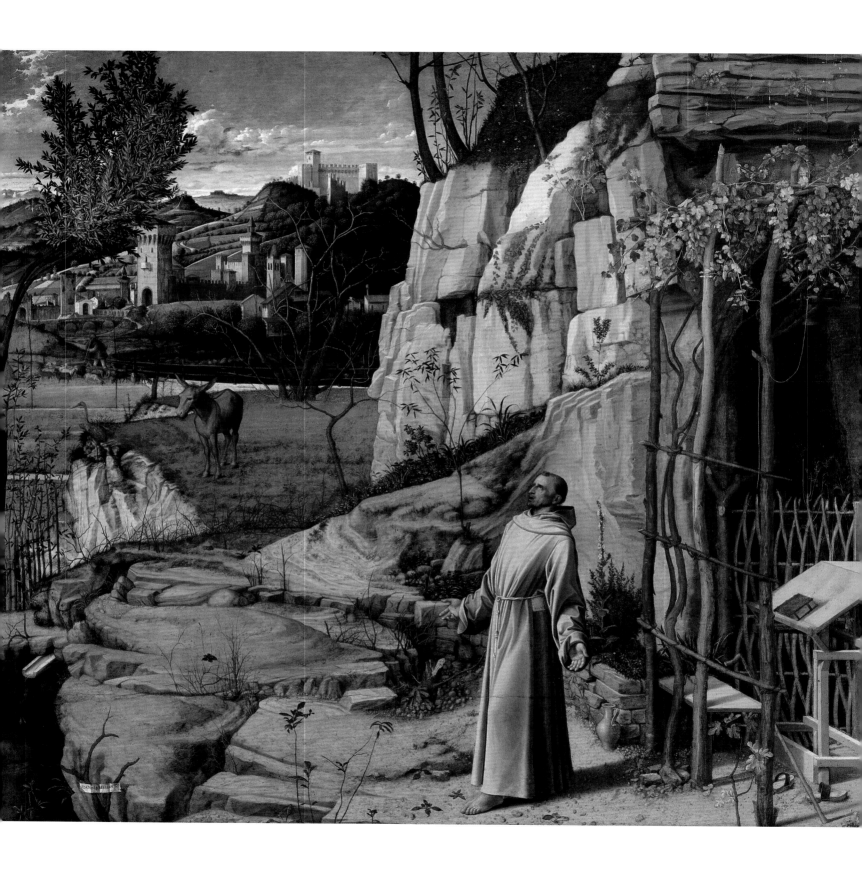

IN A NEW LIGHT

Giovanni Bellini's *St. Francis in the Desert*

Susannah Rutherglen and Charlotte Hale
Foreword by Keith Christiansen

Contributions by
Denise Allen
Michael F. Cusato, O.F.M.
Anne-Marie Eze with Raymond Carlson
Joseph Godla
With the assistance of Katie Steiner

The Frick Collection, New York
in association with
D Giles Limited, London

g

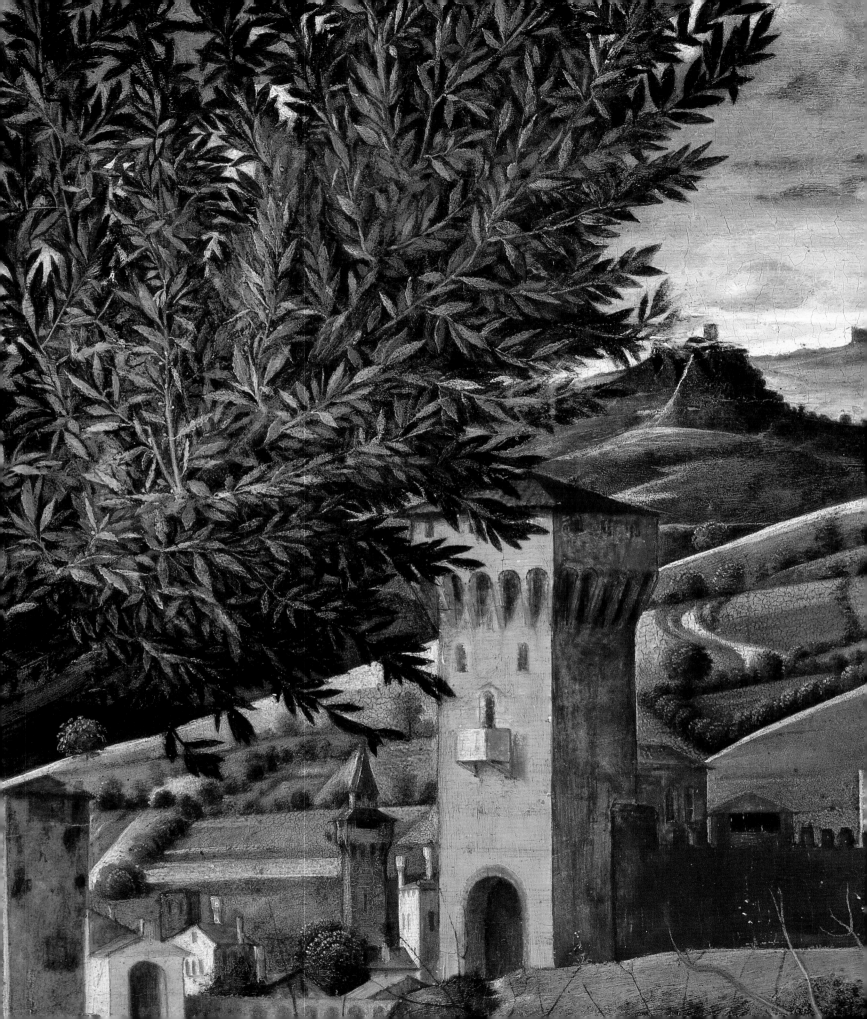

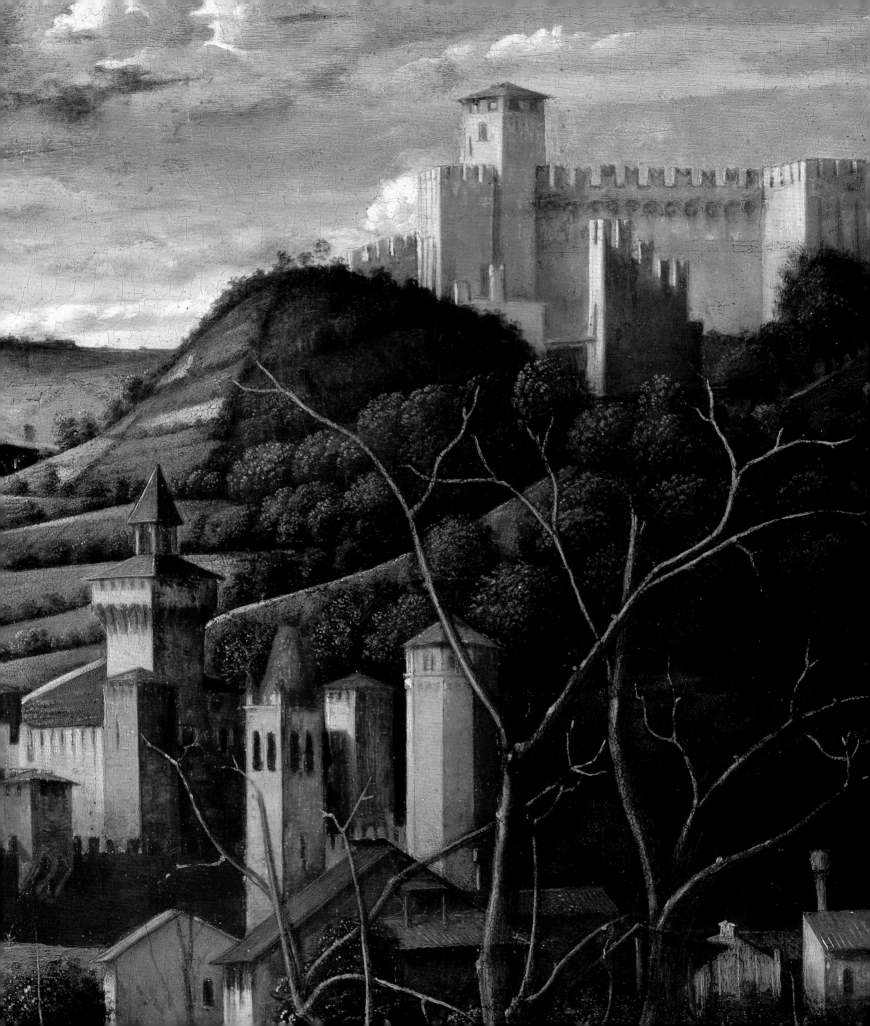

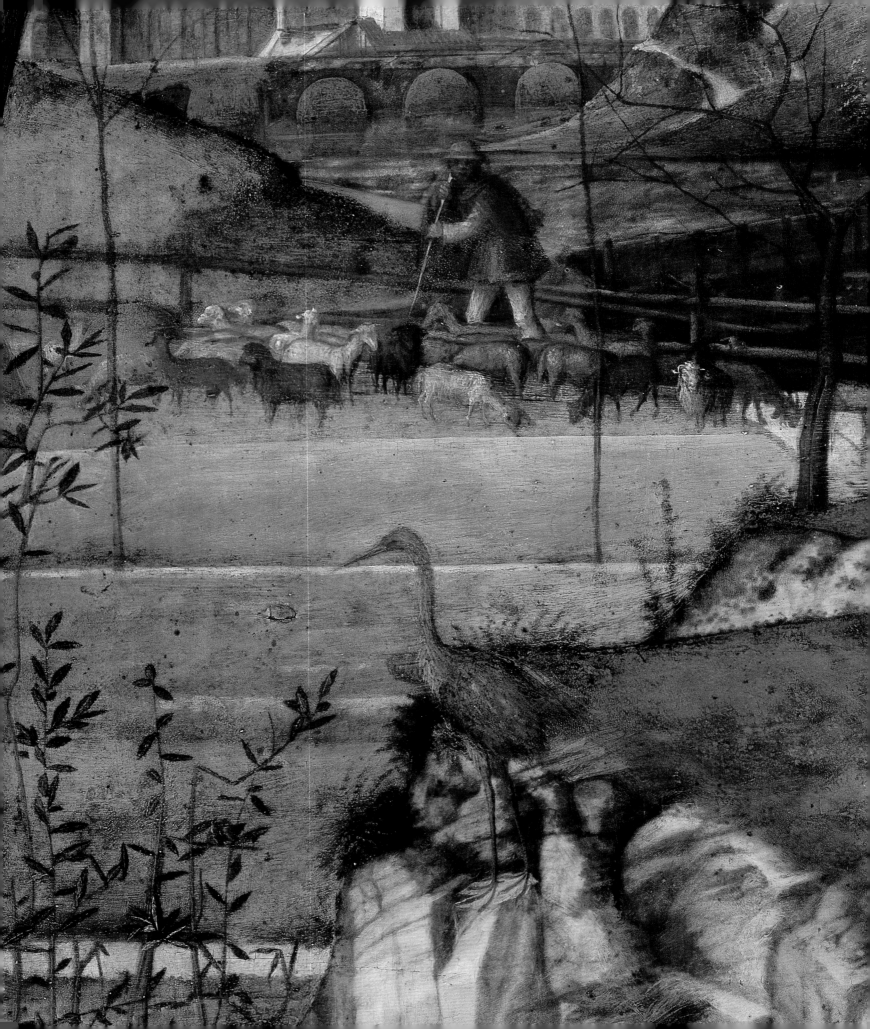

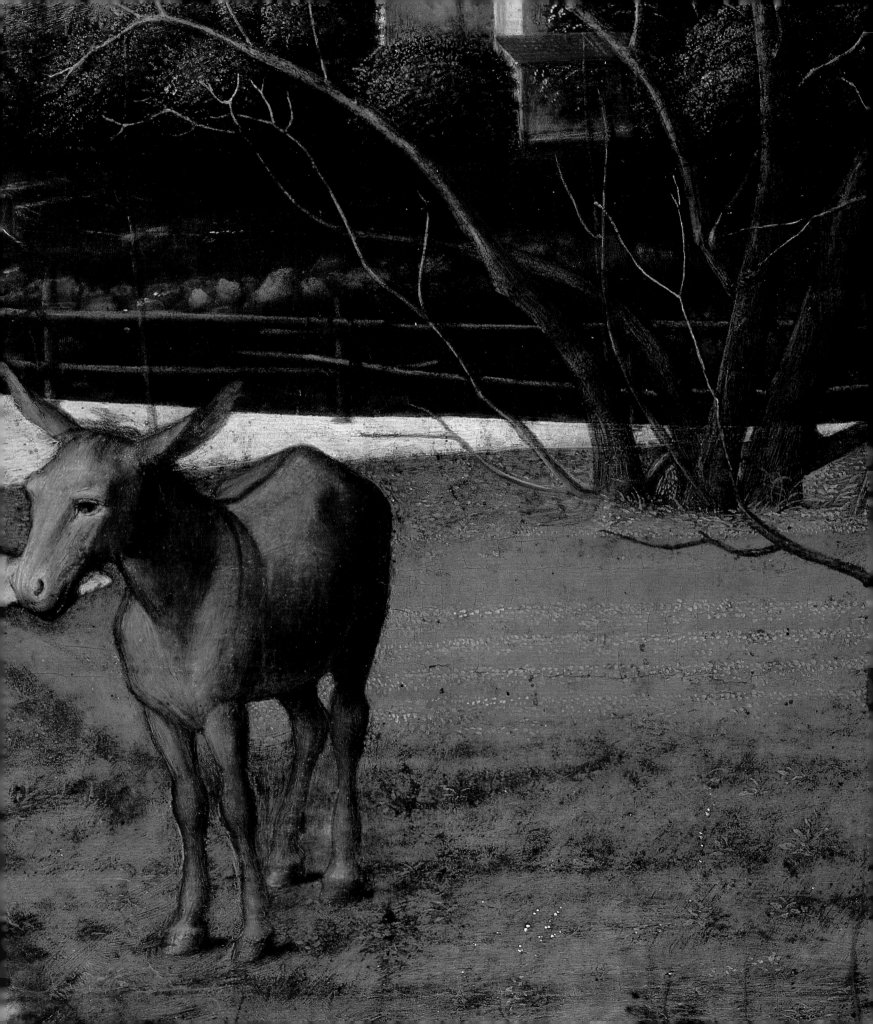

To Patricia Fortini Brown and my family
 — S.R.

To the memory of my father, John Rigby Hale
 — C.H.

ISBN: 978-1-907804-39-7

Published by The Frick Collection
Michaelyn Mitchell, Editor in Chief
Hilary Becker, Assistant Editor

In association with D Giles Limited

For D Giles Limited
Designed by Anikst Design, London
Copy edited and proofread by Sarah Kane
Printed and bound in China

The Frick Collection
1 East 70th Street
New York, NY 10021
www.frick.org

D Giles Limited
4 Crescent Stables
139 Upper Richmond Road
London SW15 2TN

Frontispiece:
Giovanni Bellini (c. 1424/35–1516), *St. Francis in the Desert*, c. 1476–78. Oil on panel, 124.6 × 142 cm (overall), 124.1 × 140.4 cm (painted surface). The Frick Collection, New York (1915.1.03)

Front and back jacket illustrations: details from Giovanni Bellini's *St. Francis in the Desert*

Pages 4–5, 6–7, 10–11, 167: details from Giovanni Bellini's *St. Francis in the Desert*

Library of Congress Cataloging-in-Publication Data

In a new light : Giovanni Bellini's "St. Francis in the Desert" at the Frick Collection / Susannah Rutherglen and Charlotte Hale ; foreword by Keith Christiansen ; contributions by Denise Allen, Michael F. Cusato, O.F.M., Anne-Marie Eze, Joseph Godla ; with the assistance of Katie Steiner and Raymond Carlson.
 p. cm.
 Includes bibliography references and index.
 ISBN 978-1-907804-39-7
1. Bellini, Giovanni, -1516. St. Francis in ecstasy. 2. Frick Collection. I. Rutherglen, Susannah. II. Hale, Charlotte, 1959- III. Christiansen, Keith. IV. Allen, D. (Denise) V. Cusato, Michael F. VI. Eze, Anne-Marie. VII. Godla, Joseph. VIII. Steiner, Katie L. IX. Carlson, Raymond (Art historian) X. Frick Collection.
 ND623.B39A73 2014
 759.5--dc23
 2014019507

. . . non per martirio corporale, ma per incendio mentale, egli doveva essere tutto trasformato nella espressa similitudine di Cristo crocifisso.

. . . he was to be utterly transformed into the direct likeness of Christ crucified, not by martyrdom of the body, but by enkindling of the mind.

—*Le Considerazioni sulle Stimmate di San Francesco*, c. 1375–80

Contents

FOREWORD
ENCOUNTERING BELLINI'S *ST. FRANCIS*

Giovanni Bellini's painting of St. Francis in a landscape is, by common consent, one of the masterpieces of Renaissance painting by the greatest artist of fifteenth-century Venice. It is also a landmark in the history of European culture: a work that created a new kind of meditational image and one that continues to resonate today. Since it entered the collection of Henry Clay Frick in 1915, countless visitors have been moved—really enraptured—by the artist's rhapsodic vision of nature and his depiction of Francis, the author of the *Laudes Creaturarum* (*Canticle of the Creatures*), who seems, with his outstretched arms and upturned head and open mouth, in a state of ecstasy. Those green meadows and distant hills, their slopes divided into fertile fields, their peaks crowned with castles and fortresses bathed in the soft, golden light of early morn, seem an affirmation of a benign nature, lived in and cultivated, and this is made the more poignant by the contrast with the barren rocks of the foreground, where the saint has created a rustic, simple, but fairly well-appointed retreat and where he tends a garden of medicinal herbs—he has even managed to coax a grapevine to flourish over the beautifully carpentered desk where he reads and meditates. Few critics have described the unique achievement of the artist as beautifully as Kenneth Clark in his classic 1949 book, *Landscape into Art*:

> [As Bellini] grew older he became more in love with the full light of day in which all things can expand and be completely themselves. This is the feeling which pervades the picture of *St. Francis* now in the Frick Collection. Here, at last, is a true illustration of St. Francis' hymn to the sun. No other great painting, perhaps, contains such a quantity of natural details, observed and rendered with incredible patience: for no other painter has been able to give to such an accumulation the unity which is only achieved by love. "As the air fills everything and is not confined to one place," says Sebastian Franck, the sixteenth-century mystic, in his *Paradoxa*, "as the light of the sun overflows the whole earth, is not on earth, and yet makes all things on earth verdant, so God dwells in everything and everything dwells in Him."

In an essay I wrote for *The New Republic* in April 2009, I compared Bellini's response to nature to that of Wordsworth in his great poem "Tintern Abbey." I did not mean by that comparison to ignore the fascinating fact that Bellini painted *St. Francis* at the very moment when pastoral poetry achieved a new status and complexity in European literature. At the court of Ferrara, the aristocratic poet Matteo Boiardo—a near contemporary of Bellini and the author of the hugely successful chivalric epic

Orlando Innamorato (*Orlando in Love*)—was composing Petrarchan love poems in which the beauty of nature provides a refuge and sometimes a counterpoint to the restless soul of the forlorn lover. Here's an example, taken from a prose translation:

> Now the shepherdess leads the white troop that is in her keeping down to the plain, for she sees the sun declining, and the hour late, and the high country-houses sending up their smoke in the distance. The bent ploughman lifts himself straight and tall, and looks about at the day that flees, and frees his oxen from the yoke that he may not be late in returning to his rest.
>
> And I alone, without any refuge, have no respite from my thoughts with the sun, and come to sigh again with the stars. Sweet unrest of love, how mild you are: for I rest neither by night nor by day, and the eternal travail does not weigh on me!

Poems such as this may seem to offer a literary counterpart to Bellini's descriptive brush. But we shouldn't press the analogy too far for the terms of Boiardo's poem make us think less of Bellini's landscape than the backgrounds of various paintings by Giorgione and Titian—for example, of the *Sacred and Profane Love* in the Galleria Borghese, Rome. And, indeed, there is a substantial literature on the relation of Titian's pastoral landscapes to the poetry of Jacopo Sannazaro, especially his vastly popular poem *Arcadia*, in which the lovelorn narrator wanders the countryside listening to the amorous or mournful songs of the shepherds he meets. The poem was written in Naples, but a pirated edition appeared in Venice in 1502, and excerpts had been circulating in manuscript for more than a decade. It is precisely by comparison with this pastoral tradition—in both its literary and visual manifestations—that we recognize the very different character of Bellini's landscape. For rather than evoking the poetic fiction of a fairytale Arcadia populated with lovelorn shepherds and nymphs, Bellini conjures up a nature that seems hauntingly familiar and real: the landscape of the Veneto, which he had ample occasion to study when he retired to his villa and in which, in this and other pictures with a religious theme, he places his sacred subjects.

Clark set out to situate Bellini's landscape vision within a poetics of western landscape painting, but he was perfectly well aware that it is a far more difficult task to locate the Frick's great picture within the artist's career and to define what it was he was trying to accomplish—the task the essays in this book seek to answer, at least within the parameters of what we know from the research of more than two generations

of scholars. Much has changed since Millard Meiss set the groundwork with his 1963 article and 1964 monograph on the painting. Thanks to the archival work of Jennifer Fletcher, we can now reconstruct Bellini's social milieu and the place where he likely met the first owner of the painting, Zuan Michiel. Both were members of a lay religious confraternity, the Scuola Grande di San Marco, where they shared devotional practices, including the performance of hymns, or *laude*. (*Laude* were composed by people as socially prominent as the Venetian statesman and orator Leonardo Giustinian, and they remind us that alongside classically inspired texts, Petrarchan poetry, and exegetical literature, there existed a more popular religious verse—Franciscan in origin—relevant to our understanding of the kinds of responses Bellini anticipated.) We also know that the owner of the picture by 1525, Taddeo Contarini, displayed it in his palace among a remarkably assorted collection of paintings, both secular and religious, among which was Giorgione's so-called *Three Philosophers*, now in the Kunsthistorisches Museum, Vienna.

The fact that the picture originated as a private commission and, at a very early date, was hung with such a diverse group of paintings strongly suggests that from the outset Bellini intended the work to appeal to cognoscenti and to elicit discussion among them. But what kind of discussion? Were they, like so many of us today, perplexed by the difficulty in identifying the scene with a specific event in the life of Francis? Or were they, like Marcantonio Michiel, who records the picture in the Contarini collection in 1525, so taken with its beauties that they were satisfied with the rather suggestive but imprecise theme of St. Francis in the Wilderness? Did they, like John Fleming in his fascinating book of 1982, see in Bellini's rich description of flora and fauna a marvelously contrived rebus of symbols relating to Francis and puzzle over the meaning of details such as the laurel tree and the rays of light that seem to bend its branches with their dramatic illumination; the shepherd, heron, and ass; the spigot of water and the little kingfisher perched on a branch; or the bluish hue of the rocky escarpment, so different from the light of early dawn sweeping across the fertile background landscape? In other words, did they assume that the primary purpose of the picture was a cued meditation directed toward devotional practice and requiring deciphering, as eloquently argued by Augusto Gentili, or did they understand it as a sacred-themed *poesia*, employing an intentionally allusive and deeply poetic language elaborating a theme rather than describing a subject and emphasizing the artist's capacity for artistic invention—in accordance with Pietro Bembo's famous declaration that Bellini liked to "wander at will in his paintings so that in a like fashion they [may] satisfy those who look at them"?

We happen to know that Marco Boschini, writing in the seventeenth century, had no hesitation in identifying the picture's subject but then immediately shifted his attention to its poetic qualities. Like Marcantonio Michiel over a century earlier, he was struck by Bellini's description of the landscape, which he interpreted as Mount La Verna, the place where Francis received the stigmata (the event Boschini believed was the subject of the painting)—and he noted that it reminded him of the verses of a poem on St. Francis composed by Maffio Venier in 1584. It's not difficult to understand why, for in the poem Venier did some word painting of his own, declaring, "Here you see valleys eminent and deep, and impenetrable caverns, broken stones hanging overhead with frozen, barren trees of great height: the saintly man chose this inhospitable landscape to be with God."

It is invariably the case that we tend to find in works of art what we expect to find and that erudite explication proceeds from an assumed intellectual position. So it may be worth stating here my own impression that the novelty of Bellini's picture lies in the way it rejects a canonical iconographic treatment of events from the saint's life in favor of a more open-ended, associative, and poetic approach. And that this was made possible by the relatively new phenomenon of pictures painted for private delectation rather than to decorate a church. But, of course, there was a theme (which is not necessarily the same as a subject); there was a patron; there was a context; and there was a very extraordinary artist who was constantly expanding the affective, as well as the descriptive, powers of painting. And that is the subject of this publication, which takes as its point of departure a detailed technical analysis undertaken at the Metropolitan Museum in the spring of 2010 and unites that information with a careful reconsideration of the scholarship that has grown up around the painting over the last century.

Keith Christiansen
John Pope-Hennessy Chairman, Department of European Paintings
The Metropolitan Museum of Art

ACKNOWLEDGMENTS

"H. C. Frick's 'St. Francis,' by Giovanni Bellini: Beautiful Painting Showing Saint Before His Cell, Recently Acquired by Mr. Frick, Considered One of the Earliest Examples of Italian Landscape," announced the *New York Times* on October 10, 1915, regarding one of the most significant acquisitions of Renaissance art in American history. "It unites to an extraordinary technical felicity, worthy of all the labors of expertise that have been spent upon it, a romantic interest sufficient to enlist the least initiated public, and into the bargain it possesses a picturesque history . . . Altogether a most lovely and interesting work, the presence of which in this country is an affair of genuine importance to all lovers of art."

We are indeed fortunate that the epic travels of Bellini's *St. Francis in the Desert* over the centuries culminated in Henry Clay Frick's purchase of this masterpiece of Renaissance painting. Viewers and scholars have long puzzled over the meaning of this spectacular picture, but its power and beauty are unquestioned, and the panel has been a sacred treasure at the Frick for generations. A meticulous and thought-provoking reconsideration of scholarship past and present, this book— the result of an unprecedented technical study of the painting undertaken at the Metropolitan Museum of Art—brings together the findings of leading experts in the fields of paintings conservation, Venetian art, the history of collecting, and Franciscan thought.

We are very grateful to the Andrew W. Mellon Foundation and the Gladys Krieble Delmas Foundation for their support of the technical and historical investigation of *St. Francis*. Thanks also go to my eminent predecessor, Anne Poulet, as well as to Colin B. Bailey, Director of Museums, Fine Arts Museums of San Francisco, and former Deputy Director and Peter Jay Sharp Chief Curator at the Frick.

A great many individuals have contributed to this study. We wish to acknowledge Denise Allen, Curator in the Department of European Sculpture and Decorative Arts at the Metropolitan Museum of Art and former Curator at The Frick Collection, who conceived and wisely guided the project and also contributed to the catalogue. Most of all, our deep appreciation goes to Susannah Rutherglen, an Andrew W. Mellon Pre-Doctoral Curatorial Fellow at the Frick from 2009 to 2011, and Charlotte Hale, Paintings Conservator at the Metropolitan Museum. As the principal authors and general editors, their contributions have been marked by exemplary dedication and meticulous scholarship, and we are profoundly grateful. For their enlightening scholarship, we also extend our deep appreciation to the other contributors: Keith Christiansen, John Pope-Hennessy Chairman, Department of European Paintings, the Metropolitan Museum of Art, who wrote the eloquent foreword; Michael F.

Cusato, O.F.M., Distinguished Professor of History, St. Bonaventure University, and former Director of its Franciscan Institute, St. Bonaventure, New York; Anne-Marie Eze, Consulting Curator at the Isabella Stewart Gardner Museum, Boston; Joseph Godla, Chief Conservator at the Frick; and Raymond Carlson, Ph.D. student at Columbia University. Katie Steiner and Caitlin Henningsen, former Curatorial Assistants at the Frick, made numerous contributions to the project. Others on the Frick staff whose efforts are to be commended include Xavier F. Salomon, Peter Jay Sharp Chief Curator; Julia Day, Associate Conservator; Rika Burnham, Head of Education; and Michael Bodycomb, Head of Photography and Digital Imaging. Finally, I would like to acknowledge the excellent work of Michaelyn Mitchell, Editor in Chief, and Hilary Becker, Assistant Editor, as well as the Frick's former Editor in Chief, Elaine Koss. The collaboration that gave rise to this volume is a cause for celebration, as is the fresh opportunity it affords to admire and reflect upon this masterpiece by Giovanni Bellini.

Ian Wardropper
Director, The Frick Collection

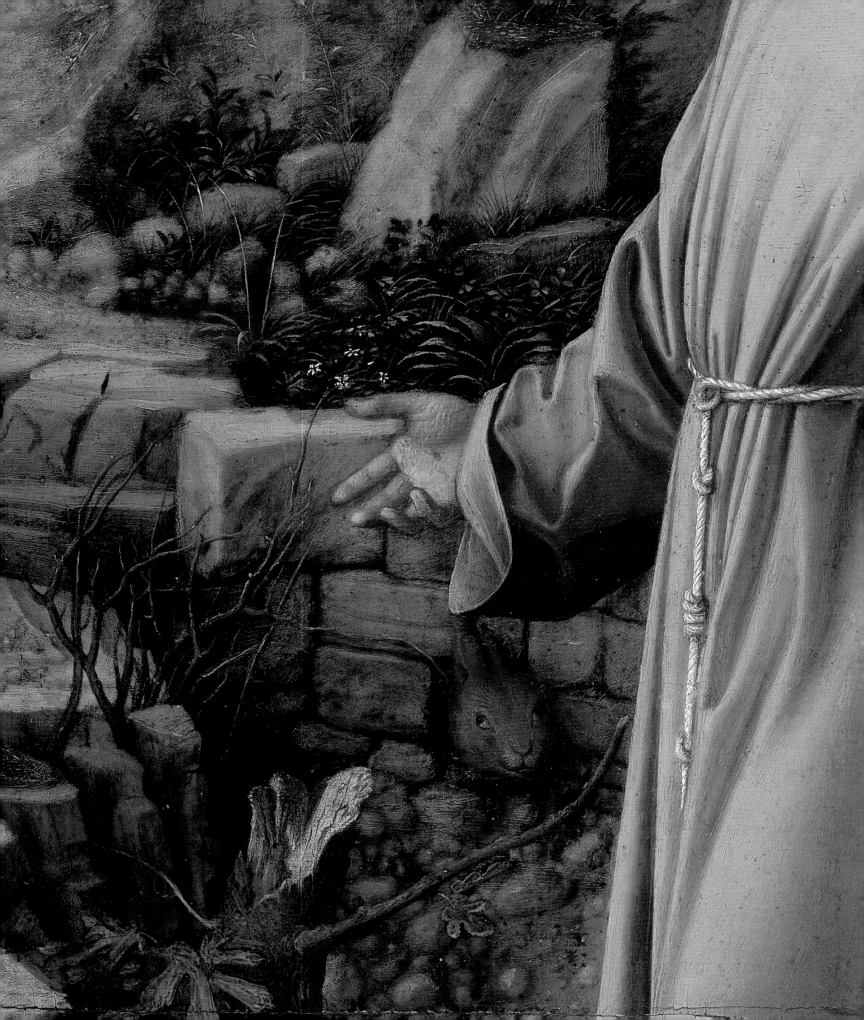

ACKNOWLEDGMENTS

It is an honor to thank the many people who have contributed to this collaborative study of Giovanni Bellini's masterpiece. Denise Allen, Curator in the Department of European Sculpture and Decorative Arts at the Metropolitan Museum of Art and former Curator at The Frick Collection, first envisioned a new inquiry into *St. Francis* and then guided the project with insight and erudition. Her dedicated mentorship and generosity have inspired this endeavor at every stage.

The technical and historical investigation of *St. Francis* was supported by the Andrew W. Mellon Foundation and the Gladys Krieble Delmas Foundation. We are grateful to Ian Wardropper, Director of the Frick; Anne Poulet, former Director; Colin B. Bailey, former Deputy Director and Peter Jay Sharp Chief Curator; and Xavier F. Salomon, Peter Jay Sharp Chief Curator, for encouraging this work as it developed from initial research and technical examination into the present book. Our profound thanks are due to Susan Grace Galassi, Margaret Iacono, Charlotte Vignon, Joseph Godla, Julia Day, Rika Burnham, Michael Bodycomb, and Inge Reist for sharing their incomparable knowledge of the painting and offering advice and support. This study would not have been possible without the contributions of Caitlin Henningsen, Nicholas Wise, and especially Katie Steiner, who coordinated countless aspects of the long-term inquiry with unsurpassed skill and commitment. Raymond Carlson, Eric Hupe, and Grant Johnson provided valuable research assistance. We are indebted to Elaine Koss, Giulia Di Filippo, and Alison Lonshein for organizing the early phases of editing and publication. Michaelyn Mitchell, Editor in Chief, and Hilary Becker, Assistant Editor, brought the volume to realization with patience and outstanding expertise.

The technical examination of *St. Francis* has been a joint effort of The Frick Collection and the Department of Paintings Conservation of the Metropolitan Museum of Art, with analyses undertaken by the Department of Scientific Research. Michael Gallagher, Sherman Fairchild Conservator in Charge of Paintings Conservation at the Metropolitan, deftly coordinated the technical investigation and interpretation of the results. The authors acknowledge the essential contributions of George Bisacca and Michael Alan Miller, in conducting the study of the panel support, and Julie Arslanoglu, Silvia A. Centeno, and Mark T. Wypyski of the Department of Scientific Research, in their work on the analyses. Thanks also to Sarah Kleiner for assistance with technical imaging and Evan Read for the illustrations. Keith Christiansen, John Pope-Hennessy Chairman, Department of European Paintings, led the observation and discussions of the picture with unmatched enthusiasm, knowledge, and generosity.

This research has been immeasurably enriched by the contributions of partici-pants in the study day devoted to Bellini's painting in March 2010: Maryan Ainsworth,

St. Francis in the Desert, detail

Carmen Bambach, Andrea Bayer, Luke Syson, and Dorothy Mahon (The Metropolitan Museum of Art); Barbara Berrie and Elizabeth Walmsley (National Gallery of Art, Washington, D.C.); and Rachel Billinge and Jill Dunkerton (The National Gallery, London). Throughout the project, these experts have shared their time and assistance and offered much new information about works by the artist. We are grateful to Giovanni C. F. Villa and Gianluca Poldi, experts on Bellini's technique, who have been unfailingly generous in sharing observations, ideas, photography, and technical images. Carolyn Wilson imparted her extensive knowledge of the painter and provided new resources and scholarly findings. We would like to extend special thanks to the anonymous descendant of the Boucher-Desforges family who granted permission to publish recently discovered documents pertaining to the nineteenth-century provenance of *St. Francis*.

The comparative study of paintings by Giovanni Bellini and other artists was made possible by scholars, curators, and conservators at many institutions: Jaynie Anderson and Jane Brown (University of Melbourne); Antonio Natali (Galleria degli Uffizi, Florence); Marzia Casini, Elena Cappelletto, Andrea Brambillasca, and Elisa Viola (Banca Popolare di Vicenza); Francesca Franciolini and Lucia De Ranieri (Palazzo Corsini, Florence); Luisa Gusmeroli, Cecilia Frosinini, and Roberto Bellucci (Opificio delle Pietre Dure, Florence); Angela Cerasuolo and Marina Santucci (Museo di Capodimonte, Naples); Matteo Ceriana and Gloria Tranquilli (Gallerie dell'Accademia, Venice); Melissa Conn (Save Venice, Inc.); Susy Marcon (Biblioteca Nazionale Marciana, Venice); Fra Pacifico Sella (Curia Provinciale, Provincia Veneta di Sant'Antonio dell'Ordine dei Frati Minori, Marghera); Frederick Ilchman (Museum of Fine Arts, Boston); Alessandro Martoni, Franco Novello, and Marta Zoppetti (Fondazione Giorgio Cini, Venice); Babette Hartwieg and Claudia Laurenze-Landsberg (Gemäldegalerie, Berlin); Nancy Ireson, Aviva Burnstock, and Genevieve Silvester (Courtauld Gallery, London); Caroline Campbell (The National Gallery, London); Arabella Chandos and Rosie O'Reilly (Sotheby's, London); Edye Weissler (Knoedler Gallery archive, formerly New York); and Deirdre Larkin (The Cloisters, The Metropolitan Museum of Art, New York).

Julie Ludwig and Susan Chore of The Frick Collection and Frick Art Reference Library Archives provided valuable guidance in interpreting documents related to Henry Clay Frick's acquisition of *St. Francis* in 1915. Stephen Bury, Suz Massen, Elizabeth Lane, and the entire staff of the Frick Art Reference Library deserve heartfelt thanks for their patient and expert assistance with countless research inquiries. Additional thanks are due to the staff of the Marquand Library of Art and Archaeology of Princeton University and the Biblioteca Nazionale Marciana and Biblioteca San Francesco della Vigna, Venice.

Lisa Candage, Vivian Gill, Floyd Sweeting III, and the staff of the Information Technology and New Media Department of The Frick Collection generously collaborated to create the first digital presentations in the galleries for the exhibition of *St. Francis* in the spring and summer of 2011. Stephen Saitas together with Adrian Anderson and Anita Jorgensen created the beautiful installation of the painting in the Oval Room. We would like to thank those who contributed expertise and support to the exhibition: Hester Diamond, Rosayn Anderson, Diane Farynyk, Allison Galea, Rebecca Brooke, Heidi Rosenau, Galen Lee, Nathaniel Silver, Adrienne Lei, Anna Finley, Viktorya Vilk, Joanna Sheers, Aimee Ng, Elyse Nelson, and Ellen Prokop.

The greatest pleasure of this research has been sharing conversations about Giovanni Bellini and Franciscan art with scholars who have also offered their advice and resources: Joanne Allen, William Barcham, Paul Barolsky, Marisa Bass, Louise Bourdua, Ruth Chavasse, Nicole Chirici, Donal Cooper, Tracy Cooper, Giada Damen, Eric Denker, Colin Eisler, Holly Flora, Leonardo Franceschi, Mary Frank, Laura Giles, Nora Hamerman, Johanna Heinrichs, Deborah Howard, Peter Humfrey, Janna Israel, Norman Land, Rosella Lauber, Ralph Lieberman, Blake de Maria, Sarah Blake McHam, Mary McKinley, Kathryn Blair Moore, Susan Nalezyty, Daniel Ortiz, Debra Pincus, John Portmann, David Rosand, Betsy Rosasco, Monika Schmitter, Anne Markham Schulz, Carey Seal, Xavier Seubert, Maddalena Signorini, and Krystina Stermole. Special gratitude is owed to Daniel Wallace Maze for his archival guidance, editorial advice, and many insightful discussions of the Bellini family and Venetian Renaissance society. The volume was completed in the welcoming community of the University of Toronto, with thanks to Philip Sohm, Angela Glover, Lynne Magnusson, Matthew Kavaler, Giancarla Periti, and Christy Anderson. We are indebted to Raina Lipsitz, John Lipsitz, and Maria Scrivani for their warm hospitality. Our deepest thanks go to Eric Switzer, George Rutherglen, Jessica Feldman, Michael Rutherglen, and Andrew and Sadie Bergen.

This study has been shaped by the exemplary knowledge and generous guidance of David Alan Brown, Curator of Italian and Spanish Paintings at the National Gallery of Art, and Patricia Fortini Brown, Professor Emerita in the Department of Art and Archaeology of Princeton University, who deserve gratitude for their illuminating scholarship and support as mentors to students of Venetian Renaissance art.

Susannah Rutherglen and Charlotte Hale

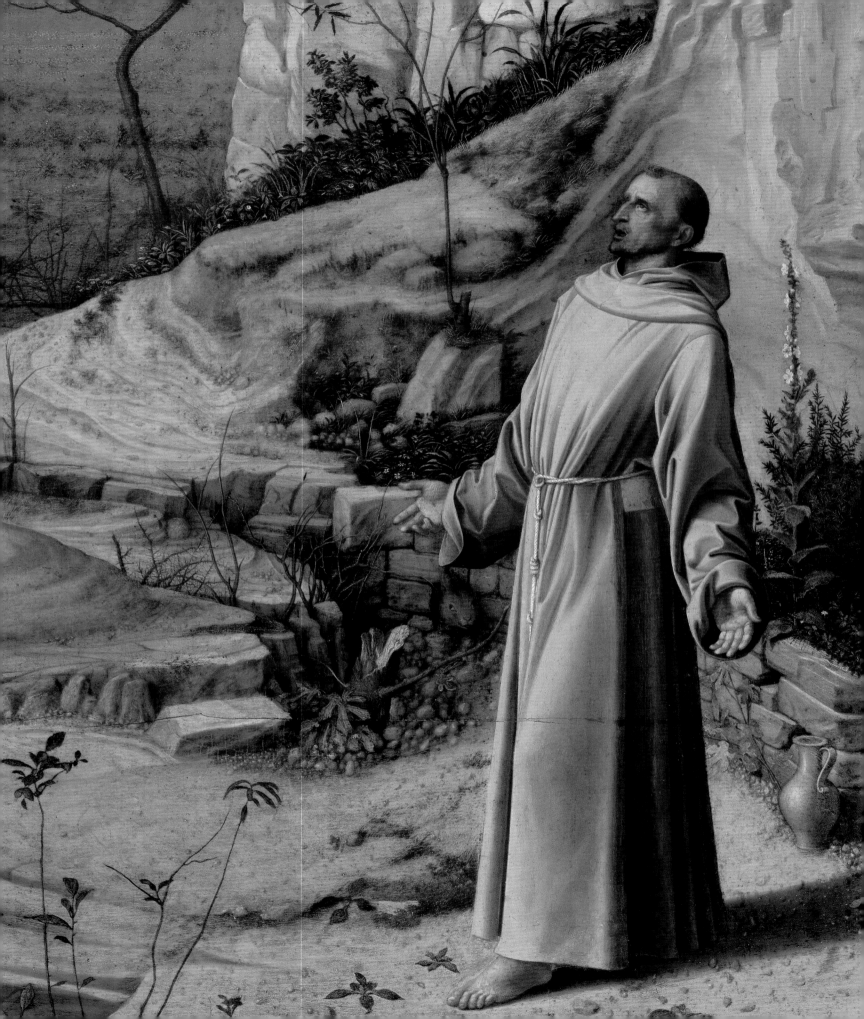

"THE FOOTPRINTS OF OUR LORD": GIOVANNI BELLINI AND THE FRANCISCAN TRADITION

by Susannah Rutherglen

A lone figure meets the light. Eyes raised, mouth parted, and arms extended, he appears caught in a singular experience of mystical transport. We might mistake him for a nameless friar, if not for his astonishing attitude—humble receptiveness mingled with divine exaltation—and the red marks on his hands and foot.[1] Here stands Francis of Assisi (1181/82–1226), the most beloved saint of western Christianity. Founder of an international religious order dedicated to the virtues of poverty, chastity, and obedience, this holy man has achieved perfect identity with the life and sufferings of Christ, manifest in the stigmata: the miraculous imprint of the wounds of the Crucified.

Francis has retreated in seclusion to a rocky wilderness, yet he wears the brown habit that signals membership in his mendicant brotherhood, the Order of Friars Minor. His sandals lie discarded on the earthen floor of his temporary shelter. Having risen from his devotions and exited his cell, the saint seems to be following in "the footprints of our Lord Jesus Christ," as he once enjoined the brethren to do.[2] His gaze is fixed on a golden radiance issuing from the sky and on an overgrown laurel tree, whose sinuous trunk and shining leaves bend and twist toward him. A donkey, patient witness to his master's supernatural transformation, perks his ears attentively; nearby, a gray heron perches in elegant profile on a narrow outcrop of stone, and a rabbit peers inquisitively from a low masonry wall.

Only one other human figure populates the saint's solitude: the distant shepherd who has paused from tending his flock to glance hauntingly in our direction (see fig. 41). He belongs to the landscape of cliffs and fields that embraces Francis, then unfolds beyond him into a depthless panorama of interleaved brown, blue, and green. From the harsh surroundings of the saint's rural hermitage to the gentle terraced hills beyond the walled town, plants of every kind have taken root—wild and cultivated, budding and dormant—an abundant view of nature that encompasses the seasons of birth, growth, death, and regeneration.

For more than five centuries, the vast world of this panel painting by the Venetian Renaissance master Giovanni Bellini (c. 1424/35–1516) has captivated beholders, the beauty of its setting and the rich density of its composition matched only by the puzzle of the artist's intentions. Has Bellini represented the moment of Francis's stigmatization, when a vision of Christ in the form of a six-winged seraph affixed to a cross impressed the five wounds of the Passion on his hands, feet, and chest? If so, why are traditional elements of the miracle absent: the angel and cross, the linear rays connecting them to the kneeling saint, his upraised arms, and the gash of the lance in his side (fig. 1)?[3] Has the painter captured a different episode from Francis's life, perhaps his singing of a canticle in praise of God's Creation? Does the scene correspond to any single narrative,

St. Francis in the Desert, detail

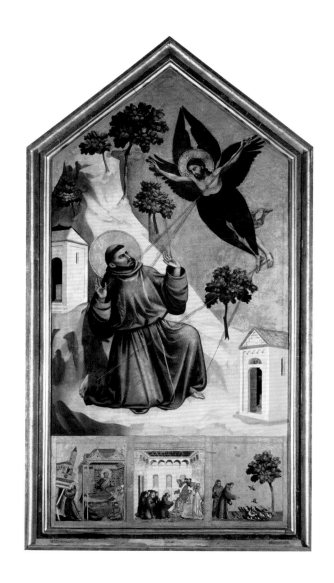

Fig. 1. Giotto di Bondone (c. 1266/67–1337), *Stigmatization of St. Francis and Scenes from His Life*, c. 1297–1300. Tempera on panel, 313.5 × 162.5 cm. Département des Peintures, Musée du Louvre, Paris

Fig. 2. Giovanni Bellini, *Madonna and Child*, c. 1485–90. Oil on panel, 88.9 × 71.1 cm. The Metropolitan Museum of Art, New York; Rogers Fund (1908)

or is it an allusive visual poem that weaves together many aspects of the saint's character and biography?[4] Could each of the picture's manifold details carry symbolic meaning,[5] or is the subject of Francis merely a pretext for an unusually elaborate landscape, among the first of its kind in Italian Renaissance painting?[6]

The bafflement surrounding Bellini's panel is reflected in the variety of titles bestowed on it over time, from *St. Francis in the Desert*[7]—first proposed in the early sixteenth century when the painting was on display in a Venetian palace (see fig. 21)—to *St. Francis Receiving the Stigmata*,[8] *St. Francis in Ecstasy*,[9] *St. Francis's Hymn to the Sun*,[10] *St. Francis before His Cell Singing Praises to the Highest*,[11] *St. Francis in a Landscape*,[12] *St. Francis as the Angel of the Sixth Seal*,[13] and *The Joy of St. Francis*.[14] In 1857, the picture appeared at the celebrated *Art Treasures* exhibition in Manchester, England, with the catalogue title *St. Francis in the Desert*, followed by a brief description: "The Saint stands in front of his Cell in the attitude of receiving the Stigmata."[15] This suggestive account inspired the connoisseur Giovanni Battista Cavalcaselle, who had studied Bellini's painting carefully at Manchester. His *History of Painting in North Italy* of 1871, written with Joseph Archer Crowe, describes "St. Francis coming out of a bower, to receive the stigmata" and standing "in a condition of momentary pain in the foreground of a valley enlivened

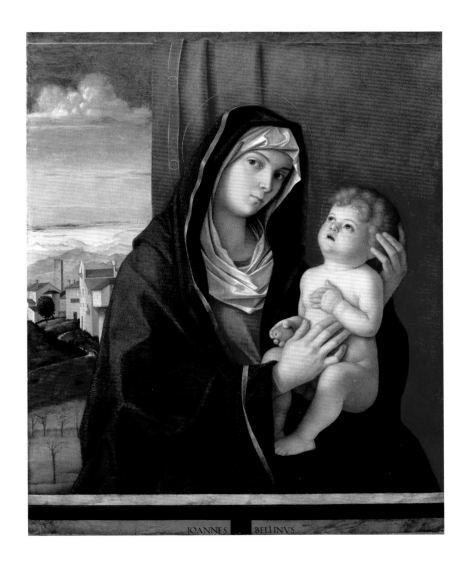

with minutiae of every imaginable kind."[16] When the dealers Colnaghi and Knoedler acquired Bellini's painting in 1912, they too echoed the Manchester catalogue, recording the title *St. Francis of Assisi, Standing before His Cell in the Attitude of Receiving the Stigmata*. After a brief stint in an English private collection, however, the work re-entered the art market in 1913 under yet another name, *St. Francis of Assisi, Standing before His Cell in the Attitude of Prayer*.[17] Upon purchasing the picture in 1915, Henry Clay Frick titled it simply *St. Francis of Assisi* in his personal records,[18] a straightforward designation favored by many subsequent scholars.[19]

In 1963, the distinguished art historian Millard Meiss first proposed an influential interpretation of Bellini's masterpiece and its elusive theme.[20] He suggested that the artist had recast the stigmatization of Francis in poetic and transcendent terms, by replacing the traditional seraphic crucifix with an extraordinary pictorial light that is the source and agent of the saint's wounds (see fig. 59). The golden effulgence at the panel's upper left corner was, he argued, the symbol of an "unseen power" that miraculously sealed Francis's flesh with the stigmata and transformed him into the likeness of God incarnate. Bellini's spreading landscape supplied a natural receptacle for this hallowed light, drawing all of Creation into ecstatic transfiguration.

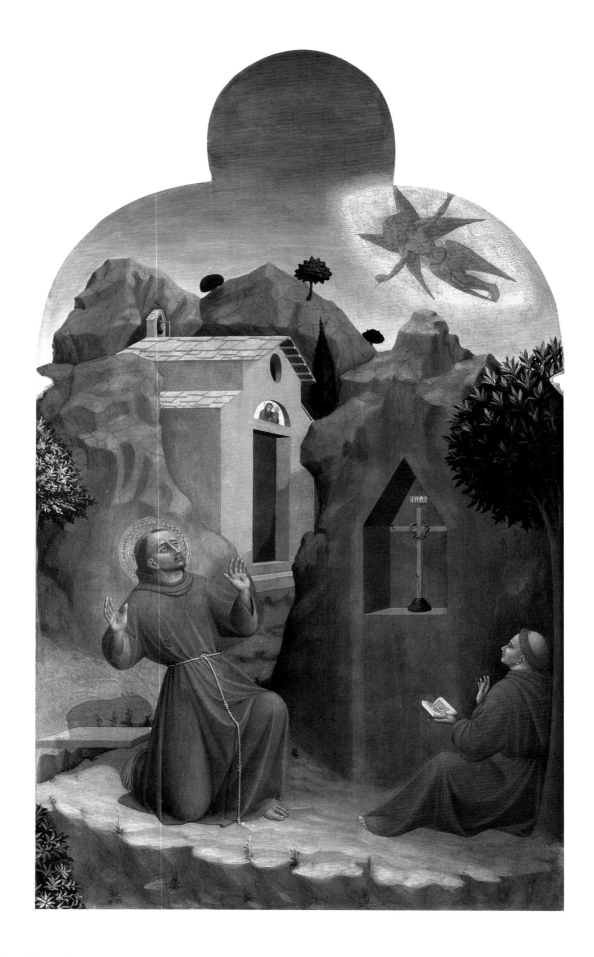

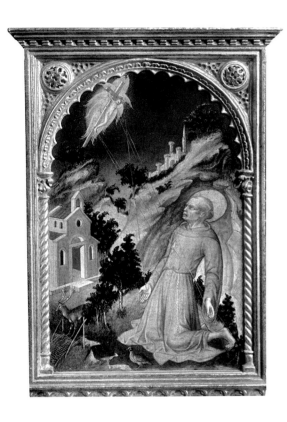

Fig. 3. Sassetta (Stefano di Giovanni, c. 1400–1450), Borgo San Sepolcro altarpiece (detail, *Stigmatization of St. Francis*), 1437–44. Tempera on panel, 89.6 × 54.4 cm. The National Gallery, London; bought with contributions from the National Art Collections Fund, Benjamin Guinness and Lord Bearsted, 1934 (NG4760)

Fig. 4. Michele Giambono (c. 1400–1462), *Stigmatization of St. Francis*, c. 1430–35. Tempera on panel, 60 × 38 cm. Formerly collection of Count Vittorio Cini, Venice

Meiss's study of *St. Francis* centered on a perceptive discussion of the panel's technique and dating and of the artist's sources and symbolism. It was the concept of a "stigmatization by light," however, that immediately incited debate and shaped all subsequent readings of the picture.[21] The argument was not as radical as it may first have appeared: golden light is an important element of Italian stigmatization scenes from the thirteenth century onward (fig. 3 and see fig. 1).[22] Moreover, at least one Venetian precedent exists for the presentation of Francis extending his hands downward to receive Christ's wounds, an otherwise unusual posture in imagery of the miracle (fig. 4).[23] Nonetheless, some experts correctly observed that the Frick painting had been cut along its top horizontal edge: perhaps, contrary to Meiss's belief, Bellini actually *had* included a conventional seraph that was later removed upon cropping of the panel.[24]

Scholars also took issue with Meiss's readings of texts associated with St. Francis. In his book of 1982, *From Bonaventure to Bellini*, John Fleming marshaled the tradition of Franciscan thought against the notion that the artist had depicted the stigmatization. In his view, the image did not transcribe any one event but was instead a compendium of biblical ideas and a visual manifestation of the saint's identity as a second Moses, Elijah, and Christ. Treating the picture as a form of scriptural exegesis, Fleming considered each element of the scene in relation to Franciscan theological writings that embedded the medieval saint in the scheme of biblical history.[25] He gave particular attention to a passage from the Book of Revelation that describes the coming of an angel bearing the seal of the living God (7:2–3), lines interpreted by St. Bonaventure and other Franciscans as a prophecy of their stigmatized leader. Fleming argued that Bellini, too, had portrayed the saint as the apocalyptic "Angel of the Sixth Seal."

Since the landmark contributions of Meiss and Fleming, scholars have identified additional texts to which the painting may be indebted and have attended to the work's local religious background.[26] In 2007, Marilyn Lavin situated the panel within the spiritual and cultural history of the island of San Francesco del Deserto in the Venetian lagoon, which the saint himself was said to have visited during his lifetime (fig. 5 and see fig. 24).[27] Focusing on the island's revitalization during the mid-fifteenth century, Lavin wove ancient legends, contemporary pious practices, and political events into a compelling interpretation of *St. Francis* and its many details. Others have addressed the genesis, provenance, and evolving significance of Bellini's masterpiece. In a pioneering article of 1972, Jennifer Fletcher established the patronage and early history of *St. Francis* and first connected the painting to religious activity at San Francesco del Deserto.[28] More recently, Rosella Lauber has made further crucial discoveries regarding the picture's cultural setting and record of ownership.[29]

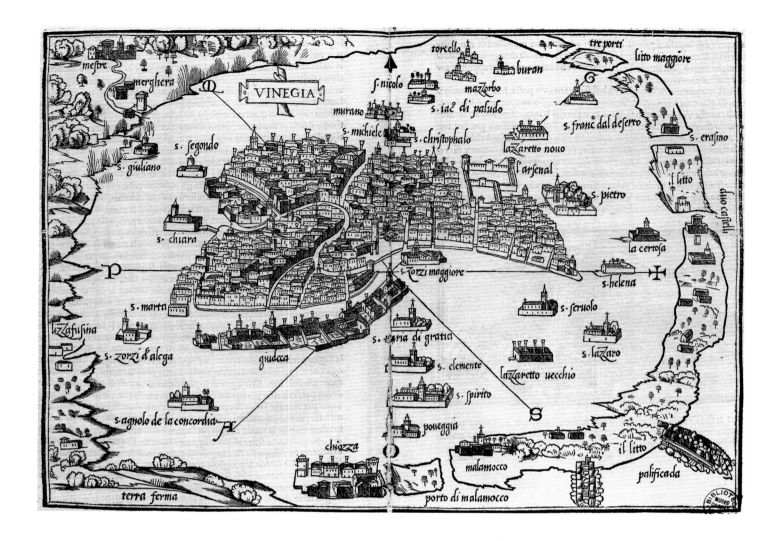

Fig. 5. Benedetto Bordone (act. 1488–1530), *Vinegia*, from *Libro di Benedetto Bordone nel Quale si Ragiona di Tutte le Isole del Mondo con li loro Nomi Antichi e Moderni . . .* , ff. 29v.–30r., 1534 (first ed. 1528). Woodcut, 22.9 × 32.8 cm. Biblioteca del Museo Correr, Venice. This is among the earliest representations of the city of Venice to show the islands of the lagoon, including San Francesco del Deserto in the northeast corner.

The many voices of scholarship from the sixteenth century to the present day agree on a fundamental point: that the Frick *St. Francis* constitutes one of the supreme statements of Franciscan spirituality of the Italian Renaissance. Yet little consensus exists about the sources and subject of the work, the messages it was intended to convey, the impetus for its creation, or even its original function and the setting in which it was first seen. The studies in this volume promise answers to some questions, while also opening new paths of historical investigation and fresh possibilities for interpretation.

Mysteries and Visions: Giovanni Bellini and Franciscan Art

Known to his contemporaries as "Zuan Bellino" or "Giambellino," Giovanni Bellini often signed his pictures on illusionistic slips of paper, or *cartellini*, with the Latin name "Ioannes Bellinus" (fig. 6).[30] He left few biographical traces, and questions remain about his date of birth and family relationships.[31] Surviving references to the master, however, reveal that he was celebrated in his lifetime. An ambassador of the Venetian Republic called him "the first painter in Italy," and humanists compared him to the fabled artists of antiquity.[32] The inscriptions on his portrait medal praise "Giovanni Bellini, Venetian, the best of painters / Of virtue and inventiveness" (fig. 7) while the

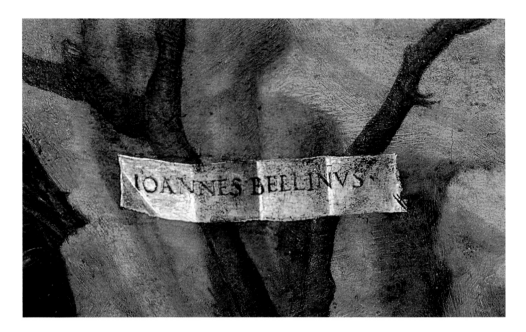

Fig. 6. *St. Francis*, detail of the artist's signature at lower left

Fig. 7. Camelio (Vettor di Antonio Gambello, c. 1455/60–1537), portrait medal of Giovanni Bellini, c. 1490–1500. Cast bronze, 5.9 cm diameter. Inscriptions: IOANNES BELLINVS VENET[us] PICTOR[um] OP[timus] (obverse), VIRTVTIS E[t] INGENII / VICTOR CAMELIVS FACIEBAT (reverse). The British Museum, London; purchased with the assistance of the National Art Collections Fund

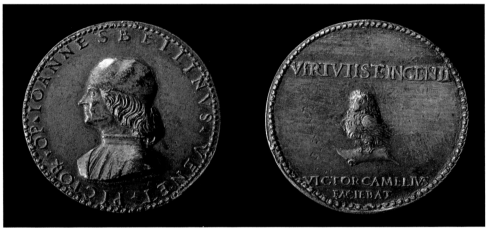

civic diarist Marin Sanudo bestowed on him the same title, "optimo pytor," upon his death in 1516.[33] Throughout his long career, Bellini and his workshop created altarpieces for prominent churches in and beyond Venice; narrative paintings to adorn the Republic's government and confraternity halls; religious and mythological works for discerning patrons of northern Italian courts; and countless images of the lives of Christ, Mary, and saints for personal prayer and contemplation. The artist excelled in portraiture and classical subjects, and his pictures served a privileged role as diplomatic gifts to foreign rulers.[34]

Bellini is still renowned today as the founder of Venetian Renaissance painting, a pioneer who married the exquisite courtly style and naturalistic imagination of his father and teacher, Jacopo (c. 1400–1470/71), with the poetic colorism that would characterize the achievements of his successors, Giorgione (c. 1476/78–1510) and Titian (c. 1488–1576). An attentive student of the artistic past, Giovanni was also in the vanguard of compositional ideas and painting techniques; a devotional master who embraced pious themes such as the Madonna and Child (see fig. 2), he proved

endlessly creative and expressive within his chosen repertoire. Bellini rarely if ever ventured beyond the Veneto, yet he welcomed the influences of Byzantine, central Italian, and northern European art that entered his cosmopolitan city. The luminous surfaces of his paintings enchant the eye, but his works also offer erudite contributions to humanist and theological discourse. *St. Francis*, possessed of both the dignity of tradition and the drama of imaginative novelty, exemplifies the harmonious oppositions that energize Bellini's art.

This essay takes the enigma of *St. Francis* as a tantalizing point of departure, asking how Bellini's achievement fits into a broader artistic legacy. Partly as a consequence of its celebrated singularity, the picture has not been fully considered within the rich history of paintings, sculpture, and architecture commissioned by the Franciscans or dedicated to their founder. It is by way of the artist's sophisticated response to tradition, however, that one might arrive at a true apprehension of his originality. Bellini's native republic was steeped in the cultural influence of the mendicant orders, and the qualities of difficulty and creative innovation so often observed in the Frick panel are in fact defining characteristics of Franciscan art from its beginnings.

St. Francis harks back to the earliest representations of the stigmatization in thirteenth-century Italian painting, which are permeated with ambiguity and divergent in their descriptions of the miracle. In these works, the seraphic crucifix varies in form and does not always deliver the saint's wounds, while Francis himself is often missing one or more of the sacred marks. Like Bellini's panel, these iconographically unstable images serve to emphasize the mystery of the stigmata.[35] The painting also relates to another profoundly enigmatic strain of Franciscan art, depictions of visions and ecstasies: in the Upper Church of San Francesco at Assisi, for example, many of the twenty-eight early frescoes of the saint's legend narrate dreams and apparitions, anticipating the visionary rapture of Bellini's figure (fig. 8).[36] While the Venetian painter probably would not have seen such models directly, his work belongs to a shared artistic genealogy originating with St. Francis himself, whose conversion was sparked by a miraculously speaking picture and whose piety was charged with symbols and images.

Bellini's picture engages more deeply with the Franciscan visual past than has been recognized; at the same time, the work's novelty is an aspect of its mendicant heritage. The Friars Minor were an engine of cultural innovation that encouraged the development of new imagery, stylistic approaches, and pictorial formats in Italian art. In his seminal study of 1885, Henry Thode argued that Franciscan thought and practice gave rise to an unprecedented realism and expressiveness in the visual arts and that by embracing the physical world as evidence of God's design, the saint and his followers

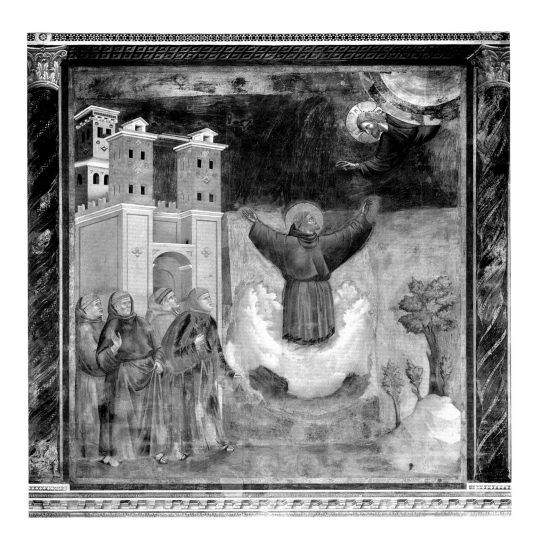

inspired vivid and attentive representations of nature. Although *St. Francis* postdates
Thode's period of focus, the action of Bellini's figure and the extraordinary landscape
surrounding him offer powerful support for this historical thesis.[37] As prolific patrons
of the arts throughout the late Middle Ages and Renaissance, the Franciscans also
fostered new genres of panel painting and the creation of dramatic narratives of
Christ's Passion that emphasized his humanity and physical suffering.[38] Here, too,
St. Francis rewards consideration within the friars' legacy of invention. Acclaimed in his
own time as a learned master who embraced multivalence and ambiguity in works
that challenged conventions of genre and subject, Bellini was highly receptive to the
imaginative possibilities of the Franciscan tradition.[39]

Franciscus alter Christus: The Saint in Art and History

Francesco di Bernardone was born in late 1181 or early 1182 to a prosperous cloth
merchant of Assisi, a thriving town of ancient Roman origin located on the slopes of
Mount Subasio in Umbria. He enjoyed a carefree and extravagant youth typical of the
emerging lifestyle of Europe's commercial classes at the dawn of capitalism.[40] Around
age twenty, however, and during the civil war between his hometown and nearby
Perugia, Francis was taken captive and became gravely ill. After his release from prison,

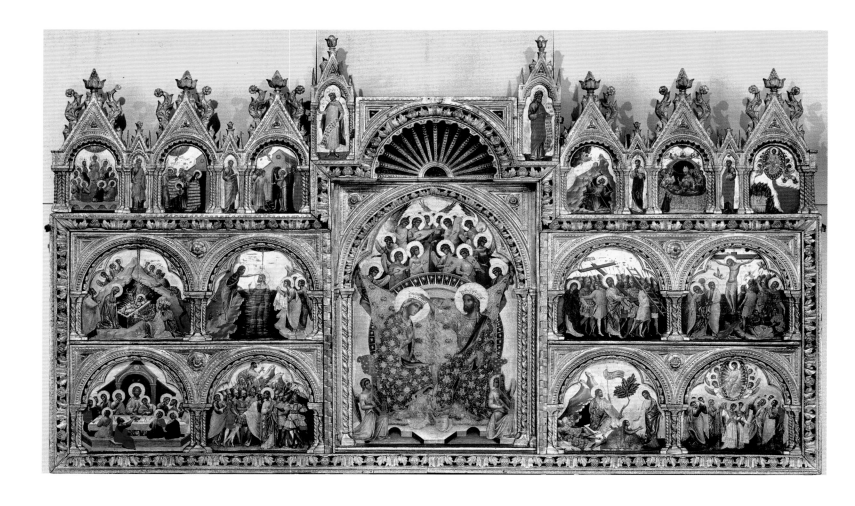

Fig. 9. Paolo Veneziano (act. 1333–58/62),
Santa Chiara altarpiece, c. 1350–55.
Tempera on panel, about 250 cm wide.
Gallerie dell'Accademia, Venice

he experienced a moving encounter with lepers, followed by a series of divine visita-
tions. As he prayed at the ruined church of San Damiano near Assisi, a Romanesque
painted crucifix came to life and addressed him by name, declaring, "Francis, go rebuild
My house; as you see, it is all being destroyed."[41] The young man's powerful response to
a work of art at this pivotal moment set the course of his life and Order, and the episode
would therefore establish the central role of images in Franciscan spirituality.[42]

On his mission to rebuild the Church, Francis rejected the social premises of his
privileged upbringing and wed Lady Poverty. As a holy man who reputedly gathered
twelve disciples around him, the saint was distinguished less by the miracles he
wrought than by his strict devotion to the literal dictates of the Scriptures: a commit-
ment to "performing the Gospel life" through his very words and deeds, including the
renunciation of all personal property and the assumption of an itinerant life of peni-
tence and preaching to all levels of society.[43] Francis's aversion to material wealth—he
was popularly called Il Poverello, or "the Little Poor One"—mirrored his love for his fellow
human beings and the natural world, which together with his artistic and lyrical
temperament found voice in his vernacular praise of God, the *Canticle of the Creatures*.[44]

Around 1210, Francis and his motley companions traveled to Rome, where they
received provisional approval of their governing Rule from Pope Innocent III. Under
Church protection, the Franciscans quickly multiplied to become one of the major
mendicant orders of the later medieval period.[45] The thirteenth-century mendicant

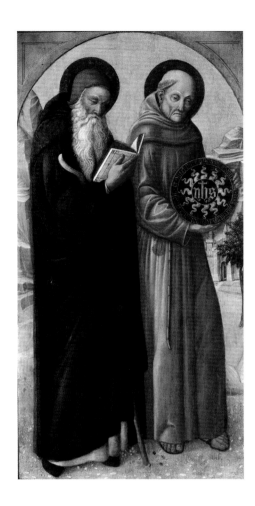

Fig. 10. Jacopo Bellini (c. 1400–1470/71), *St. Anthony Abbot and St. Bernardino da Siena*, c. 1455–60. Tempera on panel, 110 × 57 cm. National Gallery of Art, Washington, D.C.; partial gift of an Anonymous Donor, in Honor of the 50th Anniversary of the National Gallery of Art. This panel probably originally belonged to an altarpiece for the Gattamelata chapel of the Basilica del Santo, Padua. The work was signed in the names of Jacopo, Gentile, and Giovanni Bellini.

orders, including the Franciscans and Dominicans, lived communally and were bound by a strict Rule; but unlike older monastic orders such as the Benedictines and Carthusians, they were not cloistered in monasteries and did not support themselves by renting landed property. Instead, they wandered from town to town, preaching, ministering to the needy, and begging for their livelihood.[46] Whereas the members of monastic orders called themselves monks, followers of mendicant orders were known as friars or brothers. The Franciscans took this humble appellation a step lower and went by the name of Fratres Minores, or "lesser brothers."[47]

The rapid growth of the Franciscans, however, jeopardized their threadbare and peripatetic existence. During his own lifetime, the saint was a despairing witness to the increasing wealth, stability, and institutionalization of his Order.[48] These developments represented a gross violation of his ideals, while also making possible the legacy of Franciscan art and architecture to which the Frick panel belongs. After the Poverello's death, the vast affluence of the Friars Minor was embodied in the basilica constructed at Assisi to house his remains. Tensions between the austere commitments of the early brotherhood and the material demands posed by expansion continued to mount over successive centuries, resulting in the division of the Franciscans into the stricter Observant and more lenient Conventual branches, which officially split into two separate orders in 1517.[49] By this time, Francis's original Rule had long been attenuated, and even the Observants were permitted to live in convents, own personal property, and commission works of art.[50]

In the fall of 1224, during the earliest stages of these troubles, a disheartened Francis had retreated to the remote mountain of La Verna in the Tuscan Apennines (see fig. 76). There he was transformed by the stigmatization into a breathing, speaking reminder of the Crucifixion, just like the painting he had seen at San Damiano years before. As his official biographer St. Bonaventure wrote, Francis "came down from the mountain bearing with him the likeness of the Crucified, depicted not on tablets of stone or on panels of wood carved by hand, but engraved on parts of his flesh by the finger of the living God."[51]

Francis was canonized in 1228—just two years after his death—and for his acts and miracles became known as *Franciscus alter Christus*, or "another Christ." This theme was communicated in early images of the saint, most importantly the frescoes by various artists in the Upper and Lower Churches at Assisi.[52] In Venice, Paolo Veneziano's mid-fourteenth-century polyptych for the church or convent of Santa Chiara eloquently juxtaposes the lives of Francis and Christ (fig. 9).[53] Surrounding the central image of the Coronation of the Virgin are eight large scenes from the Gospels, topped by four

Fig. 11. Jacopo Bellini, *Stigmatization of St. Francis*, drawing album, ff. 64v.–65r., c. 1445. Metalpoint with pen and brown ink on parchment, 42.7 × 29 cm each. Département des Arts Graphiques, Musée du Louvre, Paris

smaller episodes from the legend of Francis and his spiritual sister, Clare. At upper left of center, the saint repudiates his earthly father and removes his garments to reveal his nudity, directly above the baptism of the nude Jesus. At right, key moments from Christ's Passion, the procession to Calvary and Crucifixion, appear below the stigmatization and death of Francis. The artist has established subtle echoes between the two sets of narratives: the cave before which the saint receives the stigmata rhymes with the cave of the tomb in the Resurrection at the foot of the altarpiece, and Christ in the Garden of Gethsemane at lower left is oriented toward Francis on Mount La Verna at upper right. In Paolo's masterful arrangement, the altarpiece's topmost register of four Franciscan scenes is flanked by the Pentecost and Last Judgment at the far left and right ends. Thus, the life of Francis is encompassed within the history of the Church as a whole, from its founding until the apocalypse, and the saint's example of apostolic poverty emerges as the means to salvation upon the second coming of Christ.[54]

The concepts of Francis as *alter Christus* and benevolent intercessor find profound expression in two monumental ensembles created by Giovanni Bellini during the 1470s, the same decade as the Frick *St. Francis*: the Pesaro altarpiece (see figs. 13–16) and the San Giobbe altarpiece (see fig. 18). Long before these epochal commissions,

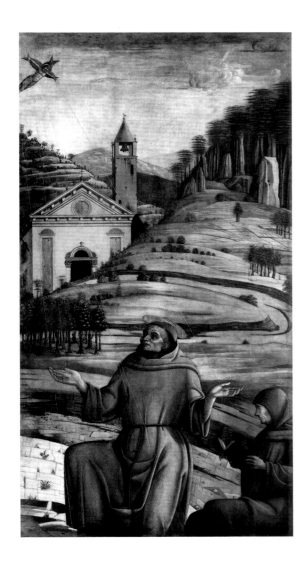

Fig. 12. Gentile Bellini (c. 1429/35–1507), *Stigmatization of St. Francis*, c. 1465. Tempera and oil on canvas, 430 × 210 cm. Chiesetta di San Teodoro, St. Mark's, Venice

which constitute the artist's largest surviving works, Bellini had enjoyed exposure to Franciscan subjects in the atelier of his father, Jacopo.[55] Among Giovanni's formative experiences as a painter were his participation in an altarpiece of c. 1455–60 for the Gattamelata chapel of the basilica of Sant'Antonio di Padova (often referred to as the Basilica del Santo or simply as Il Santo), a major site of pilgrimage and veneration of St. Francis (fig. 10);[56] and a triptych of the Nativity for the Venetian church of Santa Maria della Carità, featuring a full-length figure of Francis.[57] Bellini would also have been familiar with representations of the saint's stigmatization by his father and brother: Jacopo in both of his surviving drawing albums (fig. 11)[58] and Gentile in his organ shutters for St. Mark's Basilica in Venice (fig. 12).[59] When considering Giovanni's education in Franciscan imagery, however, one should recall that he was an ecumenical artist who worked for a variety of mendicant and monastic orders, including the Dominicans, the Augustinians, the Benedictines and their offshoot, the Camaldolese.[60] In his versatile approach to religious commissions, the artist belongs to the tradition of masters such as Giotto, whose sublime paintings still adorn the rival Franciscan and Dominican establishments of Florence.[61]

The Pesaro Altarpiece and Francis as Man of Sorrows

Bellini's first independent Franciscan commission, the *Coronation of the Virgin* for the high altar of the Conventual church of San Francesco in Pesaro, was completed with studio assistance probably between 1472 and 1475 (figs. 13–16).[62] A feat of carpentry that originally stood more than twenty feet high, the altarpiece is dominated by the extraordinary motif of the Virgin and Christ enthroned before a marble portal framing a landscape of castellated hills and sky. Bellini's exceptional design attests to the friars' adventurous spirit of artistic patronage, and both the form and content of the altarpiece convey central themes of Franciscan spirituality that herald the Frick panel.[63]

The Pesaro assembly remains largely intact, missing only its crowning *Entombment of Christ*, today in the Vatican Museums (see fig. 14). This scene of tender mourning sets the minor key of the entire altarpiece, which departs from traditional, celebratory images of Mary's coronation amid a chorus of angels.[64] In the central field, the Virgin closes her eyes and crosses her arms against her breast as she leans deferentially toward her Son, who crowns her Regina Coeli, Queen of Heaven. The idyllic hilltop fortress visible through the aperture of their double throne has been convincingly interpreted as a symbol of the Heavenly Jerusalem.[65] Francis stands at far right, his head encircled by a fine halo, his eyes downcast as he contemplates the sacrifice that has preceded the glorious meeting of Mother and Son in Heaven.

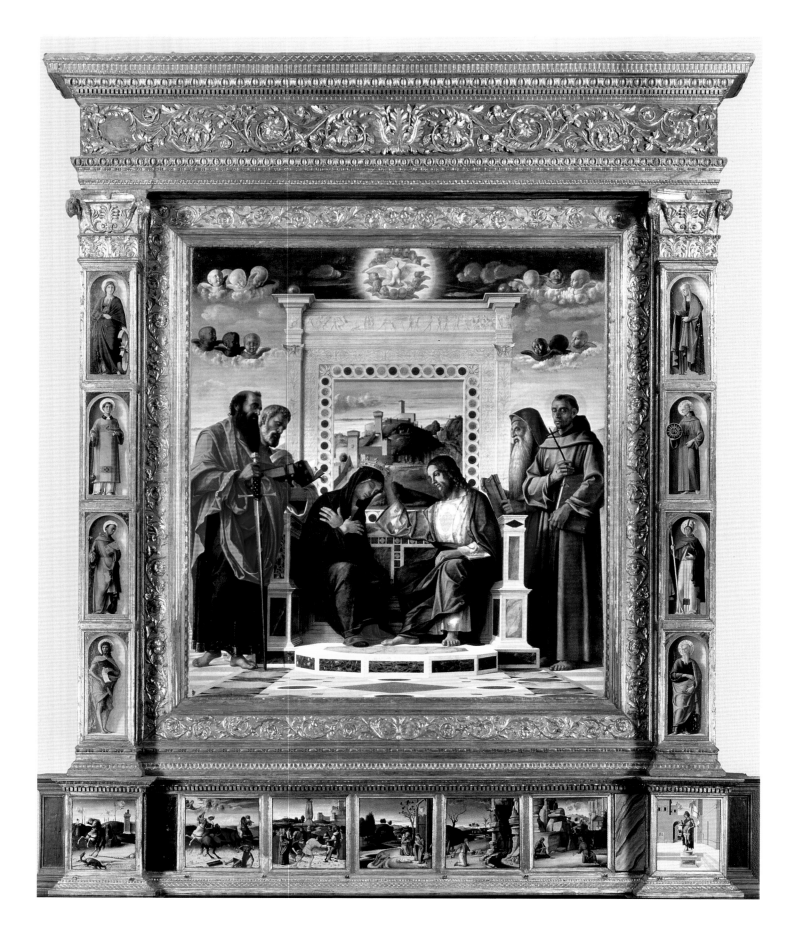

Fig. 13 (opposite). Giovanni Bellini,
Pesaro altarpiece, c. 1472–75. Oil on panel,
630 × 400 × 60 cm. Pinacoteca, Musei
Civici, Pesaro

Fig. 14 (above). Giovanni Bellini,
Entombment of Christ (pinnacle from the
Pesaro altarpiece), c. 1472–75. Oil on
panel, 107 × 84 cm. Musei Vaticani,
Vatican City

Fig. 15 (right). Giovanni Bellini,
St. Bernardino da Siena (detail of right
pilaster, Pesaro altarpiece), c. 1472–75.
Oil on panel, 61 × 25 cm. Pinacoteca,
Musei Civici, Pesaro

This sacrifice is the very subject of the altarpiece's pinnacle (see fig. 14), which evokes the Man of Sorrows, the image of the upright and dead Christ.[66] Joseph of Arimathaea has enshrouded Jesus' body in preparation for burial, Mary Magdalen enfolds his limp hands, and Nicodemus extends a jar of ointment. The three figures attend closely to the punctured left hand of Christ, a palpable reminder of his redemptive suffering. Francis, below, bears the same marks of Crucifixion, signs of his intense personal identification with the afflictions of the Savior. From their respective positions in the main field and *cimasa* of the altarpiece, the saint and the Man of Sorrows mirror each other in a visual expression of their perfect conformity.[67]

Francis's similitude to the crucified Christ reaches its fulfillment in the stigmatization depicted in the predella (see fig. 16). Bellini's essentially canonical representation of this narrative shows the saint kneeling before the rocks of Mount La Verna in the company of his companion and witness, Brother Leo. However, perhaps inspired by his father's rendition of the miracle in his London drawing album, the artist has minimized the rays that conventionally link the saint's stigmata to the red seraphic crucifix above.[68] Only brief splinters of light emanate from Francis's wounds. Bellini has focused less on the mechanics of the miracle than on the saint's somber empathy with the human ordeal of Christ, which pervades the mood of the entire ensemble. In this respect, the Pesaro altarpiece is analogous to early Franciscan mystical writings, in which an excessively literal interpretation of the physical event of stigmatization gives way to an

Fig. 16. Giovanni Bellini, *Stigmatization of St. Francis* (predella of the Pesaro altarpiece), c. 1472–75. Oil on panel, 40 × 42 cm. Pinacoteca, Musei Civici, Pesaro

Fig. 17. Michele Giambono, *Christ as Man of Sorrows with St. Francis*, c. 1420–30. Tempera on panel, 54.9 × 38.7 cm. The Metropolitan Museum of Art, New York; Rogers Fund, 1906 (06.180). Giambono's Man of Sorrows anticipates the gesture of Bellini's St. Francis, with arms fully extended downward and palms facing outward to display the wounds of the Crucifixion. The dead Christ is flanked by a small figure of Francis in prayer as he receives the stigmata in lines emanating from the Savior's wounds.

emphasis on the saint's own sorrowful experience of the Passion: what might be called his interior or spiritual stigmatization.[69]

Early sources record the Poverello's near constant absorption in thoughts of the Lord's sacrifice, his experience of Christ's suffering as if it were taking place before his own eyes. "Carried away above himself" and often unaware of his surroundings, Francis was once discovered by his brothers in the dark of night, suspended in midair as he prayed (see fig. 8).[70] In his *Letter to a Poor Clare*, Bonaventure urges the reader to emulate the saint's contemplative example by entering imaginatively into the wounds of Christ and undergoing the Crucifixion in spirit.[71] From the thirteenth century onward, the Franciscans in Italy had promoted highly graphic, even violent paintings of the Passion narrative as a visual means to die with Christ upon the Cross, inviting the viewer to experience the Lord's anguish in the mind's eye, just as Francis had.[72]

In the Pesaro altarpiece, Bellini dramatically reformulated the triumphant subject of Mary's coronation to express the same principle of Franciscan mystical piety, vicarious participation in the afflictions of Christ's Passion. The Frick *St. Francis*, completed on the heels of the Pesaro commission, takes this concept to an eloquent extreme by presenting the saint himself in the posture of Christ as Man of Sorrows. As Norman Land has demonstrated, Francis's gesture, with arms extended downward at his sides and palms facing outward to display his wounds, echoes a common variant of the theme known as "Cristo Passo" in Venetian sculpture and painting (fig. 17).[73] Bellini's quotation is apt: the Man of Sorrows is a Franciscan subject par excellence that achieves its richest formulation in artistic commissions and charitable endeavors sponsored by the Order.[74] The Frick composition heightens this association by implying that Francis, by virtue of his fervent contemplation of the plight of the Savior, has been suffused with compassionate grief and thus has been spiritually and bodily transformed into a second Man of Sorrows.[75]

Despite his likeness to the dead Christ, however, Bellini's Francis has a strong, upright demeanor and appears to be in a state of rapture, his mouth open in song or a sudden intake of breath.[76] This energetic and emotional stance is unusual in the religious oeuvre of the artist, whose "devotional manner" generally favors holy personages showing solemn restraint (see fig. 2).[77] Bellini has taken care to portray Francis not only as a Man of Sorrows but also as an exultant jester for God, a *novellus pazzus in mundo* or "new fool in the world."[78] A playful poet, singer, and dancer, the Poverello enjoyed a direct and jubilant connection to the divine, as suggested by the many ecstatic visionary experiences recorded in Franciscan legend and art. Early texts emphasize that the exuberant and mournful dimensions of the saint's spirituality were manifest in equal measure as he beheld the seraphic apparition on Mount La

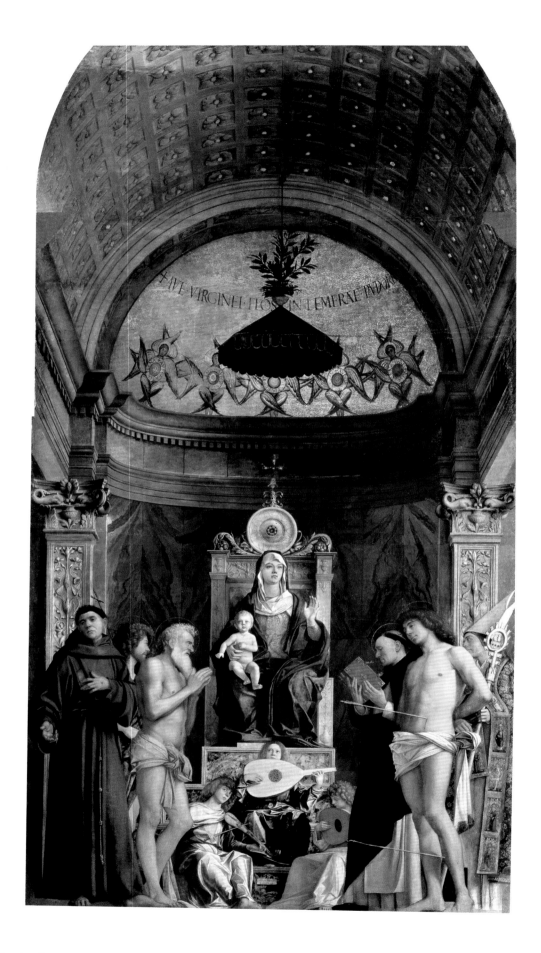

Verna. According to an addendum to the *Fioretti* (*Little Flowers*), a fourteenth-century vernacular compilation of episodes and sayings from the life of Francis:

> On seeing [the seraph], St. Francis was very much afraid, and at the same time he was filled with joy and grief and amazement. He felt intense joy from the friendly look of Christ . . . But on the other hand, seeing Him nailed to the Cross, he felt boundless grief and compassion.[79]

Francis carried in his person the enigma of Christ's sacrifice: it was the cause of the most penetrating grief and also, because it brought about the salvation of mankind, an occasion for surpassing joy. Bellini's highly inventive rendering of the figure captures this paradox with powerful simplicity.

Other elements of the composition, too, communicate the saint's playful character, his affective piety and deeply felt connection to living things. The lovingly described landscape is itself a painted canticle that sings the grandeur and munificence of God's Creation.[80] Bellini has reenacted with his brush Francis's instinctive understanding of animals, endowing the nearby donkey with an alert and gentle intelligence. The whimsical rabbit, who has emerged from his burrow to investigate the activities of his holy neighbor, tempers the gravity of the saint's experience and invites the beholder to regard Bellini's masterpiece not only with seriousness of purpose but also with the Poverello's own joyful innocence.

The multivalent presentation of Francis in the Frick panel suggests an alternate approach to the problem of its relation to the stigmatization narrative. In the Pesaro commission, the artist was more occupied by the metaphorical and internal aspects of this miracle than by its physical workings. *St. Francis*, too, by showing the holy man in a state of sorrow and joy intermingled and by reflecting the varied facets of his personality, suggests that his career was a continual process of "living in and with Christ": a stigmatization of the soul that was capped but not defined by his reception of the outer seal of the Savior's wounds.[81]

The San Giobbe Altarpiece: Observant Franciscan Values in Fifteenth-Century Venice

The Pesaro commission and *St. Francis* presaged Bellini's historic altarpiece for the Observant Franciscan church of San Giobbe in Venice (fig. 18), a work universally praised by early writers on art.[82] Traditionally dated c. 1478–80, this panel inaugurated a magnificent series of paintings by Bellini for the Friars Minor of his native city.[83] Venetians

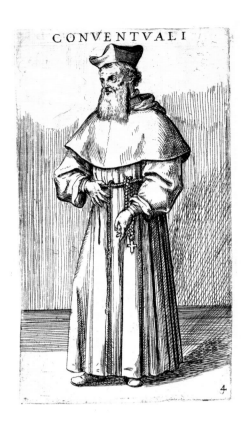

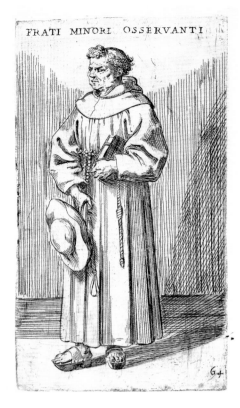

Fig. 19. Odoardo Fialetti (1573–1637/38), *De gli Habiti delle Religioni* . . . (Venice: Marco Sadeler, 1626), ff. 4, 64. Rare Books Collection, Marquand Library of Art and Archaeology, Princeton University. The figure of Bellini's *St. Francis* wears the traditional habit of an Observant Franciscan friar (right), which is distinguished from the more ample Conventual Franciscan habit by its reduced cowl, simple tailoring, and sandals (*zoccoli*).

enjoyed a special connection to the Poverello, who was reputed to have passed through the lagoon and prayed among the birds of the marsh, a legend that calls to mind the two finely detailed birds perched in the landscape of *St. Francis* (see figs. 78, 83).[84]

Bellini's monumental altarpiece is dedicated to Job, the Old Testament everyman who was revered as a saint in Venice. Job's enduring faith in the face of unfathomable hardship prefigured the torments of Christ, and the friars considered him a forerunner of Francis, who likewise endured the Lord's sufferings. Bellini has presented the two holy men side by side at left, the elderly Job nude except for a loincloth, his palms and fingertips touching in prayer. Francis inclines his head and motions toward the viewer with compassion; he not only displays the side wound that is absent from his counterpart in the Frick panel but also emphatically points to his chest, as the connoisseur Marco Boschini observed in the seventeenth century.[85] The saint's gesture is repeated by the infant Christ in Mary's lap. Thus, Francis, who historically received the stigmata in imitation of Jesus, in this painting becomes the augur and prophet of the Crucifixion.[86] The Virgin, too, beholds her son's fate, raising her left hand in acknowledgment and gazing outward with a hauntingly clairvoyant expression.

The church of San Giobbe for which Bellini executed his altarpiece belonged to the Observant branch of the Franciscan Order, revealing the artist's contact with debates that had engulfed the friars throughout the fifteenth century. In contrast to the more worldly Conventuals, the Observants sought to restore Francis's contemplative and ascetic ideal. Officially founded in 1368, they were at first a minority faction within the friars but eventually triumphed to become the core of the newly divided Order in 1517.[87] The period leading up to this schism coincided with the life of Giovanni

Bellini, and the movement gained particular traction in Venice, where Observant churches and convents came to number at least eight (though the Franciscan *casa grande* of Santa Maria Gloriosa dei Frari remained Conventual).[88] The success of the Observants in the city was largely owing to one individual, Bernardino (Albizzeschi) da Siena (1380–1444), a preacher and activist known as one of the "four pillars of the Observance." During his visits to Venice, Bernardino so transfixed the faithful with his sermons that he was later adopted as a protector of the Republic.[89] After his canonization in 1450, the church of San Giobbe was renovated and its dedication expanded to include him. The high altar of the new San Giobbe was devoted to the latter-day luminary Bernardino; hence the startling displacement of Bellini's altarpiece in honor of the church's ancient titular saint to the right wall of the nave.[90]

Giovanni himself was deeply familiar with Bernardino: the artist's father had made two fascinating drawings of the future saint preaching from an outdoor pulpit during one of his final stays in Venice in the early 1440s, when Giovanni was a child or adolescent and likely attended his sermons.[91] Bernardino is portrayed with his distinctive physiognomy and monogram in the Bellini family's joint altarpiece of c. 1455–60 for the Gattamelata chapel of the Basilica del Santo (see fig. 10).[92] Giovanni depicted the saint on the right pilaster of his Pesaro altarpiece, in a stance quite similar to that of the Frick *St. Francis*, with the left leg bent (see fig. 15). And Bernardino is tacitly present in the artist's subsequent Franciscan paintings, which bear the unmistakable imprint of Observant values.

In their sermons and reform campaigns, Bernardino and his followers called for a return to the humble lifestyle of the saint and his brethren, especially their practices of solitary devotion and meditation. The Frick panel, too, summons a vision of pure Franciscan observance. The prayerful saint is alone in a wilderness setting. His rustic cell evokes the nomadic existence of the founding friars, who were identified as *fratres de cella* for their simple dwellings.[93] Francis's rocky surroundings also recall the inhospitable conditions at Brogliano, where the Observant movement was born in the fourteenth century. The first Observants lived in utmost austerity among sharp boulders and stones; to protect their feet, they fashioned wooden clogs called *zoccoli*, for which they became known throughout Italy as *zoccolanti*, or "sandaled ones." In Bellini's painting, the pair of *zoccoli* inside the saint's shelter brings the Observants' moniker vividly to mind.[94] At the same time, Francis has removed his sandals and walks barefoot over the rough terrain. Unshod or *discalceatus*, he performs an age-old rite of reverence that also reflects Observant beliefs.[95] The tailoring of the saint's habit conforms to Observant rules, which require a modest cut of cloth and a reduced form of the cowl (fig. 19).[96] The grapevine that shades Francis's cell carries clear eucharistic

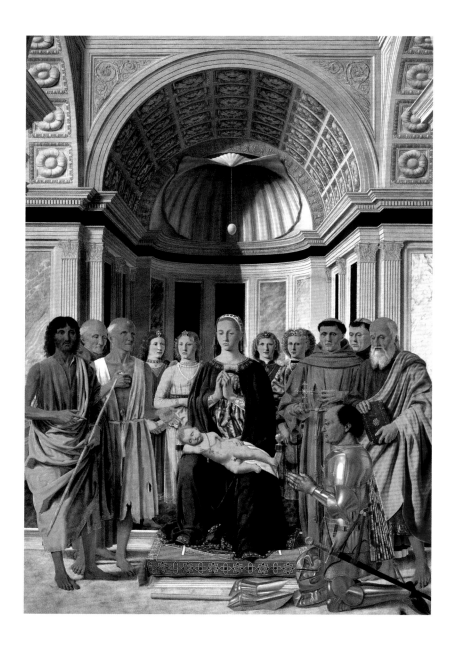

Fig. 20. Piero della Francesca (c. 1413–1492),
Montefeltro altarpiece, c. 1472–74.
Oil on panel, 248 × 170 cm. Pinacoteca
di Brera, Milan

connotations, but it would also have recalled the names of two major Observant
convents in Venice: San Francesco della Vigna, built on the site of an old vineyard and
known colloquially as "la Vigna,"[97] and the hermitage island of San Francesco del
Deserto, earlier called Isola delle Due Vigne or S. Franciscus de Vinea.[98]

 The Observant cast of *St. Francis* is nowhere more evident than in the action and
countenance of the saint. In 1457, the Observants prevailed upon the Chapter General
of the Order to declare that "since the principal, and almost the whole, cause of so many
excesses and relaxations is the lack of holy private prayer and interior recollection,"
the friars were to devote time each day to "imbibe the Spirit of the Lord and the mind
of our blessed father Francis."[99] Bellini's ecstatic figure clearly exemplifies this; absorbed
in "holy private prayer and interior recollection," he seems to "imbibe the Spirit of the
Lord" and actively encourages the beholder to do so as well. By omitting all mediating
presences, such as the seraphic crucifix and Francis's companion, Brother Leo, Bellini

draws the spectator into direct participation in the saint's visionary experience. The painting invites us to consider "the mind of our blessed father Francis," thus promulgating Observant ideals of contemplation and joyous immersion in the divine.

Such meditative concern also suffuses the San Giobbe altarpiece, whose introspective stillness is broken only by the unheard melodies of the three young musicians at the base of the Virgin's throne. Bellini has embraced the sacred figures within a palpable enclosure of air, and the unifying illusionism of the scene is heightened by its placement in a vaulted and domed space, reminiscent of a church apse or chapel.[100] This motif, of Netherlandish origin, was introduced to Italy by Piero della Francesca in his Montefeltro altarpiece (fig. 20). Piero's work, too, was intended for an Observant Franciscan church dedicated to Bernardino, raising the possibility that the friars were actively involved in transmitting such novel artistic ideas across the Italian peninsula.[101] Whether or not the Montefeltro altarpiece directly inspired the ecclesiastical backdrop of Bellini's composition, the affinities between the two paintings reveal the profound importance of this pictorial device within an Observant devotional setting. At San Giobbe, the side of the nave on which Bellini's panel originally appeared is deprived of chapels due to the adjacent cloister.[102] By effectively annexing a flat expanse of wall to create a fictive chapel, the artist endows the image with visionary immediacy, inviting the worshipper to perceive the sacred realm as fully present and accessible to "holy private prayer and interior recollection."

Despite their shared contemplative emphasis, the San Giobbe altarpiece and *St. Francis* are hardly straightforward manifestos of Observant belief: both are exceptionally rich works of art that defy the saint's injunctions to poverty. The San Giobbe panel, possibly commissioned by a prominent local confraternity dedicated to Job,[103] was realized with extremely costly materials, including ultramarine blue pigment for the mantle of Mary and gold leaf for the mosaic tesserae of the apse.[104] While the overall palette of *St. Francis* is muted by comparison, the size of the panel, the care bestowed on its autograph design, and the use of high-quality ultramarine in the sky bespeak the work's prestige and expense.[105] As lavish vehicles of Franciscan piety, these paintings capture and hold in tension the opposed values of wealth and asceticism, material splendor and intangible spirituality, which characterized the Friars Minor from their founding and would finally bifurcate the Order only six months after the death of Giovanni Bellini.[106] In these lights, the two subsequent essays in this volume consider the early history of *St. Francis*, the mendicant masterpiece whose patronage and display have paradoxically come to exemplify the rarefied world of private art collecting in Renaissance Venice.

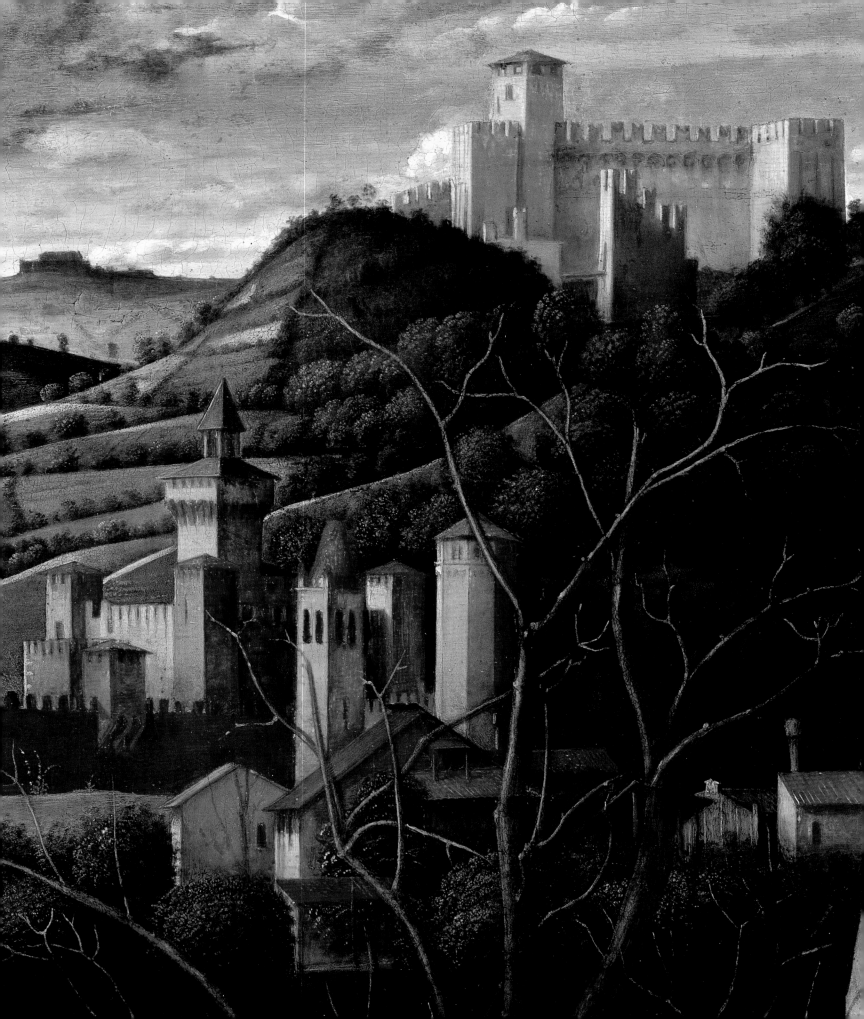

THE DESERT AND THE CITY: MARCANTONIO MICHIEL AND THE EARLY HISTORY OF *ST. FRANCIS*

by Susannah Rutherglen

Since 1915, Giovanni Bellini's *St. Francis* has invited contemplation within the opulent and hushed surroundings of Henry Clay Frick's Fifth Avenue mansion. Almost five hundred years ago, the picture was recorded in a remarkably similar setting, the urban palace of an ambitious, highly discerning businessman and art collector. Taddeo Contarini (c. 1466–1540), a Venetian patrician who had made his fortune in agriculture and maritime trade, assembled a choice group of paintings at his home in the parish of Santa Fosca in the city's Cannaregio district. In 1525, Marcantonio Michiel (1484–1552), a distinguished connoisseur and man of letters, visited the house and encountered Bellini's masterpiece:

> The panel of St. Francis in the desert, in oil, was the work of Giovanni Bellini, begun by him for Messer Zuan Michiel, and it has a landscape [or small town] nearby, wonderfully composed and detailed [fig. 21].[1]

Marcantonio entered these brief observations into his personal notes on churches, monasteries, private collections, and other monuments across northern Italy. Composed and revised over a period of more than twenty years, these informal lists of works of art might have been preparatory to an impressive but unrealized guidebook or compendium.[2] The account of paintings "in the house of Messer Taddeo Contarino" filled about one and one-third sides of the same folio (54r. and 54v.), with *St. Francis* entered last (fig. 22).

Michiel's complex and fragmentary document was first published in 1800 under the title *Notizia d'Opere di Disegno* (Information on Works of Design).[3] At an earlier date, the loose leaves had been gathered and bound with the handwritten heading "Pittori e Pitture in Diversi Luoghi" (Painters and Pictures in Various Places), a title that captures the author's topographical approach to the visual arts although he recorded many types of objects in addition to paintings.[4] Michiel's methods were informed by the example of classical writers such as Pliny the Elder, and he showed a prescient interest in provenance, valuation, attribution, inscriptions, and materials and techniques.[5] While the connoisseur sometimes erred in matters of iconography, he proved adept at designating works of ambiguous or novel subject.[6] His description of *St. Francis in the Desert* has endured, as have his titles for two other enigmatic achievements of the Venetian Renaissance, Giorgione's *Tempest* (c. 1505–8; Gallerie dell'Accademia, Venice) and *The Three Philosophers* (fig. 23).

When he noted the figure of St. Francis "in the desert," Michiel did not mean to evoke an arid wasteland; rather, he intended the term *deserto* in the more general

St. Francis in the Desert, detail

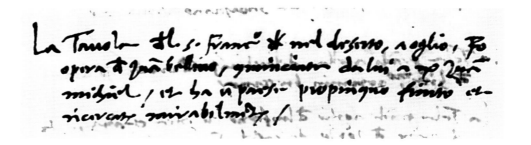

Fig. 21. Marcantonio Michiel's (1484–1552) record of *St. Francis* in the home of Taddeo Contarini, Venice, 1525: "La Tavola de 'l S[an] Franc[esc]o đ nel deserto, a oglio, fo opera de Zuan Bellino, cominciata da lui a M[esser] Zuan Michiel, et ha un paese propinquo finito et ricercato mirabilmente" (the panel of St. Francis ~~of~~ in the desert, in oil, was the work of Giovanni Bellini, begun by him for Messer Zuan Michiel, and it has a landscape [or small town] nearby, wonderfully composed and detailed). Venice, Biblioteca Nazionale Marciana, Ms. It. XI, 67 (=7351, *olim* Apostolo Zeno 346) [*Pittori e pitture in / diversi luoghi*], I, f. 54v.

sense of a wilderness or deserted place located at the margins of civilization. From the early Christian period, holy men such as St. Jerome had retreated to such "deserts," which were, in practice, hospitable to life and never far from humanity. Here the hermit enjoyed a strategic remove from the village and city: distant enough to transcend mundane politics, yet close enough to play an active part in the imaginations of urban dwellers and wield power as an impartial arbitrator in their affairs.[7] Indeed, despite his solitude, Bellini's Francis inhabits a fertile, spring-fed environment that is hardly remote from the townscape behind him. Although walled off and inaccessible from the saint's refuge, the small town, if this is how we are to interpret Michiel's word "paese," is described by him as "nearby" and has not been painted with the distancing effects of atmospheric perspective.[8]

In Venice, the concept of the desert as a liminal retreat on the fringes of society found physical form in the island of San Francesco del Deserto, located in the lagoon about four miles northeast of the city (fig. 24). The island's rich history includes a purported visit by St. Francis himself in the thirteenth century. In the 1450s, the Observant branch of the Friars Minor took custody of San Francesco del Deserto and initiated a restoration campaign, actively supported by Doge Francesco Foscari and the papacy and culminating in the dedication of the church of San Francesco delle Stimmate (St. Francis of the Stigmata) in 1466. A recent study demonstrates that the composition and symbols of Bellini's painting are profoundly linked to the legendary past and contemporary revival of this idyllic hermitage.[9] Michiel's notes offer a further clue: as Rosella Lauber has observed, the connoisseur first wrote "San Francesco d" in his entry on Bellini's painting, as if citing the island by name, before crossing out the "d" and writing "San Francesco *nel* Deserto" (see fig. 21).[10] This intriguing revision suggests that the picture triggered a recollection of San Francesco del Deserto on Michiel's part. It also raises the possibility that the patron of Bellini's painting boasted connections to the island or even that the work was once displayed there.[11]

Fig. 22. Marcantonio Michiel's record of the collection of Taddeo Contarini, 1525. Heading: "Opere in Venezia / In casa de M[esser] Taddeo Contarino 1525." Venice, Biblioteca Nazionale Marciana, Ms. It. XI, 67 (=7351, *olim* Apostolo Zeno 346) [*Pittori e pitture in / diversi luoghi*], I, ff. 54r.–54v.

At present, no documentary evidence locates *St. Francis* or its patron at San Francesco del Deserto.[12] Rather, extant records of the early history of Bellini's painting reveal its ties to the political, artistic, and social world of Venice proper, suggesting that the picture offered a visual counterpart to the storied Franciscan retreat within the compass of the city. Bellini's image resonates compellingly with the eremitic ideal realized by fifteenth-century Venetians in the waters of their lagoon. As Michiel's notes imply, *St. Francis in the Desert* played a singular role in situating the sacred desert within the urban imagination.[13]

Patron and Original Setting

Marcantonio Michiel visited Taddeo Contarini's collection in 1525, about eight or nine years after the death of Giovanni Bellini and more than forty-five years after the completion of *St. Francis*.[14] The picture had already been displaced from its original location by this time: Michiel recorded that the artist had made his painting for an individual named Zuan Michiel ("cominciata da lui a M[esser] Zuan Michiel"). The term *cominciata*, or "begun," probably means that the picture was painted for and delivered to Zuan but eventually left his possession.[15] This information, which may have come from Taddeo Contarini in his role as

host to the eminent connoisseur, counts among the few surviving pieces of evidence regarding the patronage and early history of Bellini's devotional works.[16]

The patron of *St. Francis* has been identified by the scholar Jennifer Fletcher as the prominent Venetian Zuan Giacomo Michiel, who died in 1513 (and was not closely related to the Marcantonio Michiel who set down his name in the *Notizia*).[17] Zuan Michiel lived in Santa Marina, the same parish as Giovanni Bellini, and both patron and artist belonged to the same lay confraternity, the Scuola Grande di San Marco (fig. 25).[18] Bellini was a *cittadino originario*, or original citizen of Venice—a privileged order just below the Republic's hereditary patriciate—and Zuan Michiel almost certainly belonged to this class, as well.[19] Denied the ruling powers of the nobility, *cittadini originari* attained honor and influence through the alternate channels of commerce, government and social service, and cultural achievement. Michiel followed this pattern by joining the ducal chancellery, the permanent bureaucratic administration of Venice, whose ranks were limited to *cittadini originari* in 1478.[20] Chancellery secretaries played a crucial part in maintaining the vaunted stability of the Venetian Republic: because the authority of patrician leaders was checked by their rotation through very brief terms of office, it was the career civil servants who managed the government's daily operations and constituted its working memory. Michiel excelled in this capacity, eventually rising to the position of secretary to the legendary Council of Ten, "a very severe magistracy of the top nobles of the city," as the diarist Marin Sanudo wrote.[21] In this role, Michiel would have been a well-known public figure, highly proficient in Latin, bearing a heavy workload, and steeped in the most sensitive affairs of the Republic.

In addition to his service for the state, Zuan Michiel held office on the board of the Scuola Grande di San Marco, a charitable post also reserved for certain *cittadini*.[22] His leadership of a lay confraternity, the penitential communal body whose civic functions encompassed care of the poor, suggests that personal conviction might have influenced his private patronage of Bellini's image of the Poverello. Michiel's responsibilities as "Guardian Grande" of the Scuola in 1493 and 1501 included the management of artistic projects. In August of 1501, he supervised a contract for a ceremonial pennant by Alvise Vivarini: for one hundred ducats, the artist agreed to execute the painting "with utmost diligence and grace," according to the order and form of a preliminary design approved by Michiel, and to employ precious gold leaf and ultramarine pigment as directed.[23] Although Vivarini's corporate banner and Bellini's *St. Francis* were very different commissions, Michiel may have overseen work on the Frick panel in a comparable manner more than twenty years before, specifying a preparatory design and the use of ultramarine.[24] The valuable materials and exacting technique of

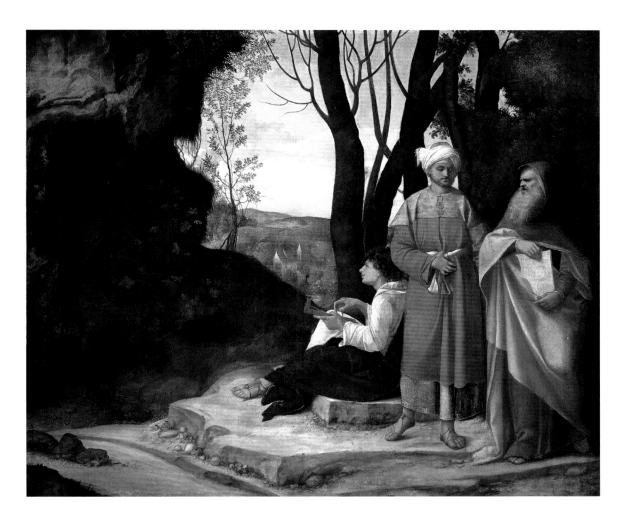

Fig. 23. Giorgione (c. 1476/78–1510), *The Three Philosophers*, c. 1505–10. Oil on canvas, 123 × 144 cm. Gemäldegalerie, Kunsthistorisches Museum, Vienna

St. Francis are consistent with a prized painting for this enlightened patron. At the same time, however, Michiel might have demonstrated respect for Bellini by granting him substantial artistic license, such as the painter later wished to exercise in a religious picture for Isabella d'Este, Marchesa of Mantua.[25]

Zuan Michiel was not alone among members of his class in supporting avant-garde work by a leading Venetian artist. *Cittadini* were adventurous patrons and collectors: less restrained than patricians by norms of tradition, modesty, and propriety and also compelled by their secondary social status to seek new modes of personal distinction, citizens sponsored innovative art that challenged conventions of iconography and style.[26] Nicolò Aurelio (c. 1464–1531), like Michiel a *cittadino* and high-ranking chancellery employee, commissioned Titian's *Sacred and Profane Love* (fig. 26), a painting analogous to *St. Francis* by virtue of its novel format, recondite symbolism, and evocative visual poetry.[27]

Recent archival discoveries by Rosella Lauber confirm the surprising fact that Zuan Michiel, patron of one of the preeminent masterpieces of Franciscan art of the Italian Renaissance, requested and was granted burial in the rival Dominican church of Venice, SS. Giovanni e Paolo.[28] Michiel's loyalty to his prestigious neighborhood church trumped allegiance to a particular mendicant order. Bellini himself was buried at SS. Giovanni e Paolo, and his art shows a nuanced approach to mendicant

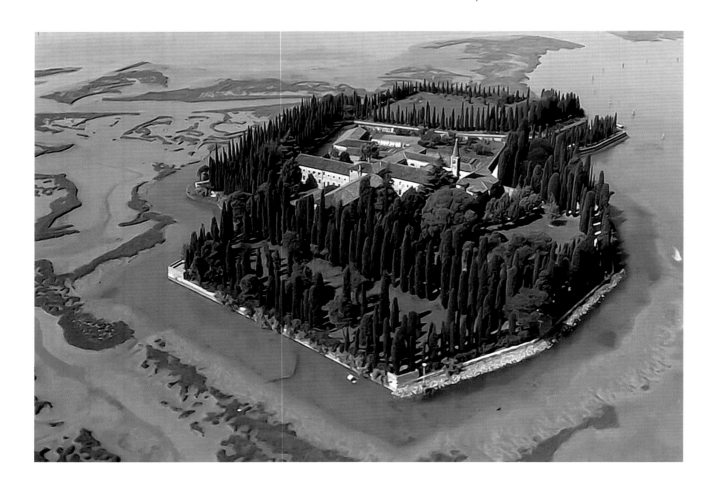

themes.[29] The reciprocal regard of the two orders is suggested by the famous cantos of Dante's *Paradiso* in which the life of St. Francis is told by a Dominican and that of St. Dominic by a Franciscan. Dante emphasizes the shared ideals and fortunes of the Frati Minori and Frati Predicatori, despite their longstanding antagonism and pronounced doctrinal differences, especially concerning the immaculate conception of the Virgin Mary.[30] Educated lay Christians, too, were more versatile in their engagement with mendicant institutions and imagery than tidy historical divisions among the orders imply.

Zuan Michiel's diverse religious sympathies have bearing on a longstanding problem, the original placement and function of *St. Francis*. In his notes of 1525, Marcantonio Michiel recorded the patron of the work but not its intended destination: on the wall of a home or perhaps above an altar in a church, convent, or confraternity. The level of finish and detail throughout Bellini's composition suggests that it was meant to be viewed up close in a domestic setting, but the panel is much larger than standard devotional pictures from his workshop. Rather, *St. Francis* corresponds approximately in dimensions to two of the artist's major public altarpieces of the 1470s, the *Resurrection* (see fig. 96) and *Transfiguration* (see fig. 97).[31] Could Zuan Michiel have planned to display the painting as an altarpiece at one of Venice's distinguished Franciscan institutions, perhaps San Francesco del Deserto, San Giobbe, or San Francesco della Vigna? Did he commission the work for a family chapel in some other church in the city?[32] Or did he always intend to hang it in his

Fig. 24. Island of San Francesco del Deserto, Venetian lagoon

Fig. 25. Pietro (c. 1430/35–1515), Tullio (c. 1455–1532) and Antonio (c. 1458–c. 1516) Lombardo, Giovanni Buora (c. 1450–1513), and Mauro Codussi (c. 1440–c. 1504), Scuola Grande di San Marco, c. 1485–95, Venice

own house? Whatever his aims, Michiel likely shared them with Bellini: the directional lighting within the scene suggests it was planned for a specific site, a niche or wall lit from the left.

In the absence of known documents recording the earliest setting of *St. Francis*, contextual study of the display of religious images in Renaissance Venice yields some evidence, as does the picture itself. In northern Italy during the fifteenth century, the theme of the solitary saint in a landscape was elaborated primarily in paintings for homes.[33] Domestic scenes of St. Jerome in the wilderness offered models for pious contemplation and a visual analogue to contemporary devotional manuals, in which metaphors of landscape and movement through space were invoked to describe the journey of the Christian soul. The vast natural world of *St. Francis*, too, invites spiritual peregrination, and its mountainous backdrop suggests themes of mystical ascent that complement the aims of personal prayer.[34] As a peaceful antidote to the bustle of the early modern court and metropolis, the household image of a desert saint might also inspire scholarly pursuits: in a discussion of the proper adornment of libraries in Angelo Decembrio's humanist dialogues *De Politia Litteraria* (completed by 1462), Leonello d'Este of Ferrara advises, "some pleasant picture of St. Jerome at his writing in the wilderness" will help to "direct the mind to the library's privacy and quiet and the application necessary to study and literary composition."[35]

The popularity of small-scale paintings of the hermit St. Jerome in Venetian residences is attested by Marcantonio Michiel's notes and by countless surviving

Fig. 26. Titian (c. 1488–1576), *Sacred and Profane Love*, c. 1514–15. Oil on canvas, 118 × 279 cm. Galleria Borghese, Rome

works, including examples by Giovanni Bellini (see figs. 40, 74), his father, and his brother.[36] Perhaps the Michiel commission gave Bellini an opportunity to monumentalize this common domestic art form—by creating a picture of unusually large size in which the traditional desert saints of early Christianity (John the Baptist and Jerome) yielded the stage to their late medieval heir, Francis. The panel's dimensions suggest that it might have adorned an altar, an oratory, or even a chapel within a home. Such ritual spaces were documented in Renaissance palaces, and a 1593 letter of Lorenzo Priuli, the Patriarch of Venice, described celebrations in household oratories and chapels as a long tradition in the city.[37] Though not all private altars were fully consecrated for performance of the Mass, they established reverential environments for the recital of prayers with instruments of the liturgy, including bells, sacred stones, and holy water. Some were decorated with paintings or sculptures, which might be identified as "domestic altarpieces," a term that captures the simultaneously grand and intimate qualities of *St. Francis*.[38]

It is important to recall, however, that religious imagery in Renaissance Venice was characterized by mobility and mutability of function and that modern distinctions between public and private, altarpiece and devotional work did not always apply.[39] In the 1480s, Bellini himself transformed the household theme of Jerome in the wilderness into the subject of an altarpiece for the church of Santa Maria dei Miracoli (see fig. 91).[40] Depictions of saints, the Virgin and Child, and scenes from Christ's life appeared above high altars or within the chapels of churches and at times moved through the streets in procession. Pious images also populated various rooms of the home, from the bedchamber and study to the *portego*, the vast hall extending the full depth of a Venetian palace's *piano nobile*. An altar was not a prerequisite for the display of a saintly picture, whose mere presence in one of these quotidian settings could serve to generate a sacred ambience.[41] Religious paintings also migrated between domestic and ecclesiastical realms, as in the case of a *Madonna and Child* by Bellini that was converted from a personal devotional picture into an altarpiece at the site of the

tomb of the merchant Luca Navagero in the church of the Madonna dell'Orto.[42] The fact that *St. Francis* was in a private collection by 1525 does not, therefore, preclude its having originated in a place of communal worship, although the transfer of holy pictures from the inner sanctum of the home to the public sphere of the church was evidently much more common.

St. Francis in Taddeo Contarini's Collection

Documents paint a richer picture of the ownership and display of *St. Francis* in the early sixteenth century. Bellini's masterpiece had come into the possession of Taddeo Contarini by 1525, when Marcantonio Michiel visited the collector's palace. Unlike the patron of *St. Francis*, the citizen Zuan Michiel, Taddeo was a wealthy patrician who belonged to the Santi Apostoli branch of the Contarini family.[43] He had humanist inclinations, as suggested by his borrowing of classical texts from the library of San Marco in 1524, but he was also a successful merchant known for his ruthless dealings.[44] In 1495, Contarini married Marietta Vendramin, sister of the prestigious art collector Gabriel Vendramin (1484–1552), and probably at this time moved into a residence adjacent to that of the Vendramin family at Santa Fosca.[45] Gabriel's and Taddeo's neighboring collections showed a common predilection for works by Bellini and Giorgione; however, Vendramin assembled a wider variety of objects, including manuscripts and antiquities, while Contarini focused on paintings.[46]

The precise date of Contarini's acquisition of *St. Francis* is unknown. The picture may have left Zuan Michiel's ownership during his lifetime or entered the market after his death in 1513. It is also possible that the work passed briefly through another proprietor or intermediary after Michiel and before Contarini.[47] The 1506 auction of the household goods and collection of the Venetian *cittadino* Michele Vianello, an event involving a broad segment of society from amateurs to the agents of Isabella d'Este, suggests one means of transmission of works of art from citizens to patricians.[48] Whatever its exact path, *St. Francis* had departed its original location within half a century of its creation, becoming a mobile collector's object that invited appreciation for both its spiritual resonance and aesthetic value.[49] As an incipient gallery picture, Bellini's panel joined the lively circulation of artifacts among local connoisseurs. Marcantonio Michiel's notes reveal that collectors of the Venetian Renaissance often sold, exchanged, bestowed, bequeathed, and altered their most prized holdings. Zuan Michiel himself, for example, had commissioned a valuable book of hours with four incipit pages illuminated by Jacometto Veneziano, which subsequently "traveled for a long time through the hands of various antiquarians."[50]

The display of *St. Francis* in the Contarini palace can be partially reconstructed from two sources: Marcantonio Michiel's notes of 1525 and a recently discovered household inventory compiled in 1556, about sixteen years after Taddeo's death.[51] These documents correspond in many respects, indicating that the collection remained basically intact over a more than thirty-year period.[52] Both the connoisseur in 1525 and the notary in 1556 moved through the palace room by room, recording objects in relevant chambers. As Monika Schmitter has shown, Michiel began his tour in the *portego*, the large central hall of the *piano nobile*, where he listed four important paintings, including Giorgione's *The Three Philosophers* (see fig. 23). These pictures were still in situ in 1556, when the notary described the same works in the *portego grando di sopra*.[53]

Michiel's itinerary of 1525 proceeded from the *portego* into successively more private rooms of the Contarini home. He did not label individual chambers but drew brief horizontal lines in his notes to indicate the separation of spaces (see fig. 22).[54] In a second *camera*, he observed four works: a painting of three women by Palma il Vecchio (see fig. 28); a small shoulder-length portrait of a woman by Giovanni Bellini; a figure of Christ carrying the Cross, also by Bellini; and a profile portrait, identified as the daughter of Ludovico Sforza, by a Milanese artist.[55] In a third chamber, Michiel encountered *St. Francis* together with a painting by the youthful Giorgione, *Finding of the Infant Paris*, now lost but known through a copy by David Teniers the Younger (fig. 27).[56] The pairing of Bellini's religious masterpiece with this mythological work—at first glance surprising—suggests that both pictures were recognized as large-scale achievements by masters in the vanguard of Venetian painting, sharing inventive subject matter and mountainous landscape settings.

Bellini's panel remained in the Contarini palace in 1556 and was recorded in the detailed household inventory of that year as "a large picture with gilded frames with the image of St. Francis."[57] By this time, the picture was on view in a room called the *camera di Dario Contarini*, evidently the study of Taddeo's recently deceased son, Dario. Whether this was the same chamber in which Michiel had seen the painting in 1525 is unclear because his notes do not name specific rooms. On both occasions, however, *St. Francis* was hanging in an inner, more secluded space of the house. This setting, in contrast to the public and convivial surroundings of the *portego*, is consonant with the devotional tenor of Bellini's scene and the solitary contemplations of its protagonist.

The installation of *St. Francis* changed in subtle respects between 1525 and 1556. Whereas Michiel noted the painting in proximity to Giorgione's *Finding of the Infant Paris*, the later inventory listed these two pictures in separate chambers.[58] By 1556, *St. Francis* was on view in the *camera di Dario Contarini* along with four other works: an

Fig. 27. David Teniers the Younger (1610–1690), *Finding of the Infant Paris* (after a lost work by Giorgione), after 1651. Oil on panel, 23 × 31.5 cm. Private collection

image of "nostro signor messer Iesù Cristo," likely identical with Bellini's painting of Christ carrying the Cross, described by Michiel in 1525;[59] the portrait of a lady by Bellini, also previously mentioned by Michiel;[60] the picture of three women, attributed in 1525 to Palma il Vecchio (see fig. 28);[61] and finally a scene of a woman looking into a mirror.[62] This last piece cannot be clearly associated with any of the works earlier noted by Michiel, but it has been suggested that the painting is Bellini's *Woman with a Mirror* of 1515 (see fig. 29). The known provenance of this panel begins with the seventeenth-century collections of Archduke Leopold Wilhelm of Austria, who also owned at least two works once belonging to Taddeo Contarini: Giorgione's *The Three Philosophers* and *Finding of the Infant Paris*.[63] It is therefore conceivable that the Contarini family's "somewhat large painting surrounded with gilded frames with a lady who regards herself in the mirror" is the Vienna picture.

The overall impression afforded by the 1556 inventory is that the sacred image of *St. Francis* was hanging in a rather bold arrangement near a figure of Christ, a portrait of a lady, a picture of three women, and a representation of a woman at her toilet. The works in the *camera di Dario Contarini* were unified not by subject matter but by authorship: at least three and possibly four of the five paintings in this chamber were by Giovanni Bellini, together constituting a "Bellini Room" comparable to an assembly of the artist's works in a modern museum. Contarini's brother-in-law and neighbor Gabriel Vendramin likewise possessed a "Titian Room" in which works of diverse genres were defined by their association with the artist.[64] Thus, by the mid-sixteenth century, *St. Francis* and nearby paintings were fully ensconced in the culture of urban collecting and connoisseurship that would shape their subsequent fortunes. Already in 1525, Michiel's notes had captured the picture in an enduring suspension between desert and city: the image of "San Francesco nel Deserto" now enjoyed the status of a "wonderfully composed and detailed" masterpiece of Giovanni Bellini, ultimately bound for Paris, London, and New York.

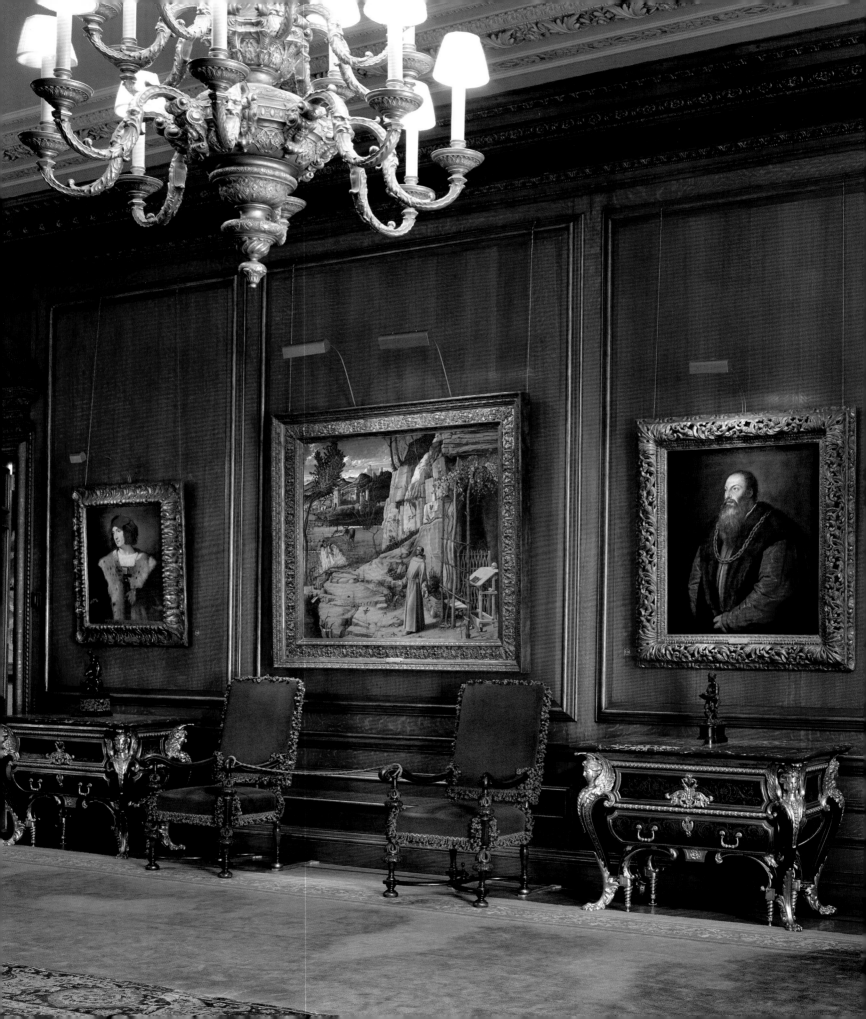

FROM THE GRAND CANAL TO FIFTH AVENUE: THE PROVENANCE OF BELLINI'S *ST. FRANCIS* FROM 1525 TO 1915

by Anne-Marie Eze
with the assistance of Raymond Carlson

The sale of Giovanni Bellini's *St. Francis in the Desert* to the industrialist and collector Henry Clay Frick—which placed the spectacular painting in its final home in 1915—was the result of many complicated dealings. The intervention of the art dealer Joseph Duveen and connoisseur Bernard Berenson into their rival Knoedler's sale was described by Edward Fowles of Duveen Brothers in this revealing account:

> One day as he [Joseph Duveen] was entering the hall, he saw two men carrying away a large painting. The painting (Giovanni Bellini's *St. Francis in Ecstasy*) had been sent in by Knoedler, and Frick so disliked it that he had asked Knoedler's men to remove it immediately. Joe told them to put it down. He would speak to Frick about it. Joe persuaded his client that this particular painting was one of the greatest masterpieces of the Venetian Renaissance, and that he should buy it. "Very well," replied Frick, "but you must get me a letter from Mr. Berenson to that effect." I contacted BB, who was quite happy to give the necessary attestation—although he seemed somewhat peeved that Frick (whom he once referred to as "that coke merchant") had not approached him directly.[1]

The masterpiece's epic journey from Venice to New York had taken more than four centuries, during which its status changed from a celebrated heirloom passed down through generations of three Venetian patrician families in the 1500s–1700s to an often undervalued item on the art market traded among European dealers and collectors during the 1800s. The sensational rediscovery of *St. Francis* in the early twentieth century, when it had been feared lost, returned the peripatetic panel to the public domain and to its rightful place in the hall of fame of Italian Renaissance painting.

In 1972, Jennifer Fletcher published the first scholarly account of the painting's provenance, covering the period dating from 1525, when it was admired in the palace of Taddeo Contarini in the parish of Santa Fosca in Venice by the connoisseur Marcantonio Michiel, to 1852, the date of its sale at Christie's in London to a certain Joseph Dingwall.[2] Fletcher identified the painting's Venetian commissioner, Zuan Michiel, and later owners Giulio Giustinian and Alba Cornaro and suggested that the panel had been imported to England by the dealer William Buchanan. However, she was unable to locate *St. Francis* between 1796 and 1852. For more than a decade, Rosella Lauber has tirelessly searched archives in Venice and elsewhere, uncovering documentary evidence to prove many of the painting's movements among the patrician families discussed by Fletcher.[3] Lauber has also published details of the work's former English owners, Dingwall and Thomas Holloway; the picture's first public display at the

St. Francis in the Living Hall of The Frick Collection, New York

Fig. 28. Palma il Vecchio (1480–1528), *Three Women*, c. 1520. Oil on panel, 88 × 123 cm. Gemäldegalerie Alte Meister, Staatliche Kunstsammlungen, Dresden

Manchester *Art Treasures* exhibition of 1857; and the turbulent years of its passage to America. The present essay, which is greatly indebted to Fletcher's and Lauber's work, is the first in English to present the history traced to date of *St. Francis*: beginning in Venice with its passage from the Contarini to the Giustinian family in the late sixteenth century, its subsequent transfer from the Giustinian to the storied Cornaro dynasty in the 1700s, followed by its departure from the lagoon city. The essay also contributes new information from recently discovered letters composed between 1812 and 1850, which document *St. Francis* in the possession of an Italian dealer and French collectors and so confirm long-suspected sojourns of the picture in Milan and Paris. These documents also provide a new *terminus ante quem* for the date of the cutting of the panel's upper horizontal edge and leave just sixteen years (1796–1812) in which the painting is unaccounted for.

Heirloom: Venetian Family Collections, 1525–1796

In 1525, the Venetian connoisseur Marcantonio Michiel describes Bellini's "panel of St. Francis in the desert" in the palace of Taddeo Contarini, a powerful patrician, businessman, and art collector who lived in Santa Fosca in Venice's Cannaregio district (see fig. 21).[4] The next extant record dates to November 1556, when the painting, still in Palazzo Contarini, is described as follows in the inventory of the possessions of the recently deceased Dario Contarini (c. 1503–1556), son of Taddeo: "In Dario Contarini's room . . . a large picture with gilded frames with the image of St. Francis."[5] The little that is known about Dario Contarini comes from his contemporary,

Fig. 29. Giovanni Bellini, *Woman with a Mirror*, 1515. Oil on panel, 62 × 79 cm. Gemäldegalerie, Kunsthistorisches Museum, Vienna

the Venetian diarist Marin Sanudo, who noted that in 1524 he was a member of the Compagnia dei Valorosi, one of the groups of young noblemen who put on lavish theatrical performances during a festivity organized by the Compagnie della Calza.[6] Three years later, Sanudo branded Dario Contarini "mad" (*mato*) without further explanation, though the diarist was probably biased by his dislike of the youth's father, Taddeo.[7] The inventory of Dario's possessions, which is unusually detailed for such a document from the mid-sixteenth century,[8] shows that the Contarini collection at Santa Fosca had remained largely intact since Michiel's visit more than three decades earlier.[9] Though seemingly prosaic in comparison to Michiel's note on the aesthetic merits of Bellini's *St. Francis*, the notary's list gives the earliest description of a frame for the painting and suggests a change in display within Palazzo Contarini since the time of Taddeo. As Susannah Rutherglen has demonstrated, in Dario Contarini's lifetime *St. Francis* no longer shared a room with the *Finding of the Infant Paris* by Bellini's pupil, Giorgione (see fig. 27).[10] It now graced the wall of his private study or bedchamber, which boasted, in addition to Palma il Vecchio's *Three Women* (fig. 28), up to three further paintings by Bellini depicting sacred and profane subjects: an image of Christ carrying the Cross,[11] the portrait of a lady, and a scene of a woman looking into a mirror, most likely identifiable with Bellini's famous panel of 1515 (fig. 29). This "Bellini Room" afforded Dario the opportunity to admire and compare a range of works from the artist's oeuvre, from intensely spiritual large- and small-scale devotional paintings to female figures, both in independent portraiture and classically inspired nudes. That Bellini, still revered as one of the greatest Venetian painters of his generation, was the

only artist to dominate a room in the Contarini palace is unsurprising. Taddeo's role as one of Bellini's collectors and probable commissioner of his *St. Jerome in the Desert* (see fig. 91) for the family's altar in the church of Santa Maria dei Miracoli[12] provided the Contarini with a personal connection to the artist that was handed down to their descendants through the paintings themselves and their lore.

Toward the end of the sixteenth century, Bellini's *St. Francis*, Palma il Vecchio's *Three Women* (see fig. 28), and other Contarini paintings passed into the possession of another prestigious family, the Giustinian, through the marriage on 20 August 1589 of Taddeo Contarini's great-granddaughter, Elisabetta, to Giulio Giustinian (born 1562).[13] One of Venice's most ancient noble families, the Giustinian had long served prominent roles in the Republic's political, military, and religious life. Elisabetta's husband belonged to the Aquile d'Oro branch of the family, which resided near the church of San Stae in the Venetian district of Santa Croce. In 1656, their grandson, also named Giulio Giustinian (1624–1699), became Procurator of St. Mark, a lifelong office second in importance only to the doge. The younger Giulio was renowned for his collection of Greek manuscripts, medals, and tapestries. His "bellissima Galeria," which included paintings by Titian and Veronese and Bonifacio de' Pitati's *Dives and Lazarus* (now Gallerie dell'Accademia, Venice), was praised in a number of widely read guides to the city, including Marco Boschini's *La Carta del Navegar Pitoresco* (Venice, 1660) and Giustiniano Martinioni's 1663 expanded edition of Francesco Sansovino's sixteenth-century guidebook, *Venetia Città Nobilissima*.[14] In the former, a hyperbolic poem in Venetian dialect celebrating the local school of painting and the wealth of art collections in the city, Boschini praised with Baroque exuberance Bellini's *St. Francis in the Desert* in Palazzo Giustinian at San Stae:

> Giovanni Bellini here represents the Seraphic Father
> Full of divine zeal, and Christ appearing to him from Heaven
> In the shape of a fiery seraph
> For sure, who sees that ardent passion
> (And here I steal a line)
> Will say: Francis is being wounded by Jesus Christ
> Hand together with hand, foot with foot, breast with breast.
> That Mount La Verna, so impressive and high,
> Is as natural to my judgment
> As Maffio Venier, that excellent Venetian poet, describes it.[15]

Fig. 30. Francesco Guardi (1712–1793),
*The Grand Canal with Palazzo Corner della Ca'
Granda, with Gondolas on the Water,*
c. 1727–93. Pen and brown ink with brown
wash, over black chalk on paper,
30.6 × 57.8 cm. The British Museum, London

Boschini's poetic account of *St. Francis* is the earliest to privilege the lone figure of the saint over the landscape setting. However, his reference to "Christ appearing to [Francis] from Heaven / In the shape of a fiery seraph" led scholars to debate whether the connoisseur had seen in the Giustinian palace a different, conventional scene of the stigmatization rather than Bellini's more originally conceived *St. Francis in the Desert*. Others raised the possibility that Boschini had indeed seen the Frick picture but in a different form: with the presence of a small seraph that was later removed upon cropping of the panel's upper edge.[16]

The question of whether the lost section of *St. Francis* included a seraph is addressed elsewhere in this volume.[17] Any doubts over the identification of the Frick Bellini with that seen by Boschini, however, are quelled by a well-documented record of its transfer of ownership through two more marriages. In 1710–11, Procurator Giulio Giustinian's grandson, Zuanne di Nicolò Giustinian (d. 1718), wed Alba di Antonio Giustinian (d. 1771) from another branch of the family but died just seven years later. On his death, his wife and mother were named his heirs.[18] Giustinian's wealthy widow remarried the following year, on 13 September 1719, to another Procurator of St. Mark, Nicolò di Francesco Cornaro (born 1677) of the "della Ca' Granda" branch, who lived in an imposing palace on the Grand Canal at San Maurizio, which gave the family its nickname (fig. 30).[19] Their marriage joined Giustinian's pictures, including *St. Francis*, with the Cornaro collection, which had been made famous in the seventeenth century by Italian writers such as Carlo Ridolfi, Boschini, and Martinioni.[20] In the eighteenth century, art-loving visitors to Venice on the Grand Tour were drawn by the fame of Procurator Cornaro's collection of Old Masters. In 1743, the Ca' Granda was visited by Francesco Algarotti (1712–1764), the foremost Italian art critic of his day. A year earlier,

Frederick Augustus II, Elector of Saxony, had appointed Algarotti as his art agent, with the task of acquiring paintings for the Royal Gallery in Dresden, which the ruler was rapidly expanding. As a well-connected native of the lagoon city, Algarotti had access to its best collections, which he inspected for representative works of the Venetian school for the royal collection.[21] The connoisseur purchased from Procuratessa Alba Cornaro one of "the best paintings" in Venice: Palma il Vecchio's *Three Women* (see fig. 28), which had hung near Bellini's *St. Francis* in Palazzo Contarini at Santa Fosca before the paintings passed together through the Giustinian to the Cornaro family. Algarotti also saw in the Cornaro palace *St. Francis* and Bonifacio de' Pitati's *Dives and Lazarus*, which he described cursorily as "un Jean Bellini" and "un Bonifazio," perhaps because they were not for sale. Preferring to mention that all three paintings were highly celebrated ("forte celebres") by Boschini, he listed their pedigree as recounted to him by the procuratessa.[22] Alba Cornaro informed Algarotti that she had inherited the three paintings from the then "extinct" Giustinian Aquile d'Oro family, adding that the Bonifacio had come to her through the Grimani del Doge family, who were also heirs of the Giustinian. Her awareness of the passages of inheritance of these paintings clearly demonstrates their status as family heirlooms. Nonetheless, Cornaro was still willing to part with Palma's *Three Women*, probably for financial motives.

A 1753 inventory of the possessions of the sons of Alba and Nicolò Cornaro in their palace in San Maurizio itemizes a collection of 806 paintings dating from the Renaissance to the eighteenth century, including a "San Francesco nel deserto Zambelin" valued at 2,200 lire, which hung in the "appartamento nobile," in the "Cameron della Regina a levante."[23] This room was on the *piano nobile* to the east of the *portego*, or central hall, overlooking the Grand Canal.[24] It was named after the family's most famous ancestor, Caterina Cornaro, Queen of Cyprus (r. 1474–89), who was declared a "daughter of St. Mark" after the death of her husband so that the Venetian Republic could take control of the important island.[25] The Cornaro's dedication of a room to the memory of their distinguished ancestor demonstrates their pride in family history, which they continued to cultivate into the early nineteenth century, by which time the room contained three portraits of the queen and a picture of her famous marriage.[26] In the "Queen's Room," Bellini's *St. Francis* was displayed beside more than thirty works of devotional Renaissance painting, some portraits, and some secular pictures. The value of 2,200 lire assigned to it by the notary far exceeded that of any of the other works, indicating that Bellini's painting was considered the masterpiece of the room.[27] The 1753 inventory also listed Bellini's *Supper at Emmaus* (lost but known from a 1743 engraving by Pietro Monaco), which was sold to Anton Maria Zanetti the Elder (1680–1767) between 1763

and 1772. More than two decades after the purchase of Palma's *Three Women* by Algarotti, therefore, the Cornaro were still selling pictures from their collection.[28] The heretofore treasured *St. Francis* would soon follow. The last reference to the picture in the Ca' Granda was published in *Storia Pittorica della Italia* (1795–96) by Luigi Lanzi, who described it as one of the painter's most beautiful works depicting "a St. Francis in a dense wooded area to inspire jealousy in the best landscape painters."[29] Lanzi (1732–1810), an antiquary and art historian, had seen the painting two years earlier, around 1793–94, when he was traveling around northern Italy preparing his history of Italian painting. In his *taccuino di viaggio* (travelbook), under the entry on Giovanni Bellini, Lanzi wrote, "Casa Corner, Ca' Grande. A St. Francis, with a very beautiful figure in a large landscape: large painting of Poussinesque dimensions esteemed with his name. Three or four other pictures by him. Madonnas and Sacred Families of diverse merit; little chiaroscuro, broad forms and largely true color."[30] His singling out of *St. Francis* indicates that the Cornaro family was about to lose not only an heirloom but also its supreme example of Bellini's work.

For Sale and on Display: England and France, 1812–1903

On 7 December 1817, a fire devastated a large part of Ca' Corner della Ca' Granda.[31] It was the cruel final blow to the once great family. Several months earlier, on 21 May, Andrea Cornaro (d. c. May–July 1817) and his wife, Marina Pisani, the son and daughter-in-law of Nicolò and Alba Cornaro, had sold the palace and all its contents to the Austrian government, which then ruled Venice as part of the Kingdom of Lombardy-Venetia, following the fall of the Venetian Republic in 1797 during the Napoleonic wars. However, an inventory of the paintings and furniture drawn up for the sale did not mention Bellini's *St. Francis* in the "Queen's Room" or anywhere else in the palace.[32] A recently discovered group of fourteen documents in a private family archive explains the painting's absence from the house in 1817 and fills a gap in the picture's provenance that has vexed scholars for over a century. The new documents show that the painting had already left Venice by 1812.

On 7 September of that year, abbé Carlo Massinelli, a Milan-based picture dealer, sold nine Italian Old Masters, including a "Giovanni Bellini: on panel, representing St. Francis in a landscape and the hermitage of Assisi," to a French art collector, Joseph Desforges, who lived in Paris (fig. 31).[33] This episode corroborates old conjectures that the painting had at one point been in the French capital.[34] On the bill of sale, the total cost for all nine paintings was given in the currencies of both the Ancien Régime and Republican France, as 530 louis d'or and 4,871 French francs and 43 cents. Desforges,

Quadri venduti a Mr. Desforges da me sottoscritto

Giovanni Bellini in tavola rappresentante S.Francesco in paese, e tremo d'essi

Tiziano: in tavola: Adorazione di Due Pastori la sacra famiglia, gloria d'angioli, paese, e architettura.

Carlo Dolci: in tela rappresentante Gesù nell'età di 8.anni con cesta di fiori.

Guercino: in tela rappresentante l'angelo che custodisce l'innocente contro il tentatore in paese.

Carlo Maratta: salvame: allegoria del tempo che tutto distrugge.

Salvatore di Leonardo da Vinci, o sua quella in tavola con paese.

Due paesi di Gaspare Poussin: vedute di Roma. sopra tela.

Coreggio: rappresentante in tela Dilesa sopra tavola il giovane che pizze dalle mani del sotto sul davanti, e la cattura di Cristo sul di dietro.

Questi sud.ti nove quadri sono stati da me venduti a Mr. Desforges per la somma: primo di cinquecento, e trenta luigi in oro, o sia valore di franchi: secondo per la somma di: quattro mille otto cento settantino franco, e quaranta cent.mi. Le quali Due somme mi si pagheranno in Due lettere di cambio pel primo quindici ottobre prossimo avvenire sopra Mr. Desfontij vue de Faubourg poissonere à Paris N. 135. ovvero 105.: terzo in contanti che ho egualmente ricevuto di lire tre mille seicento cinquanta due, e mezza di milano presenti d'Italia

Pri. 7. 7bre 1812. Milano. Carlo Massinelli.

Fig. 31. Carlo Massinelli's (doc. 1771–1822) bill of sale of paintings to Joseph Desforges, Milan, 7 September 1812, verso. Private archive, Paris

who had already given Massinelli a cash down payment of 3,652 lire, was required to pay the remaining sum in two installments before 15 October 1812. It is not known from whom Massinelli had purchased *St. Francis* or whether the painting had left the Cornaro collection before he acquired it; the years 1796–1812 remain the only gap in the picture's later provenance.

Carlo Massinelli (active 1771–1822) was originally from Bergamo and a Jesuit brother.[35] From around 1779–97, he taught literature and philosophy to students in Milan. Massinelli was also an art lover who cultivated his own connoisseurship through reading about and examining art in Milan and other Italian cities. Assured of his own expertise, in 1797 Massinelli sought a position as deputy to the prefect of Milan's Biblioteca Ambrosiana and surveyor of its museum and picture gallery.[36] The minister of internal affairs for the French Cisalpine Republic, which then ruled Milan, gave serious consideration to his proposal, instigating an investigation into Massinelli's credentials and character that concluded that the abbé was "endowed with good moral and civil qualities, learned in philosophy, and a connoisseur of pictures." Nonetheless, they rejected Massinelli's proposal due to his lack of knowledge of

languages, which the committee considered fundamental for working with the library's books and communicating with foreigners. Referring to the plundering of artworks from Milan by its new French rulers, the committee questioned the usefulness of the position of surveyor of the gallery since "the best pictures have already been carried off to another Republican sky."

Following his rejection by the Biblioteca Ambrosiana, Massinelli applied his expertise in art to speculating. This was a common practice for "lay priests" knowledgeable in art who had privileged access to dispersed collections from churches suppressed and aristocratic families ruined in the devastating aftermath of the French occupation of Italy at the turn of the nineteenth century.[37] Massinelli sold and gave opinions on paintings predominantly from northern Italian churches and private collections, such as those of the Ferrari family of Verona and of Count Guglielmo Lochis (d. 1859) of Bergamo, who bequeathed his gallery to the city's Accademia Carrara.[38] An export license issued by Milan's Accademia di Belle Arti to the abbé in 1815, permitting him to freely transport paintings outside the confines of the Kingdom of Italy, shows that he catered to a foreign clientele with the consent of the authorities.[39] Massinelli is best known for his 1821 sale of about two hundred paintings to the English collector Edward Solly, who in turn sold them to the Kaiser Friedrich Museum in Berlin. In 1867, the abbé Massinelli, who had died by this time, was remembered in the eulogy of Giuseppe Molteni (1799–1867)—the celebrated painter, restorer, and museum director, who in his youth had cleaned pictures for the dealer—as "a renowned lover of all things of art, enthusiastic for old painting, and with a sureness of eye and sound method coupled with a sufficient knowledge of the different schools and an uncommon erudition; his opinions were in those times held in the highest regard; his long experience earned him respect."[40]

Massinelli's French client was Joseph Jacques François Boucher-Desforges (1764–1838). Desforges was born on the French island Île Bourbon (present-day Réunion) in the Indian Ocean, which was governed by his grandfather and uncle in the first half of the eighteenth century.[41] From the late 1780s to early 1800s, Desforges served on the same island as an officer in the French East India Company. Between 1802 and 1805, he moved to France, settling in Paris. Desforges met Massinelli in Milan in 1812, so presumably the Frenchman traveled to Italy with the intention of building a collection of paintings: he purchased an additional five pictures from a certain Felice Ferrari, for whom Massinelli acted as an intermediary.[42] Overall, Desforges acquired a varied group of paintings by Italian High Renaissance, Mannerist, and Baroque artists from different schools, as well as French classical landscapes, which suggests he was

creating a gallery. Perhaps the Frenchman had overstretched himself with this purchase of fourteen works: he asked Massinelli to defer payments but was refused. In a letter sent to Desforges on 25 October 1812, Massinelli explained that he was not able to extend the deadline because of his commitments to his financier, a certain Andreoli in Venice, who had lent the abbé money to buy artworks on the agreement that he would be repaid within three years and receive fifty percent of the profits.[43] Could the Venetian Andreoli, who was annoyed that Massinelli had "sold for such a low price such classic and rare masterpieces," also have helped Massinelli to remove *St. Francis* from the lagoon city to Milan? The Lombard city was then the capital of the Napoleonic Kingdom of Italy (1805–14), ruled by Viceroy Eugène de Beauharnais on behalf of his stepfather Napoleon. In this period, it was a hub for artworks from suppressed religious institutions and dispersed private collections from around the Italian peninsula and also served as the point of export to northern Europe.[44]

Bellini's *St. Francis in the Desert* remained in Paris in Joseph Desforges's collection for nearly four decades, from 1812 until 1849, when his son Charles (1797–1876) offered fifteen paintings, mainly Italian Old Masters,[45] for sale to the English art dealer William Buchanan (1777–1864), who was then in the twilight of his career (fig. 32).[46] The younger Desforges and Buchanan had been introduced by Otto Mündler (1811–1870), a German art historian based in Paris who would soon publish his influential essay on Italian Old Masters in the Louvre (*Essai d'une Analyse Critique de la Notice des Tableaux Italiens du Musée National du Louvre*, 1850).[47] Later, Mündler would become the traveling agent for Charles Eastlake, the first director of the National Gallery in London, assisting him from 1855 to 1858 in his campaign to acquire early Italian paintings for the British public. Having visited Charles Desforges in Paris to examine the pictures, Buchanan, in February of the next year, decided to purchase his *St. Francis of Assisi in the Apennines* by Giovanni Bellini and an *Adoration of the Shepherds* by Palma il Vecchio for 26,000 francs—4,000 francs below Desforges's original asking price for the two pictures. Buchanan agreed to purchase the works on the condition that the paintings be in the same state in which he had seen them and that the men's transaction be kept a secret from Mündler, whom he intended to inform and pay his five percent commission only after the completion of the sale. Desforges swore to keep their deal confidential and reassured Buchanan several times that the paintings had never been cleaned since his family had owned them, which was at least thirty-five years. "In my opinion," he wrote to the dealer, "cleaning pictures is often destroying them. And such was also my father's opinion."[48] At Buchanan's behest, the transaction was completed with great speed because he had the opportunity to place *St. Francis* "in one of the first

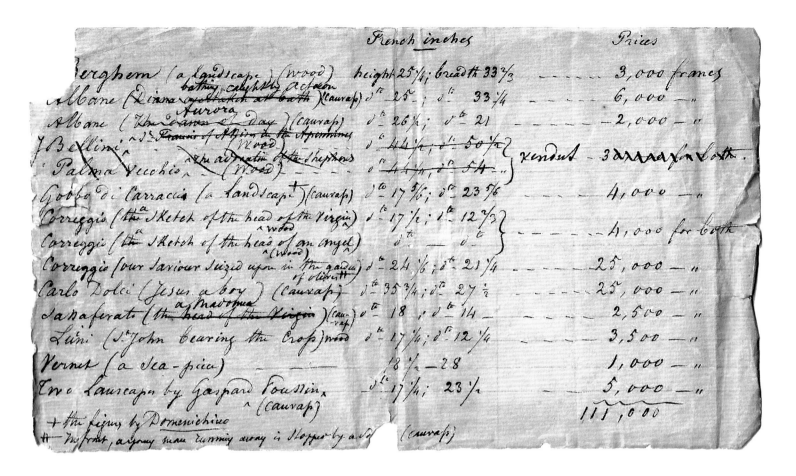

French inches | Prices

Berghem (a landscape) (wood) height 25 1/4; breadth 33 2/3 — — — 3,000 francs
Albane (Diana bathing — Actæon caught at bath) (canvas) d.º 25; d.º 33 1/4 — — 6,000 —
Albane (Aurora — Day) (canvas) d.º 26 1/2; d.º 21 — — — 2,000 — "
J Bellini — (Francis of Assisi in the Apennines) (wood) d.º 44 1/2; d.º 50 1/2
Palma Vecchio — (the adoration of the Shepherds) (wood) — d.º 44 1/2; d.º 54 — " } vendu — 3 xxxxxx for both.
Gobbo di Carraccis (a landscape) (canvas) d.º 17 5/6; d.º 23 5/6 — — — 4,000 — "
Correggio (the Sketch of the head of the Virgin) d.º 17 1/2; 1.º 12 2/3 }
Correggio (the Sketch of the head of an angel) (wood) d.º — d.º — } — — — 4,000 for both
Correggio (our Saviour seized upon in the garden of olives) d.º 24 1/2; d.º 21 1/4 — — 25,000 — "
Carlo Dolci (Jesus a boy) (canvas) d.º 35 3/4; d.º 27 1/2 — — 25,000 — "
Sassoferato (a Madonna — the head of the Virgin) (canvas) d.º 18; d.º 14 — — — 2,500 — "
Luini (St John bearing the Cross) wood d.º 17 1/4; d.º 12 1/4 — — 3,500 — "
Vernet (a Sea-piece) — 18 1/2 — 28 1,000 — "
Two Landscapes by Gaspard Poussin, (canvas) d.º 17 1/4; 23 1/2 — — 5,000 — "
————
111,000
+ the figure by Domenichino
++ the front, a young man turning away is stopped by a N.º (canvas)

Fig. 32. Charles Desforges's (1797–1876) list of paintings offered for sale to William Buchanan, Paris, May 1849. Private archive, Paris

collections of England and where my opinion has some weight."[49] This unparalleled prospect, as well as fear of competition from other art dealers, might explain why Buchanan was so intent on keeping the location of the painting and his transaction a secret.

On 21 March 1850, Charles Desforges received £800 (equivalent to 20,000 francs) for Bellini's *St. Francis* from Buchanan's bankers in Paris, Ferrère-Laffitte, and awaited the last 6,000 francs for the Palma. Following the dealer's instructions, Desforges sent the panel to be packed in its frame "with great caution and care" by the art handler Monsieur Chenue, who later sent him confirmation that ready for shipment was: "a painting by Giovanni Bellini painted on wood, one meter 42 centimeters wide and one meter 26 centimeters high, representing a landscape in the mountains with a hermit in religious dress and in ecstasy, the said painting decorated with a broad wooden frame richly carved and gilded" (fig. 33).[50] Chenue's note of 1850 is important for its description of the painting's frame at this time but more so for the information it provides on the panel's size (126 × 142 cm), which is almost identical to its current dimensions (124.6 × 142 cm). Therefore, it provides a new *terminus ante quem* of 1850 for the cutting of the upper horizontal edge of the panel, identified by recent technical examinations.[51] Charles Desforges's rigorous claims to Buchanan that the panel had not been cleaned or restored in the period since his family acquired it means that the panel was most likely altered before 1812, when his father bought it from Carlo Massinelli. A letter sent from Massinelli to the elder Desforges on 25 October 1812

Fig. 33. Chenue's packing and shipping receipt for *St. Francis*, issued to Charles Desforges, Paris, 21 March 1850. Private archive, Paris

shows that the dealer and collector had a dispute over the sale of some frames, though the details are difficult to ascertain from a single letter from Massinelli's side of the correspondence only. It seems that Massinelli sold the paintings to Desforges in new frames, but the French collector preferred the original ones and accused the dealer of profiteering from their sale. In his defense, Massinelli claimed that the old frames were useless to him and that he was unable to keep them. It is tempting to imagine that the Milanese dealer, who was accustomed to have his paintings "just cleaned or fully restored" during this period,[52] altered the height of the panel in order to fit it into the attractive, "richly carved and gilded" frame, which was retained by the Desforges family and later admired by the art handler Chenue.[53]

On 13 April 1850, three weeks after the sale of *St. Francis*, Otto Mündler learned of the transaction and received his commission of five percent, 1,300 francs.[54] A day earlier, Buchanan had offered the painting for sale to the former British prime minister, Sir Robert Peel (1788–1850), the owner of "one of the first collections of England," whom the dealer had mentioned to Desforges as a potential buyer. It is unclear whether Peel, who collected Dutch and Flemish cabinet pictures, was interested in this early Italian painting because he died a few months later.[55] The following year, Buchanan offered the painting to the National Gallery in London, which declined his offer probably because it had just emerged from a three-year moratorium on acquisitions due to the resignation of Keeper Charles Eastlake in 1847. During this time, the gallery's trustees were hesitant to purchase new artworks.[56] Having failed again to sell *St. Francis*, Buchanan was driven by his creditors to the salesroom and consigned it

anonymously to Christie's, where it went unsold, [57] probably because of the general lack of appreciation for early Italian painting in Britain at this time. Another year passed before Buchanan consigned it again to Christie's, where it finally sold to Captain Joseph Dingwall for £735 in 1852.[58] Its reserve price of £700 shows that Buchanan was prepared to take a loss on the painting, which he had purchased from Desforges for £800 more than two years earlier.[59] The sale catalogue's description of the painting as "made for a convent in the Milanese," which has long mystified scholars,[60] can now be explained by Charles Desforges's last letter to Buchanan on 3 April 1850.[61] Apparently pressed by the dealer to provide information on the provenance of the painting, the Frenchman wrote a lengthy missive in which he stated, "I can only repeat here what I said from the beginning, that the pictures were purchased at Milan between 1809 and 1813." He then proceeded to describe at length the mass dispersal of artworks from suppressed churches and fallen aristocratic families in the chaotic Napoleonic era, when "nobody thought of those minute and often useless inquiries with regard to the collections in which pictures may originally have been placed." "Judging from the subject," Desforges added, "it seems extremely probable that that eminent master, who was at the same time a devout Catholic, painted it *con amore* as a present to some convent, perhaps that of the Franciscans at Assisi." Therefore, Buchanan—who also warned Desforges, "I do not wish it to be known from whence the pictures come, farther than that they were originally purchased at Milan"—conflated these details to create "made for a convent in the Milanese" for the Christie's catalogue in order to give the impression that the painting had just been removed from its original Italian home. Buchanan must also be the source of the auctioneer's note that "a large sum was offered by the directors of the Louvre for it during the period of the late French Assembly, but the period named for payment was at too long a date to render the offer advisable to accept."[62]

The following year, in 1853, Morris Moore (1811–1855), an English collector who had studied Renaissance art in Italy, addressed a Select Committee of the House of Commons that was investigating the management of the National Gallery.[63] Moore, author of *The Abuses of the National Gallery* (1847), accused the gallery of missing the opportunity to acquire "a work of singular importance" for the nation and contrasted their purchase of Bellini's portrait *Doge Leonardo Loredan* (c. 1501–4; The National Gallery, London) for £630 in 1844 as a comparatively bad bargain. Moore was to be the only champion of *St. Francis in the Desert* in Britain until the early twentieth century.

The (hitherto mysterious) new owner of the painting, Joseph Dingwall, was born in August 1806 to Patrick Dingwall and Harriet Yates. He was married in 1848 to

Elizabeth Hird (d. 1877) of Sunninghill, near London, widow of the Reverend Joshua S. Hird and daughter of the late Philip Bedwell of Clapham-Common.[64] Originally from Scotland, Dingwall established a wine and spirits business with his brother Charles in London in 1830. Dingwall and his wife lived in Broomfield House in the parish of Egham, Surrey, to the west of the British capital. They were visited there on 4 February 1857 by George Scharf (1820–1895), secretary for *Art Treasures of the United Kingdom*, an exhibition due to open to the public at Manchester in three months.[65] A month earlier, Dingwall had written to the exhibition's organizers with an offer to lend paintings to the show, mentioning he had a painting by Giovanni Bellini that was "said to be unique."[66] Scharf, who was responsible for finding Old Masters to borrow for the show, was astounded to see Dingwall's collection, which was "wholly unknown" to him because it had not been included in Gustav Friedrich Waagen's authoritative *Treasures of Art in Great Britain* of 1854 (or his supplementary volume, *Galleries and Cabinets . . .*, of 1857).[67]

He selected ten of Dingwall's paintings for the exhibition, including works by Giulio Romano, Mabuse (later recognized as Gerard David's important *Deposition from the Cross* now in The Frick Collection, fig. 34), Rubens, van Dyck, and David Teniers.[68] Scharf also requested Bellini's "unique" *St. Francis*, of which he made a cursory sketch as an aide-mémoire (fig. 35) and traced its *cartellino* for his collection of artists' inscriptions.

Attended by throngs of art lovers from across Europe, Manchester's *Art Treasures* turned out to be the most important art exhibition of the century in Britain. There, Bellini's *St. Francis in the Desert* was exhibited in Saloon A, the gallery for "Ancient Masters."[69] It was hung on the top row of paintings (no. 116) on the south wall in a position that did not lend itself to an appreciation of the Venetian painter's exquisite and highly detailed composition. Furthermore, it was outshone by the larger and very well-received *Virgin and Child Enthroned between St. Jerome and St. Peter* (then believed to be by Raphael's teacher, Perugino), which hung beneath (fig. 36).[70] *St. Francis's*

disadvantageous placement was probably due to Scharf's misgivings about its condition and quality, aspects of which he described as "muzzy . . . ruined and unsatisfactory."[71] In the *Manchester Guardian*, he praised its "beautifully painted" background but found the figure of the saint and the wooden reading stand lacking in "truth of form, and accuracy of imitation."[72] Charles Eliot Norton (1827–1908), an American art historian and first professor of art history at Harvard from 1873, found none of the five paintings by Bellini exhibited at Manchester to be first-rate examples of the artist's work, not even *St. Francis in the Desert*.[73] The painting was more positively assessed by the great Italian connoisseur Giovanni Battista Cavalcaselle (1819–1897), who inspected paintings at Manchester, paying particular attention to fifteenth- and sixteenth-

century Italian and northern art.[74] He made two detailed drawings, one of the entire panel and the other a half-length figure of Francis, including two sketches of the upcast left eye of the awestruck saint (figs. 37, 38). Cavalcaselle's annotations on the painting's salient features, such as "verdant stones" (*sassi verdanti*) and "thin, pale man" (*homo magro privo di tinta*), show his perception of Bellini's ingenious evocation of the divine moment. He also made a brief sketch of the *cartellino* with the artist's signature.[75] Over a decade later, Cavalcaselle and his coauthor Joseph A. Crowe recalled the painting in a long chapter devoted to Bellini in their *History of Painting in North Italy* (1871), which was an important milestone in the reception of the artist in

the Anglophone world.[76] Yet the overall poor reception of *St. Francis* and other works by the artist in Manchester reflects the lack of appreciation and understanding for Bellini and other early Italian painters in Britain at the time. It was not until the latter half of the nineteenth century that so-called Primitives were valued for their own merits and not simply as necessary precursors to the great Italian artists of the Cinquecento.[77] After this unremarkable public debut, *St. Francis in the Desert* disappeared and was thought to be lost until the turn of the twentieth century.

Rediscovery and Transatlantic Crossing: London to New York, 1903–15

In 1903, the English art historian Robert Langton Douglas (1864–1951) was inspired by Marcantonio Michiel's description of *St. Francis*, which he had read in the recently published first English translation of the *Notizia d'Opere di Disegno* and in an older Italian edition of 1884. Learning that this painting was "last seen in the collection of a Mr. S Dingwall in England," Douglas decided to search for the lost masterpiece.[78] Later in life, he recalled how he was determined to write "a letter to everyone of the name of Dingwall in Great Britain, her Dominions and in the United States."[79] After several months, he received a letter from Dingwall's nephew in Australia, who told him that his uncle had abandoned his home in Sunninghill because he could no longer stand his wife and had gone to Turkey, promising never to return. On the train to London, Dingwall purportedly announced to his fellow passengers his intention to "sell immediately his home at Sunninghill, with all its contents, lock, stock and barrel, to the highest bidder." Sharing his carriage was Thomas Holloway, one of Britain's richest men, who asked Dingwall the price, and "a bargain was struck forthwith." Holloway had no precise idea of what he had purchased, but he knew that the home was pleasantly situated, well furnished, and housed a good art collection. When he took possession of the property, he found that the house was exactly as Dingwall had left it. There was wine in the cellars, clothes in closets, and private letters in drawers, as well as paintings on the walls by Bellini, Rubens, and van Dyck, but their value was not recognized by their new owner.

Thomas Holloway (1800–1883) was an English pharmaceutical manufacturer and philanthropist (fig. 39). He is best remembered for his "gifts to the nation" of Holloway Sanatorium (1885) for the care of the mentally ill and Royal Holloway College for the education of women (1886), both housed in magnificent Gothic Revival buildings. For the ladies' college, Holloway created a picture gallery to demonstrate the triumph of British art, amassing seventy-seven paintings within two years for the sum of £84,000.[80] His project to celebrate British painting naturally excluded the Old

Fig. 39. William Scott (1819–1905),
Thomas Holloway, 1845. Oil on canvas,
115.6 × 83.8 cm. Royal Holloway,
Egham, Surrey

Master paintings, acquired even faster and en bloc from Dingwall, which hung in his home. Langton Douglas traced Holloway's surviving relatives—Lady Martin-Holloway, her daughter and son-in-law—and found that the paintings sold by Dingwall, including *St. Francis in the Desert* and Gerard David's somber and dignified *Deposition from the Cross* (see fig. 34), were in the possession of the family, who "still had no idea of the importance of some of the pictures."[81]

Langton Douglas's account of his sleuthing to find the *St. Francis* and the incredible tale of its passage from Dingwall to Holloway deserve scrutiny since details of the story appear to have been confused over time. These are, namely, that Holloway purchased Tittenhurst Park or Lodge in Sunninghill from Dingwall in 1869 and that the property along with its art collection was inherited by Holloway's sister-in-law Lady Martin-Holloway (née Mary Ann Driver).[82] Holloway did purchase a house near Sunninghill from Joseph Dingwall in the 1860s, but the name of the property was Broomfield House, not Tittenhurst Lodge or Park.[83] Holloway demolished Dingwall's former home after transferring a number of paintings to Tittenhurst and erected a new building on the site that he never occupied and sold in 1872.[84] Their deal was not

completed in 1869 during a brief train journey but was begun around 1863 and finalized after 1865.[85] Also in 1863, Joseph Dingwall dissolved his partnership in his wine and spirits business.[86] He did indeed run away to Turkey, where he died a decade later, on 17 January 1873.[87] Holloway was childless and predeceased by his sister Matilda Eva Holloway (1813–1867) and wife Jane Pearce Driver (1814–1875). He bequeathed all his possessions to his wife's spinster sister Miss Mary Ann Driver (1817–1900) and not directly to his married sister-in-law Lady Martin-Holloway (née Sarah Anne Driver) (1821–1911).[88] The latter was married in 1857 to George Martin (1833–1895), who assumed the additional name of Holloway and was knighted in 1887. When Langton Douglas found St. Francis in 1903, it was in the possession of the widowed Lady Martin-Holloway, her daughter Celia Sabina Oliver (1859–1933) and son-in-law Vere Langford Oliver (1861–1942), who were now living at Whitmore Lodge, in Sunninghill.[89]

After several years, Lady Martin-Holloway decided to sell St. Francis in the Desert and Gerard David's Deposition from the Cross, offering Langton Douglas first refusal "as he had never concealed his admiration for them." However, she died in 1911 before they were able to complete the deal, and the estate passed into the control of her trustees and executors. When Langton Douglas was offered the pictures again, he was only able to afford the asking price by entering into a partnership with the recently merged London art dealers Messrs. P. & D. Colnaghi and Obach, which pained him since he had planned to keep the pictures for himself and then later "offer them to some great museum." In the meantime, the National Gallery and the Royal Academy of Arts learned of the formerly lost masterpiece, and it was decided that St. Francis in the Desert be exhibited at the winter exhibition Old Masters and Deceased Masters of the British School at Burlington House in 1912.[90] News of the Bellini's remarkable rediscovery was announced in the British press, with the Morning Post speculating whether the painting, which had been "as bad as lost," would be shown and give the public the "opportunity of examining its artistic merits."[91] When the picture was unveiled in the place of honor at the show, it caused a sensation, receiving rave reviews by some of Britain's leading art critics, who praised Bellini's original and exceptional treatment of the theme of the stigmatization of St. Francis, as well as the superb condition of the painting. Writing for the Daily Telegraph, Sir Claude Phillips, who had been the first keeper of the Wallace Collection, enthusiastically characterized Bellini's standing saint as "no longer gentle, submissive, all-enduring, but strenuous in piety, powerful in appeal, almost militant in attack."[92] The Pall Mall Gazette published a lengthy panegyric to the painting by Sir Sidney Colvin, who had been the first director of the Fitzwilliam Museum, in which he concluded that "to represent the miracle thus, by

the gesture, and gaze, and expression of the Saint alone, is a thing unique in art" and predicted that "it is not likely to be seen in England again."[93] *St. Francis in the Desert* soon became the hot topic of conversation and debate among art lovers and experts on both sides of the Atlantic. The English critic Roger Fry, author of the first English-language monograph on Giovanni Bellini in 1899, declared that the picture was by an inferior follower of the painter, a proposal that found agreement in some quarters. Art historian Mary Berenson wrote to the American collector and patron Isabella Stewart Gardner, "I have been so out of things that I have no gossip to give you, even of the art world, except that the most beautiful Bellini in existence, the most profound and spiritual picture ever painted in the Renaissance, is now on view (and I believe on sale) at Colnaghi's."[94]

Colnaghi of London was one of the leading art firms vying for clients on the booming transatlantic art market, which had seen a mass migration of Old Masters that impoverished European aristocrats sold for record-breaking prices to newly rich and culturally ambitious Americans since the late 1800s.[95] Pittsburgh industrialist Henry Clay Frick (1849–1919), who was on the lookout for art to decorate his new mansion on Fifth Avenue in New York, was one of Colnaghi's most courted clients. However, *St. Francis in the Desert*, the latest masterpiece to fall into their hands, was not offered immediately to Frick because Colnaghi believed "he would not understand [it] or be interested," referring to Frick's dislike of religious art.[96] Over the next three years, the painting changed hands, jointly owned at different points by the firms Colnaghi, Knoedler, and Thomas Agnew & Sons.[97] In 1912, *St. Francis* was sold for £45,000 to Arthur Morton Grenfell, a young London financier, but was secretly bought back from him for a heavily discounted price of £30,000 just a year later, soon before Grenfell went bankrupt. In August 1913, the Knoedler gallery showed it to Henry Clay Frick in London but rejected the American's half-hearted offer of $200,000. A year later, after the outbreak of World War I and the ensuing crisis in the European and American stock markets, the art trade slowed down and prices for pictures fell. In the winter of 1914, *St. Francis* was offered to the National Gallery in London but was rejected by the British institution for the second time in its history.[98] By early 1915, Knoedler and Agnew's desperately needed capital and were anxious to be rid of the painting, so they offered it to Frick, who had begun to take advantage of the dip in the art market to purchase a number of spectacular masterpieces at bargain prices. However, as related in the opening of this essay, Frick was reluctant to buy the work without the second opinion of Bernard Berenson; so Knoedler and Agnew's ultimately had to rely on the aid of their rivals to complete the deal. On 10 May 1915, Frick finally

agreed to pay $170,000, considerably less than the sum he had offered two years earlier.[99] Shortly afterward, he received a cablegram from Bernard Berenson: "Congratulate Frick Bellini Which One Masterpieces All Italian Art shall speak thereof fully in forthcoming articles."[100] The sale of this celebrated painting was reported in the American and European press, with the *New York Times* running the headline "H. C. Frick's St. Francis . . . Considered One of the Earliest Examples of Italian Landscape."[101] Frick displayed *St. Francis in the Desert* on the oak-paneled walls of his mansion's elegant Living Hall (p. 58), between two portraits by Bellini's student Titian, where it has remained to this day with a serenity that belies the turbulence of its centuries-long epic journey from the Grand Canal to Fifth Avenue.

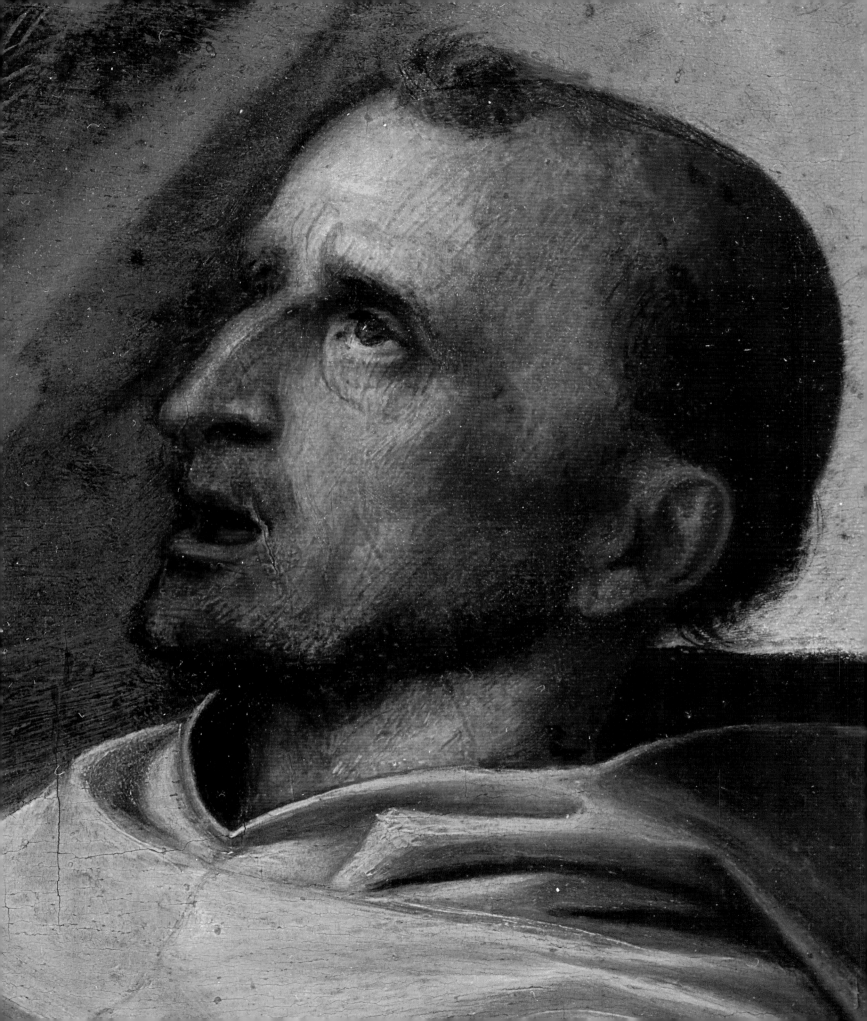

ST. FRANCIS IN THE DESERT: TECHNIQUE AND MEANING

by Susannah Rutherglen and Charlotte Hale

Giovanni Bellini's *St. Francis in the Desert* is a masterpiece of spiritual poetry that has inspired generations of visitors to The Frick Collection. Yet for all the consideration it has received, this vision of a solitary saint remains the artist's most enigmatic achievement. Consummate in its harmonies of form and color, miraculous in its texture of symbols and details, *St. Francis* is a richly confounding work that invites fundamental questions of intention and meaning. Has Bellini represented a particular event in the life of St. Francis? What might the monumental pose and rapt expression of the figure convey, and what is the significance of the surrounding landscape with its intricate variety of plant and animal life? Where does the painting stand in Bellini's development, and how has the work changed over time?

In 2010, *St. Francis* traveled to the Sherman Fairchild Paintings Conservation Center at the Metropolitan Museum of Art for a comprehensive technical examination, including infrared reflectography, X-radiography, microscopy, and paint analysis. The results of this investigation afford a glimpse over Bellini's shoulder as he conceived and realized his design and, together with a survey of related paintings, make it possible to approach longstanding questions about the picture's subject from the perspective of the working artist. Equally important, the analyses raise new problems and open further avenues of inquiry into this perennial monument of Christian art.

By the time he came to paint *St. Francis* in the later 1470s, Bellini had reached the prime of his career and was enjoying renown as the author of altarpieces, devotional works, and portraits for varied clients from his native republic of Venice to the Marches of Italy. Giovanni's date of birth and parentage remain the subject of debate. He may have been born as early as 1424 and as late as 1440, with most recent scholars preferring a date in the mid-1430s.[1] Like many Venetian painters, he belonged to a family of artists, and his training took place in the workshop of his father, the early Renaissance master Jacopo Bellini (c. 1400–1470/71). A new study, however, suggests that Jacopo was not Giovanni's biological father but rather his much older half-brother; that Giovanni was born between 1424 and 1428; and that after their father Nicolò died, Jacopo took Giovanni into the family business as an informally adopted son. Another recent analysis reveals that Giovanni had a close family relationship to a widow named Samaritana and supports a birth date closer to the mid- to late 1430s.[2]

Whatever the precise circumstances of the artist's birth and childhood, it is clear that he was effectively the son of Jacopo Bellini and was described as such by contemporary sources.[3] Gentile Bellini (c. 1429/35–1507), Jacopo's biological son, was also a painter (see fig. 12) and considered Giovanni his "dearest brother" and colleague.[4] Giovanni had established his own household in Venice by 1459 but continued to collaborate after this

St. Francis in the Desert, detail

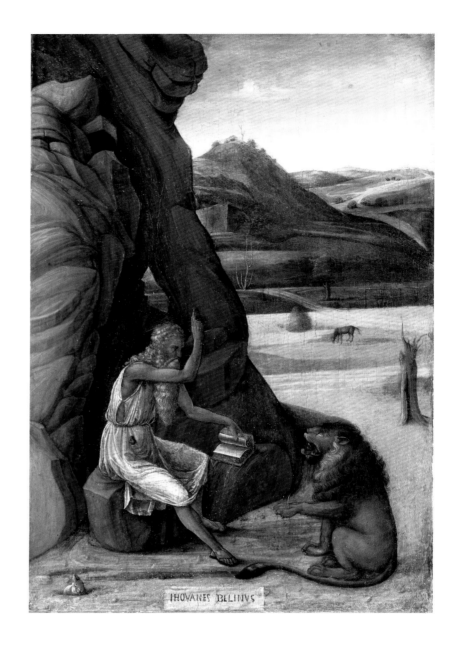

Fig. 40. Giovanni Bellini, *St. Jerome in the Desert*, c. 1450–60. Tempera on panel, 48 × 35.8 cm. Barber Institute of Fine Arts, Birmingham

date with both Jacopo and Gentile.[5] His earliest known independent work was a finely wrought scene of *St. Jerome in the Desert* (fig. 40), and he may also have gained experience during the 1450s in the small-scale format of manuscript illumination.[6]

The young Giovanni received a standard education in the technique of egg tempera, the medium traditionally employed by Italian painters on panel. Because it dries quickly to form a thin, hard, and opaque film, tempera paint requires extensive forethought and confident application in tiny strokes with the point of a soft brush. The artist learned to plan his pictures carefully and use his materials economically, painting in few layers and rarely deviating from compositional plans established during a painstaking preparatory process.

The discipline demanded by egg tempera remained with Bellini throughout his life and informed his greatest works, even as he gradually adopted the newer and more forgiving medium of drying oil. Study of the picture surface of *St. Francis* suggests

that its essential binding medium is drying oil, which sets much more slowly than tempera and has a thicker, more bodied and fluent consistency. In his notes of 1525, the connoisseur Marcantonio Michiel, too, characterized the work as an oil painting (see fig. 21). This finding was confirmed by examination of selected samples of the picture's upper paint layers.[7]

Oil can be combined with a wide range of pigments to produce rich, saturated colors, which may be applied broadly and expressively or in minute touches to achieve astonishing levels of detail. On the picture surface, oil paints can be blended, layered, modulated with translucent glazes to produce effects of glowing depth, and manipulated with the brush or other tools to create three-dimensional texture. Oil further allows the artist to deliberate and revise directly on the panel or canvas, by covering selected areas with fresh layers of color.

As he conceived the idea of *St. Francis* and painted it in oil, Bellini largely maintained the meticulous approach of a tempera-trained artist, planning and realizing each element of the composition with methodical intelligence. Within the confines of his rigorous practice, however, the painter allowed himself moments of extraordinary freedom and invention. Most significantly, Bellini altered parts of the work's content as his thinking evolved. In addition, he employed novel color combinations, explored a range of modes from concentrated detail to brushy abbreviation, and used traditional tools to capture effects of particular interest to him—above all the diffusion of light. Such passages of technical innovation and subtle virtuosity exemplify the originality of *St. Francis*, a picture whose dramatic force and intellectual complexity are revealed in new aspects with each encounter.

Preparation and Painting

Before he began to paint, Bellini must have developed the composition of *St. Francis* with preparatory drawings on paper. No such studies survive—in fact, no definite preparatory sketches for any of the artist's works are known—yet the assured design of his finished paintings and the lack of major revisions imply a diligent process of preliminary drawing. In the workshop of Jacopo Bellini, albums of drawings and "drawn pictures," or *quadros dessignatos*, were employed.[8] Giovanni certainly was aware of these materials, and circumstantial evidence points to the use of various types of drawings in his own studio.[9] The artist's working studies for *St. Francis* probably focused on the figure of the saint, the donkey at middle ground, and features of the town and landscape; the drawings may also have included overall sketches of the composition and its lighting.

Fig. 41. *St. Francis*, detail of the shepherd and landscape, showing handprints in the underlying priming layer

Fig. 42. *St. Francis*, detail of the background of the saint's rustic cell. At upper right, two fingerprints in the underlying priming layer are visible.

After this exploratory stage, Bellini turned to the preparation and execution of the picture itself. The large poplar panel of *St. Francis* was covered first with layers of white gesso, composed of gypsum and animal glue, the typical ground for Italian pictures of this period.[10] On the smoothed gesso, the artist applied his underdrawing, a detailed design in fine lines of fluid black paint. The underdrawing was the cornerstone of Bellini's practice in his early and middle years: a definitive rendering of the entire composition comprising contours, details, and hatched lines for areas of shadow. These would guide his hand as he filled the forms with color.[11] Subsequently concealed by the paint layers, underdrawings can be detected today with infrared reflectography, a noninvasive analytical technique that makes it possible to see through a picture's visible surface and produce an image of underlying strata.

The overall infrared reflectogram of *St. Francis* reveals a characteristically extensive and beautiful underdrawing, executed fully by the artist without the help of workshop assistants or obvious use of transfer methods such as tracing and pouncing. With the point of a brush, Bellini set down dark lines of varying width and control to lay in the boundaries of forms and to establish patterns of lighting (see fig. 43). Differences between this preparatory design and the final composition disclose alterations made by the artist as he worked. Infrared reflectography registers not only underdrawing

but also some of the overlying paint layers (see fig. 48) and can be used to study later stages of execution.

Once complete, the underdrawing was covered with a translucent layer of *imprimitura*, or priming, consisting of a small quantity of lead white pigment bound in oil.[12] The *imprimitura* served two main purposes: to seal the underdrawing, protecting it from damage during the painting process; and to isolate the upper paint layers from the gesso, which was highly absorbent and would otherwise leach oil from the paint above. The priming was spread evenly over the entire picture surface by hand, leaving behind whorled impressions of fingerprints and palm prints. Some of these have gradually become visible owing to increased transparency of the overlying paint through time and, in some cases, to abrasion (figs. 41, 42). This effect was unintended: fingerprints and palm prints derived from application of the *imprimitura* now appear in many of Bellini's pictures, but, almost without exception, their texture was originally completely obscured by the paint layers.[13]

Only after the laborious application of gesso, underdrawing, and priming did the process of painting begin. The quality of handling throughout the picture reveals an autograph composition. Starting with the sky at the top of the panel and working down to the foreground, Bellini brushed color within the lines of the underdrawing. For the

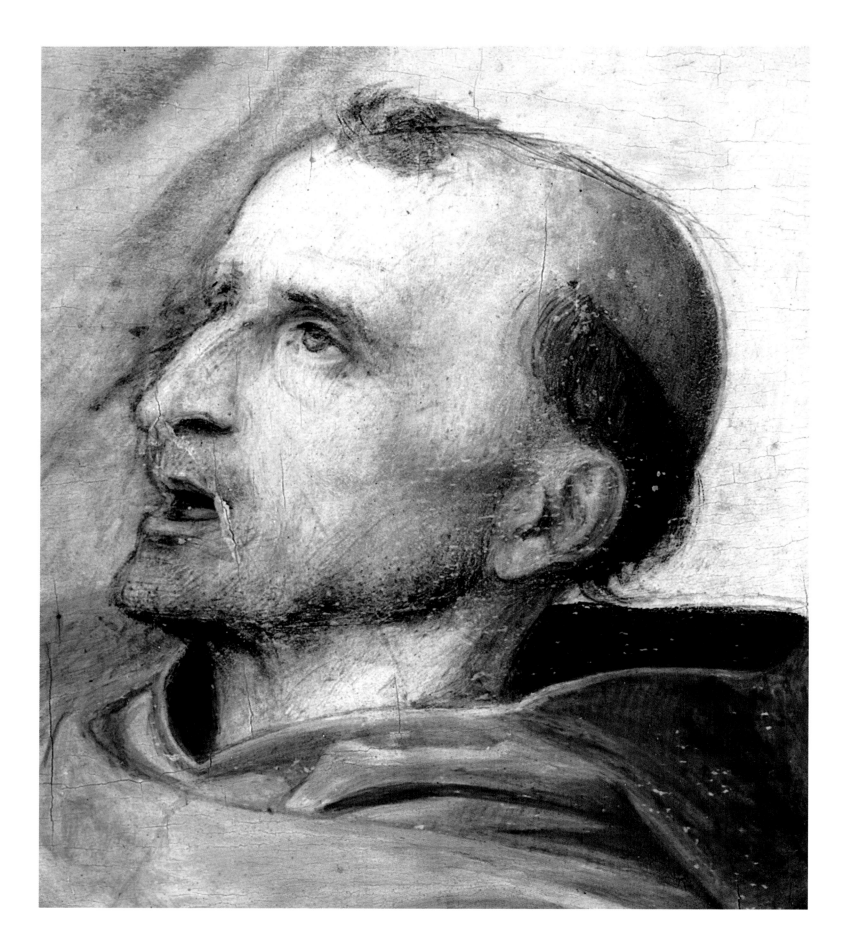

Fig. 43. *St. Francis*, infrared reflectogram detail, showing underdrawing of the head and cowl

Fig. 44. Donatello (c. 1386–1466), *St. Francis* (detail), c. 1447–50. Bronze, 147 cm high. Basilica del Santo, Padua

most part, he obeyed the dictates of this preliminary design, filling in each form or zone with just two or three layers of paint. Thus, Francis is painted directly on the white preparation rather than over a pre-existing landscape background, and the saint's surroundings are painted just up to the contour of his figure. This method, known as reserve technique, promotes efficient use of materials, and the application of minimal paint layers has the additional benefit of allowing the brilliantly reflective white preparation to illuminate the picture from within.[14] Bellini's use of careful underdrawing and reserve technique results in a precisely delineated composition with the graphic clarity and balanced structure characteristic of more traditional works in egg tempera.[15]

In certain passages, however, the artist abandoned this conservative approach, instead painting thickly to achieve texture or inflecting his chosen color with an underpaint of different hue. In other sections, he changed his mind after following the premeditated design and canceled it by adding dense layers of paint on top. The work's overall luminous depth of color, together with areas of texturing, layering, and overpainting, demonstrates his engagement with the possibilities of the oil medium.

Saint and Stigmata

The most detailed and highly calibrated element of Bellini's composition is the figure of Francis. At the underdrawing stage, the artist outlined the profile of the saint's face and tested the outer boundary of the skull with delicate, overlapping strokes (fig. 43). He used fine lines of underdrawing to indicate the furrows between Francis's brows, the fold of skin beneath his left eye, the inner contour of his opened mouth, and the border of his tonsure.

In addition to planning the structure and attributes of the saint's head in the underdrawing, Bellini considered effects of light. He modeled shadows and curved surfaces with short parallel lines of hatching in the underdrawing. An established technique among Netherlandish, Paduan, and Venetian painters, parallel hatched underdrawing appears in many works of Bellini's early and middle periods.[16] Zones of hatching define the shadows on Francis's forehead, below his cheekbone, and at the outer perimeter of his eye. To mark the border of the shadow on the side of the saint's nose, the artist applied a single, extended stroke of underdrawing.

Overall, the delicacy of underdrawing in the head appears unprecedented in works of the artist that have been analyzed.[17] As he began to describe Francis on the unpainted ground, Bellini was already attending to the figure's aquiline profile, the wrinkles of his skin and the shadows of his cheeks, and the sense of awe conveyed by his parted mouth and upraised eyes. Some of these traits are indebted to Donatello's bronze statue of Francis on the high altar of the Basilica del Santo in nearby Padua

(fig. 44).[18] Yet the animation of the face is highly specific: perhaps the painter portrayed a contemporary individual in the guise of the illustrious saint, a not uncommon practice in Venice.[19] More generally, Bellini brought the conventions of portraiture to bear on the historical Francis and, in the spirit of the holy man's early biographers, rendered him with compelling presence.[20]

The underdrawing in this area is in fact akin to a portrait sketch, and shows affinities with a surviving black chalk portrait drawing from the artist's hand (fig. 45).[21] In this likeness of his brother, Gentile, Giovanni worked out the fall of illumination with minute strokes of shading and adjusted the contours of the head and neck with tapering lines. His searching design imbues Gentile with an air of dignified reserve that reflects the honor of the Bellini family's shared profession. Likewise, the underdrawing of Francis's head and face endows him with the qualities of humility, sagacity, and spiritual elevation befitting the founder of the Friars Minor. Bellini gave final form to these attributes with very thin applications of color, laying in first the shadows and then the lighter tones of the face, with a final touch of white for the glint of the eye (p. 80). The vivid immediacy of this painted portrait mitigates the physical absence of the saint, whose body was from an early date hidden and inaccessible to the faithful.[22]

While the countenance of Francis leaves no doubt as to his devotion and the intensity of his experience, the nature of that experience is less certain. The most commonly illuminated episode from the saint's life is his stigmatization, the miracle

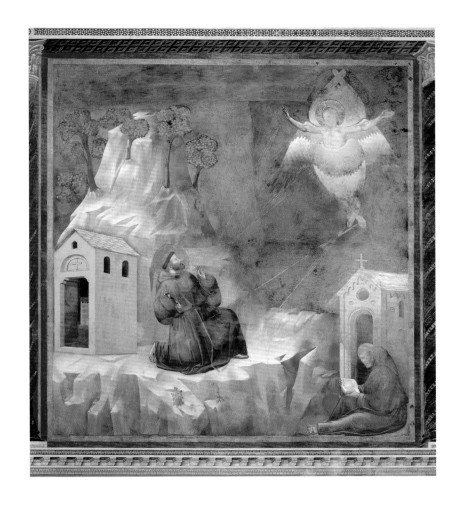

Fig. 45. Giovanni Bellini, *Portrait Study of Gentile Bellini*, c. 1496. Black chalk on paper (pounced for transfer), 23.2 × 19.4 cm. Kupferstichkabinett, Staatliche Museen zu Berlin

Fig. 46. Giotto di Bondone and assistants (?), *Stigmatization of St. Francis*, c. 1291–96. Fresco, 350 × 329 cm. Upper Church, San Francesco, Assisi

that occurred in September of 1224 during a retreat on the mountain of La Verna in the Tuscan Apennines. As Francis prayed, a vision of Christ in the form of a six-winged seraph affixed to a cross appeared from the heavens, and the five wounds of the Crucifixion began to emerge on his body. Traditional images of this event—going back as far as the late thirteenth-century fresco in the nave of the Upper Church of the basilica of San Francesco at Assisi (fig. 46)—depict the saint bending on one knee and raising his arms to receive the sacred marks on his hands, feet, and side via five connecting rays transmitted by an angelic apparition. Bellini's Francis, by contrast, stands rather than kneels; he seems to bear only two of the five stigmata, on his downward-extended hands; and he does not evidently communicate with a seraph or other divine agent (fig. 47). These incongruities have led some scholars to argue that the painting does not represent a stigmatization at all; others, however, have maintained that the picture refers unmistakably, if unconventionally, to the miracle.[23]

Bellini's novel and enigmatic conception of the saint and his action is rooted in the underdrawing, which reveals an intensely thoughtful design executed outside the comfortable templates of pictorial tradition. The artist accentuated the upright figure with outstretched arms, the elevation of the left foot from the ground, and the movement of the left leg (fig. 48). The bottom hem of Francis's habit is emphasized with broad strokes of secondary underdrawing: these curves define the vertical pleats of drapery, which lend the figure columnar stability even as he moves. The saint's

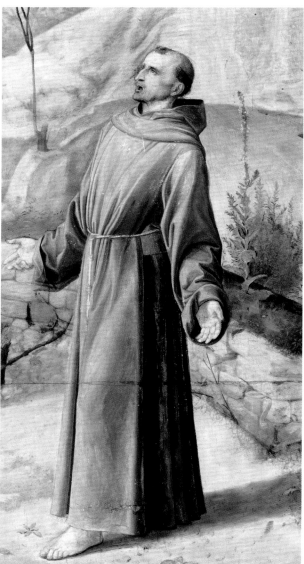

Fig. 47. *St. Francis*, detail of the figure and surroundings

Fig. 48. *St. Francis*, detail of infrared reflectogram showing the figure and surroundings. The artist initially painted a concave niche in the rock face behind Francis. The niche appears as a zone of dark gray beginning at the level of the saint's chin and the top of his cowl and extending downward on either side.

monumental posture rhymes with the upright towers in the background townscape, evoking in formal terms his role as a builder and living pillar of the Church.[24] The figure and its associations are manifold, ambiguous, and divergent from the recent conventions of Franciscan iconography. Instead, the design evokes very early images of the standing, stigmatized Francis in thirteenth-century Italian painting, although Bellini has invested this iconic type with extraordinary dynamism.[25] This vision of Francis was to inspire representations of the saint by painters including Cristoforo Caselli and Titian (fig. 49).[26]

Bellini's thorough planning of the figure allowed him to paint the flesh tones and habit with assurance and expressiveness. The tunic is a rich, golden brown, applied in a blended but brushy manner to capture the tactile effect of the deeply folded and shadowed cloth (fig. 50). To depict the saint's rough rope belt, the artist laid down thick, flowing strokes of pale yellow and then used an implement, possibly the reverse end of his brush, to score short diagonal lines into the wet paint (fig. 51).[27]

Fig. 49. Titian, *Madonna di Ca' Pesaro*, 1519–26. Oil on canvas, 478 × 266.5 cm. Santa Maria Gloriosa dei Frari, Venice

Fig. 50. *St. Francis*, photomicrograph (3.5× magnification) of the saint's left sleeve

Fig. 51. *St. Francis*, photomicrograph (5× magnification) in raking light of the saint's rope belt

Bellini also departed from custom in the representation of Francis's stigmatic wounds. Examination with a microscope revealed that the two small red blots on the saint's hands are certainly original: the paint in these areas is aged, cracked, and integral with that of the palms beneath (figs. 52, 53).[28] Despite his exacting and consistent technique, however, the artist realized the stigmata with deliberate understatement. He placed the wound on the proper left hand entirely in shadow (see fig. 52) and enlarged the proper right sleeve during the painting process to form a bright, bell-like shape that draws attention away from the palm above (fig. 54).

As he measured the effect of these two stigmata, Bellini also concentrated on the hands on which they appear. In the underdrawing, he outlined each hand, noted the joints of the fingers with short arcs, and applied dense hatching in regions of shadow (see fig. 54). He then continued to adjust the position and dimensions of both hands as he added the flesh colors in thin layers. The hands were thus conceived as dramatic vehicles, comparable to the face in their content of action and emotion. Eloquent hands are a hallmark of Bellini's

Fig. 52 (opposite, above). *St. Francis*, detail of left sleeve and hand. The sleeve casts a shadow on the wound in the center of the palm. Over time, some of the hatched and contour underdrawing of the hand has become visible through the paint.

Fig. 53 (opposite, below). *St. Francis*, detail of right hand

Fig. 54 (right). *St. Francis*, details of infrared reflectogram showing underdrawing of the saint's arms and hands. The artist enlarged the right sleeve during painting and made numerous additional adjustments. He altered the size and shape of both thumbs and reinforced the contour of the right thumb with a heavy black line during painting.

art (see fig. 14) and have been associated with his power to fix the beholder's attention and guide pious contemplation.[29] Indeed, the painter attended with diligence to the hands and arms of all his figures, making many fine changes to palms, fingers, and sleeves.

Microscopic examination of the Frick picture yielded additional findings about the stigmata. Under high magnification, islands of translucent red paint are visible on the saint's left foot, evidence that Bellini also included a wound in this location (fig. 55). This area of red was not removed intentionally but became abraded over time and is now invisible to the naked eye.[30] The technical study found no trace of the fifth wound, the horizontal gash of the lance on the chest, usually exposed through a tear in the saint's garment. The habit is clean, the chest unmarked.[31]

Bellini's muted treatment of the stigmata is consistent with Francis's own modest behavior toward these signs of his perfect conformity to Christ. According to early accounts, the saint went to great lengths to conceal his holy injuries from his fellow friars.[32] Francis did not trumpet his tortured body; though afflicted with chronic ailments and pains, he never systematically mortified himself.[33] In his minimal presentation of the stigmata, therefore, the painter depicts Francis as he would have wished to be seen. By excluding the gaping cut in the chest, Bellini reinforces the figure's robust, statuesque pose, so carefully studied in the underdrawing. This proudly vertical stance demonstrates the miraculous infusion of fortitude into a man plagued throughout his life by physical infirmities.[34] The puncture marks on the hands and foot, too, have been painted so as to disappear when viewed from a distance. The artist hints at the ineffable and unknowable nature of these sacred wounds, capturing the essence of Francis both in his corporeal martyrdom and spiritual wholeness.

The technique of St. Francis's stigmata suggests that they were intended as discreet identifying attributes and symbols of his wondrous workings in the world rather than the crux of the painted narrative. And indeed, the picture seems to lack another standard element of stigmatization scenes: the apparition of a seraph or Christ on a cross who impresses the marks of the Crucifixion on Francis's body, as in the predella of Bellini's own Pesaro altarpiece (see fig. 16). The earliest surviving notice of the Frick painting, penned in 1525 by Michiel, likewise fails to mention a seraph and does not identify the subject as a stigmatization (see fig. 21). The panel's top horizontal edge has been cut, however, and scholars have long considered it possible that a small seraph once appeared in the now missing section.[35] This alternate theory is substantiated by another early record of the painting, published in 1660 by the connoisseur Marco Boschini. His poetic description of Bellini's *St. Francis* suggests that the saint is being wounded by the apparition of Christ in the form of a fiery seraph, although the account is imprecise and allusive.[36]

Fig. 55. *St. Francis*, detail and photomicrograph (40x magnification) of the left foot, showing traces of translucent red paint in the area of the original wound, now abraded

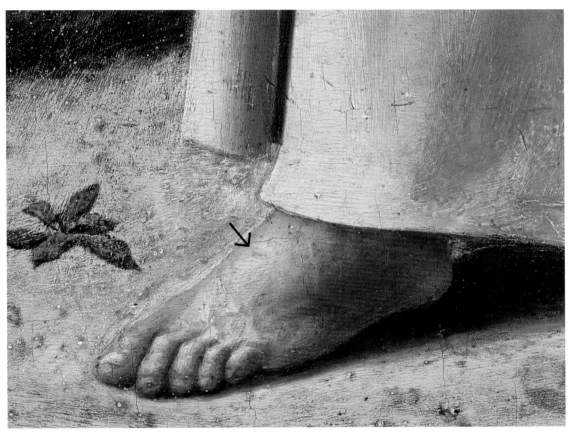

To determine how much wood had been removed from the painting's upper edge and whether there would have been enough space for a seraph or related feature, conservators examined the panel's structure and condition.[37] The topmost edge has definitely been cropped, as evidenced by the absence of a blank margin along this surface and the chipping of paint. Clues to the quantity of wood removed are furnished by the X-radiograph (see fig. 111), which reveals the construction of the large support. In its present dimensions, the panel consists of three horizontally oriented boards of different widths: the bottom board is 21.5 cm wide, the middle board is 50.4 cm wide, and the top board is the largest at 52.7 cm wide.[38]

The three joined boards were originally strengthened by two vertical battens or cross-pieces, attached to the reverse on the right and left sides.[39] These supportive members have long been removed, but the heads of nails that once attached them to the panel (or voids indicating the nails' former presence) are still in place. Before the gesso was applied, four pairs of nails were hammered through the front of the panel in an approximately symmetrical configuration: one pair at the top and bottom of each batten, with further single nails down the length of the two battens. Early Italian panels often show differences in the dimensions of their individual boards, but where practical features of construction were concerned—as in the pairs of nails at the top and bottom of each batten in the Frick picture—an overall symmetry was usually maintained. If a large portion of wood had been cut from the top of the painting, the upper two pairs of nails would have disappeared along with it. Instead, the four sets of nails remain nearly symmetrical in placement, suggesting that the panel is basically intact.

Study of the X-radiograph strongly indicates that only a small amount of wood has been removed from the top of St. Francis—a few centimeters at most—perhaps to fit the work inside a pre-existing frame or wall installation. Such alterations of gallery pictures were common in the burgeoning European art market of the sixteenth through the nineteenth centuries and, in this case, probably occurred before 1812, as discussed by Anne-Marie Eze in this volume.[40] The lost area included the unpainted upper margin and possibly a narrow band of trees, sky, and cliff. No material trace of a seraph was detected at the upper edge of the existing panel, and it appears unlikely that any such feature was located above it. As for Boschini's description of this element, his account must be understood in the context of the almost seven hundred-page poem in which it appears. The Carta del Navegar Pitoresco is an ambitious, grandly exaggerated encomium to Venetian painting—its focus is less on the precise content of pictures than on their color, form, and poetics. Boschini may have viewed St. Francis only briefly in the course of his research, then rounded out his report at a later point with stock ingredients from the saint's iconography.[41]

While the technical evidence reinforces the view that *St. Francis* was never a conventional stigmatization scene, Bellini has clearly alluded to this theme throughout the image, as is only fitting in a monumental celebration of the saint's life and character. The landscape, constructed as a series of rhyming diagonals, brings to mind the rays that traditionally emanate from the seraphic crucifix. The artist has included two distinct motifs found in Venetian images of the stigmatization from the fourteenth century onward, the cave behind Francis and his sandals.[42] Above all, the saint's wounds evoke the culminating event of his earthly life and, by their very subtlety, invite close contemplation and prayerful meditation on his physical similitude to the suffering Christ. But the painter has not been so literal-minded as to render this miracle the work's sole or overt subject. Rather, in the spirit of early Franciscan writings by St. Bonaventure and others, Bellini conveys Francis's likeness to God "not by martyrdom of the body but by enkindling of the mind" (*incendium mentis*).[43]

As he painted the area around the figure, Bellini further inflected the standard imagery of the stigmatization. At first, the artist indicated in his underdrawing a series of ridges, tunneled into the rock behind Francis and echoing the contours of his figure. Once painting began, the ridges were abandoned in favor of a single, concave niche beginning at the level of the saint's chin and the top of his cowl and extending gently downward on either side. This initial paint layer is visible in the infrared reflectogram as a wide, deep gray arc (see fig. 48). At a later stage, Bellini changed course yet again, cancelling the niche by painting over it the steep, continuous escarpment of light blue color that is visible today (see fig. 47).

The earlier, abandoned designs for the cliff recall traditional stigmatization scenes, in which Francis kneels before a pronounced niche in the rocks of Mount La Verna. In a predella panel by Marco Zoppo, which Bellini likely had the opportunity to study, the saint is framed by a series of arches tunneled sharply into the crag behind him (fig. 56).[44] This formation alludes to a legend appended to the *Fioretti*, or *Little Flowers*, a fourteenth-century compilation of episodes and sayings from the life of Francis and his followers. During his retreat on Mount La Verna, before receiving the wounds of Christ's Crucifixion, the saint escaped from an attacking devil by clinging to the rock, which miraculously yielded like liquid wax to accept the form of his body.[45]

As he deliberated over the shape and placement of the cliff behind the figure, Bellini initially conceived a ridged niche similar to that seen in Zoppo's panel and other early stigmatization scenes. The artist ultimately replaced the niche, however, with a formation that follows the outline of the saint much more closely. The rocks move and flow around Francis, parting from a point above his head and spreading past his

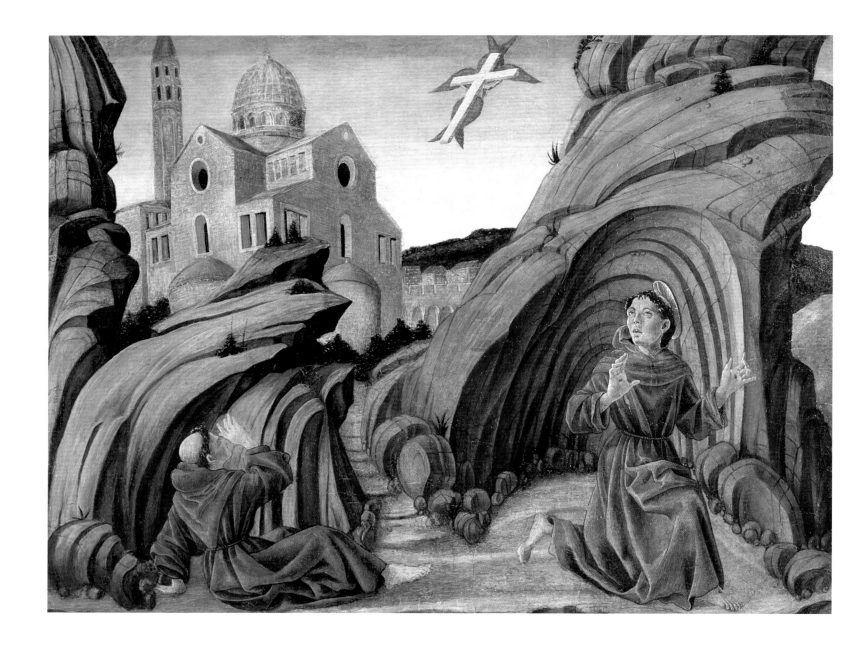

shoulders. Bellini rendered a shadowed crevice in the cliff by pulling a brush loaded with dark paint through the pale blue underlayer before it had dried completely (fig. 57). Throughout the rocks, the artist worked in a similarly brushy manner, pushing thick, bodied paint into liquid ridges and freely highlighting contours. In its final form, the molten, fluid quality of oil paint evokes with poetic immediacy the legendary melding of the rock to the saint's form. The composition marks a departure from artistic custom yet is truer to the spirit of the original Franciscan story. Hinting at the saint's incipient embrace within the topography of Mount La Verna, the artist demonstrates the expressive possibilities imparted by his evolving oil painting technique.

Sky and Lighting

Bellini favored the subject of holy figures in communion with dynamic skies (see fig. 100), and St. Francis is a supreme example of his engagement with this theme. The saint raises

Fig. 56. Marco Zoppo (c. 1432–c. 1478), *Stigmatization of St. Francis*, c. 1471. Tempera on panel, 35.1 × 46.7 cm. Walters Art Museum, Baltimore

Fig. 57. *St. Francis*, photomicrograph (3.5x magnification) of the rock face behind the saint, showing wet-in-wet manipulation of paint. To create a crevice, the artist pulled a stroke of dark paint through the upper layer of pale blue paint while it was still wet. Where the light-toned paint has been pushed aside by the darker line, handprints are visible in the priming layer beneath.

his eyes toward the heavens, painted in a rich blue that begins faintly at the horizon and then deepens and intensifies at the upper reaches of the panel (figs. 58, 59). To achieve this effect, the artist first applied a layer of pale blue paint (lead white with a little ultramarine blue) over the preparation in the lower region of the sky. He then added a layer of ultramarine mixed with varying proportions of white (figs. 60, 61). Toward the top of the picture, the pale underlayer disappears, and the ratio of ultramarine to white increases: these changes establish the gradation from a diaphanous blue near the horizon to a saturated, celestial blue at the upper edge. An analogous progression from earthly to divine blue is visible in the sky of Bellini's *Coronation of the Virgin* (see fig. 13) but is accomplished by a slightly different technique.[46] Throughout his oeuvre, the artist experimented with the potentialities of blue, a versatile color that was increasingly replacing flat fields of gold in the backgrounds of sacred images.[47]

Bellini's choice of high-quality ultramarine for the sky of *St. Francis* is noteworthy and has a bearing on the stature of the commission as a whole. Venetian ultramarine, known in local dialect as *oltremare da venecia*, was made by grinding and purifying the semiprecious stone lapis lazuli, imported from mines in present-day Afghanistan. "Ultramarine blue is a color noble, beautiful, and most perfect, beyond all other colors," wrote the early Renaissance artist Cennino Cennini, "and one could not say anything about it, or do anything with it, that its quality would not still surpass."[48] To economize on this costly pigment, Renaissance painters often used it as a finishing layer over underpaints containing less expensive varieties of blue, principally azurite.[49] Technical analyses of Bellini's works reveal that he, too, frequently employed ultramarine in combination with other blues. The firmament of *St. Francis*, consisting solely of ultramarine modulated by lead white, is remarkably lavish by comparison, recalling the composition of the mantle of Mary in several of the artist's finest paintings.[50] This jewel-like blue also shows affinities with the sky of Titian's later *Bacchus and Ariadne* (fig. 62), executed in a mixture of high-quality ultramarine and lead white. Titian painted his masterpiece for the Duke of Ferrara, Alfonso d'Este, and the materials in this area of the Frick picture imply a patron of similar refinement.[51]

The rarefied blue of Bellini's sky constitutes a pure medium for the movement of light, an otherworldly effulgence that issues in several directions from the painting's upper left-hand corner (see fig. 59). The artist has summoned an extraordinary radiance that streams in rays, pools in resplendent clouds, and disturbs the branches of the laurel. Coursing through the depths of the sky and diffusing into every corner of the landscape, this golden light evokes the fiery illumination that reputedly bathed Mount La Verna during the stigmatization and was depicted in paintings of the miracle from the thirteenth century onward.[52]

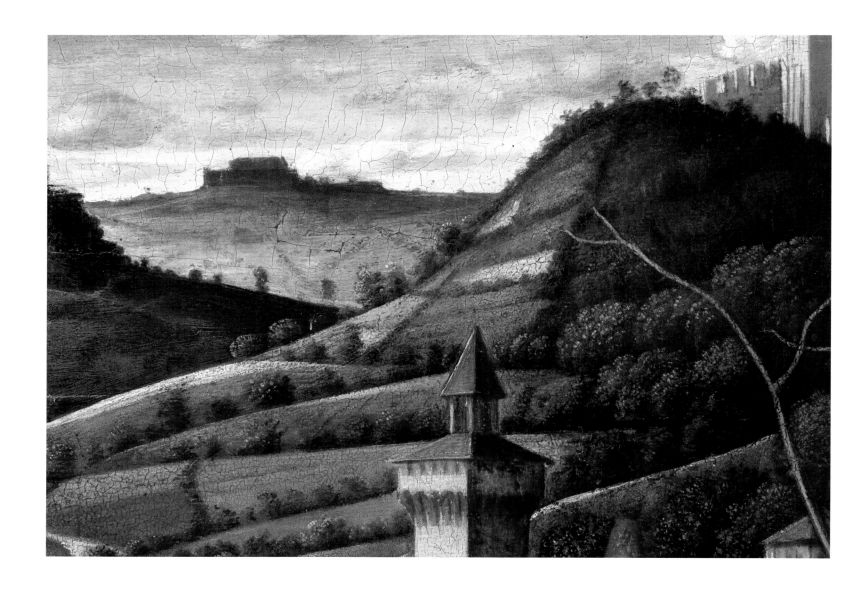

Fig. 58. *St. Francis*, detail of pale,
atmospheric blue at the horizon

Fig. 59 (above). *St. Francis*, detail of deep blue celestial sky at upper left

Fig. 60 (near right). *St. Francis*, photomicrograph (3.5x magnification) showing brushy application of ultramarine blue and white at the painting's left edge. At the margin, exposed gesso ground is visible.

Fig. 61 (far right). *St. Francis*, cross-section of paint sample (original magnification 50x) showing the layer structure of the sky at upper left. Over the thin lead white priming, the artist applied a layer of pale blue paint (lead white with a little ultramarine blue), followed by a thick layer of ultramarine mixed with lead white. The gesso ground is not present in this sample.

Fig. 62. Titian, *Bacchus and Ariadne*,
c. 1520–23. Oil on canvas, 176.5 × 191 cm.
The National Gallery, London

Fig. 63 (opposite, below). *St. Francis*,
photomicrograph (3.5x magnification)
showing impasto of yellow paint

Fig. 64 (opposite, above). Giovanni Bellini,
Diletti altarpiece (detail of the head of St.
Christopher), 1513. Oil on panel, 308 × 178
cm overall. San Giovanni Crisostomo,
Venice. Courtesy Giovanni C. F. Villa. ©
Giovanni C. F. Villa, Università degli Studi
di Bergamo, Centro di Ateneo di Arti Visive

Bellini created the light not with traditional gold but with a textured, rose-yellow paint, composed of lead-tin yellow type I and a small amount of vermilion.[53] He manipulated the color adventurously, executing the highlights of the clouds with a pronounced impasto, or raised paint surface (fig. 63).[54] To capture the trailing wisps of cloud, he applied looping lines and arabesques; for the narrow rays, he dragged a thin, uneven layer of yellow paint diagonally over the blue background, allowing the sky to show through (see fig. 59). This technique, known as scumbling, produced the delicate screens of color that conjure the effect of beams emerging from apertures in the clouds.

Though understated, Bellini's rendering of bodied light in motion anticipates significant developments in Venetian painting. Later in his career, the artist began to manipulate his paints more boldly: thick, overlapping touches of color stand off the surfaces of works such as the Diletti altarpiece, completed three years before his death (fig. 64). This evolution in technique has often been interpreted as the aging artist's response to innovations of the younger generation of painters, who freely

enlivened their compositions with impasto and scumbling.[55] In fact, however, the light of *St. Francis* demonstrates Bellini's avant-garde experimentation with the textural possibilities of oil paint much earlier in his career—by the mid- to later 1470s—suggesting that he played a leading role in their introduction to Venice. Titian's *Aldobrandini Madonna* of the early 1530s, for example, echoes *St. Francis* with its hallowed and shimmering sky represented by a brushy yellow (fig. 65). In the Frick picture, as in later works of Giorgione and Titian, the tactile and expressive handling of paint corresponds to poetical indeterminacy, atmospheric drama, and the transient effects of events bound in time, as Bellini transforms the eternal golden rays of Byzantine and early Italian icons into an enigmatic meteorological phenomenon.

In addition to achieving the palpable impression of divine illumination at upper left, the artist addressed the propagation of light through the scene as a whole. A second radiance, complementary to the rays in the sky, emanates from an unseen source in front of the picture and to the left.[56] This powerful, even glow—the *altra luce*

Fig. 65. Titian, *Aldobrandini Madonna*,
c. 1532. Oil on canvas, 100.6 × 142.2 cm.
The National Gallery, London

of which modern poet Pier Paolo Pasolini writes in his praise of Bellini's art[57]—bathes
the foreground and townscape, leaving the right sides of the buildings in shadow.
The light washes over Francis's face and chest and catches the ridges of his sleeves.
Shadow collects in the folds of his habit and on the earth behind his figure, then
continues in a cascade of parallel diagonal lines through the poles of his shelter and
the supports of his lectern (fig. 66).

Bellini conceived this second light with care, outlining several of the shadows in
the preliminary underdrawing and painting them directly on the white preparation.
At an early stage, the artist also planned the boundaries of three shadows by incising
lines into the underpaint with the point of a stylus (fig. 67). Incision was commonly
employed by Renaissance painters to map precisely constructed objects such as
buildings and furniture. Bellini's appropriation of this technique to indicate shadow
suggests that he perceived the phenomena of light as an underlying, structural
element of his compositions. The artist also incised several of the shadows in the main
field of his Pesaro altarpiece, and the later *Sacred Allegory* displays incision of both cast
shadow and reflections in water (fig. 68).[58]

The coincidence of two distinct sources of illumination at the upper left of *St.
Francis* creates the ambience of a theatrical set, with a powerful spotlight beyond the

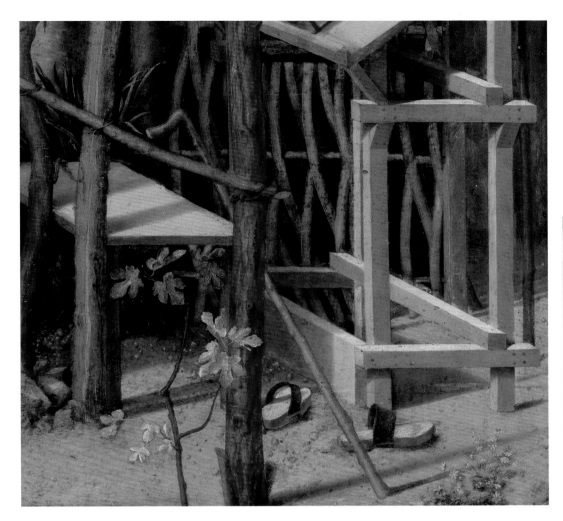

Fig. 66. *St. Francis*, detail of shadows at lower right

Fig. 67. *St. Francis*, photomicrograph in raking light (3.5x magnification) showing the lower right area of the saint's lectern. To plan the fall of shadow at the rear of the lectern, the artist incised a line into the underpaint with a stylus. Additional incisions for the carpentry of the desk appear above and to the right of the shadow.

picture amplifying the represented light within. The two radiances converge in a single transfiguring event, and Francis himself faces outward, like an actor on a stage, even as he directs his gaze upward. Bellini has modulated the color of the ground on which the saint stands by underpainting the gray-blue rock with a warm yellow (fig. 69). This underlayer "lights the stage," heightening the luminosity of the foreground. Much like the selective pale blue underpaint of the sky, it demonstrates the artist's movement away from the simple layer structure of tempera and toward complex layering of variously colored oil paints. In Venice, Bellini and his workshop pioneered the technique of underpainting with diverse colors, soon to become a characteristic practice of the city's artists.[59]

The perceptive treatment of natural light effects in *St. Francis* furthers an essential aim of Bellini's art: to create an illusion so convincing as to draw the spectator into authentic visionary experience, the sense that divinity has become fully and actually present in his world.[60] The artist did not merely observe light and shadow, however, but also orchestrated them to create formal and mystical harmonies. For example, he chose not to paint the shadows of Francis's extended arms or of the plants nearby. Instead, he confined the shadows mainly to vertical elements, producing a chorus of diagonal lines in the picture's lower right corner (see fig. 66). The selective representation

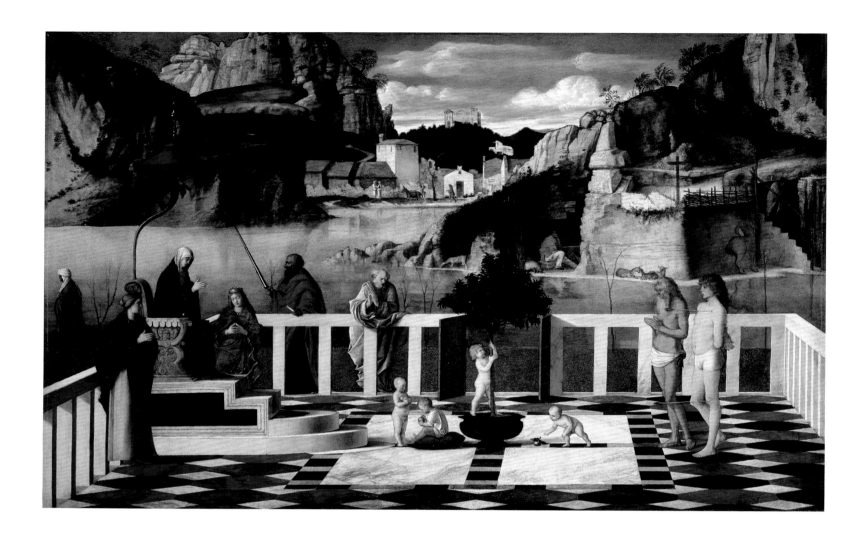

Fig. 68. Giovanni Bellini, *Sacred Allegory*, c. 1485–95. Oil on panel, 73 × 119 cm. Galleria degli Uffizi, Florence. To plan the pattern of reflections on the glassy surface of the lake in the background, Bellini incised vertical lines with a stylus into the ground. The artist also incised the front border of the shadow cast by the left foot of Job.

Fig. 69. *St. Francis*, photomicrograph (25x magnification) showing the juncture between the foreground rock and the saint's tunic. A layer of light yellow underpaint is visible beneath the blue-tinged rock.

of shadow in the area around the saint shows striking similarities to another masterpiece of fifteenth-century Franciscan art, Sassetta's polyptych for the church of San Francesco in Borgo San Sepolcro. In the stigmatization scene of this large altarpiece (see fig. 3), Sassetta deliberated intensely over the description of cast shadows, ultimately making a dramatic reduction to the shape of the shadow behind Francis. In both cases, the artists seem to have grappled with the paradoxical problem of how to signal the uncanny presence of divine illumination in a convincing and naturalistic manner.[61]

Throughout the Frick picture, Bellini not only manipulated shadow but also syncopated light and dark: the leaves of the trees on the high bank are painted dark when they fall against the light blue sky but are painted light where they fall against the dark trunks. Such alternations appear on a grander scale in other works by the artist. In the Naples *Transfiguration* (see fig. 97), one prophet is in light and the other in shadow; in the main field of the Pesaro altarpiece (see fig. 13), Christ is fully illuminated and Mary is in shadow—perhaps a naturalized allusion to the traditional placement of the sun below Jesus and the moon below the Madonna in Venetian Coronation scenes.[62] These subtle patterns and juxtapositions reveal the painter's conception of light as at once an observed physical phenomenon, a poetic device, and a carrier of the highest meaning.

Town and Landscape

Suffused with sacred warmth, the walled village and its hilltop fortress in the background of *St. Francis* invite comparisons with the Heavenly Jerusalem (fig. 70). Bellini would not have had to travel far beyond his native Venice, however, to find inspiration for this serene townscape with its towers, arched gateways, crenellations, and chimney pots.[63] In the fifteenth century, fortified cities were common throughout the Veneto, including the nearby centers of Mestre, Padua, and Treviso; the artist vacationed at a villa on the *terraferma* and portrayed monuments from the mainland in several of his paintings.[64] *St. Francis*, however, shows less topographical precision. In this scene, as in his Pesaro altarpiece (see fig. 13) and votive picture of Doge Agostino Barbarigo (1488; San Pietro Martire, Murano), majestic town and castle views do not obviously correspond to known landmarks but are imaginatively fashioned from characteristic elements of regional architecture.[65]

Bellini laid in the town of *St. Francis* with a thorough, linear underdrawing, employing a brush and straightedge to describe the outlines of walls and roofs, as well as guidelines for crenellations (fig. 71). On the large tower at left, he drew the semicircular arches between the corbels freehand, leaving tiny pools of black paint where he lifted his brush at the end of each stroke (fig. 72). As he filled the forms of the townscape with color, the artist simplified the underdrawn design, adjusting the number and position of

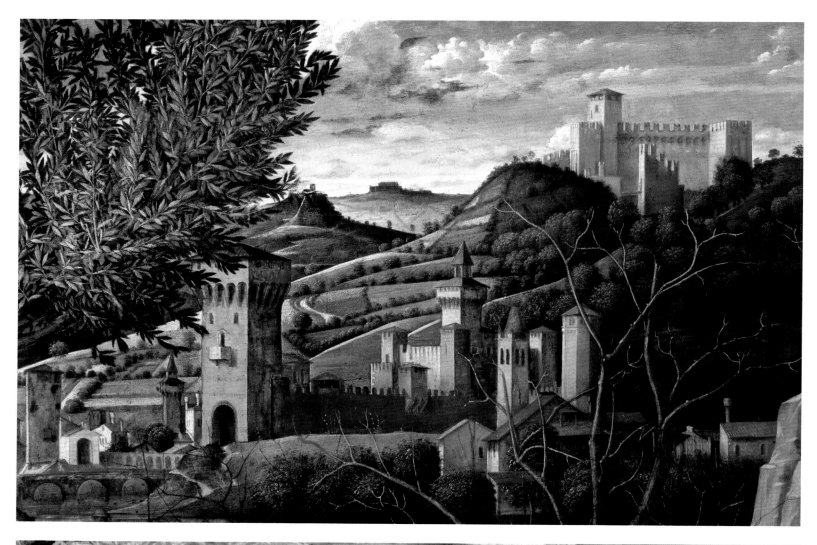

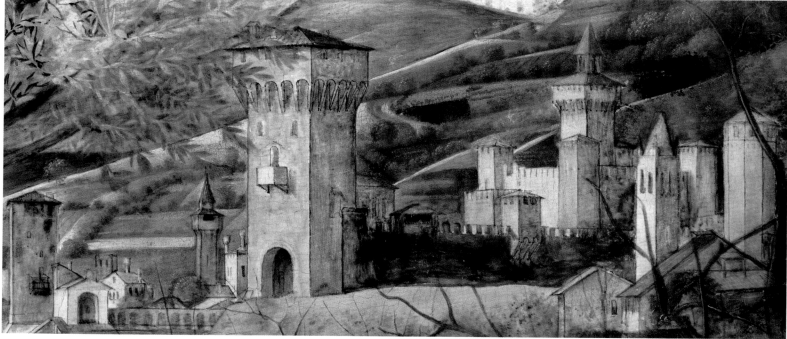

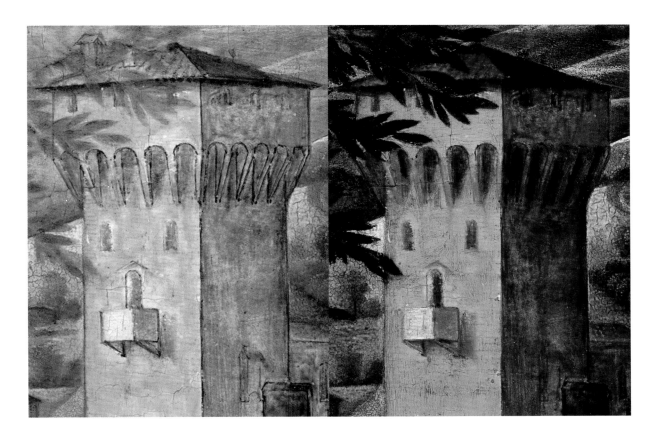

Fig. 70 (opposite, above). *St. Francis*, detail of townscape and hilltop castle

Fig. 71 (opposite, below). *St. Francis*, detail of infrared reflectogram, showing underdrawing of the townscape

Fig. 72 (above). *St. Francis*, details of infrared reflectogram and painting, showing the underdrawing and final version of the large tower at left

windows, walls, and roof lines to achieve a harmonious and uncrowded composition. He executed the buildings meticulously but with the same fluent oil technique seen throughout the picture. Beyond the walls, orderly hedgerows define the hill, crowned by a castle glinting against the sky (see fig. 70). Taking additional care with this edifice, the painter marked fine architectural details with freehand, incised lines.

As he considered the footbridge spanning the river at middle distance, Bellini changed course significantly. Originally underdrawn as a long, post-and-lintel design ending at the near right bank, the bridge was painted instead as an arched, partially ruined construction terminating on the far right bank (fig. 73). Perhaps this pentimento was meant to bring the structure into harmony with the rolling geometries of the surrounding landscape. The artist deliberately left the bridge broken, however, cutting off access to the town beyond. Arched and ruined monuments appear in many of Bellini's devotional works, from the early *Blood of the Redeemer* (The National Gallery, London) to the late *St. Jerome Reading* (fig. 74). In the Franciscan context of the Frick picture, the damaged bridge and decrepit buildings at the town's left margin might evoke an early episode from the saint's biography, in which a speaking crucifix ordered him to arise and repair the Church, which had fallen into ruins.[66]

Fig. 73. *St. Francis*, details of infrared reflectogram and painting, showing the underdrawing and final version of the bridge. The structure was conceived in the underdrawing as an extended, post-and-lintel design with gentle inclines at either end, terminating on the near right bank of the river. In the painting, however, the bridge is an arched and partially ruined construction disappearing behind the far right bank.

In contrast to the town and bridge, the remaining landscape background of *St. Francis* was sparingly underdrawn. Bellini sketched the prominent cliff face behind the figure with loose, falling lines, faintly visible in the infrared reflectogram.[67] He drew calligraphic flourishes for some contours and hatched lines for crevices and shadows. During painting, he worked with great freedom and in a highly brushy style, often deviating from the underdrawing to define light and dark facets of rock (fig. 75). The resulting formation bears a generic resemblance to the site of Francis's stigmatization, Mount La Verna, which rises above the Casentino valley between Florence and Pesaro (fig. 76). Whether or not Bellini saw this sacred mountain in person—a question much debated[68]—his version of the cliff undoubtedly recalls literary descriptions of the saint's sojourn at La Verna. According to the late fourteenth-century *Considerazioni sulle Stimmate di San Francesco* (*Considerations on the Holy Stigmata*), Francis stood outside his cell

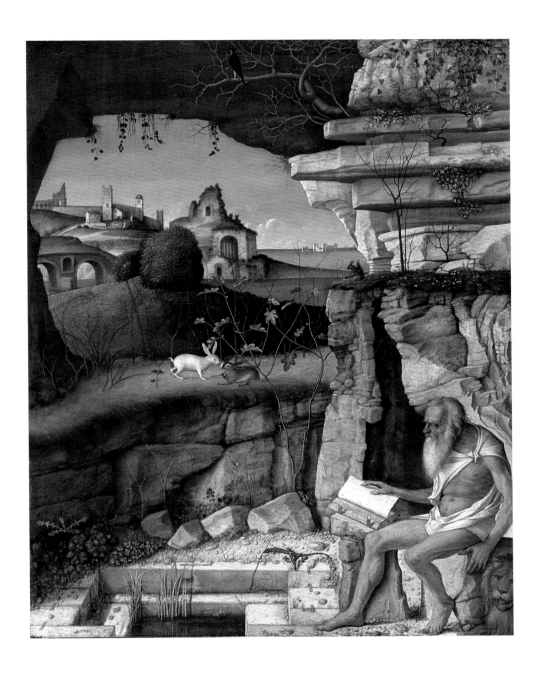

Fig. 74. Giovanni Bellini, *St. Jerome Reading*, 1505. Oil on panel, 48.9 × 39.5 cm. National Gallery of Art, Washington, D.C.; Samuel H. Kress Collection

on the mountain, "marveling at the great fissures and openings in the massive rocks," which had been made at the hour of Christ's Passion.[69] Bellini's conception of the sheer precipice may also have been influenced by a diminutive painting of St. Francis by Jan van Eyck, a version of which passed through Venice in the hands of a wealthy Bruges pilgrim of Genoese origin, Anselme Adornes, in February–March 1471 (fig. 77).[70] The landscape of this intricate stigmatization scene shows clear affinities with the Frick *St. Francis*, especially the shelves of rock opening out to a city and hills at left.

The most remarkable feature of the cliff face behind Francis is its glacial blue cast, which is not an effect of distance or atmospheric perspective but rather of the supernatural light that consecrates the saint and his surroundings. Bellini achieved this color with a mixture of azurite blue and lead white pigments applied in a single, opaque layer. This combination is unprecedented in the artist's rocky foregrounds.[71] The technique allows

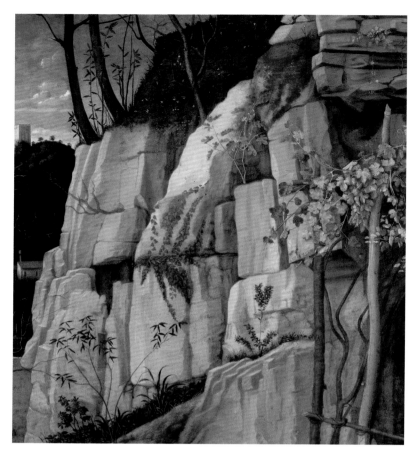

Fig. 75. *St. Francis*, detail of the rock face

Fig. 76. View of Mount La Verna, Parco Nazionale delle Foreste Casentinesi, Monte Falterona e Campigna, Italy

the muted brown of Francis's habit to glow against the cool blue stone, recalling the wondrous illumination of Christ's garments during the Transfiguration on Mount Tabor.[72]

Throughout the scene, Bellini has found opportunities to enliven mundane forms with striking infusions of color. Like the rock face, the shadows of the pebbles dotting the foreground are tinged with blue, as are the shadows cast by the buildings of the town. With this technique, also seen in works of the artist's Ferrarese contemporary Ercole de' Roberti, shadows no longer denote the absence of light but instead become translucent veils of color.[73] The cover of the book on the saint's desk was once a brilliant red (see fig. 94), calling across to the feathers on the head, throat, and chest of the small kingfisher at lower left (fig. 78).[74] The bird drinks from a narrow spout, painted with elongated strokes of buttery yellow that set off a graceful white scumble of trickling water. This fountain has been associated with the miracle in which Francis produced water from a rock to quench the thirst of a poor man; however, the motif of the water spout also appears in other works of Venetian Renaissance painting and, considering its proximity to Bellini's signature in this scene, may allude more generally to the flowing font of the artist's imagination.[75]

Plants flourish in the dank cavity beneath the spring, which nourishes an astonishing range of flora throughout the saint's wilderness hermitage. *St. Francis* was once a far more verdant painting: the artist employed four different green pigments to describe trees, stalks, and leaves, from the slender vines of the saint's shelter to the minute grasses softening the surfaces of the rocks. Bellini heightened the variety and

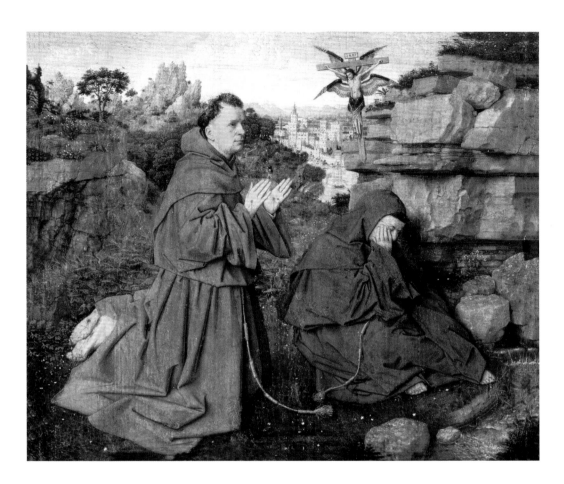

Fig. 77. Jan van Eyck (c. 1395–1441).
Stigmatization of St. Francis, c. 1430–32.
Oil on vellum on panel, 12.4 × 14.6 cm.
Philadelphia Museum of Art;
John G. Johnson Collection

nuances of green with mixtures, layering, and glazes—effects now diminished by the darkening of copper-based glazes. Perhaps Boschini, writing in the seventeenth century, was responding to the work's original lushness of color when he rhapsodized, "In painting Giovanni Bellini could be called the springtime of all the world . . . from him derives every greenery, and without him art would be winter."[76]

In the Frick picture, as in many of his works, Bellini has portrayed some plants with great botanical accuracy while rendering others in a more abbreviated manner.[77] The tiny flowers at lower right, which may be Michaelmas daisies, have yellow centers and variously colored petals. Some are white, some blue, and some a brilliant purple composed of blue and translucent red pigments (fig. 79). Other species depicted include bindweed, orris, mullein, juniper, English ivy, and fig; a small tree behind Francis's right arm is grafted.[78] The artist's talent for painting vegetation was nurtured in the workshop of Jacopo Bellini and realized even in early works. In 1648, the biographer Carlo Ridolfi singled out for praise the "wonderfully natural little plants" dotting the ground of Giovanni's youthful narrative canvas for the Venetian confraternity of St. Jerome.[79]

The strangest plant in *St. Francis*, the overgrown wild laurel at far left (see p.154 and fig. 120), is rich in Christological symbolism and has attracted varied interpretations.[80] The tree shows an unusual development from planning to execution. Bellini reserved the outlines of the trunk, the central limbs, and several peripheral branches on the panel preparation—indicating that he always planned to paint a tree rather than initially laying in a seraphic crucifix or other element.[81] Yet he amplified the design considerably

Fig. 78. *St. Francis*, detail of kingfisher and water spout at lower left

Fig. 79. *St. Francis*, detail of flowers at lower right

as he painted, making the laurel larger and more upright than first conceived. Its leaves completely cover a planned chimney on the roof of the tower at left, as indicated by the underdrawing (see fig. 72). In their final form, the laurel's mandorla-like profile and glowing quality allude subtly to the traditional seraphic apparition on Mount La Verna.[82] Bellini laid in the brilliant leaves with thick dabs of bright yellow, followed by a copper-based green glaze. He painted the narrow trunk in long, flowing strokes of green. This color choice augments the laurel's associations with the Passion, particularly Christ's journey to Calvary, when he asked, "For if they do these things in a green tree, what shall be done in the dry?"[83]

Like the laurel, the humble donkey at middle ground evokes an episode of the Passion narrative, Christ's entry into Jerusalem on the back of an ass on Palm Sunday: an episode later echoed in Francis's ascent of Mount La Verna on the back of a donkey.[84] Throughout the painting process, Bellini paid almost as much attention to the donkey as to the saint himself, who famously addressed his own body as "Frater Asinus."[85] A sensitive underdrawing defines the animal's outlines and modeling, as well as details of his muzzle and eyes (fig. 80). From the shadows of his hooves to the tips of

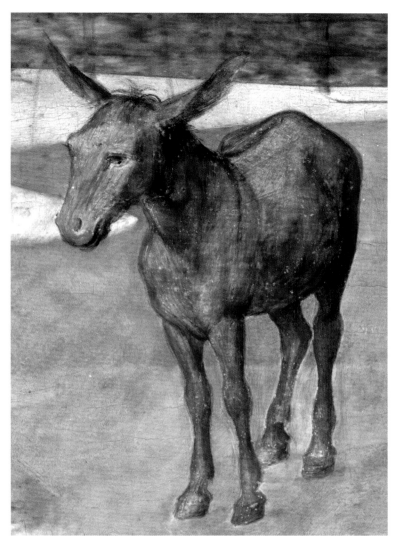
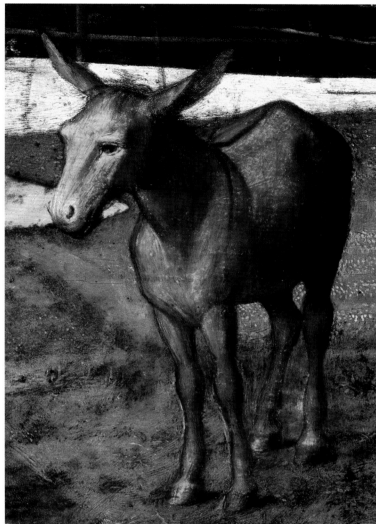

Fig. 80. *St. Francis*, detail of infrared reflectogram, showing underdrawing of the donkey

Fig. 81. *St. Francis*, detail of donkey

his ears, the donkey was completely reserved on the picture ground, then painted in carefully modulated shades of brown (fig. 81). The creature has a quiet and preternaturally aware aspect that differs markedly from the comic braying of Silenus's ass in the late *Feast of the Gods* (fig. 82). Francis's donkey must have required detailed studies from life, and, indeed, Bellini was recognized as a painter of animals: a document of 1520 describes his portrait of a gazelle belonging to the Cornaro family of Venice.[86]

In contrast to the donkey, the two other animals nearby—a gray heron standing on an outcrop of rock and a rabbit emerging from the wall behind the saint—were composed later in the painting process, and neither was underdrawn (figs. 83, 84).[87] Bellini added the tall bird and his pale yellow perch over the already laid-in background and made room for the rabbit by fashioning a makeshift hollow among the stones of the masonry wall.[88] Did the artist mean to include these creatures all along, without needing to plan extensively for such small elements?[89] Or, as seems more likely, did he decide to incorporate them as the composition evolved and create spaces for them in the landscape where none had been before? Either way, Bellini's technical treatment of these details suggests that they did not belong to a predetermined

symbolic scheme but arose from the countless observations and decisions made by the painter as he worked.

Shelter and Study

Francis's cell, a handmade edifice of poles and vines supported by stones and wooden stakes, recalls the booths of branches that housed the biblical Israelites during their wanderings in the wilderness (fig. 85). The open structure also evokes the makeshift huts that Francis and his brethren constructed on Mount La Verna before his stigmatization.[90] Bellini's plan for the hutch owes a debt to the grape arbor depicted in Andrea Mantegna's frescoes for the Ovetari chapel in the church of the Eremitani, Padua (fig. 86). Yet this cave-front study is also among the most inventive elements of St. Francis and involved much deliberation during the course of painting.

The artist planned the major contours of the hut and vines, the saint's lectern and bench, and the willow fence at the rear of the cell with underdrawing. He used a stylus and straightedge to incise the outlines of many structural features. As he painted, Bellini focused on particulars of assembly, from the knotted cords that secure the cross-pieces of the trellis to the supporting post of the saint's bench. He rendered some of the shelter's vertical poles with neatly sawn ends while leaving the rough

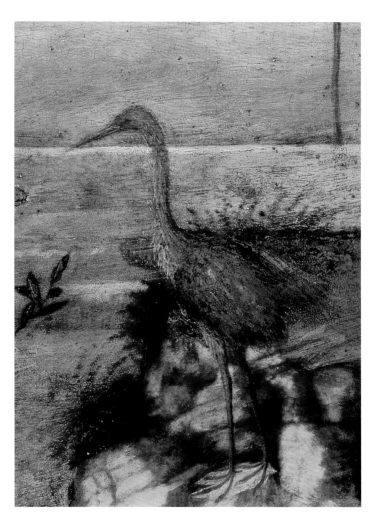

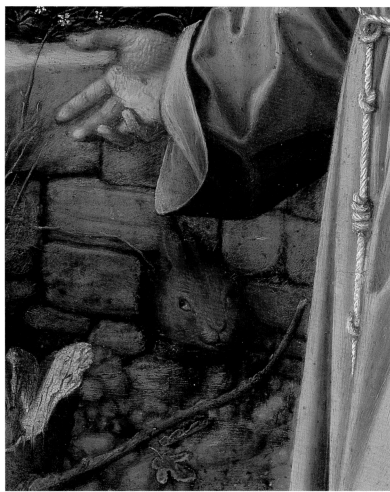

Fig. 82. Giovanni Bellini and Titian,
The Feast of the Gods (detail), 1514/1529.
Oil on canvas, 170.2 × 188 cm.
National Gallery of Art, Washington,
D.C.; Widener Collection

Fig. 83. *St. Francis*, detail of gray heron

Fig. 84. *St. Francis*, detail of rabbit

ends of others exposed. Each pole has been harvested from a different species, recalling the various types of wood composing the legendary True Cross; the second pole from the left is the grapevine that covers the roof.[91] Bellini often paid close attention to the construction of wooden artifacts, such as the grain, joins, and reinforcing stakes of the Cross (fig. 87).

The saint's oratory desk, with its opulent book resting on a narrow ledge, presented a number of formal and symbolic challenges. Bellini initially struggled to define the recession of the lectern in perspective, making small changes to the ledge and book. He also shifted the far right leg of the desk to the left, with commensurate adjustment of the cross-bars. This change of position may have been made to accommodate the most dramatic revision in all of *St. Francis*: an expansion of the desk and the addition of a skull and cross. Originally, the lectern terminated at the top of the slanted reading surface, which was planned in advance and kept in reserve on the panel preparation. Bellini added the flat shelf at the back, the supporting wood bracket, the cross, and the skull at a very late stage of painting—after the willow fence and dark background at the rear of the hut had already been completed. This pentimento is revealed by the infrared reflectogram, in which the lattice weave of the willow fence shows through the flat portion of the desk (fig. 88).

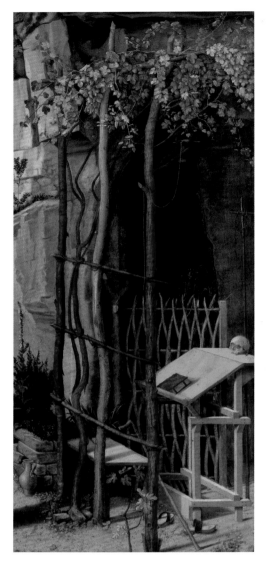

Fig. 85. *St. Francis*, detail of shelter

Fig. 86. Andrea Mantegna (c. 1431–1506),
Attempted Martyrdom of St. Christopher
(detail), c. 1453–57. Fresco, 332 cm wide.
Ovetari chapel, Church of the Eremitani,
Padua

Fig. 87. Giovanni Bellini, *Crucifixion*,
c. 1490–1505. Oil on panel, 80 × 48.9 cm.
Collezione Banca Popolare di Vicenza,
Prato

The artist's decision to include the skull and delicate cross with its crown of thorns supplied a devotional proxy for the omitted seraphic crucifix, effectively transforming the simple reading desk into a support for meditation on Christ's sacrifice (fig. 89). The presence of Francis's sandals and walking stick nearby suggests that he has only recently been seated here, considering the crowning with thorns, procession to Calvary, and Crucifixion. Indeed, according to early sources, the Passion was foremost in the saint's mind during the days and hours leading up to his stigmatization, which took place on the feast of the Exaltation of the Cross.[92] Bellini's addition of the skull and cross thus gives visual form to the central tenet of Franciscan piety. While the Passion was a common focus of medieval and Renaissance devotion, only Francis experienced the suffering and death of the Savior with such personal intensity as to receive the very wounds of Crucifixion on his own body.[93]

Like the absent seraph, the skull and cross suggest that Bellini strove to privilege the saint's interior contemplative practice over the obvious physical miracles associated with him. And like the later insertion of the rabbit and bird, this change indicates that

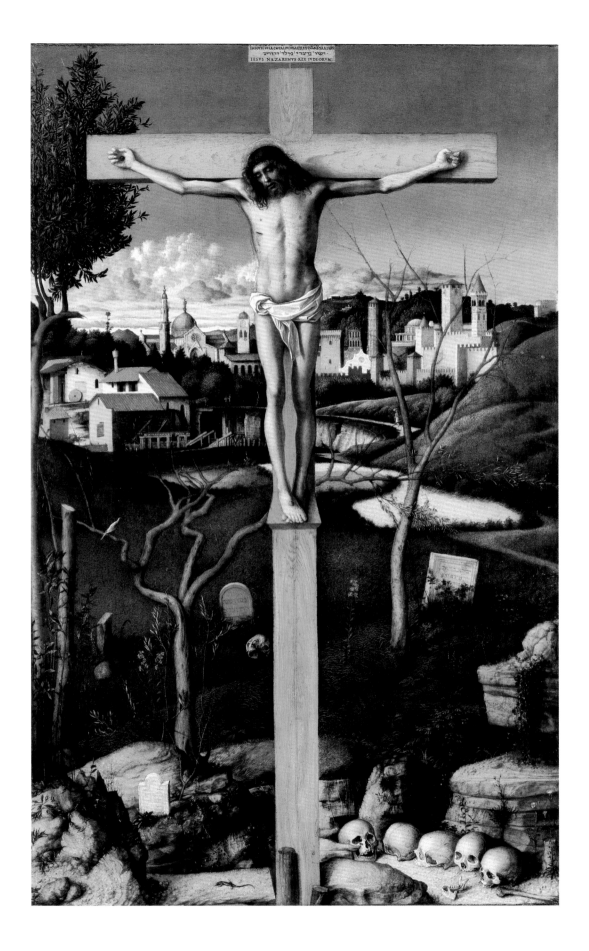

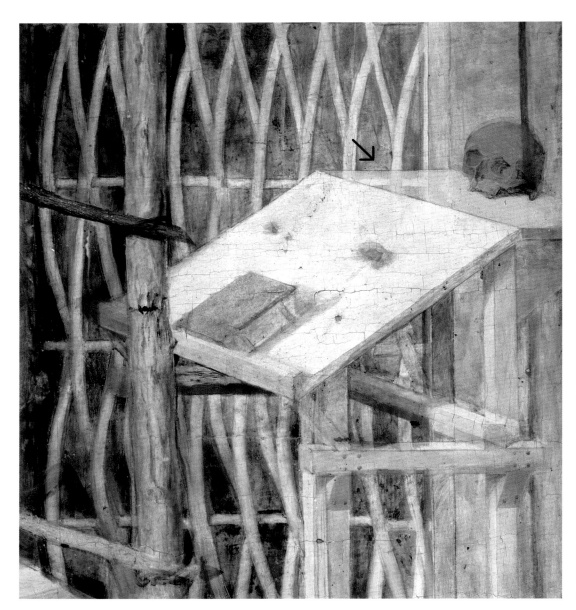

Fig. 88. *St. Francis*, detail of infrared reflecto-gram, showing later addition of the flat shelf, skull, and cross at the back of the desk. Bellini planned the slanted surface of the lectern in advance and painted it directly on the panel preparation; nothing appears beneath it in the reflectogram. By contrast, he painted the horizontal shelf over the willow fence, whose woven texture shows through. Then he added the cross, and finally the skull.

Fig. 89. *St. Francis*, detail of the cross and crown of thorns added to the back of the saint's desk

the composition as a whole was not tethered to a fixed iconographic program but rather developed during painting.[94] Symbolic revisions of this magnitude reveal a poetic approach to subject matter that was to be fully embraced by the next genera-tion of Venetian artists.

The skull and cross had become familiar attributes of Francis by the later Renaissance, but Bellini's inclusion of both these elements has few precedents. Skulls are depicted in only a handful of early Franciscan settings.[95] The cross was more common: in Venice, a thirteenth-century mosaic in St. Mark's Basilica shows Francis holding a cross.[96] So do Donatello's bronze sculpture in the Santo in Padua (see fig. 44), and Pietro and Tullio Lombardo's lunette relief sculpture for the portal of the Venetian church of San Giobbe, in which the saint extends a roughly hewn cross as he kneels in a mountainous landscape and gazes upward at darts and rays of light (fig. 90). This unusual composition resonates compellingly with the Frick picture, and the dating of

Fig. 90. Pietro and Tullio Lombardo, *Sts. Francis and Job*, c. 1470–75. Marble lunette of main portal, San Giobbe, Venice. Photograph courtesy Anne Markham Schulz.

the Lombardo family's sculptures for San Giobbe suggests that Bellini was aware of this model as he began work on *St. Francis*.[97]

The skull and cross are further indebted to the traditional iconography of St. Jerome, a father of the Church who was often depicted with these instruments while at work in his study or alone in the desert. Indeed, the presentation of Francis in a remote setting with objects of learning and penitence suggests that Bellini has superimposed the theme of Jerome in the wilderness on the character of Francis.[98] The rabbit and donkey accompanying the saint supply further Hieronymite overtones: the artist's earliest known painting of Jerome includes both these creatures (see fig. 40). The juxtaposition is apt as Jerome was a favorite of the Franciscans and often appeared adjacent to their founding saint in paintings and sculpture for the friars.[99] Furthermore, both early owners of the Frick *St. Francis* shared ties to this early Christian holy man. Zuan Michiel, who commissioned the painting, was a highly educated citizen—"supremely learned in philosophy," as the contemporary diarist Marin Sanudo wrote—and would have appreciated Bellini's allusions to Jerome, patron saint of scholars and humanists.[100] Taddeo Contarini, who acquired *St. Francis* by 1525, died in 1540 and was buried in the Franciscan church of Santa Maria dei Miracoli before an altar decorated with a painting of Jerome, almost certainly from the hand of Bellini himself.[101] This work, which may be identical with the large panel now in the Contini Bonacossi Collection (fig. 91),[102] was only one of many varied representations of Jerome created by the artist throughout his career. Bellini's portrait of Francis was thus nourished by his profound knowledge of the saint's predecessor and exemplar. As a doctor of the Church who withdrew periodically from his ecclesiastical

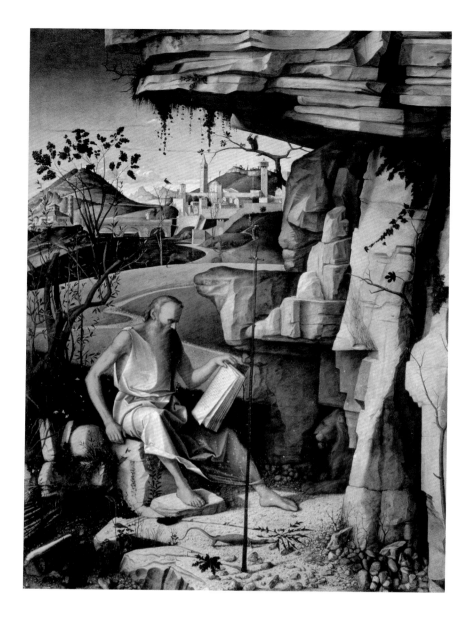

responsibilities for solitary prayer and study, Jerome provided a model for Francis's rhythmic alternation between the worlds of civilization and the desert: a marriage of apostolic mission and ascetic retreat originating with Christ himself.[103]

If the skull and cross hint at the inward musings of a wilderness hermit, another late addition to the hut, the bell suspended from its branches, suggests instead the presence of a religious community (fig. 92).[104] Bellini painted the bell and the two forked limbs from which it hangs over the black background of the cave at the rear of the cell. This treatment differs from most other structural elements of the shelter, which were left in reserve and painted directly on the panel preparation.[105] After appending the bell and its supporting branches to the design, the artist drew attention to this beautiful passage of dark-on-dark with a filament of white string or rope, knotted for tugging (fig. 93). The device complements imagery of knotting and binding elsewhere in the scene: the grafted tree, the saint's rope belt, the ties looped around the poles of his hut, and the woven willow fence behind his desk.

Fig. 91. Giovanni Bellini, *St. Jerome in the Desert*, c. 1480–85. Oil on panel, 151.7 × 113.7 cm. Contini Bonacossi Collection, Galleria degli Uffizi, Florence

Fig. 92. *St. Francis*, detail of bell

Fig. 93. *St. Francis*, photomicrograph (7x magnification) of knotted string or rope

The bell and its cord rhyme with elements of comparable delicacy throughout *St. Francis*, some of which have gradually become less visible due to abrasion. A white and gold fringed tassel hangs from the book resting on the desk (fig. 94). The hairs at the back of the saint's head are carefully painted, as are the many stemmed flowers dotting the ground near the donkey. An intricate canopy of cultivated grapevines shades the interior of Francis's cell: the painter has captured their twining cirri and elegantly folded leaves with utmost precision and artistry (fig. 95). Bellini's evident delight in rendering the exquisite surfaces of the vine recalls a well-known legend of his admiration for fine painting. Marveling at Albrecht Dürer's ability to represent individual strands of hair, Bellini reputedly asked the German master for one of the special brushes with which he painted these features; Dürer responded by showing his astonished elder several ordinary brushes. This story of the triumph of skill is rooted in Pliny the Elder's account of the ancient rivals Apelles and Protogenes, who famously competed to paint ever thinner lines in varying colors.[106] With his consummate description of the grapevine and its minuscule tendrils, the young Bellini casts his lot in this celebrated contest, ultimately proclaiming his mastery to artists throughout the ages.[107]

In fact, while the Frick composition shows a range of handling, the work as a whole counts among the most detailed of Bellini's large panel pictures, as observed in 1525 by Marcantonio Michiel, who described its "landscape . . . wonderfully composed and detailed." *St. Francis* displays a much higher degree of finish than public altarpieces of comparable size by Bellini, such as the Naples *Transfiguration* (see fig. 97) and the Contini Bonacossi *St. Jerome* (see fig. 91), suggesting that the work was intended to be scrutinized up close in an intimate setting rather than viewed from afar in a communal

one. Describing a *Nativity* completed by Bellini for the private bedroom of Isabella d'Este of Mantua, the connoisseur and agent Lorenzo da Pavia noted the picture's quality of finish and the fact that it was meant to be seen in close detail.[108] In the context of personal religious devotion, highly polished works such as the *Nativity* and *St. Francis* invite the spectator to embark on a meditational pilgrimage, with the incidental discovery of minute details a reward for prolonged engagement and attentive viewing.[109]

Dating

Despite the difficulties involved in dating Bellini's works, the technical examination of *St. Francis* affords an opportunity to relate the painting to patterns in the artist's development and to locate the panel more precisely in his career.[110] The picture's date is not documented; scholars have usually placed it on stylistic grounds in the later 1470s or early 1480s, the period after Bellini had realized the monumental *Coronation of the Virgin* for the church of San Francesco in Pesaro (see figs. 13–16).[111] This altarpiece marked his debut as an oil painter on a large scale and was executed with workshop assistance probably between 1472 and 1475.[112] The confirmation in this study that *St. Francis*, too, was painted in oil reinforces the connection between these pictures and suggests that Bellini's fluency in the medium was growing throughout the 1470s.

Beginning around 1475, the artist completed a group of three closely associated works: the *Resurrection* (fig. 96), the Frick *St. Francis*, and the *Transfiguration* (fig. 97). These pictures are of similar dimensions and display his ever-increasing confidence in the poetic evocation of landscape, atmosphere, and light.[113] All three paintings depict a miraculous event in a mountainous setting, and their skies are tinctured with a sacred radiance that infuses human figures with divinity. The *Resurrection* and *Transfiguration* are both altarpieces commissioned for funerary chapels, and records of their patrons and original locations survive. By discerning a sequence of the three paintings on the basis of technique and composition, and then using the documents to establish the periods of execution of the Berlin and Naples pictures, one can arrive at an approximate dating of *St. Francis*.

Analyses of the Frick painting, the *Resurrection*, and the *Transfiguration* confirm their proximity: Bellini executed the three pictures mainly if not completely in oil, with passages of free and inventive manipulation of the medium.[114] In the *Resurrection*, the rocks to the right of the foreground cave bend and flow around the head of the sleeping soldier, recalling the parting of the rock formations behind the figure in the Frick panel. The foreground of the *Transfiguration* is bounded by a diagonal fence composed of rough branches of wood whose knots and shedding bark are executed wet-in-wet. These features are very similar to the

Fig. 94. *St. Francis*, photomicrograph
(3.5x magnification) of book tassel

Fig. 95. *St. Francis*, detail of grapevine canopy

poles supporting the hut of *St. Francis* (see fig. 85). The Berlin and Frick pictures both show impastoed, creamy paint in the highlights, from the helmet of the standing soldier at the left edge of the *Resurrection* to the clouds at the upper left corner of *St. Francis*.

Study of underdrawings also suggests a close dating of the Frick picture, the *Transfiguration*, and the *Resurrection*. In the 1470s, concurrently with his transition to oil, Bellini began to move away from an early underdrawing style characterized by thick contour lines and light parallel hatching in areas of shadow. The underdrawings of the Berlin, Naples, and Frick pictures show thinner outer contours and finer, denser interior hatching, typical of the artist's works of the mid- to later 1470s.[115] In the *Transfiguration*, Bellini drew the right hand of Christ with a segmented outline, shorter arcs for the individual joints of the fingers, and deep hatching in the shadows of the palm (fig. 98). This technique is almost identical to the underdrawing of the hands of St. Francis (fig. 99). Likewise, the broadly hatched underdrawing of the sleeping soldier's shadowed breastplate in the *Resurrection* resembles the modeling of Francis's

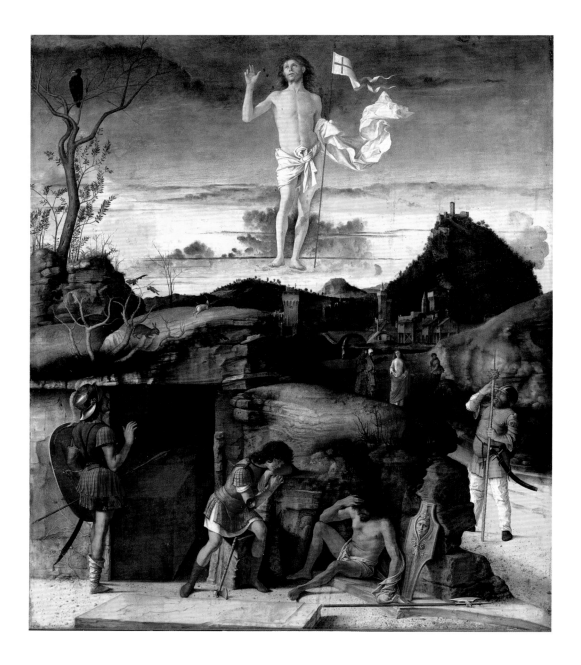

Fig. 96. Giovanni Bellini, *Resurrection*,
c. 1475–77. Oil on panel (transferred to
canvas), 147.5 × 128.8 cm. Gemäldegalerie,
Staatliche Museen zu Berlin

Fig. 97. Giovanni Bellini, *Transfiguration*,
c. 1479. Oil on panel, 115 × 154 cm.
Museo di Capodimonte, Naples

cowl. The delicacy of the underdrawing in the resurrected Christ approaches the very
subtle handling in the face of St. Francis, but the hatching in the idealized figure of
Christ is more ordered and regular.

The towers in the backgrounds of the Berlin and Frick paintings reveal an identical
method of underdrawing, with straight lines for the edges, freehand semicircles for
the arches between the corbels, and pooling of fluid paint at the ends of strokes. In all
three pictures, Bellini's elaboration of the underdrawing varies considerably, revealing
a practical focus on complicated areas of the design. The drawing of the figures and
townscapes is more detailed and careful than that of the natural landscapes, whose
planning tends to be abbreviated and improvised.

Despite these correspondences, *St. Francis*, the *Transfiguration*, and the *Resurrection*
show differences that assist in sequencing them chronologically. Of the three paintings,

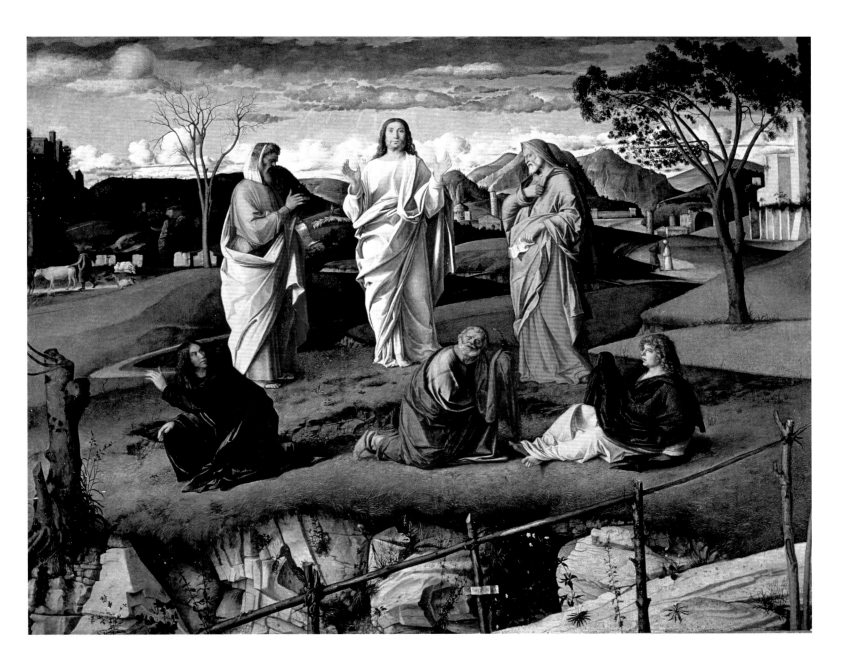

the *Resurrection* most strongly recalls the artist's early works in egg tempera and is most indebted to his renowned brother-in-law, Andrea Mantegna (c. 1431–1506). Bellini laid in the dawn sky of the *Resurrection* with sheer, horizontal bands of color, reminiscent of his own youthful tempera technique. As in the *Agony in the Garden* of the mid-1460s (fig. 100), the sky is a fine, translucent bowl shaped on either side by gentle masses of hills; in both works, the artist applied the tones of the atmosphere very thinly in distinct strata, ranging from peach and white to blue and gray.[116] The cursive highlights of the clouds in the *Resurrection* are bright and crisply defined: similarly precise highlights and gradations of color appear in Mantegna's skies, such as that of the *Crucifixion* predella panel from the San Zeno altarpiece (c. 1456–59; Musée du Louvre, Paris) and of the later *Man of Sorrows* (c. 1485–1500; Statens Museum for Kunst, Copenhagen), both in tempera.[117] Bellini's *Resurrection* contains a large, forked tree on which a black

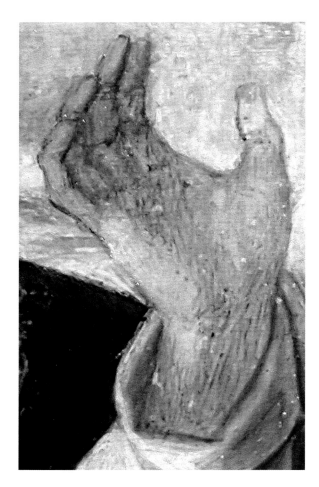

bird perches in silhouette (see fig. 96), an ominous motif that echoes the tree and bird along the right edge of Mantegna's *Agony in the Garden* (fig. 101). Moreover, one of the *Resurrection*'s soldiers is a quotation from an engraving designed by Mantegna.[118]

Also suggestive of Mantegna's example are the loincloth and funerary shroud of Christ in Bellini's *Resurrection*.[119] With their deep folds and angular, gravity-defying aspect, these fabrics recall Mantegna's draperies. By contrast, the robe of Christ in the Naples *Transfiguration* is smoother, with blended folds. The garments of the apostles before him are thickly glazed in the manner of Netherlandish paintings, a technique not seen in the Berlin and Frick pictures, in which glazing is used sparingly. The appearance of Francis's habit falls between the chiseled quality of the draperies in the *Resurrection* and the soft, rounded effect of those in the *Transfiguration*. The saint's brown sleeves are extensively folded and modeled in the underdrawing—typical of Mantegna and the school of Padua—but Bellini used paint of a creamy consistency and applied it in a brushy manner, particularly in the highlights.[120]

Overall, such features indicate that, of the Berlin, New York, and Naples pictures, the *Resurrection* is the most reminiscent of Bellini's early technique and shows the greatest attention to Mantegna's example. The composition of this work also points to an earlier date: though the painting is a modern unified-field altarpiece, its narrative is conceived as a series of distinct vignettes rather than subordinated to a single pictorial vision. The placement of detailed, miniature-like figures across the bottom edge of the scene recalls the traditional predella, the sequence of individually framed narratives along the foot of a segmented altarpiece. By contrast, the Naples *Transfiguration* is a truly single-field altarpiece anchored by three weighty figures. They are enveloped in a cohesive landscape and atmosphere, achieved technically by glazing in the shadows and softening the boundaries of forms, and compositionally by the inclusion of a meandering river that interweaves successive planes of distance. The reigning balance of the *Transfiguration* serves to emphasize areas of tension and movement, such as the recoiling of the apostles James and Peter from the glowing garment of Christ. *St. Francis* again falls in the middle: the saint stands near the bottom of the scene, like the soldiers of the *Resurrection*, but he is much larger in scale and more fully embedded in his surroundings. As in the *Transfiguration*, the artist has braided together the foreground and background of *St. Francis* by placing intricately branched trees at intermediate points in the composition.

These patterns indicate that the Berlin *Resurrection* was executed first, followed by the Frick picture and then the *Transfiguration*.[121] Bellini painted the *Resurrection* for the family funerary chapel of Marco Zorzi at the Venetian island church of San Michele

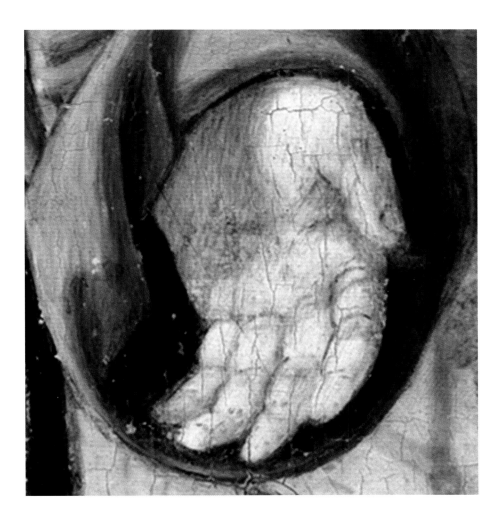

di Murano (now San Michele in Isola). The artist probably received the commission sometime after June of 1475, when the chapel was conceded to Zorzi. Construction of the space had concluded by 1477. In the summer of 1479, Zorzi's mother provided funding for Masses to be said at the altar, likely meaning that the chapel was fully furnished by this time.[122] We suggest that Bellini obtained the commission in later 1475 and delivered the picture by the time of the chapel's completion in 1477. Together with stylistic and technical evidence, this sequence of events is consistent with a dating of the *Resurrection* to c. 1475–77.[123]

Like the *Resurrection*, the Naples *Transfiguration* was painted for a funerary chapel, that of the archdeacon Alberto Fioccardo in the Cathedral of Vicenza.[124] According to a recent study, the scrolls held by Moses and Elijah, the prophets flanking Christ, are inscribed with the Hebrew calendar date of 5239. This corresponds to the period between early autumn 1478 and early autumn 1479, and c. 1479 is now accepted as the date of the *Transfiguration*.[125] The Frick painting probably falls before this time and after that of the *Resurrection* (c. 1475–77). On the basis of technique, style, and relation to documented works of the same period, therefore, we propose a dating of *St. Francis* to c. 1476–78.

This timetable for the completion of the three paintings accords well with the chronology of two major projects undertaken by Bellini's workshop at the end of the 1470s: the San Giobbe altarpiece (see fig. 18) and the narrative scenes on canvas for

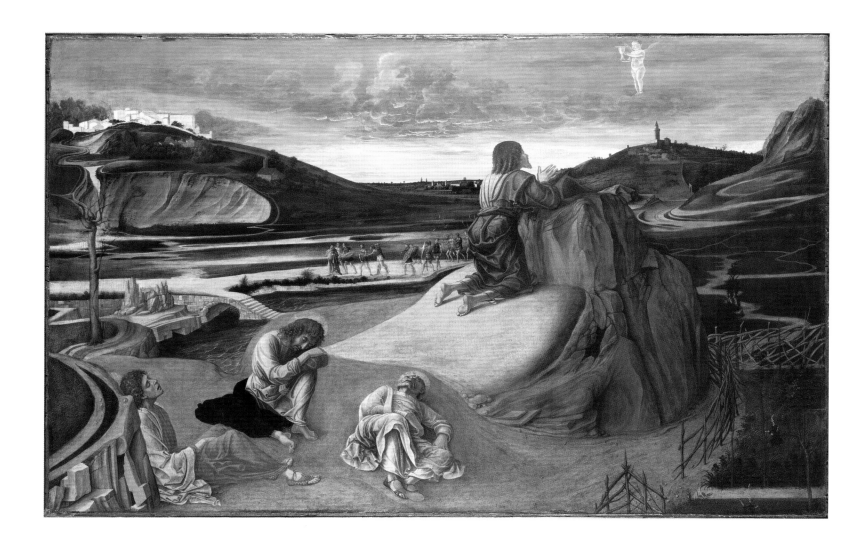

Fig. 100. Giovanni Bellini, *Agony in the Garden*, c. 1465. Tempera on panel, 81.3 × 127 cm. The National Gallery, London

Fig. 101. Andrea Mantegna, *The Agony in the Garden*, c. 1458–60. Tempera on panel, 62.9 × 80 cm. The National Gallery, London

Venice's Palazzo Ducale. In these later commissions, both executed on a large scale, ideas and techniques developed in the *Resurrection*, *St. Francis*, and *Transfiguration* found masterful articulation. The San Giobbe altarpiece was painted probably between 1478 and 1480 for the Franciscan church of the same name; like the Frick picture, the altarpiece expresses values of the contemporary Observant Franciscan movement, as explored elsewhere in this volume.[126] The technique of the two works is also similar: a thin lead white priming followed by a relatively simple structure of paint layers, and deft juxtapositions of color and medium to create an exquisitely fused atmosphere.[127]

Bellini's narrative paintings for the Great Council Hall of the Palazzo Ducale were destroyed by fire in 1577, but documents indicate that his workshop was engaged on these canvases from 1479 onward.[128] In Renaissance Venice, canvas supports were associated with the oil medium at an early date, and the artist probably executed his ducal palace narratives in oil.[129] Bellini's progressive mastery of oil technique in the *Resurrection*, *St. Francis*, and *Transfiguration* during the years 1475–79 prepared him to contribute to this state-sponsored program. His experiments in the narration of Christian miracles in the Berlin, Naples, and Frick pictures no doubt informed the composition of the Palazzo Ducale scenes, and the earlier paintings hint at the unity and complexity of these lost pictures.

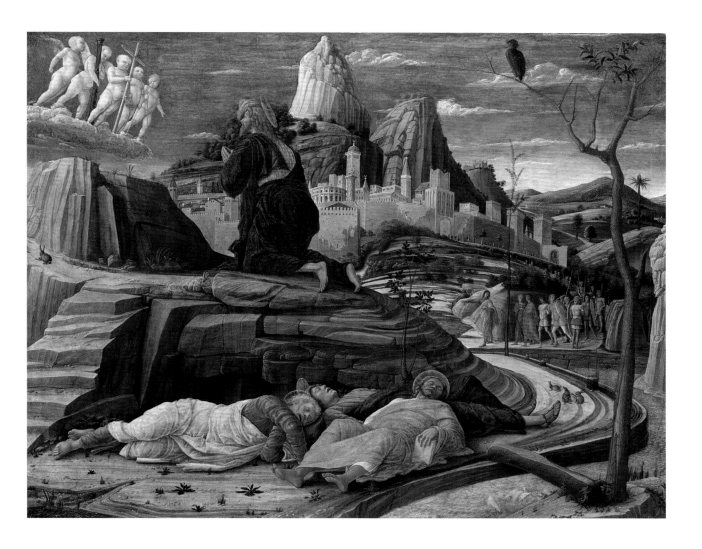

The San Giobbe altarpiece and Palazzo Ducale canvases were vast commissions requiring greater coordination and delegation within Bellini's studio; at the same time, they brought prestige and further demand for his pictures. Beginning in the late 1470s, the artist's workshop became more involved in the manufacture of pictures bearing his imprimatur. Assistants were increasingly enlisted to transfer underdrawings, to paint smaller devotional works, and to execute the secondary figures and backgrounds of major altarpieces.[130] The Frick panel, completed just before this expansion of Bellini's practice, shows the painter working at greater leisure and in complete control of each stage of the creative process. *St. Francis* was neither the first nor the last of his autograph masterpieces of devotional painting. Yet in its monumental size, breadth of vision, and depth of detail, and in the extent of the artist's investment in every element of its singular design, the picture marks a milestone on what Roberto Longhi called the "long road" of Bellini's exceptional career.[131]

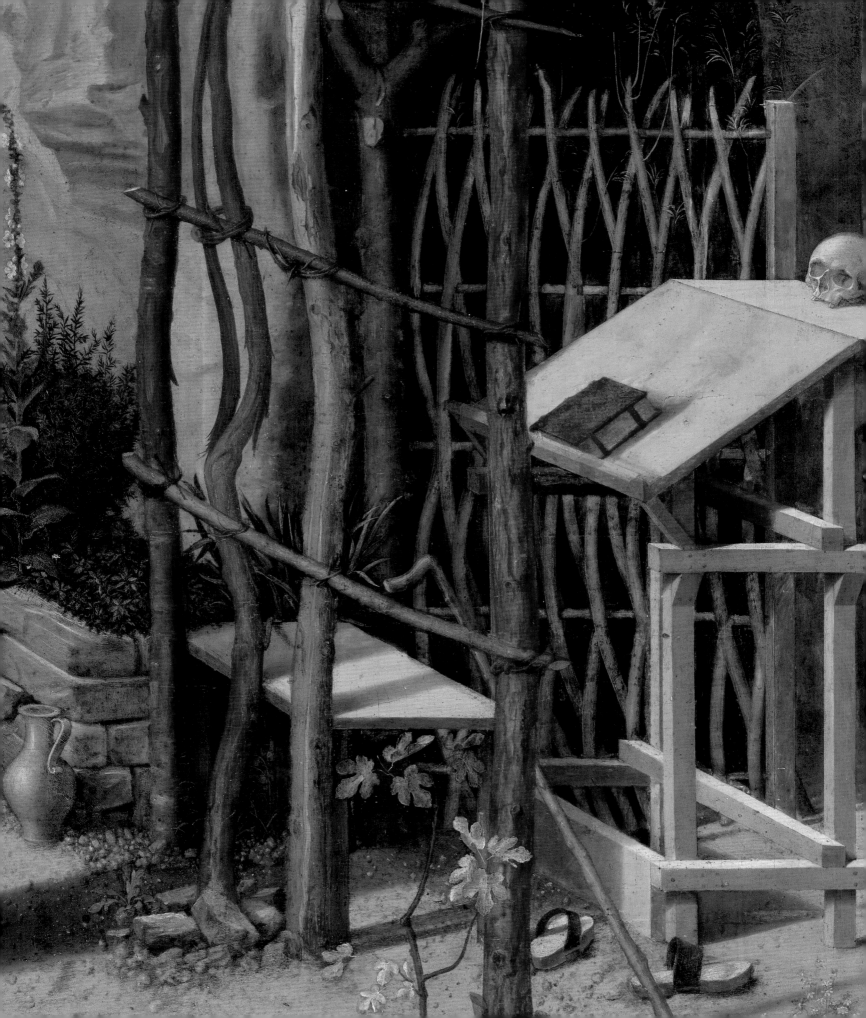

by Joseph Godla and Denise Allen

In *Journey of the Mind into God*, the Franciscan theologian Bonaventure of Bagnoregio (1221–1274) describes his pilgrimage to Mount La Verna, the holy site where Francis received the stigmata:

> I shall begin by invoking through His Son Our Lord Jesus Christ, the First Principle, from Whom all enlightenment descends as through the Father of Light . . . and through the intercession of the blessed Francis, our guide and father, [that] He might give illumination to the eyes of our mind to point our feet in the direction of peace, which reaches beyond perception . . . Following the example of the blessed father Francis, I made an exhaustive spiritual search for this peace . . . I went seeking Mount La Verna, where I remained.[1]

On the sacred mountain, Bonaventure receives the vision of the crucified savior that had been granted to Francis. *Journey of the Mind into God* (originally titled *The Meditation of the Poor Man in the Desert*) was inspired by this miracle.

Francis's and Bonaventure's sojourns on Mount La Verna were undertaken far from the works of men, surrounded by nature's immensity. Bonaventure wrote of his experience on the mountain to guide his readers' inward devotional pilgrimages. As John Fleming has suggested, Giovanni Bellini's *St. Francis in the Desert* is at its heart a pictorial counterpart to Bonaventure's text.[2] Bellini renders the place of miracles, La Verna, with striking clarity so that those who view it might likewise believe, remember, and be inspired to follow the saint's spiritual journey. He portrays nature as luminous, sanctified through its creation by God—a perfect landscape that reveals even the smallest flowers as it grandly unfolds to include towering mountains and skies that extend beyond what the eye can see. As we stand before the picture, Francis appears close to us; and the landscape around him encompasses us. Embraced by the saint's world, we witness his solitary vision.[3]

Bellini treats landscape not as background or environment but rather as a dynamic element in the devotional drama.[4] He was the first Italian painter to transform what had been a setting into a force that could move the viewer's emotions and mind with a power equal to the heroic characters described by Leon Battista Alberti in his treatise *De Pictura* (*On Painting*).[5] Alberti dedicated his treatise to the creation of moralizing narratives (*istorie*), the representation of which he considered to be the highest purpose of painting. Serving this goal was Alberti's application of the science of optics to the composition of pictures, which included instructions on how to construct linear centric-point perspective.[6] Based on Renaissance concepts of the

St. Francis in the Desert, detail

geometry of vision, Albertian perspective modeled the way in which the eye comprehends distance, allowing the painter to create a convincing depiction of receding space and the figures and objects within it.[7] Perspective structured the illusionistic world of Alberti's moralizing narratives. He famously compared such paintings to windows.[8] They extended what could be physically experienced to reveal historical and mythic events, religious truths, and visions.

In fifteenth- and sixteenth-century Venice and its environs, Giovanni Bellini was celebrated as a master of perspective. He is mentioned with his brother Gentile in print for the first time in *Laus Perspectivae*, written by the humanist Matteo Colacio around 1475, shortly before *St. Francis in the Desert* was painted.[9] In his *Summa de Arithmetica, Geometria, Proportioni et Proportionalità* of 1497, Luca Pacioli praised the brothers for their skill in this art.[10] His view was reiterated by the Venetian humanist and mathematician Daniele Barbaro, who lauded Giovanni in *Pratica della Prospettiva* of 1569.[11] Barbaro's esteem for the Bellini family's perspective expertise culminated a longstanding tradition. Before 1440, the engineer, geometer, and polymath Giovanni della Fontana had dedicated his treatise on painting to Giovanni and Gentile's father, Jacopo. All that survives is Fontana's short passage on the rendering of light and shade, but his treatise is believed to have also contained a discussion dedicated to perspective construction.[12] Present-day scholars such as Colin Eisler, Jennifer Fletcher, and Giovanni Agosti have examined Giovanni Bellini's knowledge of perspective in the cultural context of Renaissance Venice.[13] Others, such as Brigit Blass-Simmen, Janna Israel, and Rebecca Zorach, have interpreted his manipulation of perspective in relation to his pictures' patronage, location, and symbolic content.[14] The perspective structures of a few of his paintings, most notably the San Giobbe altarpiece, have been diagrammed;[15] but this exercise, so familiar in the literature devoted to the art of Bellini's contemporaries Piero della Francesca and Leonardo da Vinci, remains rare.[16] The type and structure of the perspective Bellini employed for *St. Francis in the Desert* have never been analyzed.

Giovanni Bellini was neither a geometer nor a theoretician, and, unlike Piero and Leonardo, he left no writings that explain his principles for rendering pictorial illusion. He is a quintessential Venetian painter, heir to the tradition of silence in matters of art and, more importantly, to its custom of pragmatic craftsmanship.[17] For Bellini, the art of perspective was but one of many skills developed over a lifetime of experience. He used more than one perspectival method and was not wedded to any one of them. His paintings reveal that he was cognizant of Albertian centric-point perspective, as well as traditional distance-point (bifocal) perspective. Sometimes he manipulated aspects

of both these systems within a single painting, and St. Francis in the Desert provides one such example. Bellini's comprehensive approach to perspective is analogous to his transition from painting with tempera to painting with oils. He never abandoned customary methods that he considered meaningful and useful but rather inventively merged them with the new.[18] St. Francis, which was planned like a tempera painting but executed in oil, has the detailed lucidity of the highly esteemed early Netherlandish landscapes that inspired it.[19] Like them, the perspective structure of St. Francis evolved from the tradition of craftsmanship, not theory.

This essay explores the types of linear perspectival constructions Jacopo and Giovanni Bellini might have employed to structure their narrative landscapes. Constructed from images of the works of art, a series of diagrams reveal how indebted Giovanni was to his father's breakthroughs in perspective and how greatly he transcended them. The narrative landscape was a subject novel to Renaissance Italy, one that for the artists posed the tremendous challenge of creating spatially convincing depictions of irregular nature using perspectival geometry limited by a rectilinear grid. The bifocal and Albertian perspective methods used by Italian artists of that time were ill suited to the depiction of landscapes. The diagrams of Jacopo's drawings and Giovanni's paintings presented here suggest how both men inventively adapted perspective to accommodate nature's varied stage. Finding original perspective constructions in underdrawing is rare. Infrared examination of the paintings discussed here, for example, has revealed no evidence of them.[20] Diagrams drafted from photographic reproductions are imprecise.[21] This essay suggests that high-resolution digital images used in combination with graphic design software can afford the degree of accuracy required to identify the elements of a perspective construction that are hidden in plain sight within a completed drawing or painting. Current technology has the potential to offer unprecedented insight into structures that were ingeniously drafted with the simplest of tools and almost certainly were less complex than any modern diagram.[22]

Jacopo Bellini: Drawing Albums

Giovanni's approach to linear perspective was grounded in the workshop methods of his father, Jacopo, whose two volumes of large-scale scenographic drawings (c. 1430–70; Musée du Louvre, Paris; British Museum, London) reveal a sophisticated practitioner of the art.[23] Jacopo experimented with various techniques, including bifocal and Albertian perspective, and even touched upon one of Piero's key methods long before it was widely known.[24] He may have intended his albums to be virtuoso

Fig. 102. Jacopo Bellini's *Crucifixion* (British Museum drawing album, f. 76r.), with proposed reconstruction of bifocal perspective

demonstrations of invention and skill for his learned patrons,[25] in which case they would have served a similar purpose and audience as Alberti's Latin treatise *De Pictura*.[26] As examples meant to instruct painters in Jacopo's shop, the albums shared the didactic function of the Italian version of Alberti's treatise (*Della Pittura*), which was dedicated to Brunelleschi and his fellow Florentine artists.[27] Jacopo's drawings, like the *Crucifixion* and *Christ Nailed to the Cross* discussed here, were narrative and "perspective performances."[28] An impressive number of them were grand crowd-filled landscapes that lacked the checkerboard tiled pavements (*pavimenti*) that painters employing the bifocal or Albertian methods often relied upon to create the stage-like platforms that revealed the plotted units of spatial recession.[29] The multicolored tiled

loggia in Giovanni Bellini's *Sacred Allegory* (see fig. 68), for example, illustrates a pavement demarcating the receding spatial grid upon which the foreshortened figures are disposed. Similar linear perspective structures are embedded within Jacopo's narrative landscape vistas.[30] His son Giovanni's ability to craft such a hidden perspective framework is what creates the unified topography of *St. Francis in the Desert*.

Jacopo Bellini's *Crucifixion*: Bifocal (Distance-Point) Construction

Current in Italy until well into the fifteenth century, bifocal perspective is a traditional method employed to create the illusion of spatial recession on a flat surface, or picture plane.[31] The bifocal method was inherently craft-based: artists did not need to understand the method's geometric proofs in order to draft structures that evolved from its proportional relationships. Once the painter established the size and shape of the surface to be depicted, he needed only a compass and a straightedge (if the surface was small) or a nail and a string (if the surface was large) to lay out the linear perspectival scheme. The diagram overlay on Jacopo's *Crucifixion* (fig. 102) illustrates the drawing's bifocal perspective framework. Jacopo plotted an equal number of units of measurement at the sheet's bottom edge (twelve units are shown) and chose the height of the horizon line (in red). At the horizon line's terminations at the edges of the paper are the two distance points from which the term *bifocal perspective* derives. Diagonal lines, or orthogonals (in blue), were drawn from each distance point to each unit of measurement at the bottom of the sheet. The intersection of the orthogonals at the center of the page determined the centerline (in black). Horizontal lines, termed transversals (in blue), were drawn through the intersections of the orthogonals to demarcate the scaled recession into depth. This last step completed the bifocal spatial grid. Two of Jacopo's lightly drawn horizontal transversal lines, still visible on the lower left edge of the *Crucifixion*, were used to generate the diagram.

In the bifocal system, the equal length between either of the distance points and the vertical centerline determines the conceptual distance between the viewer and the picture plane, as well as the rate of the composition's scaled recession into depth. During the Renaissance, distance points were traditionally drawn within the picture plane or, as in the *Crucifixion*, at its edges.[32] Therefore the length between distance point and centerline tended to be short and enforced a close viewing distance between the image and its audience. The abbreviated length between distance point and centerline created a rapid rate of recession into pictorial depth, which caused any object that was depicted close to the picture plane (especially at its corners) to be so radically foreshortened as to appear overlarge, bulging, and otherwise distorted. These

characteristics of the bifocal system could be exaggerated or tempered by Renaissance artists. In the *Crucifixion*, Jacopo slows the rate of spatial recession by setting the horizon line low, putting it where the wooden plank of Christ's cross emerges above the crowd. To avoid extreme foreshortening, he places the three foreground horsemen, situated to the left and right of the centerline, a full two scaled units of measurement into depth. The diagram illustrates the drawing's second lowest transversal grazed by these three horses' rear hooves. Below the hooves lies unarticulated barren ground. It is the sole, bleak glimpse of Golgotha. Jacopo otherwise hides the place of Christ's crucifixion beneath the vast, milling crowd of executioners and onlookers. In his grand narrative vista, the commotion of humanity, not the landscape, recedes along the walls of Jerusalem toward the stony, distant mountains.

Jacopo manipulates the *Crucifixion*'s bifocal perspective framework, as well as the figures within it. He orients the structure on a diagonal, creating an oblique construction directed toward the left distance point (fig. 103). This is a departure from conventional Renaissance bifocal constructions, which typically recede toward a point located on the centerline.[33] In Jacopo's drawing, Christ's head falls toward the left distance point at which the orthogonal lines converge, and the arms of the three crosses and the crowd rapidly recede toward it. In contrast, the right distance point is ignored; space does not recede in that direction. On this side of the composition, Jacopo emphasizes planarity, sometimes at the expense of perspectival correctness. This is most apparent between the crucified thief and the right edge of the paper, where the horses immediately below the wall are too large relative to their location in spatial depth, and their hindquarters are oriented too strongly parallel to the picture plane. However, Jacopo also emphasizes apparent distortions that are consistent with the bifocal structure. The impenitent thief at right appears oversized; yet his scale and foreshortening conform to the spatial grid. The suffering of this sinner, damned for his refusal to recognize Christ, provides a sobering visual point of entry into the scene. In the distance, Christ's cross rises directly above the centerline, the vertical axis of the perspective framework, to anchor the entire composition. The cross's strong diagonal orientation toward the left heightens the scene's tension. For Jacopo, as for most artists of his time, drafting a perspective structure was a fundamental step on the path to pictorial invention. In the *Crucifixion*, his daring manipulation of the bifocal system to create an oblique composition oriented toward a single distance point was a precedent for Giovanni's construction of the landscape in *St. Francis in the Desert*.

Jacopo's *Christ Nailed to the Cross*: Alberti's Centric-Point Construction

Jacopo also experimented with Alberti's system of centric-point perspective around the time *De Pictura* was written. Samuel Edgerton has suggested that Jacopo may have known Alberti and become familiar with his perspective concepts and method in Ferrara, when they were both at the Este court.[34] As Edgerton has shown, Jacopo's drawings in the Louvre and British Museum albums that illustrate city squares paved with tiled *pavimenti* reflect knowledge of Alberti's technique.[35] Other drawings, like *Christ Nailed to the Cross*, reveal Jacopo seemingly adapting centric-point perspective to structure a vast amorphous landscape. The Albertian method depends on initially

fixing the location of a single centric point on a horizon line that is laid across a picture plane of established dimensions.[36] The centric point is typically located at the center of the picture plane and is understood to face directly opposite the viewer's eye.[37] All the diagonal orthogonal lines within the painting's perspective structure converge at the centric point, also termed the vanishing point. In the Albertian system, the picture plane is analogous to a flat mirror, with the viewer standing directly before it. Visual rays believed to radiate outward from the viewer's eye create the cone of vision whose base intersects with the picture plane. The orthogonal lines receding to the vanishing point within the mirror reflect the viewer's cone of visual rays in reverse.[38] Alberti termed the single, central ray within the visual cone that travels directly in a straight line from the viewer's eye to the vanishing point the "prince of rays."[39] The requirement of a single, fixed vanishing point that reflects the ideal position of the viewer's eye distinguishes Albertian perspective from the earlier bifocal method.

Alberti recommended placing the horizon line at the height of an upright man depicted standing with his feet at the bottom edge of the picture plane. One third of the man's height, or one *braccio*, provides the unit of measurement used to mark the divisions at the picture plane's bottom edge.[40] Diagonal orthogonal lines connect the vanishing point on the horizon line to the unit divisions below. To determine the scaled recession of the horizontal transversal lines into depth, Alberti encouraged painters to select an ideal distance between the viewer and picture plane.[41] Albertian viewing distances could be much greater than those customarily employed in bifocal perspective. Often falling well outside the confines of the picture plane, they could be used to establish a direct relationship between the location of the painting and its audience. For example, Giovanni Bellini's Pesaro altarpiece (see fig. 13), executed just a few years before *St. Francis in the Desert*, is predicated on a viewing distance situated far away from the picture plane.[42] Exploiting the freedom of Alberti's method, Giovanni chose a distant viewpoint so that the figures of the Virgin and Christ appear to be near viewers standing in the nave of the church, far from the altarpiece.

The diagram overlay on Jacopo's drawing of *Christ Nailed to the Cross* (fig. 104) follows Edgerton's convention for illustrating the elements of centric-point perspective, which include Alberti's separate operation for establishing the viewer's ideal distance from the picture plane and the composition's rate of recession.[43] On the drawing, the horizon line (in red) is shown with the vanishing point appropriately located almost exactly at the center of the sheet. The horizon line extends outside the drawing, terminating at a point indicating the location of the viewer's eye. The vertical line (in black) represents the picture plane rotated ninety degrees to face the viewer.

The space between the viewer's eye and the vertical picture plane denotes the viewer's ideal distance from the image. Diagonal orthogonal lines extend as rays from the viewer's eye to the units of measurement at the diagram's bottom edge. The intersection of these diagonal lines with the vertical picture plane generates the horizontal transversal lines that overlay the drawing to register its scaled recession into depth.[44] Although Jacopo had the freedom to do otherwise, the diagram demonstrates that he chose the extremely short viewing distance typical of bifocal perspective, which precipitated distorted foreground foreshortenings and a rapid rate of spatial recession.[45] To slow down this rate, Jacopo places his figures one scaled unit into depth. The foot of Christ's cross lying on the ground, for example, just touches the top of the lowest transversal. This is Jacopo's sole significant adjustment. He relies on the shallow viewing distance to ensure that the large rectangular scene of Christ's crucifixion appears to encompass the viewer's field of vision.

In *Christ Nailed to the Cross*, Jacopo combines centric-point construction with the short viewing distance typical of bifocal perspective. The scene expands directly before the eyes of the viewer, whose gaze is fixed opposite the vanishing point at the composition's center. The Crucifixion takes place on a flat, featureless plain, on which Jacopo orients the instruments of execution along the diagonals that impel the composition's rapid spatial recession. The long arms of the cross at left, the log at far right, the rungs of the ladder on the ground, and the major upright of Christ's cross all lie on the orthogonals that converge at the vanishing point on the horizon. The runged ladder, which resembles a single segment of tiled pavement, might be Jacopo's nod to the *pavimenti* that allowed viewers to plot a composition's scaled spatial intervals. But in Jacopo's barren landscape only the crouching executioners and this ladder provide a small measure of visual purchase. Everything else in the foreground, including Christ's prone body (highlighted in white), drives the viewer's gaze onward until it is blocked abruptly by the crowd's impenetrable ranks. The height of Christ's figure approximately conforms to the three scaled units of measurement recommended by Alberti. Yet Christ's position close to the picture plane enforces such a radical degree of foreshortening that his body appears impossibly attenuated. His outstretched form simultaneously captures the viewer's gaze and compels it to meet the eyes, located on the horizon line, of the distant multitudes of onlookers. By exaggerating tensions inherent in the perspective structure, Jacopo dramatizes the act of seeing and makes the viewer a participant in the religious narrative. This manipulation of perspective to actively engage the viewer was a fundamental lesson that Giovanni brought to his composition of St. *Francis in the Desert*.

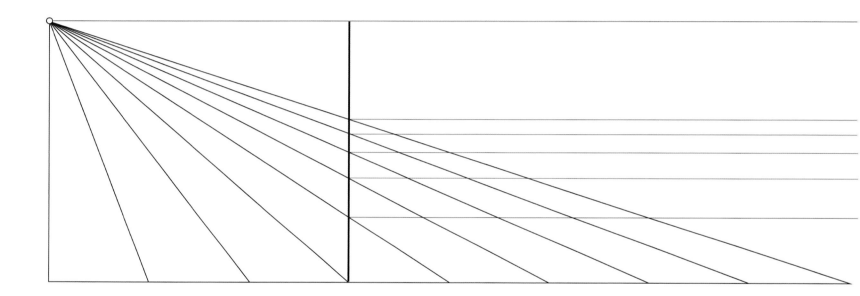

Fig. 104. Jacopo Bellini's *Christ Nailed to the Cross* (Louvre drawing album, f. 7r.), with proposed reconstruction of Albertian perspective

Giovanni's *Agony in the Garden*: Consonant Perspective Structures

Giovanni Bellini painted *Agony in the Garden* (fig. 105) at the beginning of his artistic maturity. Keith Christiansen has termed this devotional picture his "first great landscape narrative."[46] Bellini depicts Christ on the eve of the Crucifixion kneeling before a vast silent world, praying for deliverance. An angel floating high above the rising dawn offers him the cup symbolizing his imminent sacrifice. The apostles sleep; the viewer is the sole witness to Christ's suffering. Christiansen notes that in this groundbreaking picture Giovanni "moves beyond the landscape conventions of his father."[47] Mastery of the perspective lessons learned under Jacopo was a means by which he did so. Like his father, Giovanni daringly structures the irregular landscape on an embedded perspective framework. The diagram overlay of *Agony in the Garden* shows that he could have employed the Albertian centric-point method, setting the horizon line slightly below Christ's waist and the vanishing point almost at the picture's center.[48] As in Jacopo's *Christ Nailed to the Cross*, the painting combines a wide rectangular format with a short viewing distance to enhance the landscape's panoramic effect. Giovanni, however,

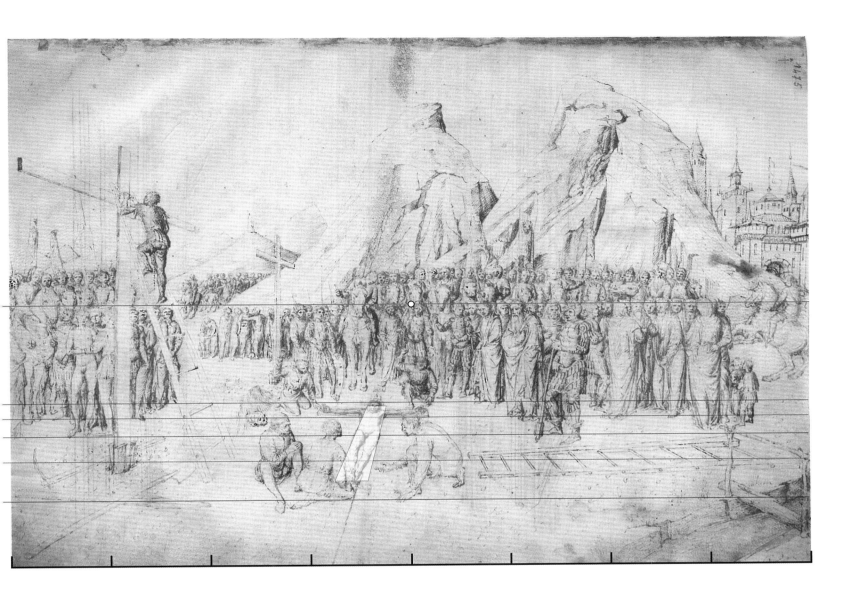

boldly places large figures directly at the foot of the picture plane. He pushes the perspective framework's limits, robustly negotiating the foreground distortions at the picture's lowest corners, something Jacopo had avoided. To offset the bulging appearance of the rock formation at far left, for example, Giovanni depicts the apostle leaning against it in profile and posed parallel to the picture plane. At far right, he cloaks the oddly protuberant woven fence in semi-darkness. The position and extreme foreshortening of the centermost apostle (highlighted in white) echo those of Jacopo's prone Savior in *Christ Nailed to the Cross*, and the apostle is also approximately Alberti's recommended three scaled units in height. But unlike the multitude of small figures in Jacopo's drawing, Giovanni's few large and imposing characters focus the viewer's attention on the drama.

Agony in the Garden's sophisticated blending of a close-up dramatic narrative with a distant evocative landscape transcends Jacopo's perspective designs. Giovanni, unlike his father, does not call attention to the unifying framework underpinning the composition's grand recession into depth. Only the tiny steps on the distant bridge exactly overlap the orthogonals (highlighted in blue), and these steps should be understood as delicate

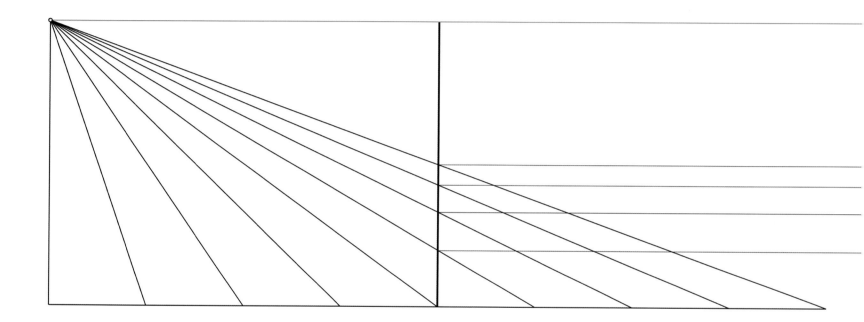

Fig. 105. Giovanni Bellini's *Agony in the Garden* (The National Gallery, London), with proposed reconstruction of Albertian perspective

artifacts of Giovanni's meticulous perspectival consistency. Giovanni also emphasizes components of the composition's two-dimensional design in order to moderate the perspective structure's visual drive toward the vanishing point, thus reducing the power of a device Jacopo had keenly emphasized in his drawings. The bluff on which Christ kneels, his reverse pose, and his gaze toward the luminous angel create a strong upward diagonal movement that is disconnected from the perspective framework and that counters its central recession into depth. Rocky outcroppings scattered across the foreground and mid-ground afford only partial views onto the remote plain whose flat expanse is interrupted by the coils of a meandering river. The plain terminates at the horizon line located at the foot of the dark distant hills, subsuming the vanishing point with it. Above, along the hillcrest and backlit by the rising dawn, lies the painting's visual horizon. By coherently extending the landscape above its perspectival footprint, Giovanni magnifies its encompassing grandeur. His relegation of the vanishing point to a mere element of structure, rather than the focus of the composition, invites viewers to survey the landscape just as they would when experiencing nature itself.

The manipulations evident in *Agony in the Garden* were hard-won solutions, arrived at by a brilliant painter who was gaining confidence in crafting perspective structures. Tough, pragmatic experience also would have taught Giovanni that the bifocal and Albertian methods could be used to achieve the same results. His father knew this. Jacopo could have drafted the perspective framework of *Christ Nailed to the Cross* using the bifocal method. Giovanni could have done the same for *Agony in the Garden*.[49] In his 1505 treatise on bifocal perspective, *De Artificiali Perspectiva*, the French humanist Jean Pélerin inadvertently elucidated the correspondences between the two methods that allow for their occasional interchangeability. Pélerin's diagram (fig. 106) illustrates a landscape rendered with a version of the bifocal technique.[50] The overlaid blue and red lines highlight the diagram's consonance with the Albertian method. The overlay in blue shows the composition's orthogonal lines receding toward a single central vanishing point. The overlay in red reveals the hidden platform underpinning the foreground's scaled recession into depth. Pélerin included four separate decoratively tiled pavements, which are reminiscent of Albertian

pavimenti, to emphasize the importance of the large embedded platform as a device that structures the spatial recession of an inherently irregular landscape. Lastly, to prove his diagram's accuracy, Pélerin illustrated a black diagonal line correctly intersecting the orthogonals and transversals. This quick test was also recommended by Alberti.[51] The test was valid for each method because they were geometrically equivalent. Theoreticians of perspective did not prove the geometric unity between the bifocal and Albertian methods until the late sixteenth century.[52] Pragmatically trained painters such as Jacopo and Giovanni Bellini had creatively dealt with the consequences of this unity long before. Giovanni's breakthrough landscapes—*Agony in the Garden* and *St. Francis in the Desert*, among others—reflect his ability to combine aspects of each system. The perspective structure of *St. Francis* has long resisted analysis, partly because it barely relates to a theoretical tradition that encourages thinking about the bifocal and Albertian systems as separate entities. To Giovanni, who was steeped in the Venetian tradition of hands-on craftsmanship, such theoretical distinctions did not matter. Understanding the perspective framework of *St. Francis in the Desert* hinges on identifying the inventive practical steps that Giovanni might have used to draft it.

Giovanni's *St. Francis in the Desert*: Crafting a Perspective Structure

The single material component common to both the bifocal and Albertian systems is the image's support, whether it be a wall, ceiling, canvas, panel, paper, or parchment. Giovanni painted *St. Francis in the Desert* on a sturdy, gessoed panel made from three solidly joined wood planks.[53] The panel established the dimensions of the picture plane from which Giovanni's perspective structure evolved. Probably before 1812, a portion from the uppermost plank of the panel was cut off. How much remains uncertain, although recent technical examination suggests it may have been "a few centimeters at most."[54] Any attempt to reconstruct the perspective framework of *St. Francis* could end here; for if the original dimensions of the panel are unknown, then so too are the dimensions of the picture plane that frames its perspective structure. Fortunately, the panel's original size is only one element in an interconnected scheme. Bifocal and Albertian systems describe geometrically proportional relationships among their common components—the picture plane, horizon line, distance or vanishing points, viewing distance, orthogonals, and transversals—and determining the relationships among the existing parts of a structure allows for a reconstruction of the whole. The diagram overlay on *St. Francis in the Desert* (fig. 107) illustrates orthogonal lines (in yellow) converging at left at a

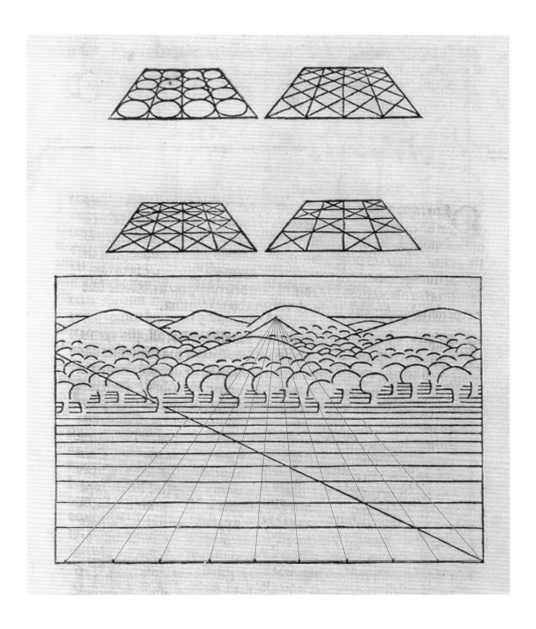

Fig. 106. Page Avii from Jean Pélerin's *De Artificiali Perspectiva* (Toulouse: Pierre Jacques, 1505), with overdrawing showing orthogonals

point that, according to bifocal and Albertian definitions, is situated on the horizon line (in red). Because none of the other diagonals in Giovanni's painting consistently intersects at a single point, the yellow lines must identify the perspective structure's orthogonals. Their convergence establishes the location of the horizon line, as well as that of the distance or vanishing point. Together these three components—orthogonals, horizon line, and the distance or vanishing point—provide enough information to reconstruct Giovanni's full perspective scheme. The perspective reconstruction requires a picture plane measuring 127 by 142 cm, which suggests that the panel was reduced in height by only about 2.4 cm.[55] The concordant results offered by the perspective reconstruction and the panel's technical examination suggest that the narrative in *St. Francis in the Desert* is complete. The panel's missing portion was too small to accommodate a depiction of the crucified Christ as a seraph that appeared to St. Francis when he received the stigmata on Mount La Verna.[56] The vision that transfixes the saint was always left for the viewer to imagine, to contemplate, and to seek.

Even in this preliminary state, the perspective structure of *St. Francis* is unfamiliar. If it is bifocal, then Giovanni has oriented it toward a single distance point, as in Jacopo's *Crucifixion*; but in this case, the distance point lies well outside of its traditional location within or at the edge of the picture plane. If the structure is Albertian, then the vanishing point is far removed from its customary placement at the center of the composition, as was seen in *Christ Nailed to the Cross* and *Agony in the Garden*. Instead, Giovanni combines aspects from both perspective systems, using a version of Jacopo's oblique bifocal construction. But Giovanni's emphasis on the vanishing point as fundamental to the painting's ideal relationship to the viewer, as well as his flexible approach to the painting's viewing distance, reflects his sophisticated understanding of Albertian concepts.[57] For example, he depicts St. Francis directing his gaze along the trajectory of orthogonal lines that converge at the distance point, which serves as the picture's single vanishing point. Giovanni makes this invisible termination the numinous focus of the saint's vision. Because this point lies outside the painting, directly opposite the saint's gaze, it cannot sustain Alberti's definition of it. Instead, Giovanni endows Alberti's ideal, direct relationship between the vanishing point and the viewer's eye with devotional significance. St. Francis alone is granted privileged sight. Excluded from his revelation, the viewer becomes a witness to the saint gripped by the presence of God in a vast beautiful landscape.[58]

Giovanni's symbolic use of the vanishing point in *St. Francis in the Desert* suggests that the painting's perspective structure evolved in concert with its subject.[59] Composing a narrative landscape for a picture of this format and scale must have been daunting. *St. Francis* is almost square and about two thirds again as large as the more forgivingly rectangular *Agony in the Garden*. The unusual panel informed Giovanni's perspectival decisions. He chose a short viewing distance so that the large, square-shaped picture plane literally encompasses the viewer's visual field. And he placed the horizon line very high so that the landscape would rapidly recede into the distance. Figure 108 suggests the process of thought that might have governed the creation of this framework:

108.1. Giovanni could have begun by inscribing a circle around the picture plane (illustrated with the panel's missing portion highlighted in red)[60] and then bisecting both horizontally. The diameter of the circle (in red) that extends beyond the edges of the picture plane would become the painting's horizon line. The circle's radius—the distance between its center and circumference (in red and hashed lines)—is the perspective structure's basic geometric unit of length.

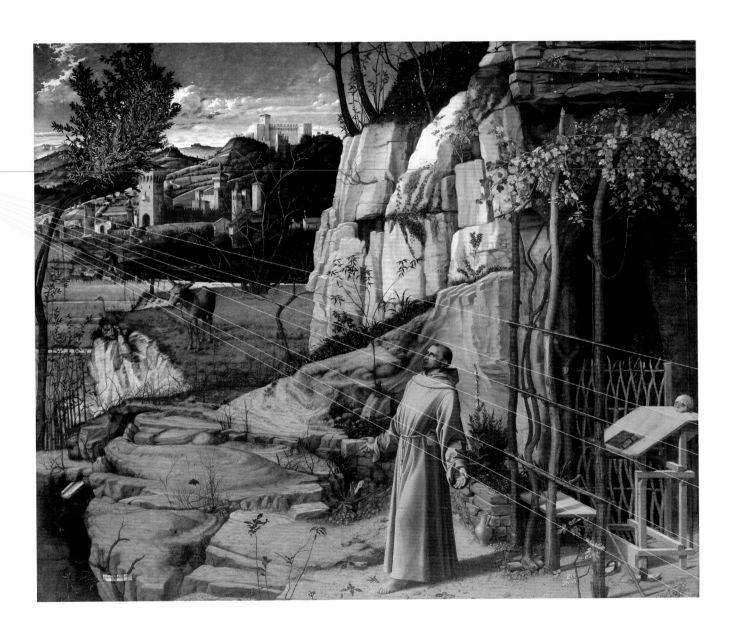

Fig. 107. *St. Francis*, with overdrawing showing
location of the vanishing point

108.2. The line in blue is the viewing distance. It is one radius in length and indicates the distance between the viewer's eye (C) and the picture plane (A). According to Alberti, the cone of visual rays (highlighted in gray) radiates from the viewer's eye to intersect the circle and picture plane within it. The diagram illustrates how, when actually seen from this distance of approximately 96 cm, the area of the painting completely fills the viewer's ninety-degree field of vision.

108.3. When the circle is elevated so that the bottom of the picture plane is tangent to it, it takes the horizon line along with it, thereby maintaining the picture plane and the circle's proportional relationship. The perspective structure's vertical centerline (D–E) is one radius in length.

108.4. The distance points are situated on the horizon line at the ends of the circle's diameter rather than at their traditional locations at the edges or within the picture plane. Giovanni thus manipulates the viewing distance with some degree of Albertian freedom for he has extended the length between distance point and centerline to equal the circle radius. Lastly, diagonal orthogonal lines connect each distance point to the units of measurement at the bottom of the picture plane to establish the scale for the composition's recession into depth.

The proposed perspective structure of *St. Francis in the Desert* is elegant, but it is not complex. Giovanni could have developed it using a craftsman's pragmatically learned and practically applied geometry. He could have quickly sketched his preliminary ideas for it freehand. By this time, thinking in bifocal or Albertian structural terms must have been second nature to him. The types of drawings he might have made to refine such constructions and the means he used to transfer them to the panel are unknown. But if the drawings were small, they would have required only a compass and straightedge— or if to scale, a nail and a string—to execute accurately. The beauty of the perspective structure for *St. Francis in the Desert* lies in its lucid, free-thinking simplicity.

Giovanni's inscription of a circle around a square-shaped panel probably was a creative decision that easily allowed him to draft a perspective scheme that was larger than the picture plane (fig. 109). The resultant landscape conveys an impression of limitlessness because in a very real sense it does not end at the confines of the painting. Giovanni reinforces this expansive effect by setting the horizon line (in red) very high, which affords an elevated viewpoint from which to survey the scene. The

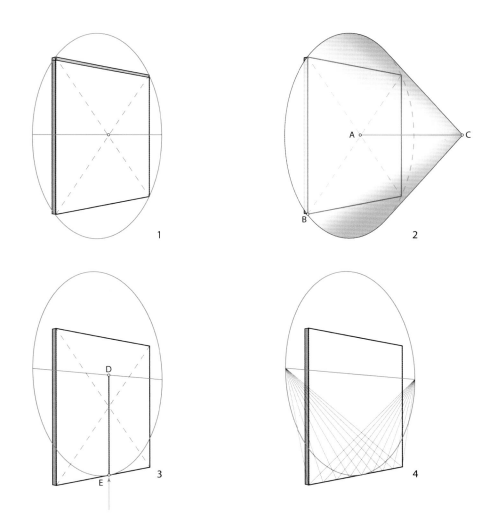

Fig. 108. Possible practical approach for establishing the bifocal perspective of *St. Francis*: (1) locate center point with diagonals and circumscribe rectangular panel with circle, (2) viewing distance A–C is equal to radius A–B, (3) elevate circle so that the bottom edge of the panel is a tangent to the circle, (4) draw diagonals from *braccia* divisions at bottom of panel to distance points

high horizon line also causes an extremely rapid rate of spatial recession toward the left vanishing point, increasing the landscape's vastness in that direction. Bellini locates his figures to guide the viewer's comprehension of this enormous distance. St. Francis stands in the foreground with his foot at the bottom of the picture plane. The donkey, in the mid-ground, is eight scaled transversal units (in blue) away from the saint. In the background at far left, located eight scaled transversal units beyond the donkey, is the diminutive shepherd (see fig. 41) who looks out at the viewer. As shown in the diagram, the shepherd is situated where spatial recession accelerates so rapidly that it causes the transversals to blur together. Giovanni elegantly renders a flowing river coursing over this horizontal border of perspectival ambiguity. He depicts the large castle immediately below the horizon line and the landscape above it using methods that only loosely relate to the painting's perspectival framework.[61] He extends this distant landscape far above the structure's horizon line. The composition's visual horizon ends with a glimpse of mountains so remote that they have taken on the color of the sky.

St. Francis in the Desert is an oblique bifocal perspective construction. Francis's foot points exactly at the centerline. To its left, space recedes; and to its right, it does not. Bellini orients the towering massive cliff, the dark wickered entrance to the saint's cave, and the side of the hut and lectern parallel to the picture plane to halt spatial recession

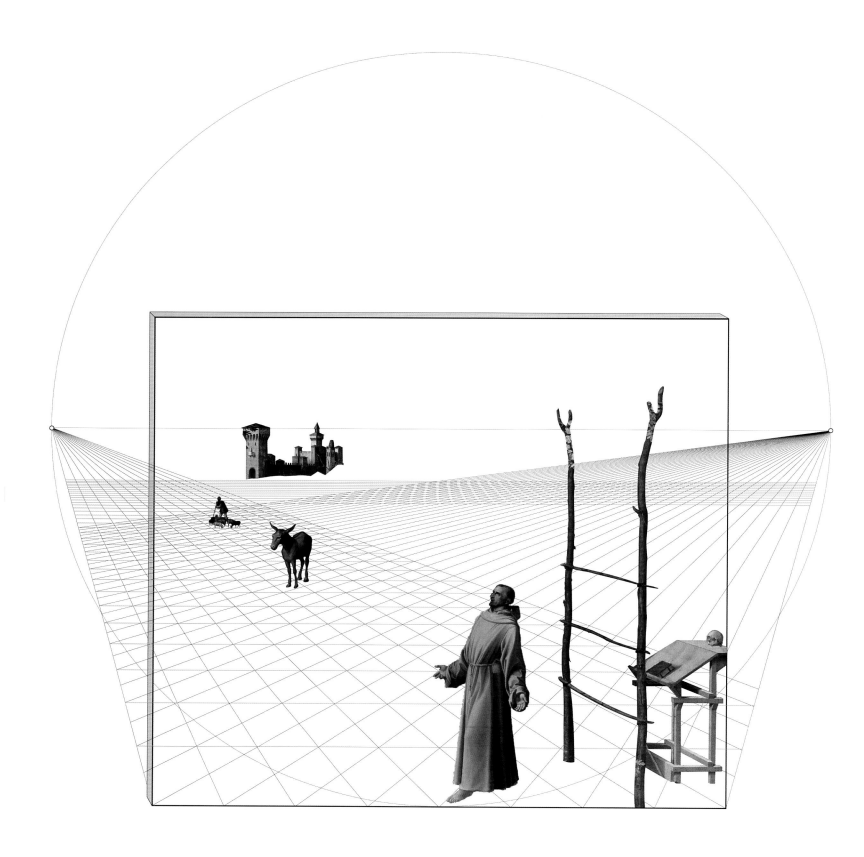

Fig. 109. Diagram with elements from
St. Francis showing the use of diagonals to
establish the location of transversals

in that direction. He boldly extends a rock formation diagonally across the picture to counter and conceal the landscape's accelerated progression into depth. Francis stands isolated before this stony backdrop, yet joined with the unfolding landscape beyond. The diagram illustrates that Bellini rendered the hut, the lectern, and the saint, as well as the donkey and the distant shepherd, in three-quarter view to aptly relate these objects and figures to the landscape's oblique perspective structure. Each is meticulously scaled according to its location. St. Francis, who stands at the foot of the picture plane, is approximately three *braccia* in height, and his figure provides the Albertian unit of measure that determines the construction's recession into depth.[62] The wooden branches of the trellised hut and the boards of the lectern form an oblique three-dimensional grid that cogently reveals the landscape's hidden framework. In their foreshortened complexity, these humble furnishings recall the *mazzocchii* and other bravura exercises in solid geometry that proclaimed Renaissance painters' mastery of linear perspective.[63] In their function as a three-dimensional key to the painting's construction, they surpass the flat checkerboard *pavimenti* that announced the use of bifocal and Albertian perspective. The placement of such fundamentally important structures at the lower right corner of the composition, where bulging perspectival distortions could occur, was the daring means by which Giovanni exploited the painting's shallow viewing distance and potential for extreme foreground foreshortening to enhance these objects' volumetric projection. St. Francis shares their salient effect, and his figure appears palpably close, even when seen from a distance. At the picture's lower left corner, Giovanni negates the composition's forward thrust by depicting a concave shadowed pool and his signature, suspended on a flat *cartellino*, beside it. The dark pool contrasts with the burst of light at the painting's upper left (see figs. 59, 63) whose golden beams penetrate the leaves of the bending laurel tree and radiate toward the saint. This freely painted, resplendent brilliance is neither underdrawn nor part of the perspective construction. It is rather Giovanni's unforgettable rendering of God manifested by light at the moment he becomes radiantly tangible to the saint and to the picture's viewers. In *St. Francis in the Desert*, Bellini crafted an unprecedented work. The painting's perspective structure as much as the luminous landscape itself testify to the rigorous beauty and profound spirituality with which the ingenious master let his mind and soul "wander at will."[64]

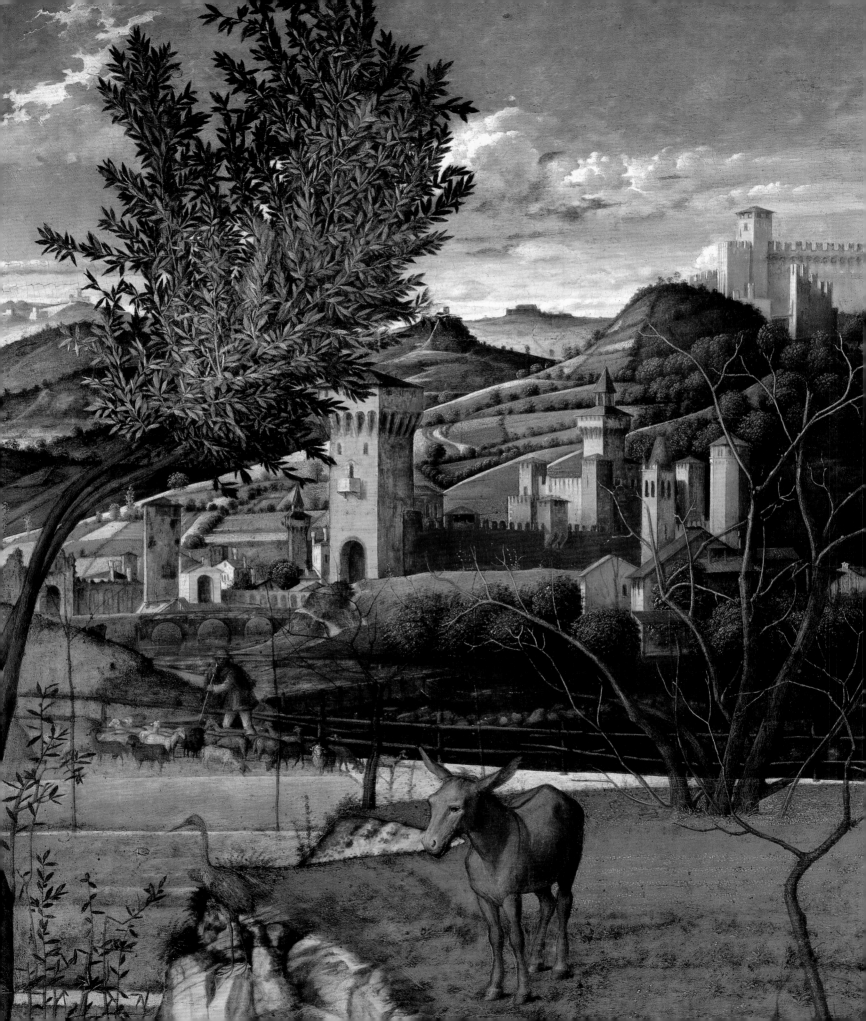

THE FORMATIVE STIMULUS FOR BELLINI'S ST. FRANCIS IN THE DESERT: HISTORY AND LITERATURE OF THE FRANCISCAN MOVEMENT IN LATE MEDIEVAL ITALY

by Michael F. Cusato, O.F.M.

The painting by Giovanni Bellini known in some circles as *San Francesco nel Deserto*, in others as *St. Francis in Ecstasy*, and in still others as simply the Frick *St. Francis* is one of the most evocative and complex portrayals of the Poverello in the history of western art. Yet it has been shrouded in mystery since its beginnings. This study considers the picture's sources of inspiration and intended audience against the background of developments in Franciscan religious practice and literature of the thirteenth through the fifteenth centuries. I do not attempt to explain the painting itself; experts such as John Fleming (in his magisterial essay of 1982) have gone a long way to doing just that. However, the following discussion of the painting's historical and literary context should allow those more versed in the art of interpretation to continue their work with new elements to consider.

The Larger Framework: A Thumbnail Sketch of the Franciscan Movement in the Middle Ages

When Francis of Assisi died, in October 1226,[1] the movement he founded had already been organized by the papacy into three different juridical branches of followers. The First Order consisted of the friars themselves, the male followers of Francis: members of the religious order known as the Friars Minor who professed an approved Rule of religious life (the Regula Bullata) and were characterized by a life of radical material poverty.[2] The Second Order was composed of female followers of Francis's early companion, Clare of Assisi; these women were quickly channeled by the papacy into the contemplative life of cloistered nuns, eventually following a Rule written for them by Clare herself, which was similarly marked by rigorous poverty. These are the Poor Clares.[3] The Third Order was made up of lay men and women desiring to follow in the way of Francis but preferring to remain in the world, as married or single people. These lay penitents formed themselves into confraternities of devout Christians and were given a Rule by Rome and spiritual counsel by Francis in shaping their lives.[4] Beginning in the third quarter of the thirteenth century, groups of these penitents, almost exclusively women, began living together in the manner of the professed religious, eventually constituting a group known as the sisters of the Third Order Regular, dedicated to works of mercy.[5] All these groups play a role in the story of Bellini's painting.

It is important to understand not only the overall structure and membership of the Order in the century after Francis's death and canonization but also the history of the poverty question within the First Order. The controversy over the observance of poverty has been the single most frequently treated subject by historians of the Franciscans.[6] Disputes broke out, even during the lifetime of Francis, over how to

St. Francis in the Desert, detail

observe evangelical poverty and minority (the latter term referring to the relationship of the friars to the various classes of society, especially the poor).[7] These internal debates eventually erupted into open revolt during the first decades of the fourteenth century, threatening the division of the Order. This is the infamous quarrel between the zealots of rigorous poverty, known as the Spiritual Franciscans, and the exponents of a less stringent, more moderated form, often referred to as "the Community."[8] The divisions eventually provoked the intervention of the papacy in the person of John XXII, who turned on the whole Order and its ideal of poverty, which ultimately led to the discrediting of its more radical wing—the Spirituals—by the 1330s.[9]

Paradoxically, it is in this same decade that historians locate the informal beginnings of yet another reform movement advocating a return to the zeal of former days: the Franciscan Observants, officially founded in 1368. This is the birth of the Franciscan Observants: an urgent call to observe the Rule as it was intended, in all its rigor, with a special emphasis upon material poverty and intense personal prayer in the silence of hermitages, far from the pastoral activities being carried out by the friars of the Community in the cities, now increasingly called Conventual Franciscans (since they were living in the sprawling urban convents of Italy).[10]

Broadly speaking, two generations of these central Italian Observants can be distinguished.[11] The first, spanning almost sixty years, was led by figures such as Giovanni della Valle, Gentile da Spoleto, and Paoluccio dei Trinci of Foligno. These men received permission to leave the large urban convents and live in the quiet of remote hermitages. Shortly after the turn of the fifteenth century, with the entrance into this movement of four supremely gifted friars—the famous four pillars of the Observant Reform: Bernardino da Siena, Giovanni da Capistrano, Giacomo delle Marche, and Alberto da Sarteano—a second generation of Observants began to change the exclusively eremitical orientation of the Italian Observants by returning to the cities to preach to the masses. Two features, in particular, still distinguished them from the Conventuals. First, instead of settling in the center of the towns where they intended to preach, the Observants located themselves as much as possible on the edges of the cities, at some distance from the hubbub of town life, while retaining those remote hermitages as way stations between their urban preaching missions. And second, because their lifestyle had now become more itinerant and required books for the preparation of their sermons and spiritual treatises, they began advocating a somewhat less harsh, more moderated form of Franciscan poverty based especially on the papal interpretations of the Rule: a *via media* between the rigor of the Italian hermits

of the first generation of Observants and the increasingly urbane Conventuals. One of the classic signs of this worldly engagement by the Conventual Franciscans was their involvement as patrons of the arts for their convents and churches.

In order to prevent the persecution of these more zealous friars by their less intense confrères, the papacy, by the 1420s, allowed the Observants to exist under their own religious superiors, though still under the ultimate jurisdiction of the Minister General of the Franciscan Order.[12] Italy, for example, was divided in half, with the Observant friars of northern and southern Italy each under the direct jurisdiction of a vicar general (Bernardino da Siena and Giovanni da Capistrano, respectively). This situation persisted in Italy both before the attempt at reconciliation and compromise between the Observants and Conventuals at the momentous General Chapter of Assisi in 1430, as well as in the wake of the unraveling of these attempts shortly after the chapter.[13] These two versions of Franciscan life among the friars in the cities of Italy (with a third version still tucked away in the background in the rural hermitages) coexisted uneasily in Venice at the time Bellini was commissioned to create his extraordinary presentation of Francis of Assisi.

The Franciscans of Venice in the Late Fifteenth Century

By 1476–78, the approximate dates of Bellini's *St. Francis*, four principal Franciscan establishments of the First Order were flourishing in Venice (fig. 110).[14] Foremost was the magnificent basilica and attendant convent of Santa Maria Gloriosa dei Frari, seat of the Conventuals.[15] Work on the first church at San Tomà in the heart of the city began in 1250. The early structure was eventually replaced by the present Gothic edifice, whose construction commenced in 1330. The choir, transepts, and campanile were effectively complete by 1391, but building progressed slowly and the church was not consecrated until a century later, in 1492. After the adjacent convent's destruction by fire in 1369, it was considerably enlarged, taking on the name of Magna Domus Venetiarum, and a smaller church and convent was established next door to serve the elderly (San Nicoletto della Lattuga ai Frari). The Frari became an important center of artistic patronage, and today it still shelters some of the highest achievements of Venetian Renaissance sculpture and painting, including Bellini's triptych of the *Madonna and Child with Sts. Nicholas of Bari, Peter, Mark, and Benedict* (1488) for the Pesaro family chapel of the sacristy.

Another Franciscan establishment in Venice proper is associated with the priest Giovanni Contarini, who set up a private hospice and oratory around 1378–80 in the extreme northwest corner of the city. The small institution was dedicated to San

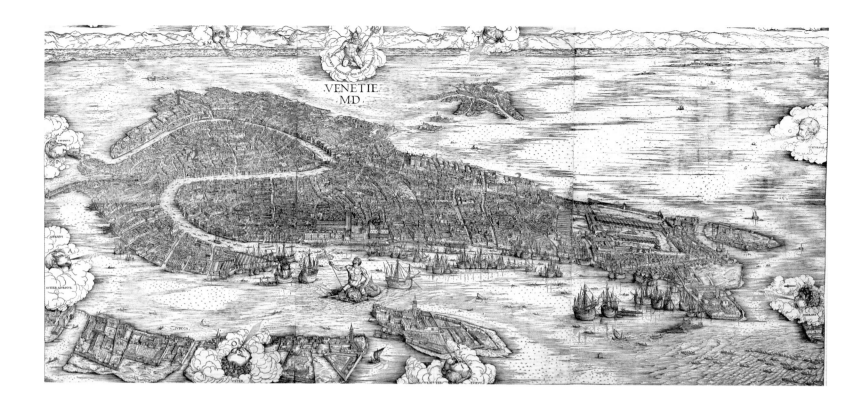

Fig. 110. Jacopo de' Barbari (c. 1460/70–c. 1516), *Venetie*, 1500. Woodcut, 134 × 280.8 cm. The British Museum, London. The approximate locations of the principal First Order Franciscan establishments in Venice are indicated from west to east: 1. San Giobbe, 2. Santa Maria Gloriosa dei Frari, 3. San Francesco della Vigna, 4. San Francesco del Deserto.

Giobbe (Job).[16] In 1428, with the expansion of the Observant Reform movement into the Veneto, and to Venice in particular, the hospice was taken over by the Observants with the consent of Pope Martin V. San Giobbe's location on the insalubrious margins of the city was perfectly aligned with Observant settlement practices, and the complex was slowly augmented by the friars with a church and convent. The preacher and reformer Bernardino da Siena may have stayed at this humble community during his last visit to Venice in 1443. After his death, San Giobbe was further expanded through the largesse of future doge Cristoforo Moro.

A third establishment predates both the great complex of the Frari and San Giobbe: the church and convent on the island known today as San Francesco del Deserto. According to popular tradition, the saint rested here on his way back from the Holy Land in 1220. By the early thirteenth century, the island was privately owned by a Venetian merchant, Iacopo Michiel, who presented it to the Friars Minor shortly before his death in 1233. The Franciscans lived here in community until the 1430s, when an infestation of malaria forced abandonment of the island.[17] Some friars moved to a convent on the northern edge of Venice, where they had been settled since the mid-thirteenth century. Previously known as San Marco della Vigna, it now took the name of San Francesco della Vigna.[18] Both of these Franciscan sites were integral to the origins of the Republic itself: according to the local tradition known as the *praedestinatio* (predestination), the patron saint of La Serenissima, Mark the Evangelist, had visited, during his apostolate, the future locations of San Francesco del Deserto in the lagoon and San Francesco della Vigna on the city's outskirts, where he experienced a prophetic vision that Venice would be his final resting place.[19]

During the fifteenth century, the ascendant Observants, attracted by the opportunities for solitude and eremitical quiet afforded by the now-abandoned island

of San Francesco del Deserto, began to push to return to this remote place. In 1453, Doge Francesco Foscari approved the collection of monies on behalf of the reclamation and restoration project; and in 1460, the Senate of Venice authorized the passing of the juridical ownership of the complex to the papacy in the person of Pius II on behalf of the Observants. In 1466, the name of the church was officially changed to San Francesco delle Stimmate.[20] Although comprising a large, institutional structure of convent and church, the setting itself preserved a sense of the solitude cherished by the earliest Observant friars.

The Prime Literary Source of Inspiration for Bellini's Painting

Recent commentators have associated Bellini's painting with the Franciscan Observant convent on San Francesco del Deserto primarily for two reasons: the listing of the work under the title *San Francesco nel Deserto* by the connoisseur Marcantonio Michiel (see fig. 21) and the emphasis upon the eremitical both within the composition and in the Franciscan Observant Reform movement as a whole.[21] These correlations, however, may be somewhat misguided. Is the subject of the desert in Bellini's picture dependent upon a supposed intended location of the work (i.e., the island of San Francesco del Deserto), or was Michiel's titling guided instead by broader thematic considerations? I would suggest the latter; and here I follow the approach laid out by John Fleming in describing the painting's extraordinarily sophisticated exegetical program. This approach does not, however, completely obviate a possible association between the painting and the Observant island convent.

Fleming argues that the painting does not portray the stigmatization of Francis or even a "stigmatization by light," to use Millard Meiss's elegant phrase. His assessment is based on what he believes to be the work's purpose or subject matter and his conviction that the composition was not directly inspired by any single literary source.[22]

I agree with Fleming that Bellini's painting represents a profound statement about and visual testimony to the role and meaning of St. Francis in history. Drawing upon a standard theme in Franciscan writing—from the prologue of the *Legenda Maior* (*Major Legend*) of Bonaventure to the sermons of Bernardino da Siena on the stigmata and beyond—Francis, standing as it were between Moses and Elijah on the mountain of Transfiguration, is the Angel of the Sixth Seal, bearing "the seal of the living God," whose coming heralds the last stage of human history (Revelation 7:2–3).[23] In short, this is a painting *about* Francis rather than *of* Francis. Indeed, Fleming explicates in vivid detail how Bellini's symbols testify to the saint's unique eschatological role. The motifs of mountain and desert recall Moses and the burning bush, as well as the

Transfiguration in which, as *alter Christus*, bearing the marks of the stigmata, Francis stands, in full conformity to Christ, eschatologically in his place, foreshadowing his second and definitive coming.[24] Francis is—and does not his posture convey this?—a kind of living Tau: a cruciform figure evoked by the *chartula* parchment to which Bellini may have alluded by the object folded over the cord at the saint's waist.[25]

Such parallels scarcely summarize the depth and breadth of the typologies explicated by Fleming. Nonetheless, he has not entirely accounted for one thing in particular: what is Francis actually doing in the painting? The Poor Man of Assisi is pictured in a desert locale, up on a mountain and removed from the city, not only to evoke Moses and the Transfiguration but also because he is praying. Francis is in rapture—ecstasy—caught up in a form of prayer that conveys to the viewer his unique relationship and cruciform conformity to the God-Man of human history. In other words, his eschatological role is conveyed and displayed through the visualization of his unique spiritual conformity to Christ through rapturous union, as well as through the sharing of the marks of Jesus' Passion. Both ideas are integral and inseparable in Bellini's conception.

While I am essentially in agreement with Fleming's conclusions regarding the overall meaning of the work, I differ with his contention that the painting is not based on any specific literary account of Francis, be it the commissioned *legendae* of Thomas of Celano or Bonaventure of Bagnoregio or the texts of the companions of Francis and their later followers. Fleming's eschewing of a literary foundation is based upon his assessment that the tableau is not a depiction of the stigmatization of the Poor Man of Assisi. And here he is partly right. The painting is not, per se, a representation of any literary account of the stigmatization of Francis. Bellini is not attempting to capture and depict a single event but rather a combination of events and ideas that convey the meaning of Francis for history. Fleming does argue, however, for a strong influence of Bonaventurian imagery and parallelisms that have been drawn from his *Legenda Maior*, *Legenda Minor*, and even from the *Itinerarium Mentis in Deum (Journey of the Mind into God)*, the last of which purports to be the journey of a poor Christian *viator* or wayfarer going out into the desert.[26]

I contend that there *is* a literary basis or foundation for many key elements of the painting: a kind of structural framework supporting the multiple layers of symbolic imagery that create the dazzling visual impact on those who gaze upon this exceptional work of art.

Franciscan Literary Sources

In the wake of Paul Sabatier's work on early Franciscan literature, scholars have generally categorized the medieval texts concerning the life and meaning of Francis of Assisi as either official sources—those commissioned by the papacy or the Order itself—or non-official sources—anecdotal stories that arose out of the tradition of the companions of Francis.[27] Celano and Bonaventure, for example, would belong to the first category; collections such as the *Legenda Trium Sociorum* (*Legend of the Three Companions*) of 1246, the *Compilatio Assisiensis* (*Assisi Compilation*) of 1310–12, the *Speculum Perfectionis* (*Mirror of Perfection*) of 1318, and the *Fioretti* (*Little Flowers*) (1370s) would be in the second. A tension has been posited between these two types of sources since they tend to represent contrasting visions of Franciscan life: the first, more institutional and clerical in orientation; the second, more eremitical and zealous in the observance of material poverty.

This dichotomy, we now know, is overly schematic and can be misleading. For example, with respect to our subject, the addendum to the *Fioretti* known as the *Considerazioni sulle Stimmate di San Francesco* (*Considerations on the Holy Stigmata*)—both products of the Spirituals' tradition in the hermitages of the Marches of Ancona and thus non-official sources—shows familiarity with Bonaventure's *Legenda Maior* and relies closely upon its theologized portrait of Francis. This is to be expected, for Bonaventure's work was the only official biography sanctioned within the Order since the declaration of the General Chapter in 1266.[28] Furthermore, there is a direct thematic connection between Bonaventure's portrayal of Francis as *alter Christus* and his attributing to Francis an eschatological role in history with similar assertions made by the Spiritual Franciscan Ubertino da Casale in Book V of his *Arbor Vitae Crucifixae Jesu* (*The Tree of the Crucified Life of Christ*). This kind of exaggerated theological paralleling between Christ and Francis would culminate in Bartholomew of Pisa's massive *Liber de Conformitate Vitae Sancti Francisci ad Vitam Domini Iesu* (*Book of the Conformity of the Life of Blessed Francis to the Life of the Lord Jesus*) of 1385–99.[29] All these sources would have been known and used by the Italian Observants of the second generation and disseminated within other Franciscan circles.

These literary relationships are crucial to understanding Bellini's work. Despite Fleming's claim that the painting is not a pictorialized version of any one of the stories in the sources, there is compelling reason to believe that commissioner, artist, and potential theological advisors were all drawing from an urtext: the *Considerazioni sulle Stimmate di San Francesco*.[30] Probably written between 1375 and 1380, this vernacular Italian source was intended to supply a full version of events leading up to, during, and

after Francis's reception of the stigmata. Given the significant expansion of incidents and commentary added to the skeleton provided by Bonaventure in the thirteenth chapter of his *Legenda Maior*, one is inclined to be wary of the historical veracity of these accounts. However, our concern here is not with historicity but rather with the spiritual imagery depicted in paint and meant for the imagination.[31]

Le Considerazioni sulle Stimmate di San Francesco

The work is divided into five *Considerazioni*, one for each of the stigmata.[32] The stigmatization occurs in the third; the final two chapters deal with the immediate aftermath and posthumous miracles occasioned by Francis's stigmata. My concern is primarily with the first two *Considerazioni*. Although the narrative combines incidents that may have occurred over a span of some fourteen years (1210–24), here they are recounted as if they are part of a seamless journey toward, up, and then down the mountain of La Verna.

The first *Considerazione* begins with an account of a journey made by Francis and Leo to the Romagna, where, in Montefeltro, they encounter Count Orlando of Chiusi, who, after receiving spiritual counsel from Francis, offers him and his friars a secluded and unspoiled place for prayer on a mountain in Tuscany called La Verna.[33] Francis promises to send him a few friars to assess its appropriateness. Upon his return to the Portiuncula, he sends two friars who ascend the mountain and, judging the place acceptable, build a poor little hut of branches to serve as a locus for the friars. After their return to Francis, the Poverello announces that a Lent of St. Michael of forty days (15 August–29 September) is fast approaching; after a moment of prayer, he sets out, with three companions, for La Verna. On the first night, they lodge with some friars along the way; on the second, they are forced to sleep in a forest, finding shelter in an abandoned church. Here, during his prayer, Francis is assailed by demons, but he prays to be able to accept all the pain and adversity that the Lord wishes to send his way. Once the demons flee, he goes further into the forest to pray and is seen by his companions caught up in the air in rapture. This is the first experience of rapture presented in the account.

As they set out in the morning, the friars come upon a peasant whose donkey they ask to borrow so that Francis, ill and weakened, might be able to ascend the mountain. Instead, the peasant saddles up his ass and leads the mounted Francis on the arduous climb. Halfway up the mountain, the peasant becomes parched with thirst, whereby Francis, after a moment of prayer, directs him to a rock where he finds flowing water to slake his thirst. They resume the journey, and near the summit they come upon an oak tree where Francis asks to rest. A massing of chirping birds con-

firms for Francis that they have made the right decision to come to La Verna. They then proceed to the locus already set up for them by the previous friar scouts. This concludes the first *Considerazione*. Already presented in the narrative are important symbols that will find expression in the painting: the rugged mountain removed from the city; the peasant; a donkey; water flowing from dry rock; the presence of birds; and the use of branches for the locus of the friars.

The second *Considerazione* opens with a joyous visit by Count Orlando to the friars' place on La Verna. As he leaves, he offers the friars whatever they might need for their future welfare. Privately, while commending the count's generosity, Francis discourses on the *commercium* that the friars have made with the world whereby God will provide for them as long as they remain faithful to poverty.[34] With the help of Leo (now serving as his companion), Francis places himself at some distance from the cells of the other friars. A few days later, he takes note of the peculiar shape of the rocks of the mountain, believing their formation to have been made at the moment of Christ's Passion: a Passion soon to be renewed on this same mountain in the gift of the stigmata. During another moment of rapture—the second such experience in the account—Leo sees the Poor Man of Assisi raised up again from the ground. Leo is then seized by some kind of personal crisis and comes to Francis, who, to console him, writes a blessing for him on a small piece of parchment—the famous *chartula*—and the crisis abates.[35] Leo will merit seeing him a third time in rapturous prayer, surrounded by radiance and a golden scroll above his head stating, "here is the grace of God."[36] A few days later, Francis himself will experience a crisis about the future of his Order, during which God offers him, in his prayer, profound assurances and consolations.

At this point in the narrative, we have arrived at the Feast of the Assumption (15 August): the beginning of the Lent of St. Michael. With Leo's help, the two friars search out an even more remote place for Francis's prayer: a cleft in the rock on the south side of the mountain, separated by a deep chasm bridged by them with a fallen log. Leo positions himself at a certain distance, with protocols established for contact. As Francis enters more deeply into prayer, he asks that he might experience divine illumination. One day, while praying outside his cell, he is again assailed by demons; to escape their fury he literally melts into the rocks and the rocks receive his shape. After the consolation of birds and a falcon, he experiences yet another rapture—we might call this the Great Rapture—depicted as a great light above him, during which time an angel is said to be playing a heart-rending melody in this moment of ecstasy.[37]

Thus ends the second *Considerazione*. To recap the symbols: the *chartula* given to Leo (which is possibly the object draped over Francis's cord in the painting); the shape

of the rocks and their melting like wax; the description of the moments of prayer as radiance, illumination, and especially a great light; the southern exposure of Francis's cell; and the location of Leo vis-à-vis Francis (below him and across a chasm). Indeed, the whole narrative is suffused with moments of prayer, great and small. The third *Considerazione* then gives a very brief description of the stigmatization itself.[38]

I believe that the first two *Considerazioni* serve as the framework upon which Bellini (and possibly one or more artistic advisors steeped in the theological symbolism earlier employed by Bonaventure) layers rich Mosaic and Christological parallels. However, to fully understand the engagement of artist, patron, and potential advisors with this text, the *Considerazioni* must be seen within the broader development and transmission of Franciscan literature in the later Middle Ages.

The *Considerazioni* and the Growth of Franciscan Vernacular Literature

The monumental work of Bartholomew of Pisa, the *Liber de Conformitate Vitae Sancti Francisci ad Vitam Domini Iesu* (1385–99),[39] is usually looked upon as the final and most elaborate work in Latin on the life and meaning of Francis of Assisi. The same period witnessed the emergence of a different genre of Franciscan texts in the Italian vernacular. Rather than simple translations of the Latin sources, these were creative amalgamations that introduced a few previously unheard of episodes in the life of Francis. For example, the *Fioretti* of the 1370s is not just an Italian translation of the *Actus Beati Francisci et Sociorum Eius*, written around 1337 by Ugolino of Montegiorgio; it represents both a careful selection and sometimes a considerable expansion of these inherited stories. And the appended *Considerazioni sulle Stimmate* is also a uniquely Italian addition to this corpus.

One phenomenon associated with this frenetic work of translation, embellishment, and expansion of sources is the transformation of the official biography of the Order: the *Legenda Maior*, commissioned from the Minister General at the General Chapter of Narbonne in 1260 and accepted by the General Chapter of Pisa in 1263. Bonaventure's work comes to be translated into a text known as the *Vita di Messer Santo Francesco*, a process begun in the last decades of the fourteenth century, roughly contemporaneous with the *Fioretti* and *Considerazioni*.[40] However, something interesting happens as all these texts are copied and begin traveling together as collections. By the late 1420s, a strange amalgamation starts to take place: the creation of a hybrid text of sorts. This new text usually contained the first twelve chapters of the vulgarization of the *Legenda Maior* (being the officially sanctioned biography of the

saint). At chapter 13, however—the start of Bonaventure's chapter on the stigmatization—the prologue of the *Fioretti* asserting the eschatological import of Francis is now inserted, followed by the long account of the five *Considerazioni sulle Stimmate*.[41] The content of the rest of the work may vary from manuscript to manuscript, but the dramatic alteration has been made: replacing Bonaventure's briefer, theologized account with the more expansive narrative of the *Considerazioni*, filled with new characters and various symbols.

The emergence of this hybrid text—Bonaventure's *Legenda Maior* combined with the *Considerazioni* version of the stigmatization account—is representative of a broader surge in the transmission of source materials. Beginning in the late 1420s in central Italy—the period in which the Observant Reform movement was coming into its own—we witness the beginning of a new and exciting phase of Franciscan literature sparked not only by the copying of Latin sources but also by the creation of vernacular translations of traditional source materials, sometimes even with the addition of new elements. This creative literary activity was initially associated with the reform of several Clarian monasteries in central Italy that, fired by the ideals of the Observant movement among the men, were calling for a return to a stricter observance of their Rule especially in matters of poverty and to reform their monasteries on the basis of the retrieval of the Rule of St. Clare.[42] Over the next several decades, manuscripts containing, most essentially, the *Fioretti*, the *Considerazioni*, and this hybrid version of the *Legenda Maior* in Italian were being copied and disseminated from central Italy into northern Italy, especially among the lay Franciscan confraternities of these regions who were eager to have a more direct access to the story of Francis and the early friars. Such vernacular texts provided to members of the Third Order of Franciscans (comprising by this time both lay confraternities *and* religious communities: the Third Order Secular and Third Order Regular) the formative materials for their image of Francis and the content of their Franciscan ideals.[43]

Especially fascinating in this regard is a manuscript currently housed in the Biblioteca Riccardiana in Florence (ms. 1295) that contains, among other items, the three key elements noted above: the vulgarized version of the *Legenda Maior* (the *Vita di Messer Santo Francesco*), the *Fioretti*, and the *Considerazioni*.[44] An inscription dated 5 April 1518 in Venice notes that the work is in the possession of a certain Zuan (or Giovanni) Piero Michiel. The surname Michiel was common in Venice, and the individual identified here is not Zuan Giacomo Michiel, who owned and probably commissioned *St. Francis in the Desert*.[45] Nonetheless, it is possible that Giovanni *Piero* Michiel, custodian of the Franciscan manuscript, was a relative or associate of Zuan Giacomo, who died

in 1513. Could the patron of *St. Francis* at one time have possessed or viewed this work, the handwriting of which has been dated to the late fifteenth or early sixteenth century?[46] At the very least, the manuscript's survival indicates that such amalgamated texts were in active circulation in northern Italy during the era of Bellini's masterpiece. In turn, the painting's multiplicity of reference, creative recombination and interpretation of canonical sources, and Observant tenor are highly consistent with the character of these hybrid vernacular works.

Given these connections, the additional possibility arises that Zuan Giacomo Michiel or a member of his circle belonged to the Third Order Secular within whose ambit many vulgarized Franciscan texts were being generated, read, and shared. Michiel was evidently more closely affiliated with the Dominicans of Venice than with the Franciscans and was buried at the Dominican church of SS. Giovanni e Paolo. However, the early donor of the island of San Francesco del Deserto, Iacopo Michiel (d. 1233), was a member of a Franciscan penitential confraternity. We also know that a Secular Franciscan confraternity of relatively recent vintage had been started in Venice (possibly associated with the Observants).[47] Moreover, two famous Franciscan preachers of the Observant tradition—Bernardino da Feltre ("Piccolomino") and Marco da Bologna—were an energizing presence in the city, drawing their listeners to the story of Francis and his eschatological significance. And finally, the works of Joachim of Fiore (both genuine and spurious) were soon to be printed for the first time, in the city of Venice, in the early sixteenth century.[48] Bellini's patron, Zuan Giacomo Michiel, might have been inspired by the vulgarized version of Bonaventure's *Legenda Maior*—with its creative insertion of eschatological motifs and the expansive account of events on the deserted mountain of La Verna in the *Considerazioni sulle Stimmate*—in formulating, with the spiritual assistance and theological acumen of some Venetian friars, the sophisticated exegesis and pictorial symbolism of a Francis in ecstatic communion with God. This would make it more likely that Bellini's wondrous painting was a product of the lay Franciscan environment in urban Venice rather than, strictly speaking, of the Observant Franciscans on the somewhat removed island of San Francesco del Deserto.[49]

St. Francis in the Desert, detail

APPENDIX A: THE TECHNICAL EXAMINATION OF
ST. FRANCIS IN THE DESERT
by Charlotte Hale

In March 2010, Giovanni Bellini's *St. Francis in the Desert* departed The Frick Collection for the first time since its acquisition in 1915 and traveled to the Sherman Fairchild Paintings Conservation Center of the Metropolitan Museum of Art for technical examination. Undertaken for the exhibition *In a New Light: Bellini's "St. Francis in the Desert"* (held at the Frick from May 22 through August 28, 2011), this study involved surface examination, X-radiography, infrared reflectography, and selective paint analysis. The main findings are presented here.

Support

The panel support is constructed of three poplar boards of tangential or sub-radial cut, with the grain oriented horizontally (fig. 111).[1] The boards are of uneven widths: the bottom board is 21.5 cm wide, the middle board 50.4 cm wide, and the top board 52.7 cm wide.[2] The top horizontal edge of the panel has been cut: whereas an unpainted gesso border is visible along the other three edges, none appears here. The cropping evidently took place after the paint had become cross-linked and brittle as there are chips in the paint all along the top edge. Between the top and middle boards are three original butterfly inserts at the sides and center of the panel; these were applied to strengthen the joint between the large top and middle boards but were apparently not considered necessary for the attachment of the narrower bottom board.[3]

The panel was originally supported by vertically oriented lateral battens or cross-pieces on the reverse.[4] These wooden battens were attached using iron nails, hammered through the front of the panel, before the gesso ground was applied. The battens were removed in a past intervention, but the nail heads are, for the most part, still in place. Some nail heads protrude from the picture surface due to the shrinkage of the wood over time (fig. 112); the original locations of nails that are no longer present can be identified by cracks, depressions, fills, and retouching. Single nails are applied along the length of the battens. In addition, there are pairs of nails at the top and bottom of each batten, placed horizontally approximately 6 cm apart. The symmetrical arrangement of these paired nails indicates that very little is missing from the top of the panel.[5]

The panel has a history of instability in response to fluctuations in relative humidity and has been reinforced with additional butterfly inserts applied from the reverse. It was thinned to approximately 1.1 cm in a prior structural treatment; the original thickness is unknown. The present mahogany cradle was attached to the panel in 1928.[6]

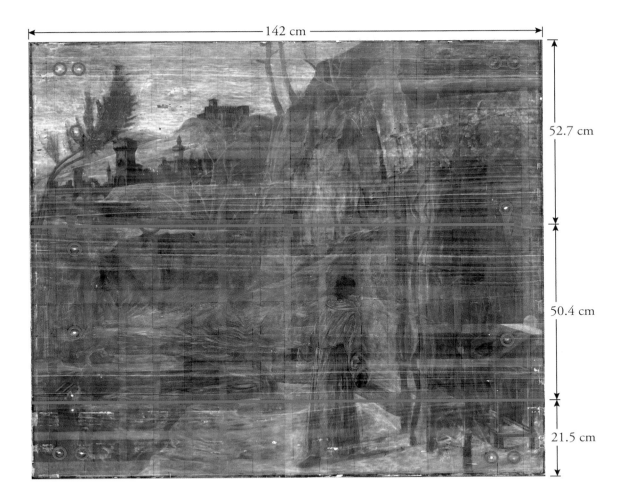

142 cm

52.7 cm

50.4 cm

21.5 cm

Fig. 111. *St. Francis*, X-radiograph overlaid with diagram of panel construction. The red circles show the locations of original nails for supportive cross-pieces.

Ground

A white gesso ground comprising gypsum and animal glue is seen on the unpainted borders at the right, left, and bottom.[7] At the right and left sides of the panel are two sets of scored lines: fine, straight lines partially visible at the perimeter of the composition (approximately 8 mm from the edge of the support) and deeper lines at the very edge of the support. The interior lines, which are, for the most part, obscured by paint, are original and would have defined the margins of the painted surface; they may also have served as guides for the attachment of a temporary frame (see below, *Barbe*). The lines at the outer edges, by contrast, may have been added during a later restoration of the panel. These lines would have been used as guides for straightening up the edges prior to the application of a cradle.[8] There are no scored lines at the bottom or top edge of the painting, which has been cut (see above, Support).

Underdrawing and Incisions

In 1548, the Venetian art theorist Paolo Pino described Bellini's diligent underdrawings as "wasted effort" (*fatica gettata*) because they were subsequently obscured by the paint layers.[9] The author's judgment aside, it is significant that more than three decades after his death Bellini maintained a reputation for careful underdrawing. The extensive underdrawing observed in *St. Francis* is consistent with other works by the artist of the 1470s that have been examined, notably the Berlin *Resurrection* (see

Fig. 112. *St. Francis*, photomicrograph (3.5x magnification) of protruding nail head (one of the nails used to attach the cross-pieces to the reverse of the panel), upper left corner

fig. 96) and the Naples *Transfiguration* (see figs. 97, 98).[10] In the Frick painting, Bellini used the underdrawing to define contours—even of small details—and to establish the fall of light.[11] The degree and handling of underdrawing vary considerably according to different areas of the composition: figure, townscape, rocks, cell. In each, he recorded as much or as little as he needed, anticipating the layers of color that would follow. There is no evidence of a transfer technique; the preparatory underdrawing was executed directly on the gesso prior to the application of the priming, using very fluid, carbon-based paint and a fine brush.[12] A thorough underdrawing was a prerequisite for reserve technique (see below), but Bellini's care in planning his composition did not preclude making changes as he worked. The contours of some compositional features (including several trees) were added during painting. These revisions were carefully considered and executed, with further underdrawing applied on top of the initial paint layers. Similarly, a number of much thicker strokes of bodied, black underdrawing were added during painting to correct or clarify contours in and around the figure of Francis. The artist also used incisions to define elements of the rustic cell, one building of the townscape, the saint's forelock, and three of the foreground shadows.

Underdrawing in the Townscape
The architecture of the town was underdrawn thoroughly and precisely, down to the smallest detail (see figs. 71, 72). In the hilltop *castello*, three, fine, hand-drawn horizontal

lines were incised in the wall below the arches; these appear to be the only incised lines in the architecture.[13]

The most striking feature of the underdrawing in this area is Bellini's original design of the bridge: a post-and-lintel structure with a span that reached to the near side of the right bank (see fig. 73). The bridge was redrawn and subsequently painted as a partially ruined, arched structure, just beyond the initial position, disappearing behind the right bank. The bridge and its surroundings constituted one of many passages in which technical examination brought features to light but also raised new questions; the paint here is worn, and this makes it hard to fully understand the relationship between the water and the architecture. Why, for example, does the bluish paint of the bridge end unevenly at the tops of the arches, following the contour of the underside of the initial, underdrawn post-and-lintel structure? And what is the significance of the greenish-blue paint seen through the two arches on the right? The underdrawing does clarify that the water continued behind the right section of the final painted bridge; a horizontal drawn line on the far arched bridge that intersects the piles shows where they met the water. In the painting, the bottom halves of the piles should read as reflections, but this effect is barely evident due to wear.

Several additional changes made during painting rhyme with the transformation of the original post-and-lintel bridge into the arched and decrepit bridge. The portal at the right of the laurel tree was underdrawn with square towers; Bellini replaced these in paint with spires in a state of partial ruin. He also added the dilapidated structures to the left of the tree over the already painted field.

Numerous minor changes between the drawn and painted image of the town underscore the artist's care and attention to detail at all stages of execution. In general, his editorial process during painting was one of simplification: removing distracting detail and streamlining the composition. For example, in the tower above the left end of the bridge, three arched windows, a balcony, and a chimney were underdrawn but not painted; and below the roof, a small arched window was underdrawn, but a large rectangular window was painted in its place.[14]

Underdrawing in the Landscape

In contrast to the precise and controlled underdrawing of the townscape, the rock formations were underdrawn in a rather free and cursory manner, indicating contours that were not always strictly adhered to during painting but served more as suggestions. The fall of light was indicated variably. On the rocky escarpment behind the saint, single drawn lines describe intersections of facets where one side is in shade,

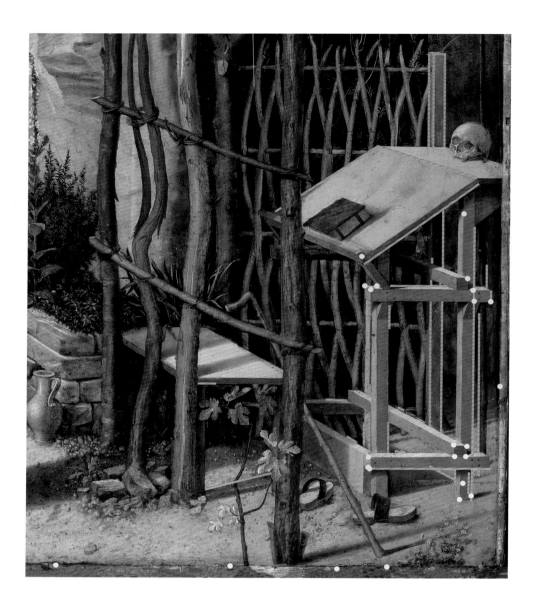

Fig. 113. *St. Francis*, detail of study
with incised lines and stylus
points highlighted

the other in light; in some cases—such as the passage above the ivy—the underdrawn
line divides a very subtle shift in tones. The shadows of two of the facets are indicated
with fine hatching. Shadowed passages in the foreground—including the rocks around
the water spout—have more extensive, broadly hatched underdrawing.

The trunks and larger branches of the trees were drawn with continuous
contour lines. However, while the tall laurel at the far left and the trees on the top of
the escarpment at upper right were planned from the beginning, the other trees were
added *over* the existing landscape: first drawn and then painted. In the tall laurel tree,
no underdrawing can be imaged beneath the dense paint of the foliage (see below,
Adjustments and Pentimenti).[15]

Underdrawing and Incisions in the Cell
The right foreground is intricate and complex in design and meaning, and it is not
surprising to discover detailed underdrawing beneath the trellis, vine, willow fence,
lectern, and bench. Despite the careful preparation, this section of the painting shows

numerous adjustments and changes at all stages of creation. The artist's deviations from the initial design allow the clearest reading of the underdrawing, for example where a section of the vine was drawn slightly to the left of where it was eventually painted. Though the detailed description of the construction and joinery of wooden structures is a recurrent feature of Bellini's compositions, the rendering of the perspective of the bench, lectern, and book evidently presented challenges (see fig. 88). The front edge of the lectern and the pages of the book were originally drawn and painted with perspectively incorrect perpendicular lines that were later adjusted; similarly, Bellini refined the position and angle of the bench as he painted. He also shifted the initial position of the far right leg of the lectern and the two long cross-bars slightly toward the left, a revision that may have been prompted by a more significant change on the far right side of the composition: the addition of the flat shelf on the back of the lectern, the cross, and the skull (see below, Adjustments and Pentimenti).

In and around the bench, lectern, and willow fence are a number of incised lines made using a straightedge (fig. 113). The use of incisions—normally used to define structural features—to indicate the shadows cast by the leg of the bench and the seat of the bench (under the lectern) is especially interesting (see fig. 67).[16] Some of the lines in this area were incised at the design stage, and others were incised during painting, either to make adjustments or to reinstate contours that had been obscured by underpaint. There does not appear to have been a consistent or systematic approach to what was incised initially. In addition to the incised lines, there are a number of stylus points in the lectern; most of these occur at the intersection of planes.[17] Like the incisions, some of the stylus points were part of the initial design process, and others were made during the adjustments at the right side. There are also a number of stylus points at the right and bottom edges that border this area; they were probably used as guides of some kind, but their precise function remains unclear.

Underdrawing and Incisions in the Figure of the Saint
The underdrawing in the figure of Francis is more extensive, fine, and controlled than that seen in the rest of the painting (see fig. 48). Most remarkable is the drawing of the head, at once searching, sensitive, and assertive: this feature clearly held special significance for the artist (see fig. 43). The saint's physiognomy and expression and the play of light were all indicated at this stage. The drawing of the head ranges from extremely fine testing lines around the cranium to the heavy black stroke that describes the inside of the bottom lip. The line of the tonsure is lightly drawn, and the front of the forelock is indicated emphatically with three short incisions rather than

drawn lines. The contour of the face, wrinkles, folds, and tendons are described with bold lines while the form is modeled with delicate hatched lines: curved hatching on the forehead and cheek, fine vertical hatching below the eye, and distinctive horizontal and diagonal hatching applied in very straight lines that intersect on the chin.[18]

In the rest of the figure, the underdrawing compares closely with that seen in the figures of the Berlin *Resurrection* and Naples *Transfiguration*: linear contours, close parallel hatching for shadows, and pooling of paint at the ends of strokes due to the fluidity of the medium.[19] In *St. Francis*, much attention was paid to the preparatory drawing of the hands and the foot, key features of the composition. In the hands, each joint was indicated, and areas of shadow were laid in with very fine hatching (see fig. 54). The contours of the thumbs were redrawn larger over the paint of the background using bodied black paint, creating thicker, heavier lines than those of the initial underdrawing. During painting, further lines of strong, secondary underdrawing were made to clarify important contours around the wrist of the right sleeve, at the bottom of the tunic, the bottom of the foot, and, most emphatically, the shadow below the foot. The latter stroke reinforces fine, freehand incisions indicating the saint's shadow.

The object tucked into the saint's belt has never been definitively identified (see Appendix B). The significance of this small detail is underscored by the fact that it was evidently planned from the beginning, as it was underdrawn and held in reserve (see below, Reserve Technique). Infrared reflectography and surface examination did not reveal any trace of an inscription though they did clarify that the two reddish marks at the bottom are varnish-filled paint losses.

Underdrawing in the Donkey
Underdrawing similar to that of the figure of the saint is seen in the donkey—an important feature of the painting that was planned and executed with great care—with a combination of fine and thick lines for contours, features, and hatched shading (see fig. 80). Both eyes were outlined; the eye in lost profile was drawn with the corner of the eye and an eyelash visible, but these were not executed in paint. Lines of underdrawing are seen in the forehead and between the proper left eye and nostril, running along the muzzle. Diagonal hatching was used to model the form of the animal's body.

Priming
Over the gesso, priming (*imprimitura*) of lead white in oil was applied.[20] This layer sealed and protected the gesso and underdrawing in preparation for painting in oil. It was applied so thinly that the underdrawing would have shown through it.[21] The lead

white heightened the brilliance of the white gesso ground beneath and also served to accelerate the drying of the priming layer. The texture of palm prints and fingerprints from smoothing of the *imprimitura* after it had been spread over the panel, a technique later described by Giorgio Vasari, is seen throughout the painting, both from the picture surface and in the X-radiograph.[22] Originally these fingerprints and handprints were completely obscured by the paint layers. The degree to which the prints are evident has increased over time, as the overlying paint has become more transparent and in some cases abraded, and the tiny depressions in the prints hold remnants of glazes and discolored coatings. The texture of handprints is most evident where the overlying paint is thinly applied, as in the mid-tones and shadows of the rock face and the dark interior of the cave. The area with the highest concentration of handprints is in and around the cave at far right, including in the rocks above, the willow fence, and the uprights for the grapevine canopy; there is also a concentration of prints in and around the shepherd (see figs. 41, 42).

Barbe

At the left, right, and bottom edges are borders of unpainted gesso (approximately 8 mm wide at the left and right and 5 mm wide at the bottom). There is a slight *barbe* (a ridge or lip) of paint along sections of the lateral edges of the panel.[23] There is no such trace of a *barbe* along the bottom edge. Typically, a *barbe* derives from a buildup of paint against an engaged frame. The presence of the *barbe* on the sides of the *St. Francis* suggests that the panel may have been held in a frame or other temporary supportive structure while it was painted.[24]

Paint Layers

Paint Medium

When the connoisseur Marcantonio Michiel described *St. Francis* in 1525, he made a point of its medium: *a oglio* (see fig. 21). That the picture appears to be painted entirely in oil was confirmed by a limited but representative number of samples taken for medium analysis.[25] The analysis demonstrates that white, blue, and pale yellow paints in the sky were painted with a type of oil with a similar fatty acid ratio (characterized as non-heat-bodied drying oil, linseed or possibly walnut).[26] Samples from a discolored copper-based green glaze and a dark brownish shadow in the rock to the right of the cave opening show heat-bodied linseed oil.[27] Though oil would have been familiar to Bellini as a medium for glazing over egg tempera, the artist may have begun using drying oils more extensively as early as the late 1450s or early 1460s. *St. Francis* was

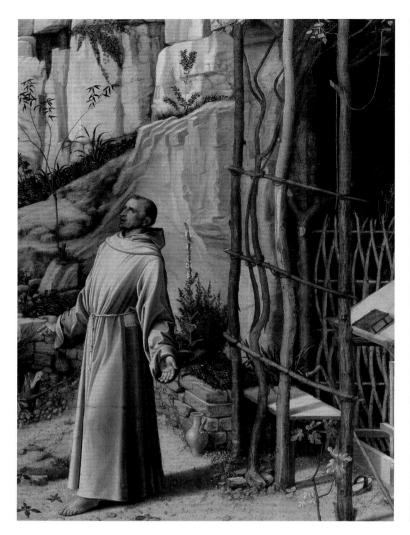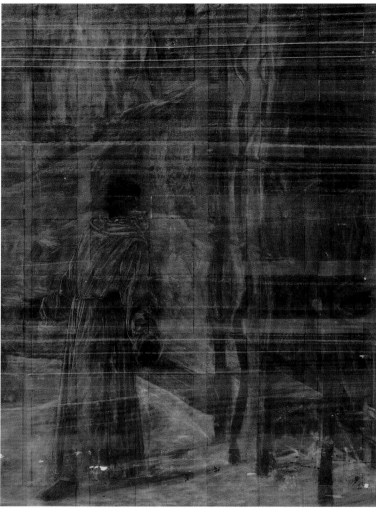

Fig. 114. *St. Francis*, foreground detail with X-radiograph, illustrating dark or X-ray transparent features "reserved" in the first stages of painting

painted shortly after the Pesaro altarpiece of c. 1472–75, which shows a complete mastery of oil.[28] Medium defects characteristic of oil paint are evident in the Frick picture but limited to localized areas, including fine drying cracks in the saint's tunic (see fig. 50), the fence and the water above the donkey's head, and the hill to the left of the *castello*.[29]

Reserve Technique

Bellini's calculated approach to laying in his composition derived from his early training in egg tempera, an exacting technique that permitted few changes and required extensive planning.[30] The detailed underdrawing played an essential role in guiding his hand as he applied the layers of color. The artist first painted the background around the main forms of the composition—including the buildings, the figure of the saint, and the donkey—which were left "in reserve" to be painted directly on the *imprimitura* once the paint of the background had set. This so-called "reserve technique" is characteristic of the painter and his contemporaries. Because the underdrawing remained in view as work progressed, the definition of each form was maintained. Crucially, reserve technique enabled the artist to paint all the forms outlined in the underdraw-

ing directly on the luminous white ground, contributing to the rich, limpid color of the finished painting.

Reserve technique causes a distinctive, frieze-like appearance in X-radiographs, where thinly painted, reserved forms often appear as dark silhouettes in contrast to light, X-ray opaque areas of sky or landscape.[31] The X-radiograph of the *St. Francis* provides a fascinating "snapshot" of the initial lay-in of paint around the structural features—which for Bellini included shadows (fig. 114). Even very small and slender forms were held in reserve, including the saint's rope belt, the donkey's ears, and the sinuous trunk and branches of the vine; so were key features such as the unidentified item tucked into Francis's belt and his book lying on the lectern.[32] Bellini's consistent use of reserve technique gives rise to one of the most distinctive features of his art, the lyricism of his negative spaces. The buoyant reciprocity between objects and the areas around them endows the composition with rhythmic grace.

Paint Application

Using oil as his medium but maintaining many of the traditional methods of tempera, Bellini married painterly resonance and depth with compositional clarity. In *St. Francis*, reserve technique, a simple layer structure (there are in general no more than two or three layers of paint), and selective use of glazing allowed him to retain the brightness and decorative character of tempera while harnessing the potential of oil to create a multitude of pictorial effects. We see him blending whisper-thin passages of paint in the sensitive rendering of the saint's face; painting broadly wet-in-wet in the rock face behind the figure; dragging dark strokes into light to create the cracks in the stump of the fig tree below Francis's right hand; scoring into the paint to emphasize the strong, straight, diagonal highlight of the hill directly beyond the town; and charging the landscape with lively brushwork, even raised impasto in the clouds. The handling combines precision with great painterliness. Brushstrokes are much in evidence and impart an energetic and tactile quality to the painting as a whole, while remaining contained within the contours of each individual form or zone—as, for example, in the rendering of the buildings (fig. 115). There are passages of striking, though never gratuitous, virtuosity, like the water spout: the pipe captured with a few long strokes of buttery paint and the running water with sparse touches of white where the light catches it twisting over the rim (see fig. 78). Surface examination and technical imaging do not indicate any division of labor; though the handling varies according to the different areas and features of the composition, there is an overall consistency that points to Bellini having painted the entire picture himself.

Fig. 115. *St. Francis*, details showing consistency in brushwork across the painting

In addition to freely working and texturing paint, the artist was able to manipulate his medium to achieve great precision on a miniature scale. Pebbles are ubiquitous features of Bellini's work, and in *St. Francis* they are made with two different techniques: the larger pebbles were painted with a brush, and the perfectly round pebbles in the foreground (which are quite raised in profile) were likely made with paint flicked from a stiff brush.[33] The depiction of tiny grasses at the top of the rocks is a characteristically understated feature that records the artist's close observation of nature while also serving to soften the edge of the form; like many other details, this element is highly decorative. Similarly, the dancing, looping tendrils of the vine are beautifully observed and rendered, with tiny gaps where the tendrils cross over themselves (see fig. 95).

The marks of the stigmata on the saint's hands are original. The paint of the wounds is aged, cracked, and intimately associated with the flesh paint below. The wounds on the hands were painted with an opaque red paint followed by a translucent red layer. This red glaze is deep purplish-red in color, and the individual particles are large and jewel-like when viewed under high magnification (see figs. 52, 53).

Microscopic examination also revealed traces of a wound on the foot (see fig. 55). The foot has suffered from abrasion and has many small paint losses.[34] Barely visible to

Fig. 116. *St. Francis*, cross-section from bottom edge (original magnification 20x) showing the yellow underlayer modulating the blue rock of the foreground. The whitish layer at the bottom is the gesso ground.

the unaided eye, tiny islands of translucent red paint can be seen under magnification in what would be the appropriate location for the stigma.[35] Above the islands of translucent red is a dilute black horizontal line; this likely indicates the placement of the wound. The examination revealed no evidence that the artist ever planned a wound in the saint's side.

Bellini's achievements as a colorist were admired even by his contemporaries.[36] Like his fellow artists and artisans, he was able to select a wide range of pigments of extremely high quality from the Venetian color merchants.[37] The following pigments— all typical of fifteenth-century Venetian painting—were identified in the *St. Francis*: lead white; yellows: lead-tin yellow type I and iron oxide; blues: ultramarine and azurite; greens: malachite, pseudomalachite, verdigris, and copper-based green glazes; reds: vermilion, red iron oxide, and an unspecified red lake; and carbon-based black.[38] Close examination reveals the ways Bellini manipulated the relatively small range of pigments available to maximum effect. His inventive use of color is particularly striking in a painting whose subject—the saint in his drab friar's habit in a rocky landscape—places limitations on the palette.

One technique employed by the artist to create powerful coloristic effects was the application of local underlayers. The lower section of the intensely blue sky was underpainted with a layer of lead white tinted with a little ultramarine that provided a brilliant pale blue base for the overlying mixture of ultramarine and lead white (see fig. 61). The bright green grass was underpainted with a layer of lead-tin yellow type I; over this the artist applied a layer of verdigris, a copper-based green pigment. More surprising, the flat, stage-like area of foreground rock was underpainted with warm yellow, comprising an iron oxide with a small amount of carbon-based black and lead white that imparts an unearthly radiance to the overlying azurite and lead white used for the rocks (fig. 116 and see fig. 69).

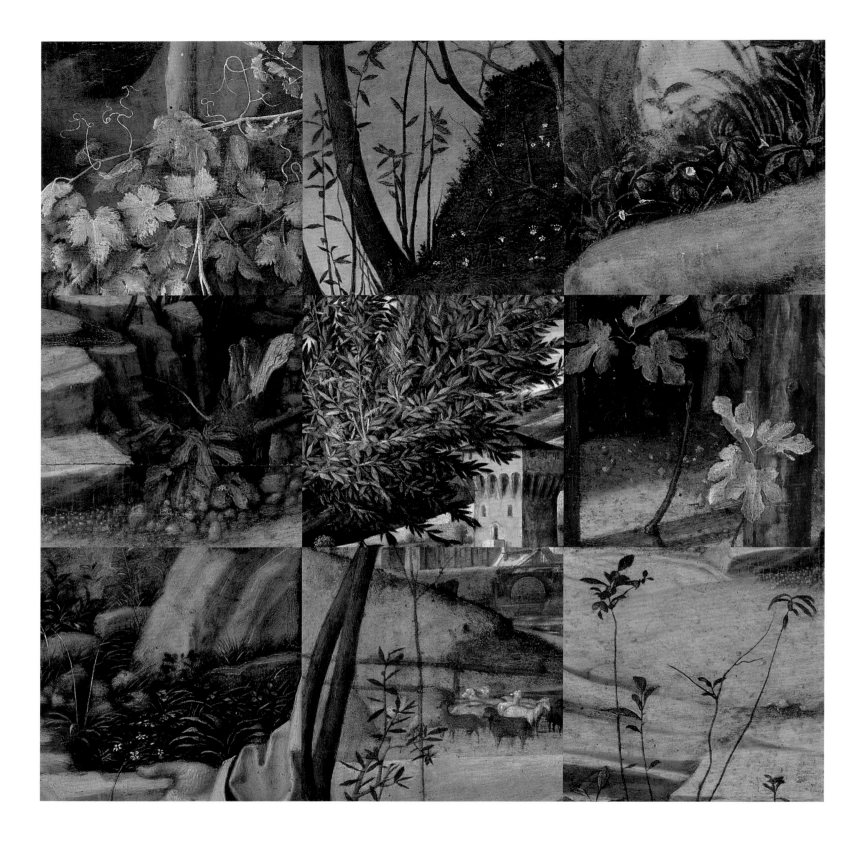

Fig. 117. *St. Francis*, details of plants, showing variegated use of green pigments

Fig. 118. *St. Francis*, photomicrograph (20x magnification) showing the speckled appearance of a red lake glaze on leaves of a plant in the foreground (see bottom right corner of previous figure)

The celadon-hued rocks are the boldest example of another technique used by Bellini to ramp up the color in his paintings: selecting brilliantly colored pigments for features that might more predictably have been painted with earth-colored pigments.[39] The shadowed rocks above the entrance to the cave were painted using an iron earth, a carbon-based black pigment, and lead white, plus azurite. Blue is used for the shadows of the flesh tones and of the buildings, as well as the contours and shadows of the pebbles.[40] The trunks of the large laurel tree and the trees at the top of the rocky outcrop are painted a rich green, not brown.

In the wide variety of flora, four green pigments were identified: the minerals malachite and pseudomalachite, verdigris (a brilliant green pigment manufactured by exposing metallic copper to organic substances such as vinegar), and a translucent green glaze containing a copper-based pigment, most likely verdigris (fig. 117). Bellini expanded the range of hues and tones by using selective underpaints and additional pigments (lead-tin yellow type I, lead white, and carbon-based black) and by modifying final glazes. The trunk of the laurel tree at far left, for example, was painted with a thick layer of malachite over a pinkish underlayer comprising lead white, vermilion, and a little copper-based green. The brightly illuminated leaves of the foliage were laid in with thick strokes of lead-tin yellow type I and then glazed with a copper-based green glaze; originally a deep green, the glaze has turned brown over time. This darkening is seen in many areas of the painting but is most evident where the underpaint is thinner or non-existent, as in the leaves at the perimeter of the tree.[41] Another alteration, on a much smaller scale, relates to an unexpected layering. Some of the green leaves in the foreground plants were found to have an unusual glaze of red lake; the effect is barely perceptible due to a drying defect of the red lake (the paint has reticulated, appearing as tiny dark brown spots), but originally this combination—

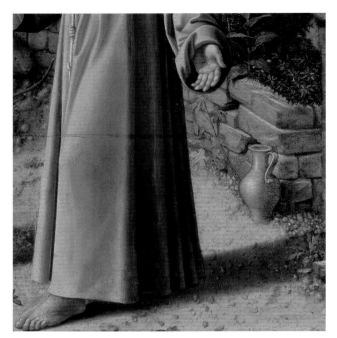

Original Height Final Height

Fig. 119. *St. Francis*, details of painting and X-radiograph showing enlargement of the masonry wall behind the saint's left arm. The original wall was shorter; its dimensions are visible in the X-radiograph as a zone of darkness (X-ray transparency) where the initial shape was underdrawn and thinly painted. The final wall includes additional lower courses of stones and wraps more tightly around the figure of the saint.

which seems to have been observed only in Venetian painting—would have produced a translucent, rich, warm green (fig. 118).[42]

Adjustments and Pentimenti

Adjustments to the figure show the artist fine-tuning his representation of the saint—in particular, the stigmatized hands and foot—in the course of painting: the right sleeve was made fuller, both thumbs were enlarged, and the foot was narrowed. In contrast, the immediately surrounding landscape shows multiple changes of plan. In his initial underdrawing, the artist indicated a series of ridges tunneled into the rock behind Francis, echoing the contours of his figure. Once painting began, the body-hugging ridges were abandoned in favor of a single, concave niche beginning at the level of the saint's chin and the top of his cowl and extending gently downward on either side (see figs. 47, 48). At a later stage, Bellini changed course yet again, painting over the niche the steep, continuous escarpment of light blue color that is visible today. Additionally, he minimized the area of ground behind Francis by nearly doubling the height of the wall and adding the pitcher (fig. 119).

The saint's cell area features a major set of changes and some smaller adjustments. Most significantly, the lectern, which originally consisted of only the inclined surface, was extended with the addition of the horizontal shelf along with the skull and cross (see fig. 88). Always attentive to the details of construction, Bellini painted a bracket to support the shelf. The pale ochre-colored paint of the added shelf is wrinkled, a defect that probably resulted from its having been applied before the underlying paint had fully set. The contour of the skull was first drawn with a fine line over the background rock and then painted slightly larger. Incised lines—which would have shown more clearly than black lines—were used to place the cross.[43] Adjustments were also made in the rendering of the front ledge of the lectern and the bench (see above, Underdrawing and Incisions in the Cell). The bell with its elegant looped rope

Fig. 120. *St. Francis*, detail of the laurel tree, and X-radiograph, showing the earlier, "reserved" form of the foliage, which was enlarged during painting

was a further addition to the cell area. Bellini "grafted" a branch onto the tree as an inconspicuous and convenient support for the bell: a device similar to the bracket supplied for the shelf.

The large laurel tree at the left edge of the painting was planned from the beginning, but the shape of the branches and foliage changed during painting (see above, Underdrawing in the Landscape). This is seen very clearly in the X-radiograph due to the reserve that comprises the densest zone and several leafy branches that extend upward from the higher branch (fig. 120). One of these—a narrow fan-shape in the X-radiograph—was not executed in paint. While it is logical that peripheral branches and leaves would be painted over the sky—so that glimpses of the sky could show through them—the final shape of the tree is much fuller than the reserved shape. The bowed-over aspect of the tree would have been more extreme in its initial iteration.

Like the large laurel, the two trees at the top of the cliff at upper right were also held in reserve, even some of the tiny branches, but the artist adjusted the position and the angle of several of the branches during painting. All the other trees were added during painting, as were the shepherd and his flock (see above, Underdrawing in the Landscape)—that is, they were not part of the initial underdrawing and were not reserved. It makes practical sense that small features and *staffage* be painted over the landscape, but in this and other works Bellini did reserve some very small forms (see above, Reserve Technique).[44] Without underdrawing or a reserve, it is impossible to say what constitutes a feature that he had in mind from the outset as opposed to one for which the idea came during painting. The heron and the rabbit were also later additions. Compelled by the same practical impulse to paint the bracket for the shelf and the branch for the bell, for the heron he painted a pale outcrop of rock for a perch,[45] and for the rabbit he created a hollow in the stone wall.[46]

Condition Notes

The painting is essentially in very good condition and reads well. The last major conservation treatment, by William Suhr, took place in 1942–43.[47] The panel has a history of infestation by wood-boring insects, a common occurrence in poplar panels, and there are numerous narrow, linear depressions in the paint surface where the paint has sunken slightly into underlying voids caused by worm channeling. Examination and treatment reports document a history of flaking in response to fluctuations in environmental conditions; there is also a large paint loss in the clouds to the right of the tree. All of these losses, retouched in the 1942 treatment, are readily evident in the X-radiograph. Along the cut top edge of the panel, the paint is chipped.

Two significant changes in the appearance of the painting should be noted: the darkening of originally green copper-based glazes, which now appear brown, and abrasion that has affected these areas in particular. The browning of the once green glaze is most pronounced where it is used as a single layer over a light underlayer, as in the leaves on the perimeters of the trees over the sky and clouds; by contrast, where the glaze is painted over a bright green underlayer (as in the body of the leaves of the laurel tree), it is much less discolored. The abrasion of these glazes affects the foliage and grasses in the foreground rocks and mid-ground field, the stones at the bottom of the vine, the shadow of the foremost upright of the canopy (which was left in reserve), and the stems and leaves of the diminutive flowers in the bottom right. Additional areas of abrasion are in the flesh of the saint, particularly the foot and the little finger of the left hand, the blue shadows of the pebbles to the right of the saint, and the dark clouds in the sky. The translucent red paint of the saint's book on the lectern is damaged. Fragments of intact paint indicate that the entire cover of the book was originally deep red. At the center of the book are fragments of yellow and other pigments in a mixture, which evidently constituted a decorative element of the cover but are now largely lost due to abrasion.

The paint has increased in transparency over time. This effect is especially evident in the most thinly painted passages, including the saint's face and hands and the paint of the river, which has both darkened and become more transparent so that it no longer reads very well as water.

Protocols for Analysis

For pigment analysis, Raman spectra were recorded with a Renishaw Raman System 1000, configured with a Leica DM LM microscope, and equipped with 785 nm and 514 nm lasers. The laser beam was focused on different areas of the sample scrapings or in

layers of sample cross-sections using a 50x objective lens, allowing spatial resolution in the order of 3 microns. Integration times were set between 10 and 120 seconds. In order to avoid changes of the sample materials, neutral density filters were used to set the laser power at the sample to values between 0.2 and 4.0 mW. The Raman analyses were conducted by Silvia A. Centeno, Research Scientist, Department of Scientific Research, the Metropolitan Museum of Art. Elemental analysis was undertaken by Mark T. Wypyski, Research Scientist, using energy dispersive X-ray spectrometry in the scanning electron microscope (SEM-EDS), using an Oxford Instruments INCA Energy 300 Microanalysis system attached to a LEO 1455 variable pressure SEM. Sample scrapings as well as embedded and cross-sectioned samples were given a conductive carbon coating and examined under high-vacuum conditions at an accelerating voltage of 20.0 kV.

Characterization of the binding media was performed by Fourier transform infrared spectroscopy (FTIR), gas chromatography/mass spectrometry (GC/MS), and pyrolysis-GC/MS (Py-GC/MS) at the Metropolitan Museum of Art by Julie Arslanoglu, Associate Research Scientist, Department of Scientific Research. Paint scrapings were crushed in a micro-compression diamond cell (Spectra-Tech) and analyzed by FTIR in transmission mode using a Hyperion microscope (15x IR objective) interfaced to a Bruker Vertex 70 spectrometer equipped with an MCT (mercury cadmium telluride) detector. Interpretation of the FTIR spectra was based on comparison with in-house and IRUG reference libraries (IRUG Spectral Database, Edition 2000) and with data reported in the literature.

Quantitative analysis of paint scrapings for protein and oil was performed by GC/MS using protocols adapted from the literature.[48] Samples were weighed on a Mettler Toledo UMX2 Ultra Microbalance. Analysis was performed on a Hewlett Packard 6890N gas chromatograph coupled to a 5973N single quadruple mass selective detector. Data analysis was performed on an Agilent MSD ChemStation D.02.00.275 and with the NIST 2005 spectral libraries. Identification was achieved by comparison to a protein database. Semi-quantitative analysis for oils, waxes, and resins was performed by Py-GC/MS without and with the derivatizing agent tetramethyl ammonium hydroxide (TMAH-Py-GC/MS).[49] All samples were weighed before analysis as above. The GC was equipped with a Frontier PY-2020iD Double-Shot vertical furnace pyrolyzer fitted with an AS-1020E Auto-Shot autosampler. Data analysis was performed as above. Saturated and unsaturated fatty acid ratios, as well as glycerol estimation, were used to characterize the oils in the binding media. These values were compared against values reported in the literature, as well as dried reference oils.

APPENDIX B:
DETAIL AT THE WAIST OF THE SAINT'S HABIT

by Susannah Rutherglen

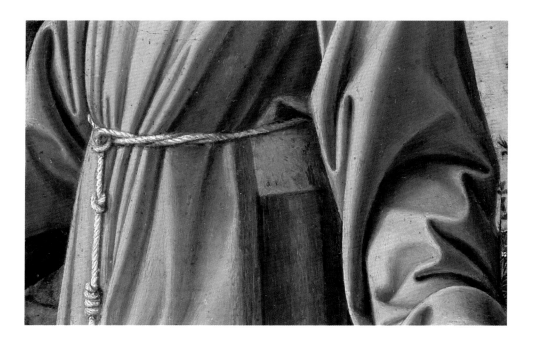

Fig. 121. *St. Francis*, detail of object at the saint's waist

Fig. 122. Niccolò Colantonio (c. 1420–c. 1470), *Brother Masseo* (pilaster detail of the San Lorenzo Maggiore altarpiece), c. 1444–50. Tempera on panel, 42.5 × 10.6 cm. Heirs of Count Vittorio Cini, Venice

Among the most puzzling elements of *St. Francis* is the rectangle of pale material positioned along the proper left side of the figure, near the elbow (fig. 121), a detail that has often been analyzed without attention to historical context. It has been identified as a fabric patch, a letter, a transcription of the saint's *Canticle of the Creatures*, and the *chartula*: a piece of parchment on which Francis wrote a prayer, blessing, and the sign of the Tau and which he then gave to his companion on Mount La Verna, Brother Leo.[1] A definitive interpretation requires careful analysis of the artist's works, related images of Franciscan friars and saints, and trends in mendicant theology, observance, and dress. This overview of artistic and technical evidence is intended to suggest avenues for future investigation.

The technical examination showed that Bellini planned the object carefully in the underdrawing and left it in reserve on the panel preparation.[2] The item displays no evidence of writing or other inscriptions. Two areas of paint loss near the bottom of the rectangle have filled with varnish and appear red, a later effect not intended by the artist.[3]

Bellini was educated in the art of letters and depicted papers, books, signatures, and carved inscriptions in his paintings. His Latin and Hebrew scripts are often legible and accurate.[4] The painter signed many of his works on illusionistic slips of paper that

·B°· MAFFEVS·

not only are eminently readable today but also conform to standards of elegant fifteenth-century humanist script.[5] When the artist wished to represent a particular text, such as lines derived from Propertius or the opening pages of the book of Ecclesiasticus, he rendered the words clearly.[6] Conversely, in his early *St. Jerome*, he left the pages of the saint's book blank and its title open to question (see fig. 40).[7] Bellini might have planned for the object at Francis's waist to be a specific document, such as a poem, letter, or the *chartula*, but if so, the lack of recognizable writing on its surface would be uncharacteristic of his artistic practice.[8] The technical analysis did not permit identification of the object with any one inscribed text or image, though it is possible that the item is a generic piece of paper or parchment alluding more broadly to Francis's reputation as a draftsman and poet.

The alternative identification of the article as a fabric patch is attractive because the Franciscan Rule required the friars to patch rather than replace their simple habits,[9] and many later Italian and Spanish paintings depict the saint's tunic with extensive patching. However, the rectangle of material in the Frick picture does not follow the shadowed folds of the darker fabric beneath. The item is not sewn to the tunic but rather tucked into and overlapping the saint's rope belt.

An as yet unexplored possibility is that the object reflects Bellini's close study of the practical design of contemporary Franciscan habits. Recent scholarship indicates that the artist looked carefully at the croziers carried by his bishop saints[10] and, likewise, historical overview of religious dress suggests that the painter observed the costume of St. Francis from life. The habit is anthropologically correct and conforms to the style worn by the Observant branch of the Franciscan friars, with a reduced form of the cowl, simple tailoring, and sandals (see fig. 19).[11] The habits of the mendicant orders did not have pockets, and friars often hung objects of everyday use from their belts, for example rosary beads, pouches, knives, keys, spectacles, or handkerchiefs.[12] The Observant Franciscan preacher and saint Bernardino da Siena was often portrayed with his spectacles case hanging from his belt.[13] In Bellini's early *St. Jerome* (see fig. 40), a spectacles case dangles from the saint's waist; a similar detail appears in Jacopo Bellini's drawing of St. Francis standing in a niche in the Louvre album.[14] On one of the pilasters of his altarpiece for the church of San Lorenzo Maggiore in Naples, Niccolò Colantonio depicted Brother Masseo, an early companion of Francis, with a small pouch containing a book hanging from his belt—the same position as the object in the Frick painting (fig. 122). Perhaps the item at Francis's waist, too, is a pouch or handkerchief for ordinary use. Bellini's thorough planning of this mundane detail would be in keeping with his faithful representation of the saint in the guise of a fifteenth-century friar.

NOTES

"The Footprints of Our Lord": Giovanni Bellini and the Franciscan Tradition (pp. 22–45)

1 The stigmatic wound on the proper left foot of Francis is abraded and no longer visible to the naked eye (see fig. 55).

2 "The rule and life of these brothers is this, namely: 'to live in obedience, in chastity, and without anything of their own,' and to follow the teaching and footprints of our Lord Jesus Christ" (Francis of Assisi, Earlier Rule [1209/10–21]; see Armstrong, Hellmann, and Short 1999–2002, vol. 1, 63–64; Cunningham 2004, 65).

3 Early accounts of the stigmatization describe the apparition in various ways, including a crucified man like a seraph with six wings and Christ crucified and enfolded in seraph wings (Armstrong, Hellmann, and Short 1999–2002, vol. 1, 263–65; vol. 2, 632–33). For early images of the miracle in relation to textual narratives of the stigmatization, see Goffen 1988; Frugoni 1993; Cook 1996; Davidson 1998; Brooke 2006, 160–217, 281–83, 401–4; Chatterjee 2012.

4 Fleming 1982, 30; Goffen 1989, 107; Lavin 2007, 238–39.

5 Gentili 2004a, 173; Gentili 2006, 18–19. Fletcher 1972 cautions against excessively specific iconographic readings of the picture, as do Aikema 1994, 106, and Grave 1998. Referring to the related genre of images of St. Jerome in Renaissance Venice, Echols and Brown note that ostensibly symbolic motifs "may not necessarily have a consistent or specific meaning" (Echols 1994; Boskovits and Brown 2003, 73).

6 The landscape of Bellini's painting was praised by the Renaissance connoisseur Marcantonio Michiel: "the panel of St. Francis in the desert, in oil, was the work of Giovanni Bellini, begun by him for Messer Zuan Michiel, and it has a landscape [or small town] nearby, wonderfully composed and detailed." Luigi Lanzi admired the landscape of Bellini's painting foremost in his travelbook (Lanzi 1793–94/1988, 13) and his history of Italian painting (Lanzi 1815–16, vol. 3, 39). According to Berenson, Bellini meant for the painting "to be a landscape, but European man had not yet made sufficient advance toward nature to compose a landscape without some pretext of a religious, legendary, or at least romantic subject . . . the pretext here was St. Francis receiving the Stigmata" (Berenson 1916, 97–98). Mather claims that "the picture is a landscape, and as such offers no problems" (Mather 1936, 101).

7 Manchester 1857, cat. 116; Hall 1992, 82; Aikema 1994, 108; Hirdt 1997, 4; Christiansen 2004b, 42; Gentili 2004a, 172; Lauber 2005, 98; Bätschmann 2007, 110; and Lavin 2007, 234.

8 Or, The Stigmatization of St. Francis: see Venturi 1915, 310; Berenson 1932, 71; Dussler 1935, 137; Mather 1938, 322, 354; Dussler 1949, 22; Berenson 1957, vol. 1, 32; Pallucchini 1962, 145; Bottari 1963, vol. 1, 39; Meiss 1963, 111; Barocchi 1971–77, vol. 3, 2883 n. 3; Pächt 2002, 232; De Marchi 2006, 125; Mary Berenson in Saltzman 2008, 234.

9 Or, The Ecstasy of St. Francis: Gronau 1930, xxiv; van Marle 1935, 268; Hartt 1940, 35; Hendy and Goldscheider 1945, 27; Longhi 1949, 281; Frick 1968, 203; Pignatti and Bonnefoy 1969/1975, 97; Pochat 1973, 351; Castelfranchi Vegas 1983, 159, 188 n. 17; Goffen 1989, 112; Lucco 1990, 441, 446; Janson 1994; Aikema and Brown 1999, 18–19; P. F. Brown 1999, 513; Pignatti and Pedrocco 1999, 48; Tempestini 2000, 83; Elkins 2001, 75; Wills 2001, 286; Hartt and Wilkins 2003, 455; Villa 2008b, 118–19; Campbell and Cole 2012, 245.

10 Or, Francis Singing the Canticle of the Creatures: Clark 1949, 24; Anderson 1997, 158. See also Mather 1936, 100–101; Gamba 1937, 107–8; Turner 1966, 65; Robertson 1968, 77; Pochat 1973, 352; Smart 1973, 470; Wilde 1974, 29; Janson 1994, 50–52; Hirdt 1997, 15.

11 New York Times 1915.

12 Moschini 1943, 47.

13 Fleming 1982, 140.

14 Lavin 2007 and Lavin 2013.

15 Manchester 1857, cat. 116. See "From the Grand Canal to Fifth Avenue: The Provenance of Bellini's St. Francis from 1525 to 1915" in this volume.

16 Crowe and Cavalcaselle 1871, vol. 1, 159; Crowe and Cavalcaselle 1871/1912, vol. 1, 158. Lauber has found an annotated copy of the Manchester exhibition catalogue among Cavalcaselle's papers at the Biblioteca Nazionale Marciana, Venice (Lauber forthcoming).

17 See "From the Grand Canal to Fifth Avenue: The Provenance of Bellini's St. Francis from 1525 to 1915" in this volume, n. 97.

18 Frick's record of the painting on his "Red Envelope" of May 1915 titles the work St. Francis of Assisi (Henry Clay Frick Art Collection Files. The Frick Collection/Frick Art Reference Library Archives). Frick's 1915 privately printed catalogue of his collection, Pictures in the Collection of Henry Clay Frick, at One East Seventieth Street, New York, also lists the title as St. Francis of Assisi.

19 St. Francis or The Frick St. Francis: Berenson 1916, 95; Gamba 1937, 107; Hendy and Goldscheider 1945, 27; Arslan 1962, 47; Heinemann 1962, 65; Fletcher 1972; Huse 1972, 38; Eisler 1979; Goffen 1986b, 57; Huse and Wolters 1990, 212; Grave 1998; Hammond 2007; Lugli 2009, 28.

20 Meiss 1963; published with some revisions the next year as a monograph (Meiss 1964). Meiss's argument was anticipated by Venturi 1915, 310.

21 Although Meiss's arguments have been oversimplified by later scholars, some thoughtful objections have been raised. Turner notes that one of the stigmata is in shadow, "which may shake our confidence in the idea of stigmatization by light" (Turner 1966, 63). Meiss's thesis has been accepted and elaborated by authors including Settis 1978/1990, 43; Hirdt 1997.

22 The depiction of the stigmatization in a blaze of golden light derives from early oral and textual sources and may be found in Bonaventura Berlinghieri's St. Francis and Scenes from His Life and

Afterlife (c. 1235; San Francesco, Pescia; see Chatterjee 2012, 55), the Bardi Dossal (c. 1245–50; Bardi chapel, Santa Croce, Florence; see Frugoni 1988, 26–28, and Goffen 1988, 42), Giotto's Louvre *Stigmatization* (c. 1297–1300; see Gardner 1982, 226, and D. Cooper 2013), Paolo Veneziano's Santa Chiara altarpiece (c. 1350–55; Gallerie dell'Accademia, Venice; see Cook 1996, 25), as well as works of Taddeo Gaddi, Gentile da Fabriano, Sassetta, and others (Hills 1987, 75–79, 115–19; Christiansen 2006, 31–32; Toyama 2009, 310). Frugoni believes that Bellini's *St. Francis* marks the culmination of the trend of depicting the stigmatization in a bath of light (Frugoni 1993, 160–61).

23 Meiss 1964, 16. However, Giambono's figure kneels in a more typical position for the stigmatization while Bellini's Francis stands (Lavin 2007, 246–47).

24 This persistent controversy, along with new evidence about the construction and alteration of the support, are addressed in this volume in "*St. Francis in the Desert*: Technique and Meaning" and Appendix A.

25 Fleming 1982. Fleming's views have been taken up with variations by Hirdt 1997, Gentili 2004b, and Lavin 2007.

26 For example, vernacular religious literature, prayer manuals, and the poetry and songs used in Venetian devotional practice. Several authors have identified an early Franciscan text known as the *Speculum Perfectionis* as a source for Bellini's composition (Smart 1973; Janson 1994, 50–51); however, Fleming disputes this association (Fleming 1982, 14–16). Christiansen suggests that Bellini's picture, as a "meditational *poesia*," may have drawn on *laude* and canticles performed at Venetian devotional confraternities (Christiansen 2013). Gentili discusses a meditational treatise, the *Monte de la Oratione*, in relation to the mountaintop setting of *St. Francis*, which may be identified with spiritual refinement and the ascent of the soul (Gentili 2004a, 308 n. 12).

27 Lavin 2007; Lavin 2013. This essay cites the 2007 version of Lavin's article. This subject was first addressed by Jennifer Fletcher (Brown and Fletcher 1972, 405) and later by Colin Eisler in a lecture at The Frick Collection, "A Mysterious Masterpiece: What's Really Going on in Bellini's *Saint Francis in the Desert?*" (18 February 2004).

28 Fletcher 1972; Brown and Fletcher 1972, 405.

29 Lauber 2004; Lauber 2005, 100–101; Lauber 2007a, 31–33; Lauber 2007b; Lauber 2008; Lauber 2009.

30 For Bellini's signatures, see Matthew 1998, 620–41; Pincus 2008; Rawlings 2009, 146–55.

31 For a contextual study of Bellini's social world, see Fletcher 2004.

32 "Primo pytor de Italia" (Letter of Giovanni Badoer, Venetian ambassador in France, to the Senate, 31 October 1516: see Sanudo 1879–1903, vol. 23, 204; Fletcher in Chambers and Pullan 2001, 407–8). For comparisons between Bellini and ancient artists, see Sciolla 1993.

33 For the medal, see Wilchusky in Scher 1994, 104–6; Fletcher 2004, 40–41; Pollard 2007, vol. 1, 189. For the artist's death, see Sanudo 1879–1903, vol. 23, 256.

34 The Venetian Republic commissioned a painting by Bellini as a gift to Marguerite de Valois, sister of the King of France, in 1515–16: see Fletcher in Chambers and Pullan 2001, 406–8. The government also presented a painting by Bellini of Christ as Man of Sorrows to the French governor of Milan in 1517 (Sanudo 1879–1903, vol. 24, 63; see Fletcher 2004, 27). According to Giorgio Vasari, a painting by Bellini in the church of San Francesco della Vigna was given as a gift to King Louis XII of France (Vasari 1568/1906, vol. 3, 163; Goffen 1989, 301 n. 71; Bull 1991; Onda 2008, 189).

35 Frugoni 1993; Cook 1999, 165–68; Chatterjee 2012.

36 Barolsky 1997; Cook 2004, 144; Brooke 2006, 382.

37 Thode 1885/1998 (2nd ed. 1904); Thode/Bellosi 1993. Curiously, I have not found any mention of Thode in the extensive scholarly literature on Bellini's painting. For further discussion of the "mendicant thesis" in art history, see Bourdua 2002 and Dunlop 2007.

38 For Franciscan innovations in panel painting, see Krüger 1992; Belting 1994, 308, 349–76; Flora 2006, 28–31. For the Franciscans' role in transforming the representation of Christ's Passion, see Derbes 1996.

39 For Bellini's independence from conventional iconographical formulae and his assertion of triumph in art through the medium of his paintings, see McHam 2008 and Lavin 2009, 143–74. D'Elia 2006 demonstrates that Bellini's works were understood even in the early sixteenth century as multivalent, enigmatic images in which conventional genres such as allegory, myth, and realistic portrait were conflated. *St. Francis* likewise blurs traditional categories of narrative and devotional image (Lugli 2009). For structured ambiguity in Renaissance art, see Nagel and Pericolo 2010, esp. 1–42; Gilbert 1952; Harbison 1992.

40 Little 1978, esp. 146–69; Vauchez 2009/2012, 6–9.

41 Thomas of Celano's *Second Life of Francis* (1245–47):

see Armstrong, Hellmann, and Short 1999–2002, vol. 2, 249. The incident is also recounted by Bonaventure (ibid., 536, 686, 760). See Moorman 1968/1988, 6; Cunningham 2004, 13–14.

42 Freedberg 1989, 301–12; Derbes 1996, 160; Brooke 2006, 160.

43 Cunningham 2004.

44 Composed in three stages around 1225: see Armstrong, Hellmann, and Short 1999–2002, vol. 1, 113–14. For Francis's artistic temperament, see Thode 1885/1998, 77–84.

45 Vauchez 2009/2012, 49–57. For the early history of the Franciscan movement, see Cusato 2009.

46 Brooke 1975; Lawrence 1994; Cannon 2004, 104–12.

47 Cusato 2009, xxvii.

48 The conflict came to a head at the infamous Chapter of Mats in 1220/1221, when Francis abdicated leadership of the Order (Moorman 1968/1988, 50–52; Vauchez 2009/2012, 94–100).

49 Moorman 1968/1988, 369–83, 441–532, 569–85; Nimmo 1987, 576–645.

50 For Franciscan policies regarding the use of property and commissioning of art, see Moorman 1968/1988, 90–91, 148–49, 179–81; Bourdua 2002; Bourdua 2004, 18–31; Cobianchi 2009b.

51 *Major Legend* (1260–63): see Armstrong, Hellmann, and Short 1999–2002, vol. 2, 634. For the implications of Francis's reception of the likeness of Christ as an image on his physical body, see Belting 2010.

52 For *Franciscus alter Christus* in art, see van Os 1974; Mundy 1977; Lavin 1990, 36–39. For the Assisi frescoes, see, for example, Tintori and Meiss 1967; Belting 1977; Stubblebine 1985; Zanardi 1996; Ladis 1998; Brooke 2006, 280–453; Cooper and Robson 2013.

53 Moschini Marconi 1955–70, vol. 1, 15–16; Nepi Scirè 1991, 30–31. For the church and convent of Santa Chiara in Venice, see Zorzi 1972, vol. 2, 323–24; Tassini 1988, 163–65.

54 For this interpretation of the Pentecost and Last Judgment scenes, see Cook 1996, 26.

55 Complete with its original frames, the Pesaro altarpiece measures 630 by 400 by 60 cm (Poldi and Villa 2011, 28). The San Giobbe altarpiece is the largest surviving single-field work in Bellini's oeuvre (Spezzani 1994, 27; Goffen 1989, 155).

56 The Gattamelata altarpiece was signed in the names of Jacopo, Gentile, and Giovanni Bellini: see Callegari 1997, 30.

57 The triptych of the Nativity (Gallerie dell'Accademia, Venice) belongs to a series of four altarpieces completed for the Augustinian

church of Santa Maria della Carità in Venice (c. 1462–64) and usually attributed to Jacopo Bellini and his workshop. The involvement of Giovanni Bellini in the central panel of the Nativity triptych has been suggested on the basis of the underdrawing and fine execution of the face of Mary (Wilson 2008, 118, 121–22). See Andrisani 1960, 343–44; Goffen 1989, 276–77; Humfrey 1993a, 180–81, 341; Goffen and Nepi Scirè 2000, 26–35, 122–26; Lucco 2008a.

58 Jacopo represented the stigmatization of St. Francis on ff. 64v.–65r. of his Louvre sketchbook (Degenhart and Schmitt 1990, vol. 7, pl. 82–83) and on ff. 41v.–42r. of his British Museum sketchbook (ibid., vol. 8, pl. 200–201). See also Eisler 1989, 392–93, 400–402. For Jacopo's sketchbooks, see P. F. Brown 1992; P. F. Brown 1996, 116–41; Bass 2010.

59 Meyer zur Capellen 1985, 140; Scarpa 1994; Conn and Rosand 2011, 320–23. I thank Daniel Wallace Maze, Melissa Conn, and Frederick Ilchman for further information about this ensemble.

60 Fletcher 1991, 778.

61 Cannon 2004.

62 Wilson 1977; Valazzi 1988b; Goffen 1989, 122–37; Humfrey 1993a, 188–93, 345; Poldi and Villa 2011. For the carpentry and frames, see Bertorello and Martellotti 1988.

63 Little documentation of the commission and execution of the Pesaro altarpiece survives (Valazzi 1988a). Although scholars have proposed that the altarpiece was commissioned by the Sforza family, it seems far more likely that the project was undertaken by the friars of San Francesco (Wilson 1977, 404–5; Humfrey 1993a, 189).

64 Meiss 1964, 17; Wilson 1977, 7–144; Goffen 1989, 123–30.

65 Wilson 1977, 161–209.

66 Wilson 1977, 285–86. For the Man of Sorrows, see Panofsky 1927; Eisler 1969; Schiller 1972; Belting 1980–81; Puglisi and Barcham 2011. Bellini himself frequently painted the Man of Sorrows theme (Belting 1985; Bona Castellotti and Pulini 2012; De Marchi, Di Lorenzo, and Galli Michero 2012).

67 Goffen 1989, 128–30.

68 Meiss 1964, 28; Wilson 1977, 260–66. The rays of stigmatization are omitted in Jacopo Bellini's representation of the miracle in his British Museum album (ff. 41v.–42r.; c. 1455–60; see Eisler 1989, 392–93). The rays are also minimized in paintings of the miracle by Sassetta (The National Gallery, London), Piero della Francesca (Galleria Nazionale dell'Umbria, Perugia), and Marco Zoppo (Walters Art Museum, Baltimore):

see Toyama 2009, 310–11 n. 22.

69 The following observations are indebted to a lecture by Michael F. Cusato, O.F.M., at The Frick Collection in December 2012. Francis's corporeal stigmatization was only the sixth of seven apparitions of the Cross of Christ to the saint, who devoted his adult life to imitation of Jesus' ministry and meditation on his sacrifice. See the conclusion of the thirteenth chapter of St. Bonaventure's *Major Legend* (Armstrong, Hellmann, and Short 1999–2002, vol. 2, 638–39).

70 *Major Legend*, chap. 10, "Zeal for Prayer and the Power of Prayer": see Armstrong, Hellmann, and Short 1999–2002, vol. 2, 605–11.

71 Bonaventure of Bagnoregio 1898, 120; trans. Moorman 1968/1988, 260–61. Franciscan texts such as the *Meditationes Vitae Christi* likewise encouraged a participatory and performative spirituality (Flora 2006, 29–31; Flora 2009; Seubert 2011).

72 Derbes 1996, esp. 16–24.

73 Land 1980; see also Land 1974, 23–26, 151–53. For the term "Cristo Passo" in Venice, see Puglisi and Barcham 2006 and Puglisi and Barcham 2011, 13–15. A collection of essays on the Man of Sorrows edited by Puglisi and Barcham is forthcoming (Medieval Institute Publications, Western Michigan University, Kalamazoo).

74 In Byzantium and Italy, the Franciscans were associated with the Man of Sorrows from an early date (Cannon 1999; Seubert 2011). The Man of Sorrows was the logo of the Monte di Pietà, a charitable lending institution established in the fifteenth century by the Observant Franciscans in Italy and promoted by Bernardino da Feltre in the Veneto (though not in Venice proper): see Puglisi and Barcham 2008.

75 As Land 1980 has shown, Giambono's *Christ as Man of Sorrows with St. Francis* emphasizes the contemplative dimension of Franciscan spirituality, suggesting that the saint achieves likeness to Christ by virtue of the intensity of his consideration of the Passion.

76 Anderson compares the posture of Francis with that of a singing friar in an early sixteenth-century woodcut (Anderson 1997, 159; Bätschmann 2007, 110–18). Meiss, however, argues that the saint's attitude is "not creative but receptive" (Meiss 1964, 21). Fletcher notes that "the open mouth, so suggestive of song or speech, is a common symptom of rapture" (Fletcher 1972, 211).

77 For Bellini's *maniera divota*, see Christiansen 2004b, 28.

78 Armstrong, Hellmann, and Short 1999–2002, vol. 2, 132–33. See Moorman 1968/1988, 46–55;

Le Goff 1999, 169; Vauchez 2009/2012, 104.

79 From the *Considerazioni sulle Stimmate di San Francesco* (Pratesi and Sabatelli 1982, 231). See also Bonaventure, *Major Legend* (Armstrong, Hellmann, and Short 1999–2002, vol. 2, 632). A fourteenth-century poem of Ugo Panziera pictures the saint as full of joy yet also constantly weeping over the Passion (Moorman 1968/1988, 400).

80 Gamba 1937, 107–8. Wilde suggests that Bellini's composition expresses the spirit of Francis's connection to nature (Wilde 1974, 29).

81 Snyder 1997, 76.

82 The earliest known mention of the San Giobbe altarpiece appears in the Venetian historian Marc'Antonio Sabellico's *De Situ Urbis Venetae* of c. 1490–91 (Sabellico 1502/1985, 21; see Agosti 2009, 29–30, and for the dating of the text, Chavasse 2003, 29–30). Marin Sanudo praised the work in his *De Origine, Situ et Magistratibus Urbis Venetae*: Sanudo 1493–1530/2011, 47. See also Vasari 1568/1906, vol. 3, 155; Sansovino 1581/2002, 57r.; Ridolfi 1648/1965, vol. 1, 66; Boschini 1660/1966, 46–48.

83 Among the commissions completed by Bellini and his workshop for the Franciscans in Venice are the renowned triptych of 1488 for the Pesaro chapel in the sacristy of Santa Maria Gloriosa dei Frari (Goffen 1986b, 30–72; Poldi and Villa 2008, 124–51); an altarpiece of St. Jerome for Santa Maria dei Miracoli (Sansovino 1581/2002, 63r.; Howard 1989, 685); organ shutters of the Annunciation, also for Santa Maria dei Miracoli (Howard 2004, 157–60); and two paintings for the church of San Francesco della Vigna, the *Sacra Conversazione Dolfin* (Poldi and Villa 2008, 182–231), and a work described by Vasari that is sometimes identified with the *Dead Christ* now in Stockholm, Nationalmuseum (Vasari 1568/1906, vol. 3, 163; Goffen 1989, 301 n. 71; Bull 1991; Onda 2008, 189).

84 Bonaventure, *Major Legend* (Armstrong, Hellmann, and Short 1999–2002, vol. 2, 592–93). See also Bourdua 2004, 16–18; Lavin 2007, 234–35, 244.

85 Boschini 1660/1966, 47.

86 Hills forthcoming.

87 Moorman 1968/1988, 369–83, 441–532, 569–85; Goffen 1986b, 79–82; Nimmo 1987, 576–645; Merlo 1989; Robson 2006, 181–222.

88 An early list of Observant Franciscan institutions in Venice is provided by Marin Sanudo in his *De Origine, Situ et Magistratibus Urbis Venetae* (Sanudo 1493–1530/2011, 157–58).

89 For Bernardino, see da Milano 1945; Origo 1962; Robson 2006, 192–201; Israëls 2007; Israëls

2009a. For the saint's presence in Venice, see Goffen 1986a; Goffen 1986b, 157–58; Lavin 2007, 236; Wilson 2008, 119.

90 For the architectural history of San Giobbe, see Cicogna 1969–70, vol. 6, pt. 1, 529–758; McAndrew 1980, 134–43; Ceriana 1992–93; Howard 2002, 128–30; Israel 2007. For the displacement of Bellini's altarpiece, see Goffen 1986a.

91 London, British Museum sketchbook, ff. 80v., 82v. (c. 1443; see Degenhart and Schmitt 1990, vol. 6, 519, 524–25; vol. 8, pl. 278, 282). See also Cobianchi 2009a, 59. Bernardino exhorted parents to bring children five and older to his sermons (Robson 2006, 198).

92 For portraits of Bernardino, see Israëls 2007 and Cobianchi 2009a.

93 Spimpolo 1933–39, vol. 1, 22.

94 For the term zoccolanti, see Moorman 1968/1988, 369–83; Gieben 1996, 457–58.

95 Fleming describes the Mosaic origins of the discalcement ritual and notes that "by Bellini's time, discalcement was an effective, if not quite an official, emblem of the Observance" (Fleming 1982, 56–57).

96 Gieben 1996, 452–58; Rocca 2000, 333–35. See also Rossetti 1989 for the original habit of Francis.

97 Howard 1987, 64–74. For the sixteenth-century reconstruction of the church and convent by Jacopo Sansovino and Andrea Palladio, see ibid.; T. Cooper 2005, 76–103; de Maria 2010, 75–85.

98 Lavin 2007; see also Brown and Fletcher 1972, 405. For the history of San Francesco del Deserto, see Cicogna 1969–70, vol. 5, 481–90; Bianchi and Ferrari 1970; Ferrari 1990.

99 Moorman 1968/1988, 507–8.

100 I thank Johanna Heinrichs for discussing the painted architecture of the altarpiece. See Goffen 1986a and Nepi Scirè 1994, 21. The painting's sculpted frame (still in situ) is continuous with the illusionistic architecture of the scene (Pincus 2004, 126–30; Ceriana 2008, 96–97). This feature was praised by both Ridolfi and Boschini (Ridolfi 1648/1965, 66; Boschini 1660/1966, 47–48).

101 Lavin 2002, 283–84; see also Meiss and Jones 1966, 204–5. For Piero's possible influence on Bellini, see Longhi 1914, 241–56. Affinities between the Montefeltro and San Giobbe altarpieces are discussed by Goffen 1989, 150; and Finocchi Ghersi 2003–4, 25, 28–29, 32. For a model of the centralized dissemination of artistic ideas among the Observant Franciscans, see Cobianchi 2006.

102 Paoletti 1893–97, pt. 2, 190–91; Howard 2002, 128.

103 Goffen 1986a, 64–65; Humfrey 1993a, 347; Israel 2007, 294–98.

104 Volpin and Lazzarini 1994, 32; Dunkerton 2004, 210–13. See also Banker 2009.

105 See "St. Francis in the Desert: Technique and Meaning" in this volume.

106 On 29 November 1516, Marin Sanudo recorded the recent death of Bellini (Sanudo 1879–1903, vol. 23, 256). The division of the Franciscans occurred at the Pentecost meeting of the Order on 30–31 May 1517 (Moorman 1968/1988, 582–83).

The Desert and the City: Marcantonio Michiel and the Early History of *St. Francis* (pp. 46–57)

1 Crowe and Cavalcaselle apparently first identified *St. Francis* with the painting described by Michiel in the home of Taddeo Contarini (Crowe and Cavalcaselle 1871, vol. 1, 159). However, the title given the painting in the 1857 Manchester *Art Treasures* exhibition, *St. Francis in the Desert*, accords with Michiel's entry and suggests that the connection was understood by this date (Manchester 1857, 21).

2 Fletcher 1973; Fletcher 1981a; Fletcher 1981b; Anderson 1997, 53–60; Schmitter 1997; Lauber 2002a; Schmitter 2003; Schmitter 2004; Lauber 2007a.

3 Morelli 1800. See also subsequent printed editions of the *Notizia*: Frizzoni 1884; Frimmel 1888 (reprinted as Frimmel 1896), who first identifies the author as Michiel; Frimmel 1907; Barocchi 1971–77, vol. 3, 2867–91 (based on Frimmel's 1888 edition); De Benedictis 2000 (based on Frimmel's 1896 edition). An early English translation is Mussi 1903. The most technically correct but also least cited version of the notes is Frimmel 1907 (see Schmitter 1997, 29 n. 56). An updated critical edition of the *Notizia* is forthcoming by Rosella Lauber (*Marcantonio Michiel e la "Notizia d'Opere di Disegno,"* Udine 2014).

4 The title page is written in a late sixteenth-century hand (Schmitter 1997, 29–30).

5 Lauber 2005, 82.

6 Fletcher 1981b, 604, notes that "religious iconography was Michiel's weak point."

7 P. Brown 1982. See also Le Goff 1988; Merlo 1989; Lynn-Davis 1998, 185–88.

8 Fletcher notes that "'paese' is frequently used by Marcantonio Michiel to indicate painted landscape, but in this instance 'paese' could equally well refer to the small town clearly visible in the middle distance" (Fletcher 1972, 206–9 n. 1). The term *propinquo* as used by Michiel has been interpreted in various ways but is now usually considered to be related to the Latin *propinquus*, or "near" (Fletcher 1972; Lavin 2007; Lauber forthcoming).

9 Lavin 2007; Lavin 2013. For the history of San Francesco del Deserto, see Cicogna 1969–70, vol. 5, 481–90; Bianchi and Ferrari 1970; Ferrari 1990.

10 Lauber 2005, 101. Cancellations and revisions appear frequently in Michiel's notes (Fletcher 1981b, 602–3).

11 The possibility that *St. Francis* was commissioned for San Francesco del Deserto was first suggested by Jennifer Fletcher (Brown and Fletcher 1972, 405). The subject was also addressed by Colin Eisler in a lecture at The Frick Collection, "A Mysterious Masterpiece: What's Really Going on in Bellini's *Saint Francis in the Desert*?" (18 February 2004).

12 Lavin 2007, 234, 248, observes that the patron of Bellini's picture, Zuan Michiel, and the early owner of San Francesco del Deserto, Iacopo Michiel, had the same family name. It should be noted, however, that Michiel was a very common surname in Venice and that no documentary evidence connects Zuan Michiel or Bellini's painting to San Francesco del Deserto. In July 2010, Charlotte Hale and the author took measurements of various spaces within the church of San Francesco delle Stimmate on the island. Bellini's painting would have fit comfortably both on the high altar of the church and on the altar of the present-day Cappella della Madonna adjacent to the nave. However, archival research at the Curia Provinciale, Provincia Veneta di Sant'Antonio dell'Ordine dei Frati Minori (Marghera), did not yield any documentation of a connection between Bellini's painting and the island.

13 This interpretation is indebted to Barbara Lynn-Davis's penetrating account of the image of St. Jerome in Venetian culture: see Lynn-Davis 1998, 183–228.

14 Bellini died in late 1516 (Sanudo 1879–1903, vol. 23, 256).

15 Fletcher 1972, 209 n. 1. See also *New York Times* 1915; van Marle 1935, 269; Lavin 2007, 231.

16 Kasl 2004b, 84; Morse 2006, 343.

17 Fletcher 1972 and Fletcher 1981a, 462. Confusingly, Zuan Michiel (c. 1440–1513) shares his first name with Giovanni Bellini (Zuan is Venetian dialect for "Giovanni") and his last name with Marcantonio Michiel. He will be called Zuan in this essay to distinguish him from Giovanni Bellini, who is identified throughout the volume by the Italianized form of his name. Zuan Michiel's brother, Andrea Squarzòla, was a satirical poet

who composed verses praising Giovanni Bellini (Rossi 1895, 53–54; Fletcher 1991, 780).

18 Rosella Lauber's recent discovery of the last will of Zuan Michiel, 15 April 1513 (Archivio di Stato di Venezia [ASV], Notarile, Testamenti, Gio. Giacomo Bestici, b. 38, n. 75), confirms that he lived in the parish of Santa Marina (Lauber 2005, 100, 116 n. 204; and Lauber forthcoming). For Michiel's and Bellini's membership in the Scuola Grande di San Marco, see Neff 1985, 481; Fletcher 1998, 148; Fletcher 2004, 15–24; Köster 2008, 218–35, 394–96.

19 Toward the end of the sixteenth century, the *cittadini originari*, or "original citizens" of Venice, were legally defined as non-nobles of established families who claimed three generations of legitimate Venetian ancestry through the paternal line and were untainted by the practice of manual labor (Neff 1985, 10–25). For Giovanni Bellini's status as a *cittadino originario*, see Ridolfi 1648/1965, vol. 1, 63; and Fletcher 2004, 13–15. Zuan Michiel is included in Giuseppe Tassini's lists of "Cittadini Veneziani, Famiglie Veneziane Originarie," but his father and grandfather are not recorded (Tassini 1888, vol. 3, 203–4). Michiel served as a secretary in the ducal chancellery of Venice (Neff 1985, 479–81), a role that was limited to *cittadini originari* in 1478. Although he had begun working for the chancellery by 1462, the fact that he enjoyed promotions within this institution suggests that he was considered a *cittadino originario* by his contemporaries. See Casini 1991; Casini 1992; Zannini 1993; Grubb 2000; Bellavitis 2001; Schmitter 2004, esp. 909–15; T. Cooper 2007; de Maria 2010, 25–31. I am grateful to Daniel Wallace Maze, Anne-Marie Eze, and Blake de Maria for advice on this subject.

20 For Michiel's career as a chancellery secretary, see Neff 1985, 114 n. 153, 131, 169, 185, 186, 230–31, 269, 285, 479–81. See also Neff 1981; Zannini 1993; Bellavitis 2001, 65–104.

21 Sanudo 1493–1530/2011, 93; Chambers and Pullan 2001, 54–56.

22 Neff 1985, 481. See also Pullan 1971, 99–131; Bellavitis 2001, 105–37, 335.

23 Cecchetti 1887, 247–48; Paoletti and Ludwig 1899, 274–75; Ludwig 1905, 21–22; Steer 1982, 172–73. Vivarini's pennant is apparently lost, or the commission might not have been fulfilled.

24 It was common practice for patrons to specify the quality of gold and ultramarine in painting contracts (Baxandall 1988, 3–14; O'Malley 2005, 47–76).

25 Meiss 1964, 32–33; Fletcher 1972, 214; Humfrey 2008, 73. For Bellini's negotiations between 1496

and c. 1504 regarding a *Nativity* for Isabella d'Este, see Fletcher 1971 and Christiansen 2004b, 44–47.

26 Schmitter 2004. See also Luchs 1995, 9–30; T. Cooper 2007; de Maria 2010.

27 For Aurelio, see Neff 1985, 361–64; Howard 2013. For the *Sacred and Profane Love*, see Goffen 1993b; Jaffé 2003, 92–95; B. Brown 2008.

28 In his will, Michiel expressed his desire to be buried in SS. Giovanni e Paolo (Lauber forthcoming). Sanudo recorded that Michiel was buried there upon his death on 13 June 1513 (Sanudo 1879–1903, vol. 16, 371).

29 Fletcher 1991, 778; Fletcher 2004, 42–45.

30 *Paradiso* XI–XII; see Auerbach 1945, 167.

31 Among those suggesting that the painting originally hung in a private domestic setting are Meiss 1964, 32; Wohl 1999, 191–92; Christiansen 2004b, 9; Lavin 2007, 248; Christiansen 2013; Di Vito forthcoming; Giovanni C. F. Villa, verbal communication, 7 November 2011. For a different view, see Huse 1972, 38–48.

32 Neff has found only three chancellery secretaries who constructed chapels within Venetian churches (Neff 1985, 271).

33 Lynn-Davis 1998, 183–228.

34 Lynn-Davis 1998, 216–18. See also Baxandall 1988, 45–48; Gentili et al. 1985, 229–31; Gentili 2004a, 308 n. 12.

35 Baxandall 1965, 196.

36 Meiss 1964, 19–20; Meiss 1974, 194–95; Friedmann 1980, 73–81; Lattanzi and Mercalli 1983; Echols 1994; Alexander-Skipnes 2003.

37 Gallicciolli 1795, 213–14; Morse 2007, 170–77. See also McAndrew 1980, 197–99; Crouzet-Pavan 1992, vol. 1, 650–51; Kasl 2004b, 68–73; Morse 2006, 165–73. I thank Blake de Maria for advice on this subject.

38 For example, in the sixteenth century, Ca' Cuccina on the Grand Canal at Sant'Aponal included a *giesola* or private chapel with an altarpiece on canvas by Tintoretto (de Maria 2010, 131, 258 n. 27). Carpaccio's *Vision of St. Augustine* (c. 1502–7; Scuola di San Giorgio degli Schiavoni, Venice) depicts an altar in a niche along the back wall, decorated with a sculpture of the resurrected Christ.

39 Baxandall 1988, 5; Hills 1990.

40 Humfrey 1991, 109.

41 Muir 1989; Kasl 2004b, 66–68; Morse 2007, 156.

42 Goffen 1989, 89–90; Kasl 2004b, 81–82; Morse 2013, 150. For a similar example, see Paoletti 1894–95, vol. 1, 15; Douglas-Scott 1996; Humfrey in Brown and Ferino-Pagden 2006, 76–79.

43 There were at least three individuals named Taddeo in the Santi Apostoli branch of the patrician Contarini family in the early sixteenth

century, leading to past confusion about which was the owner of *St. Francis* (for clarification, see Anderson 1997, 352 n. 48). In 1511, Marin Sanudo noted "sier Tadio Contarini, quondam sier Nicolò" among the "80 di primi richi di la terra" (Sanudo 1879–1903, vol. 12, 336). This Taddeo, son of Nicolò, was first correctly identified as the owner of Bellini's *St. Francis* by Settis 1978, 139–44. See also Battilotti and Franco 1978, 58–61; Battilotti and Franco 1994, 205–7; Anderson 1997, 148–60; Gardner 1998–2011, vol. 1, 248–49; Vescovo 2000; Lauber 2002a, 105–7; Lauber 2008.

44 Anderson 1997, 148; Vescovo 2000, 114–16; Lauber 2008, 263.

45 Battilotti and Franco 1978, 60; Battilotti and Franco 1994, 205–7. These accounts correct the location of the house given by Settis 1978, 142–43 (Settis 1978/1990, 155–56).

46 Vescovo 2000, 116. For Vendramin, see Ravà 1920; Battilotti and Franco 1978, 64–68; Battilotti and Franco 1994, 226–29; Vescovo 1999; Lauber 2002b; Lauber in Hochmann et al. 2008, 317–19, 371–75; Lauber 2009–10.

47 Vescovo argues that Michiel's death in 1513 provides a *terminus post quem* for Taddeo Contarini's acquisition of the painting (Vescovo 2000, 117). However, the available documentary evidence is not sufficient to rule out the possibility that the picture left Zuan Michiel's possession before his death.

48 C. Brown 1972; Hochmann 2008a, 3; Cecchini in Hochmann et al. 2008, 323–24. I thank Anne-Marie Eze for this suggestion.

49 Belting 1985, 8–15, similarly demonstrates that Bellini's *Pietà* (Pinacoteca di Brera, Milan) marries the functions of *Andachtsbild* (devotional image) and *Sammlerbild* (collector's piece).

50 Frimmel 1907, 55; Schmitter 2004, 922.

51 The 1556 inventory was compiled after the death of Taddeo's son, Dario (Archivio di Stato di Venezia [ASV], Notarile, Atti [Pietro Contarini], b. 2567, part 1, c. 76v.–100v. [17 October–13 November 1556]). It was apparently discovered by Charles Hope and first published in part by Anderson 1997, 148–50, 365. It is discussed in further detail by Vescovo 2000 and Schmitter 2011, 722–28.

52 Vescovo 2000, 119. However, Michiel in 1525 listed ten paintings whereas the 1556 inventory noted at least sixteen.

53 The four paintings listed first in Michiel's notes correspond with those recorded in the *portego grando di sopra* in the 1556 inventory. They are Giorgione's *The Three Philosophers*, a cavalry scene

by Girolamo Romanino, a painting by Giorgione of "the inferno with Aeneas and Anchises," and a picture of unspecified subject by Palma il Vecchio (Frimmel 1907, 54; Nova 1998; Vescovo 2000, 118, #13–16; Schmitter 2011, 723–25).

54 Lauber 2002a, 105, 114 n. 103; Schmitter 2011, 723 n. 104.

55 Frimmel 1907, 54. The first three of these paintings reappear in the household inventory of 1556 (discussed below). The last painting cannot at present be identified with any of the works in the later household inventory (Vescovo 2000, 119).

56 Anderson 1997, 149, 317. Although Michiel described the subject as the birth of Paris (Frimmel 1907, 54), the copy suggests that the scene depicted the abandoned infant's discovery by shepherds on Mount Ida. Another fragmentary copy is in the Szépművészeti Múzeum (Museum of Fine Arts), Budapest.

57 "Un quadro grando con sue soazze indorate con l'immagine di San Francesco" (Vescovo 2000, 118, #2).

58 In the 1556 inventory, Giorgione's *Finding of Paris* was recorded not in the "camera di Dario Contarini" (the location of *St. Francis*) but rather in the "camera sopra il canal de Santa Fosca" (Vescovo 2000, 118, #8).

59 "Uno quadreto scieto con la figura del nostro signor messer Iesù Cristo" (Vescovo 2000, 118, #1). In 1525, Michiel noted, "El quadro del Christo cun la croce in spalla insino alle spalle fo de mano de Zuan Bellino" (Frimmel 1907, 54).

60 "Un quadro fatto de man de Zuan Bellin con una figura d'una donna" (Vescovo 2000, 118, #3). In 1525, Michiel recorded, "El quadretto della donna retratta al naturale insino alle spalle fo de mano de Zuan Bellino" (Frimmel 1907, 54). This picture is difficult to identify because of the lack of surviving female portraits by Giovanni Bellini (Anderson 1997, 150).

61 "Un altro quadro grandeto con tre figure di donna nude con sue soazze dorade" (Vescovo 2000, 118, #5). In 1525, Michiel noted, "El quadro delle 3 donne retratte dal naturale insino al cinto, fo de man del Palma" (Frimmel 1907, 54). The painting is now in Dresden, Staatliche Kunstsammlungen, Gemäldegalerie Alte Meister (Lauber 2007a, 31–32 n. 101). The figures in the painting are clothed, but the 1556 inventory describes them as nude (perhaps a reference to their décolletage).

62 "Un quadro grandeto con sue soazze intorno dorade con una donna che si varda in specchio" (Vescovo 2000, 118, #4).

63 Anderson 1997, 150; Ferino-Pagden and Deiters 2004, 282, 285; McHam 2008. Leopold Wilhelm acquired *Woman with a Mirror* from the collection of the Duke of Hamilton in 1649.

64 Ravà 1920, 178; Whistler and Dunkerton 2009, 540.

From the Grand Canal to Fifth Avenue: The Provenance of Bellini's *St. Francis* from 1525 to 1915 (pp. 58-79)

We would like to thank Susannah Rutherglen, Denise Allen, Colin Bailey, Linda Borean, Lucia Brunetti, Matteo Casini, Silvia Castelli, Susan Chore, Philip Cottrell, Nicholas Donaldson, Lavinia Galli, Barbara Gariboldi, Annabel Gill, Carla Giunchedi, Elaine Koss, Rosella Lauber, Julie Ludwig, Claudia Musto, Hans-Christian Pauckstadt, Nicholas Penny, Fabio Poli, Dorit Raines, Elizabeth Reluga, Valter Rosa, Nathaniel Silver, Katie Steiner, Peter Trippi, Andrea Zonca, and a descendant of the Boucher-Desforges family.

1 Fowles 1976, 94. Edward Fowles (1885–1971) directed the Paris branch of Duveen Brothers from 1917 to 1938, then purchased the firm from Lord Duveen in 1939 with two partners. By 1958, he had bought out his partners. Fowles was vice president of the gallery from 1938 to 1945, when he became president. In 1964, he sold the firm to the Norton Simon Foundation.

2 Fletcher 1972; Brown and Fletcher 1972. According to Marco Barbaro's genealogy, there were at least three individuals named Taddeo Contarini belonging to the Santi Apostoli branch of the family. Anderson 1997, 352 n. 48. Following Frizzoni 1884, 168, Fletcher incorrectly identified Taddeo Contarini as the one who was a member of the Council of Ten, Savio di Terra Ferma, and died in 1545. Fletcher 1972, 209 and 209 n. 7. Settis 1978, 139–44, was the first to correctly identify the owner of *St. Francis* as Gabriel Vendramin's brother-in-law living at Santa Fosca.

3 See Lauber 2001; Lauber 2004; Lauber 2005; Lauber 2007a; Lauber 2007b; Lauber 2008; Lauber 2009; Lauber forthcoming.

4 Venice, Biblioteca Nazionale Marciana, Ms. It. XI, 67 (=7351, *olim* Apostolo Zeno 346) [*Pittori e pitture in / diversi luoghi*], I, f. 54v. See "The Desert and the City: Marcantonio Michiel and the Early History of *St. Francis*" in this volume; Anderson 1997, 148–60; Lauber 2008, 263–64.

5 Archivio di Stato di Venezia (ASV), Notarile, Atti (Pietro Contarini), b. 2567, part 1, c. 76v.–100v. (17 October–13 November 1556). "In camera di Dario Contarini . . . Un quadro grando con sue soazze indorate con l'immagine di San Francesco." Anderson 1997, 148–50, 365; and Vescovo 2000, 118, #8. Dario Contarini's date of birth is calculated here on the basis of his having reached maturity (eighteen years of age) by 28 September 1521, when he was presented in the Balla d'Oro by his father. ASV, Avogaria di Comun, Balla d'Oro, b. 165/IV, f. 85r. Battilotti and Franco 1978, 60.

6 See Battilotti and Franco 1978, 60.

7 Lauber 2008, 263. See Vescovo 2000, 114, for Sanudo's disparaging remarks and description of Taddeo Contarini as an unscrupulous merchant who rarely participated in civic life unless for his own benefit.

8 Hochmann 2008a, 21.

9 See "The Desert and the City: Marcantonio Michiel and the Early History of *St. Francis*" in this volume.

10 Giorgione's painting was described by Michiel: "The canvas of the landscape with the birth of Paris, with two standing shepherds, was by the hand of Giorgio of Castelfranco, and was among his earliest works." Frimmel 1907, 54. Although Michiel described the subject as the birth of Paris, the copy suggests that the scene depicted the abandoned infant's discovery by shepherds on Mount Ida.

11 The painting may be related to a version of *Christ Carrying the Cross* attributed to Bellini in the Toledo Museum of Art. Anderson 1997, 323; Lucco and Villa 2008, 306–7.

12 According to the 1556 will of Dario Contarini and the 1611 will and codicil of his son, Taddeo Contarini (d. 1540) was buried in Santa Maria dei Miracoli before a marble altar decorated with a painting of St. Jerome, which he had commissioned. Battilotti and Franco 1978, 60–61; Settis 1978/1990, 154; Anderson 1997, 148, 352 n. 51; Vescovo 2000, 123 n. 18; Lauber forthcoming. This painting has been identified as the "San Hieronimo nel deserto" by Giovanni Bellini on the left side of the nave, as described by various early sources, including Francesco Sansovino. Sansovino 1581/2002, 63r.; Howard 1989, 685; Humfrey 1993a, 218; Lauber 2005, 101; Lauber 2008, 264; Lauber forthcoming.

13 Lauber 2007a, 31–32 n. 101.

14 Sansovino and Martinioni 1663/1998, 375; Lauber 2007b, 276–77.

15 Boschini 1660/1966, 344. Maffio Venier (1550–1586) was Archbishop of Corfu, dramatist, and Venetian dialect poet. English translation by Fletcher 1972, 210.

16 Fletcher 1972, 210. Lauber forthcoming summarizes the various arguments of the debate.

17 See "*St. Francis in the Desert*: Technique and Meaning" in this volume.

18 A detailed inventory of the possessions of Zuanne di Nicolò Giustinian, drawn up after his death in 1718, includes subjects, attributions, and locations of paintings: Archivio di Stato di Venezia (ASV), Giudici di Petizion, Inventari, b. 415/80, [n. 4], 27 January 1717 *more Veneto* (=1718). Inventario de Mobili di ragione et esistenti nella casa del fu Nob. Huomo *quondam* Zuanne Giustinian a San Stae nel tempo della di lui morte seguita a 27 gennaio 1717 *more Veneto* (=1718). The inventory does not list Bellini's *St. Francis in the Desert* unless, as Lauber has suggested, it is the painting described as "San Francesco nel deserto in tola [tavola] di Vittor Carpatio . . . cornice nera." This is problematic because of its attribution and frame color but interesting because of the pairing with a "San Girolamo nel deserto di Victo Carpatio . . . cornice d'oro." Lauber 2001; Lauber 2007a, 31–32 n. 101; Lauber 2007b, 276; Lauber forthcoming.

19 Fletcher 1972, 211 n. 14.

20 Lauber 2009, 260; Lauber forthcoming.

21 See Posse 1931 and Krellig 2009.

22 Posse 1931, 51–52; Fletcher 1972, 211; Lauber 2001; Lauber forthcoming.

23 Archivio di Stato di Venezia (ASV), Notarile, Atti (M. Porta), b. 11315, a. 1753. Quadri elencati nell'inventario dei beni esistenti nel palazzo a S. Maurizio dei N. N. H. H. Francesco, Antonio, Andrea, Mons. Giovanni, Marco e Giulio fratelli Cornaro furono de Nicolò, che vengono assegnati in pagamento di dote alle N.D.D.D. Benetta Soranzo, Elena Pesaro e Lucrezia Dolfin. Bernardi 1990, 216–18, 241–49; Lauber forthcoming.

24 Romanelli 1993, 148.

25 Bernardi 1990, 216–18, 241–49; Lauber forthcoming.

26 Romanelli 1993, 148.

27 Bernardi 1990, 242.

28 See Magrini 2009, 319.

29 Lanzi 1795–76/1968–74, vol. 2, 25. Fletcher 1972, 211, preferred to translate *folta* as "sparse."

30 Lanzi 1793–94/1988, 13; Fletcher 1972, 211; Lauber 2001; Lauber 2007a, 32; Lauber forthcoming.

31 Romanelli 1993, 148.

32 Archivio di Stato di Venezia (ASV), Direzione Demanio Provincie Venete. Venezia. Fabbriche, b. 695, fasc. 167, n. 1277. Preliminare di vendita del Palazzo Corner al Demanio austriaco. 21 May 1817; ASV, Direzione Demanio Provincie Venete. Venezia. Fabbriche, b. 695, fasc. 617/25024/7729, n. 624. Inventario dei mobili e dei quadri presenti nel palazzo Corner al momento dell'indemaniazione, 23 November 1817; ASV, Direzione Demanio Provincie Venete. Venezia. Fabbriche, b. 695, fasc. 167, n. 302. Inventario dei mobili e dei quadri proprietà di Marina Pisani Corner presenti nel Palazzo al momento dell'indemaniazione da parte del Governo austriaco. 21 May 1817. Romanelli 1993, 192–201, nos. 65–67, respectively.

33 Bill of sale from Carlo Massinelli to Joseph Desforges, Milan, 7 September 1812, verso. "Giovanni Bellini in tavola rappresentante S. Francesco in paese, ed eremo d'Assisi." Private archive, Paris.

34 Frizzoni 1884, 168; Fletcher 1972, 211 n. 17; Lauber forthcoming.

35 He described himself as "Sigr. Fratello, novizio della Compagnia di Gesu" in a letter to fellow Bergamasco Mascheroni in 1771. Bergamo, Biblioteca "A. Mai," MMB665, 5–6. Letter from Carlo Massinelli to Lorenzo Mascheroni, Milan, 3 October 1771. See Fiammazzo 1904, 104–6.

36 Ballarini 2000, 346.

37 For example, abbé Luigi Celotti (1759–1843), Massinelli's contemporary, operated within a network of priests-turned-dealers in Venice, from where he traveled to Milan and beyond to traffic pictures. See Eze 2009 and Eze 2010.

38 Gardner 1998–2011, vol. 3, 25–26, 86.

39 Milan, Archivio Storico dell'Accademia di Brera, Tea M.I.38. Esportazione opere d'arte 1814–96. Documentation on export license granted to Count Francesco Gambarana and Carlo Massinelli from the Accademia di Belle Arti, 1–15 April 1815.

40 Caimi 1866–67, 8–9; Anderson 2000, 55 n. 8.

41 Antoine Desforges-Boucher (1681–1725) and Antoine-Marie Desforges-Boucher (1713–1790) were governors of the island in the 1720s and 1740s–50s, respectively. Members of the family used the last names Boucher, Desforges, Boucher-Desforges, and Desforges-Boucher interchangeably. I am grateful to a descendant of the family, who wishes to remain anonymous, for sharing the fourteen documents related to *St. Francis* in his family archive, as well as details of his genealogy.

42 Bill of sale from Carlo Massinelli to Joseph Desforges, Milan, 7 September 1812, recto. Private archive, Paris.

43 Letter from Carlo Massinelli to Joseph Desforges, Milan, 25 October 1812. Private archive, Paris.

44 The art dealer Luigi Celotti, Massinelli's contemporary, moved his merchandise from Venice to Milan in 1810 to profit from Beauharnais's court but removed it following the viceroy's abdication and the exile of Napoleon in 1814. Eze 2010. For the art market in early nineteenth-century Venice, see Cecchini 2009, 166–67. For Napoleonic Milan, see Pillepich 2001.

45 Joseph-Charles Boucher-Desforges (1797–1876), known as Charles, was the only child of Joseph Desforges and Eléonore Fréon (1775–1854). He was born on Île Bourbon and remained there until 1812 when he joined his father in Paris. There he was educated at the Lycée Louis-le-Grand and, from 1815, at the École Polytechnique, where he graduated in law. In 1848, he ran for political office in legislative elections for a Parisian constituency but was not elected. In 1852, he married Coralie de Tussac, with whom he had one daughter, named Marie (b. 1857). Soon after her birth, the family moved to Nice, where they lived for sixteen years. In 1873, they returned to Paris, living at 86 rue du Bac, until Charles's death in 1876.

46 The sale is documented in twelve letters, dated May 1849–15 April 1850, among Charles Desforges, William Buchanan, Otto Mündler, and Monsieur Chenue. Private archive, Paris.

47 Letter from William Buchanan to Charles Desforges, 23 February 1850. Private archive, Paris.

48 Letter from Charles Desforges to William Buchanan, Paris, 26 February 1850. Private archive, Paris.

49 Letter from William Buchanan to Charles Desforges, 16 March 1850. Private archive, Paris.

50 Chenue. Packing and shipping receipt issued from Chenue to Charles Desforges, Paris, 21 March 1850. Private archive, Paris.

51 Charles Desforges also included dimensions for the panel in his 1849 list of paintings for sale to Buchanan: 44 ½ height × 50 ½ breadth (given in French inches). These dimensions are equivalent to 120.46 × 136.7 cm (on a scale of 1 French inch = 2.707 cm or 1.066 inches). These measurements are smaller than those taken by Chenue and so were probably a rough estimate. Lauber forthcoming suggests a *terminus ante quem* of 1857 based on Giovanni Battista Cavalcaselle's detailed drawing of the painting made at the Manchester *Art Treasures* exhibition. However, I find that his sketch of the top edge of the panel is not accurate enough to support her argument. More reliable is Crowe and Cavalcaselle 1871/1912, vol. 1, 159 n. 2, which gives the dimensions as 4 feet 7 ½ in. by 4 feet high, i.e., width 140.97 cm by height 121.92 cm. See Fletcher 1972, 211 n. 17. For the cutting of the panel, see Rutherglen 2011, 5, and the present volume.

52 According to the Milanese restorer Giuseppe Molteni, who had cleaned pictures for Massinelli in his youth. Morelli/Frizzoni 1893, 5, n. 1.

53 Charlotte Hale identified fragments of gold leaf on *St. Francis*'s paint surface and at the edges, including the present upper edge. Her findings are consistent with the presence of one or more gilded frames at some period or periods in the painting's history. The fact that the gold is seen along the present upper edge suggests that the painting might have had a gilded frame after the top was cropped (consistent with the 1850 Chenue document). The present frame of *St. Francis* probably dates to the nineteenth century, but further investigation is needed.

54 Acknowledgment of receipt of commission from Charles Desforges by Otto Mündler, 15 April 1850. Private archive, Paris.

55 Kingston, England, Surrey County Record Office, Goulbourn manuscripts. Letter from William Buchanan to Robert Peel, 12 April 1850. Brigstocke 1981, 83; Brigstocke 1982, 35, 41 n. 44; Lauber forthcoming.

56 The National Gallery, London. Letter from W. Buchanan offering pictures for sale, 28 Feb. 1851. Brigstocke 1982, 35; Lauber 2001; Lauber forthcoming.

57 17 July 1851, lot 20. See Brigstocke 1982, 480.

58 Sir John Murray and others sale, 19 June 1852, lot 48.

59 The reserve price is recorded in an annotated copy of the sale catalogue in Christie's Archive. Fletcher 1972, 211, adds that a pencil note states that the price was set by a Mr. A. See Lauber forthcoming.

60 Frick 1968, "Taken from a convent in the Milanese"; Fletcher 1972, 211 n. 17; Lauber forthcoming.

61 Letter from Charles Desforges to William Buchanan, Paris, 3 April 1850. Private archive, Paris.

62 Fletcher 1972, 211 n. 17. At present, there is no evidence to prove that the Louvre made an offer for the painting.

63 Fletcher 1972, 211 n. 17; Lauber 2001; Lauber forthcoming.

64 Urban 1848, 648; Fordyce 1885, 61, no. 229.

65 For Scharf and Dingwall, see Haskell 2000; Pergam 2011; Cottrell 2012; Lauber forthcoming. The success of the exhibition earned Scharf the position of first director of the National Portrait Gallery.

66 Manchester Central Library M6/2/11/1082, Letters Received. Joseph Dingwall to Thomas Hamilton, secretary of the Executive Committee, 5 January 1857. Pergam 2011, 151, 190 n. 51.

67 See Waagen 1854 and Waagen 1857. Waagen's *Treasures* was the indispensable guide for the Manchester exhibition's executive committee and staff. Pergam 2011, 151 and n. 50.

68 Pergam 2011, 190 n. 51.

69 It was described (but not illustrated) in the exhibition's catalogue as "Giovanni Bellini, 1426–1516. St. Francis in the Desert. The Saint stands in front of his Cell in the attitude of receiving the Stigmata. P. Signed 'JOANNES BELLINUS.' Imported by Buchanan. Mentioned in the Government Report on the National Gallery in 1853, page 678." Manchester 1857, 21, no. 116.

70 Pergam 2011, 151. Musée Condé, Chantilly, now attributed to Andrea d'Assisi, called L'Ingegno.

71 Cottrell 2012, 623. London, National Portrait Gallery, Heinz Archive, NPG7/2/2/4/4, George Scharf, General Notes, vol. 4, p. 49, 4 February 1857.

72 Scharf 1857. See Pergam 2011, 151.

73 These were "A Dominican Monk" (*A Dominican, with the Attributes of St. Peter Martyr*, The National Gallery, London); "Christ on the Mount of Olives" (*The Agony in the Garden*, The National Gallery, London); "Portrait of a Young Man" (*Portrait of a Boy*, Barber Institute of Fine Arts, Birmingham); "The Virgin and Child between St. Francis and a Monastic Saint" (*Madonna and Child with Sts. Francis and Clare*, now attributed to Cima da Conegliano, The Metropolitan Museum of Art, New York). Pergam 2011, 189 n. 49.

74 Levi 1988, 68–77, on Cavalcaselle at the Manchester exhibition, figs. 19–20; and Haskell 2000, 85, 178 n. 10.

75 Venice, Biblioteca Nazionale Marciana, Ms. It. IV, 2036 (=12277), tacc. IV, ff. 33r.–34r. The sketch after the *cartellino* appears on f. 33r.

76 Crowe and Cavalcaselle 1871/1912, vol. 1, 158 n. 2, 159. They were also apparently the first to connect the entry in Michiel's *Notizia* with the painting: "a small panel was finished which once belonged to the Contarini at Venice, and afterward came into the hands of an English collector." However, the title given to the painting in the 1857 Manchester *Art Treasures* exhibition, *St. Francis in the Desert*, accords with Marcantonio Michiel's description and suggests that the connection was understood by this date (Manchester 1857, 21). See also Lauber forthcoming; Humfrey forthcoming.

77 Humfrey forthcoming.

78 Frizzoni 1884, 168; Mussi 1903, 105 n. 1.

79 Letter from Robert Langton Douglas to Mrs. Margaret E. Gilman, secretary of the Fogg Art Museum, Cambridge, Mass., 30 November 1943. Copy in Henry Clay Frick Art Collection Files. The Frick Collection/Frick Art Reference Library Archives. Pergam 2011, 190 n. 54; Lauber forthcoming.

80 See Barringer 2009.

81 Letter from Robert Langton Douglas to Mrs. Margaret E. Gilman, secretary of the Fogg Art Museum, Cambridge, Mass., 30 November 1943. Copy in Henry Clay Frick Art Collection Files. The Frick Collection/Frick Art Reference Library Archives.

82 Frick 1968, 208; Lauber 2004, 81, 86–87; Barringer 2009, 12; Pergam 2011, 151.

83 *London Gazette* 1865a, 3380; *London Gazette* 1865b, 3450.

84 Harrison-Barbet 1994, 40; Elliott 1996, 47.

85 On 20 June 1865, Joseph Dingwall, of Bitterne, near Southampton, his wife Elizabeth, and her first husband's spinster sisters petitioned for the sale of the "freehold messuages, lands, heritaments, and premises, commonly known as Broomfield, in the parish of Egham, in the county of Berks," which had belonged to his late father-in-law Philip Bedwell, upon the terms of an agreement of 25 September 1863 to Thomas Holloway. *London Gazette* 1865a, 3380; *London Gazette* 1865b, 3450.

86 Fordyce 1885, 6, no. 229.

87 Some of his business partners were his wife's relatives. *London Gazette* 1863, 43.

88 As stated in Boase 1891, 182; Royal Academy of Arts 1912, 14, no. 40. Correct in Lauber 2004, 81, 87; Lauber forthcoming.

89 On George Martin-Holloway's death, he had been living in Tittenhurst, so perhaps his widow and children moved to Whitmore Lodge, or Langton Douglas misremembered the name of their home. See *London Gazette* 1896, 317. The Holloway-Martin-Oliver family's dates of birth and death are derived from the family's gravestones in St. Michael and All Angels Churchyard, Sunninghill, Berkshire.

90 Royal Academy of Arts 1912, 14, no. 41. "St. Francis of Assisi. Giovanni Bellini. Trustees of the Late Miss M.[ary] A.[nn] Driver. Full length figure of the Saint, standing to l. [sic], with arms outstretched under a high cliff in front of his cell, which is seen to the r.; on high ground to the l., beyond a valley in the middle distance, is seen a walled town; blue sky, with clouds. Signed on a label, 'Ioannes Bellinus.' Panel, 49 by 55 in."

91 *Morning Post* 1911.

92 *Daily Telegraph* 1911.

93 *Pall Mall Gazette* 1912.

94 Isabella Stewart Gardner Museum, Boston. Mary Berenson to Isabella Stewart Gardner, Ford Place, Arundel, 27 July 1912. Hadley 1987, 497.

95 See Saltzman 2008.

96 Otto Gutekunst of Colnaghi to Charles Carstairs of Knoedler, 1912. Saltzman 2010, 35.

97 In spring 1912 to Colnaghi & Knoedler from the Driver Collection, Knoedler 1912 inventory, no. 12932, "St. Francis of Assisi, standing before his cell in the attitude of receiving the stigmata"; Sept. 1912–June 1913, sold for £45,000 to Arthur Morton Grenfell (1873–1958), London; June 1913–May 1915, with Knoedler and Agnew, Knoedler 1913 inventory, no. 13260, "St. Francis of Assisi, standing before his cell in the attitude of prayer." See Saltzman 2008 and Saltzman 2010.

98 The sale was discussed between November 1914 and May 1915 in the correspondence of Charles Carstairs of Knoedler Gallery and Lockett Agnew of Agnew's, but there is no record of the offer in the National Gallery's archive. The Getty Research Institute, Knoedler records, 1848–1971.

99 He paid $168,000 in cash and the rest with 367 shares of Columbia Trust Co. stock.

100 16–17 May 1915. Henry Clay Frick Art Collection Files. The Frick Collection/Frick Art Reference Library Archives.

101 *New York Times* 1915.

St. Francis in the Desert: Technique and Meaning (pp. 80–131)

1 Longhi 1949, 277–78; Gibbons 1963; Robertson 1968, 9–12; Goffen 1989, 3–4; Lucco 1990, 410–13; Christiansen 2004a, 53; Humfrey 2004, 5–6; Bellosi 2008, 104; Lucco 2008a, 21; Agosti 2009, 13–15, 23–24, 111–12; Maze 2013.

2 Maze 2013; Brown and Pizzati 2014. It has also been suggested that Giovanni was illegitimate because he was not mentioned in the last will (1471) of Jacopo's wife, Anna Rinversi (summary by Humfrey 2004, 5–6).

3 When Giovanni witnessed a testament of 1459, he was identified as "Iohannes filius magistri Iacobi Belini" (Paoletti 1894–95, vol. 1, 11; Barausse 2008, 334 doc. 16). Jacopo Bellini signed the Gattamelata altarpiece of c. 1455–60 in the names of himself and his sons, Gentile and Giovanni (Callegari 1997, 30).

4 Gentile's will of 18 February 1506 (Venetian calendar): "Ioannem, fratrem meum carissimum" (Eisler 1989, 533; Barausse 2008, 354 doc. 105). Upon the death of Giovanni Bellini in 1516, Marin Sanudo described the artist's burial in SS. Giovanni e Paolo near "Zentil Belin suo fradelo" (Sanudo 1879–1903, vol. 23, 256). Jacopo also had at least one other biological son, Niccolò (C. Brown 1969).

5 Paoletti 1894–95, vol. 1, 11; Barausse 2008, 334 doc. 16.

6 For the artist's training and early career, see Robertson 1968, 14–55; Eisler 1989; Conti 1994; Fletcher 1998; Bellosi 2008; Villa 2008b, 21–37.

7 The analytical results of selected scrapings of the upper paint layers show that *St. Francis* was painted using drying oil: linseed and possibly walnut (see Appendix A). Due to sampling restrictions, it was not possible to study the binding media of the lower layers as comprehensively. Though oil would have been familiar to Bellini as a medium used for glazing over egg tempera, the artist may have begun employing drying oil as a binder more extensively as early as the late 1450s or early 1460s. Oil has been identified as the binding medium in samples of two early works by the artist, the *Dead Christ Supported by Two Angels* and *Transfiguration* (Museo Civico Correr, Venice): see Dorigato 1993, 46, 48, 219. Bellini did not abandon egg tempera wholesale for oil but incorporated both mediums into his practice over time (Volpin and Stevanato 1994, 41; Galassi 1998, 95 n. 128; Wallert and van Oosterhout 1998; Bagarotto 2000, 190–91; Mancuso and Gallone 2004, 138–42).

8 Paoletti 1894–95, vol. 1, 11; Gilbert 1992, 35–36; Degenhart and Schmitt 1990.

9 For Bellini's drawings, see Tietze and Tietze-Conrat 1944, 73–94; Skipsey 1990, 36–39; Fletcher 1998, 136, 144–46; Goldner 2004. Bellini's workshop employed cartoons to transfer and record compositions (Bambach 1999, 101; Golden 2004; Oberthaler and Walmsley 2006, 287–88). A *simile* drawing was made after the landscape background of the artist's *Resurrection* altarpiece (Gemäldegalerie, Berlin) and was subsequently used as a model for several Venetian paintings (Ludwig and Bode 1903, 140–41; Tietze and Tietze-Conrat 1944, cat. 347).

10 Gypsum was identified by analysis (see Appendix A); the medium of the ground was not analyzed but traditionally would have been animal glue.

11 For Bellini's underdrawings, see Dorigato 1993; Galassi 1998; Bagarotto 2000; Bomford 2002; Villa 2003–4, 73–74; Dunkerton 2004; Poldi and Villa 2006; Poldi and Villa 2008; Lucco 2008b; Villa 2009.

12 Lead white was identified by analysis (see Appendix A); the characterization of the medium of the *imprimitura* as a drying oil was based on visual inspection of the picture surface. Lead white pigment (known as *biacca* or *bianco da Venezia*) was an ideal ingredient for primings because its chemical properties accelerated the drying of the oil in this layer; because of its highly reflective quality, which imparted luminosity to the paint above; and because it was a readily available specialty of Venetian color sellers (Bagarotto 2000, 191; Krischel 2002, 128–29; Matthew 2002, 684; Berrie and Matthew 2011). Lead white primings have been reported in numerous paintings by Bellini and other Venetian masters.

13 Visible fingerprints and palm prints belonging to an overall layer of *imprimitura* appear in areas of thin application of paint (especially flesh tones) or abrasion; they cross pictorial zones indiscriminately rather than being confined within particular forms; and they show the stippled texture of suction caused by lifting hands vertically from an oil-containing layer. In X-radiographs, hand-applied primings appear as extensive networks of prints, which are opaque because of the lead content of the white pigment. During surface examination, the authors identified fingerprints and palm prints most likely belonging to an overall priming layer in the following pictures by Bellini: *St. Jerome in the Desert* (Contini Bonacossi Collection, Florence), *Transfiguration* (Museo di Capodimonte, Naples), *Madonna and Child* (National Gallery of Art, Washington, D.C., Kress Collection, 1939.1.352), Rogers *Madonna and Child* (The Metropolitan Museum of Art, New York), *Sacred Allegory* (Galleria degli Uffizi, Florence), Prato *Crucifixion* (Collezione Banca Popolare di Vicenza), *St. Jerome Reading* (The National Gallery, London), and the *Madonna Contarini*, *Madonna dei Cherubini Rossi*, *Madonna and Child between Two Saints*, and *Pietà Donà dalle Rose* (Gallerie dell'Accademia, Venice). A hand-applied *imprimitura* has also been found in the *Death of St. Peter Martyr* (Courtauld Gallery, London; see Fletcher and Skipsey 1991, 5) and *Madonna and Child with St. John the Baptist* (Indianapolis Museum of Art; see Miller 2004, 154, 155 fig. 4). It has been suggested that certain visible handprints in Bellini's works pertain not to the priming but to the artist's texturing of the upper paint layers or blotting of glazes with his fingers; however, our analyses suggest that the vast majority of prints now visible in his works belong to the underlying *imprimitura*.

14 For Bellini's standard use of reserve technique, see Packard 1970–71, 69–75; Bull and Plesters 1990, 61–62, 66–67; Plesters 1993a, 377–78; Bagarotto 2000, 193. The artist frequently combined thin paint layers with a highly reflective white *imprimitura* (Volpin and Lazzarini 1994, 31; Galassi 1998, 61, 64; Hills 1999, 133).

15 Allen 1999, xv.

16 Braham et al. 1978, 22; Goffen 1993a, 18–19; Spezzani 1994, 27–28; Dunkerton 1999, 96; Galassi 2000; Christiansen 2001; Hochmann 2008b, 19.

17 Giovanni C. F. Villa and Gianluca Poldi, verbal communication, November 2011.

18 Wohl 1999, 195.

19 In *St. Augustine in His Study* (c. 1502–7; Scuola di San Giorgio degli Schiavoni, Venice), Vittore Carpaccio portrayed Cardinal Bessarion in the guise of St. Augustine (P. F. Brown 1988, 222; P. F. Brown 1999). Bellini himself portrayed Fra Teodoro of Urbino as St. Dominic (1515; The National Gallery, London; see Christiansen and Weppelmann 2011, 371–73).

20 According to Thomas of Celano, Francis "was of medium height, closer to short, his head was of medium size and round. His face was somewhat long and drawn, his forehead small and smooth, with medium eyes black and clear. His hair was dark; his eyebrows were straight, and his nose even and thin; his ears small and upright, and his temples smooth" (Armstrong, Hellmann, and Short 1999–2002, vol. 1, 253).

21 The Berlin drawing was a preparatory cartoon (pounced for transfer) for the portrait of Gentile in the *Procession in Piazza San Marco* of 1496 for the Albergo of the Scuola Grande di San Giovanni Evangelista (now Gallerie dell'Accademia, Venice; see Tietze and Tietze-Conrat 1944, cat. A261; Fletcher 1990–91, 48; Schulze Altcappenberg 1995, 69–71; Campbell and Chong 2005, 120–21; Christiansen and Weppelmann 2011, 357–59). In June 2012, the authors compared a mylar tracing of the Berlin drawing with the image of Gentile in the *Procession in Piazza San Marco*. The outlines of the drawing closely match those of the figure, indicating that the design was almost certainly preparatory to the Accademia canvas. The drawing is attributed here to Giovanni Bellini on the basis of similarities with the underdrawing of the head of Francis.

22 D. Cooper 2005; Brooke 2006, 454–71. Similarly, after Bernardino da Siena died in 1444, the lack of his body in Siena was assuaged by a local tradition of highly veristic portraits (Israëls 2007).

23 Among those identifying the picture as a stigmatization scene are Crowe and Cavalcaselle 1871/1912, vol. 1, 158–59; Berenson 1916, 98; Moschini 1943, 22, 47; Pallucchini 1959, 66; Meiss 1964; Fletcher 1972; Eisler 1979, 18; Land 1989; Hirdt 1997; Davidson 1998, 119; Hammond 2002, 26; Pächt 2002, 232; Gentili 2004b, 65. Arguments that the picture does not represent the stigmatization or is a conflation of the stigmatization with other events include Hartt 1940, 35; Clark 1949, 24; Turner 1966, 64–65; Robertson 1968, 77; Smart 1973; Fleming 1982; Goffen 1989, 107–11; Janson 1994; Wohl 1999; Wills 2001, 285–90; Lavin 2007; Lugli 2009.

24 Wills 2001, 290; Englebert 1979, 33–41.

25 Lavin 2007, 246.

26 Cristoforo Caselli, *St. Francis of Assisi between St. Louis of Toulouse and the Blessed John Capistrano* (Walters Art Museum, Baltimore). See Wohl 1999, 188.

27 Similar scoring techniques were observed in the *Sacred Allegory* (Galleria degli Uffizi, Florence), *Portrait of Doge Leonardo Loredan* (The National Gallery, London; see Dunkerton 2004, 216), and Prato *Crucifixion* (Collezione Banca Popolare di Vicenza). For Giorgione's use of the same technique, see Oberthaler 2004, 268; Poldi 2009–10, 227.

28 Bellini applied a translucent red glaze over a base of opaque scarlet, a combination also used for the wounds of Christ in the Prato *Crucifixion* (Collezione Banca Popolare di Vicenza). See also Rigon and Dal Pozzolo 2003–4, and Aldrovandi et al. 2007. Red lake over opaque vermilion was a common formula for the depiction of blood in Renaissance painting.

29 Kasl 2004b, 80; van Os et al. 1978, 31.

30 The thin layers of red applied over the thicker, bodied paint of the foot would have been particularly vulnerable to abrasion during cleanings. Another intriguing possibility is that this region became worn due to repeated touching of the foot by reverent spectators, a phenomenon documented with respect to medieval cult statues and other objects of devotion (Jung 2010). The authors thank Xavier Seubert for this suggestion. See also Israëls 2007, 111, and Krüger 1992, 50–56.

31 John 19:34. Many early representations of the stigmatized Francis do not include the side wound (Meiss 1964, 21–22; Cook 1996, 9; Davidson 1998, 106).

32 Armstrong, Hellmann, and Short 1999–2002, vol. 1, 265, vol. 2, 335. For early images of St. Francis that confront "the hidden, unknown, and unknowable nature of his wounds," see Chatterjee 2012.

33 Le Goff 2004, 26–27.

34 Lavin 2007, 246–47.

35 The question of whether the missing segment contained a seraph, crucifix, or related element has been much discussed: Meiss 1964, 27, 48 n. 96; Steer 1965, 533–34; Meiss 1966, 27; Fletcher 1972, 213–14; Lauber 2005, 100–101; De Marchi 2006, 125–26; Lavin 2007, 248; Lugli 2009.

36 Boschini 1660/1966, 344. Boschini indicates that a seraph is present, but he does not actually say that the seraph is wounding Francis and instead quotes the poet Maffio Venier on the stigmatization.

37 For further discussion, see Appendix A.

38 Italian panel paintings of this period often exhibit such variations in construction, resulting from the most efficient use of available wood. Large panel pictures in Renaissance Venice were usually constructed with horizontally oriented boards, whether the compositions were horizontal or vertical: see Dunkerton and Roy 1986, 5; Fletcher and Skipsey 1991, 5.

39 For an example of a painted panel of c. 1490 with intact supporting battens on its reverse, see Dunkerton et al. 1991, 152–53.

40 Conti 2007, 99–137.

41 Lugli 2009, 22–24. For the aims and rhetoric of Boschini's art criticism, see Sohm 1991.

42 Cook 1996, 9; Cook 1999, 156, 224–25.

43 Bonaventure, *Major Legend*: Armstrong, Hellmann, and Short 1999–2002, vol. 2, 632. Repeated in later Franciscan texts, including the *Considerazioni sulle Stimmate di San Francesco*: see Settis 1978/1990, 44; Pratesi and Sabatelli 1982, 232; Israëls 2009a, 138; Seubert 2011, 31.

44 Zoppo's panel originally belonged to a large altarpiece (1471) for the church of San Giovanni Battista in Pesaro. Bellini almost certainly viewed this work, which shows many affinities with his *Coronation of the Virgin* (c. 1472–75) for the high altar of the church of San Francesco in the same city. See Armstrong 1976, 92–110, and Humfrey 1993b.

45 From the *Considerazioni sulle Stimmate*: Pratesi and Sabatelli 1982, 223–24. See Meiss 1964, 24; Elkins 2001, 79–80.

46 The sky of the *Coronation* consists of an azurite underlayer, followed by a layer of ultramarine mixed with varying proportions of white. The gradation from pale to deep blue is achieved at least partly by an increasing quantity of azurite in the underlayer (Poldi 2009, 173; Poldi and Villa 2011, 33–34).

47 Hills 1999, 57–64; Hills 2004, 186–88.

48 Cennini 2003, 103; trans. Cennini 1960, 36. For natural ultramarine, see Plesters 1993b, 37–54. In Venice, specialized "color sellers" (*vendecolori*) ground and purified lapis lazuli to extract the deep blue pigment: see Lazzarini 1983, 136; Krischel 2002, 119–20; Matthew 2002, 680, 682–83.

49 Lazzarini 1983, tav. XV n. 1; Dunkerton and Roy 1986, 10, 26 n. 22; Dunkerton 1994, 65; Poldi et al. 2006, 246, 249.

50 In pictures by Bellini and his workshop whose paint composition has been analyzed, ultramarine is often accompanied by less expensive blues, mainly azurite but also smalt and indigo: see van Os et al. 1978, 16, cats. 2, 4; Bagarotto 2000, 193; Mancuso and Gallone 2004, 132–33, 135; Poldi 2009, 162–76; Poldi and Villa 2011, 34; Manoli and Zanolini 2012, 90. Bellini sometimes used pure ultramarine, modeled only by the admixture of lead white, for blue draperies: examples include the rich mantle of the Morelli *Madonna* (Accademia Carrara, Bergamo; see Poldi 2009, 173), the draperies of the Madonna and one of the angels in the San Giobbe altarpiece (Volpin and Lazzarini 1994, 32, 34 n. 3, 35 n. 7), and the costumes of several figures in the *Feast of the Gods* (Bull and Plesters 1990, 62–63; Plesters 1993a, 381).

51 Lucas and Plesters 1978, 40; Dunkerton 2003, 46–47.

52 Pratesi and Sabatelli 1982, 232. Accounts of the illumination of Mount La Verna at the stigmatization date back at least as far as 1282 and may have originated in oral legends (Meiss 1964, 47 n. 85; Frugoni 1993, 160–61). For the supernatural light in Bellini's painting, see Mather 1936, 99; Dussler 1949, 22; Land 1989, 304; Hirdt 1997; P. F. Brown 1999, 513.

53 *St. Francis* exemplifies the artist's movement away from the use of gold and toward yellow pigments over the course of his career (Poldi 2009, 194–96). Especially in his early works, the painter did employ gold to varied effect (Dorigato 1993, 127, 131; Dunkerton 2004, 197; Manoli and Zanolini 2012, 89–90).

54 First observed by Meiss 1964, 27.

55 Poldi and Villa 2008, 245–48; Poldi 2009, 207–13; Mazzotta 2012, 42–87. For Giorgione's and Titian's innovations in oil painting, see, for example, Rosand 1981 and Ilchman et al. 2009. Wilson defines Bellini's role in the development of the Vasarian *maniera moderna* (Wilson 2004). Already in the eighteenth century, Zanetti cautioned against considering Bellini a follower of the younger generation of painters (Zanetti 1771/1972, 47).

56 The nature and sources of light in *St. Francis* have been much debated: see Crowe and Cavalcaselle 1871/1912, vol. 1, 159; Hendy and Goldscheider 1945, 27; Meiss 1964, 26–27; Turner 1966, 60; Frick 1968, 203; Robertson 1968, 77; Fletcher 1972, 212 n. 25; Pochat 1973, 352; Fleming 1982, 129–30; Land 1989, 302; Hirdt 1997, 45–56; Land 1998, 21; Wohl 1999, 195, 198 n. 48; Villa 2008b, 134.

57 Pasolini 2003, vol. 2, 294.

58 In the Pesaro altarpiece, the shadows of Christ's foot and St. Paul's sword are incised (Bertorello and Martellotti 1988, 89, 91). In the *Sacred Allegory* (Galleria degli Uffizi, Florence), Bellini incised vertical lines to plan the pattern of reflections on the glassy surface of the lake; he also incised one edge of the shadow cast by the left foot of Job (observed from the picture surface, July 2010).

59 Plesters 1993a, 381; Mancuso and Gallone 2004, 133; Berrie and Matthew 2006, 303; Oberthaler and Walmsley 2006, 288.

60 Barolsky 1996 and 1997. For the visionary and symbolic functions of light, see Meiss 1945, Gombrich 1976, and Hills 1987.

61 Billinge 2009a, 372–73; Billinge 2009b, 14–16; Toyama 2009, 311–15.

62 Wilson 1977, 119–20.

63 Wilson 1977, 161–209; Janson 1994. For the symbolism of Bellini's sacred landscapes, see Goffen 1975, 503–4; Battisti 1991; Gentili 2004a; Grave 2004, esp. 43–86; Blass-Simmen forthcoming.

64 For walled cities in the Veneto, see Bortolami 1988. In a letter of 25 June 1501, Michele Vianello informed Isabella d'Este that Bellini was "at the villa" (Brown and Lorenzoni 1982, 159; Fletcher 1971, 704). For topographical views in Bellini's works, see Gibbons 1977; Fletcher 1991, 778; Rigon 2003–4; Lucco 2004, 78.

65 Frizzoni identifies the townscape behind Francis as Assisi (Frizzoni 1884, 168), but Gibbons argues that "the fortified village of the Frick *St. Francis* cannot be identified today, nor can one say with certainty that this exact village existed in the artist's own time" (Gibbons 1977, 180). The townscape does show similarities to Montagnana, Soave, Este, Asolo, and Marostica (see Bortolami 1988). However, as far as can be determined from surviving structures, the artist has not portrayed any specific city in the region.

66 Armstrong, Hellmann, and Short 1999–2002, vol. 2, 249.

67 Traces of underdrawing are also visible in the landscapes of the *Sacred Allegory* (Galleria degli Uffizi, Florence) and *St. Jerome Reading* (National Gallery of Art, Washington, D.C.).

68 Boschini identifies the mountain in *St. Francis* as La Verna (Boschini 1660/1966, 344). See also *New York Times* 1915; Meiss 1964, 22; Fleming 1982, 32; Gentili 2004b, 65. Bellini may have taken an extended trip along the Adriatic coast to Pesaro in the 1470s (Gibbons 1977, 179–81; Christiansen 2009, 28). This journey could have included a pilgrimage to Mount La Verna, located about 75 miles from Pesaro (Meiss 1964, 22; Di Vito forthcoming). Close to La Verna was Borgo San Sepolcro, which Bellini may also have visited (Longhi 1914, 241–56). Other sources suggest that the artist ventured as far south as Rome (Fletcher 1990, 170, 172–74). Given the highly circumstantial evidence of Bellini's travels, some scholars have argued against the identification of the cliff in *St. Francis* as Mount La Verna: Turner 1966, 60; Lavin 2007, 244.

69 Pratesi and Sabatelli 1982, 218–19.

70 Heers and de Groër 1978, 483–85; de Groër 1987, 82; van Asperen de Boer et al. 1997; Lucco 2004, 82–85. Nuttall, however, suggests that a version of van Eyck's painting was known in Italy before Adornes's pilgrimage (Nuttall 2000, 175–80). The townscape of *St. Francis* also shows affinities with the view of Jerusalem in the background of an Eyckian *Crucifixion* that was present in Padua by the mid-fifteenth century (Campbell 1981, 468; Aikema and Brown 1999, 202–3).

71 The artist sometimes added blue pigments to render distant rocks in aerial perspective, for example, in *St. Jerome Reading* (The National Gallery, London). However, the composition of the foreground cliff in *St. Francis* is apparently unique in the artist's surviving oeuvre. The authors thank Gianluca Poldi and Giovanni C. F. Villa for comparative discussion of this subject.

72 Matthew 17:1–2; Mark 9:2–3; Luke 9:28–29. See Fleming 1982, 94.

73 Allen 1999, xxiii.

74 Hammond 2007. Di Vito forthcoming interprets the bird as a symbol of Venice. Fleming, however, identifies the bird as a bittern and an allusion to the biblical *nycticorax* (Fleming 1982, 41).

75 Armstrong, Hellmann, and Short 1999–2002, vol. 2, 705. For the fountain in Venetian Renaissance art and its relation to the mechanisms of imagination, see Bass 2010. A similar motif of a small bird near a water spout appears in Cima da Conegliano's *St. Jerome in the Desert* (c. 1495–1500; Harewood House, Yorkshire; see Villa 2010, 118–21).

76 Boschini 1660/1966, 665.

77 Bellini's Prato *Crucifixion* (Collezione Banca Popolare di Vicenza) depicts more than thirty identifiable botanical species (Giulini 2003–4; Lucco 2006, 308).

78 The authors thank Deirdre Larkin, Associate Managing Horticulturist at the Cloisters, the Metropolitan Museum of Art, New York, for identifying the flora in *St. Francis*. See also Di Vito forthcoming.

79 Ridolfi 1648/1965, 64; Humfrey 1985.

80 The *Laurus nobilis* was considered indestructible by fire and associated with eternity, the

Resurrection, and the wood of the Cross; it was also related to the concept of the Cross as *lignum vitae* (tree of life) and the cult of the Immaculate Conception of the Virgin (Levi d'Ancona 1977, 201–4; Eisler 1979, 21; Goffen 1989, 111; Land 1989, 301–2; Lugli 2009, 29–47). Fleming and Hirdt associate the laurel in the Frick picture with the burning bush through which God appeared to Moses (Fleming 1982, 49–56; Hirdt 1997, 21–23).

81 Gamba 1937, 108, was perhaps the first to suggest that Bellini's tree concealed an initial iteration of a seraph or other holy apparition.

82 Lugli 2009, 29–47.

83 Luke 23:31. See Land 1989, 301; Bennett 1926; Levi d'Ancona 1977, 382–83.

84 Pratesi and Sabatelli 1982, 214. See also Meiss 1964, 23, and Robertson 1968, 77.

85 Armstrong, Hellmann, and Short 1999–2002, vol. 2, 325. The donkey has been identified as an onager, or wild ass, and also as an ordinary domestic donkey (*Equus asinus*): see Meiss 1964, 23; Fleming 1982, 5, 38–41; Levi d'Ancona 2001, 55–59; Hammond 2002.

86 Campori 1874, 589–90. See also Shapley 1945, Tietze-Conrat 1946, and Friedmann 1947.

87 For interpretations of the gray heron (sometimes identified as a crane), see Meiss 1964, 23; Frick 1968, 203; Fleming 1982, 41–44; Hammond 2007, 36; Lavin 2007, 244; Di Vito forthcoming. For the rabbit, see Fleming 1982, 44–46, 60–62; Wohl 1999, 195; Wills 2001, 290; Boskovits and Brown 2003, 73.

88 First observed by Maryan Ainsworth, examination of the painting with infrared reflectography, October 1986.

89 Bellini sometimes painted details such as hanging draperies and tree branches over the landscape background "because it would have been tedious and fiddling to leave such small areas in reserve" (Bull and Plesters 1990, 62). Conceivably, this is the logic that governed the artist's inclusion of the bird and rabbit of *St. Francis* without underdrawing or reserve technique.

90 Pratesi and Sabatelli 1982, 211.

91 de Voragine 1993, vol. 1, 278; Lavin 2007, 239.

92 Pratesi and Sabatelli 1982, 230; Armstrong, Hellmann, and Short 1999–2002, vol. 2, 631.

93 Derbes 1996, 17–19.

94 The fact that Bellini rarely made major changes to the content of his paintings invests such revisions with additional significance. A case similar to the desk of *St. Francis* is the *Sacred Allegory* (Galleria degli Uffizi, Florence), in which the figure of St. Sebastian was added over the pavement and balustrade in the background, as revealed by the X-radiograph and infrared reflectogram. See Coltellacci and Lattanzi 1981, 64–65; Poldi and Villa 2006, 391; Signorini 2006, 85.

95 According to Meiss, the skull's connection with St. Francis "seems to begin in the Frick panel," except for the image of a skeleton in a fresco in the Lower Church of the basilica of San Francesco at Assisi (Meiss 1964, 20, 46 n. 49). A skull is also depicted in the fresco of the *Allegory of Obedience*, vault of the Lower Church, Assisi, and a skeleton appears next to the image of St. Anthony in the chapter hall of the Santo in Padua (Louise Bourdua, written communication, June 2013). Bellini's interest in this theme is suggested by an independent picture, recently attributed to the artist, of a skull as *memento mori* (now in a private collection; see Tempestini 2008, 54–55).

96 Demus 1988, 122; Cook 1996, 9. For other early images of Francis holding a cross, see Cook 1999, 42, 83, 85–86, 131–32. Francis holds a cross in the main field of Bellini's Pesaro altarpiece.

97 The authors thank Denise Allen for this identification. The Lombardo family completed additional work for the interior of the church (Cicogna 1860–61, 530; Dittmar 1984). A *terminus ante quem* of January 1474 for the completion of the portal sculptures is suggested by a document of that date relating to the construction of the church of San Bernardino in Verona, whose portal is a faithful copy of that at San Giobbe (Ceriana 1992–93, 23, 37 n. 14; but see Schulz 2010–12, 231, for further discussion of this evidence). In 1475, the humanist Matteo Colacio praised Pietro Lombardo's sculptures for San Giobbe (Cicogna 1860–61, 531; Savettieri 1998, 20–21). His remarks strongly suggest that Lombardo's contributions to the church decoration were complete by this time, shortly before Bellini began work on *St. Francis*.

98 Meiss 1964, 19–21; Fletcher 1972, 213.

99 Northern Italian painting in the mid-fifteenth century saw an "iconographic combination" of Francis and Jerome, with the image of Francis receiving the stigmata often joined to that of Jerome repenting in the desert (Bisogni 1985, 234–36).

100 In April 1499, Sanudo recorded that Michiel took part in a theological dispute and described him and other participants in the debate as "doctissimi in philosofia" (Sanudo 1879–1903, vol. 2, 579–80; see also Fletcher 1972, 209 n. 5, and Wohl 1999, 192).

101 Described in the 1556 will of his son, Dario: "altar di marmori con una immagine in pittura de messer San Jeronimo" (Battilotti and Franco 1978, 60–61; Settis 1978/1990, 154; Anderson 1997, 148, 352 n. 51; Vescovo 2000, 123 n. 18). The same picture is described in the 1611 will and codicil of Dario's son (Lauber forthcoming). The painting above the Contarini family altar has been identified with a picture of "San Hieronimo nel deserto" by Giovanni Bellini on the left side of the nave (Sansovino 1581/2002, 63r.; Howard 1989, 685; Humfrey 1993a, 218; Lauber 2005, 101; Lauber 2008, 264).

102 Rearick 2003, 181; Paolucci et al. 2005–6, 218; Lauber 2005, 101; Lauber 2008, 264; Christiansen 2013.

103 Le Goff 2004, 11. See also Merlo 1989 and Flora 2009, 19–20.

104 Wills 2001, 289. According to the *Considerazioni sulle Stimmate*, when Francis was living alone on Mount La Verna he asked Brother Leo to visit daily to say matins with him (Pratesi and Sabatelli 1982, 222–23). The bell also recalls images of wilderness saints from the circle of Ercole de' Roberti (Allen and Syson 1999, xxviii–xxix, xxxvi–xxxvii).

105 This difference is visible in the infrared reflectogram, in which the upright poles of the shelter appear light because they were left in reserve, whereas the grafted branches holding the bell were added on top of the background cave and are consequently much darker.

106 For the anecdote of Joachim Camerarius, a humanist and friend of Dürer, see Rupprich 1956, 309; and Dürer/Fry 1995, 103. As discussed by Smith 1972, the episode resonates with the legendary rivalry of Apelles and Protogenes recounted by Pliny the Elder (*Natural History* 35.36.81–83; see Pliny/Rackham 1952, 321–23, and McHam 2013).

107 The painter's assertion of his epochal talent is all the more fitting in light of early comparisons between Bellini and Apelles: see Sciolla 1993; Goffen 1989, 1; Ziliotto 1950, 78.

108 Letter of 16 July 1504 from Lorenzo da Pavia to Isabella d'Este: "tuti che à visto questo quadreto, ogneuno l'à comendato per una mirabile opera, et è ben finite quele cose è da vedere per sotile" (Fletcher 1971, 710; Brown and Lorenzoni 1982, 84; Land 1994, 117). The authors thank David Alan Brown and Giada Damen for discussing this letter.

109 Christiansen 2004b, 47–51.

110 Bellini inscribed dates on only a few of his pictures, and his earliest such work, the *Madonna degli Alberetti* of 1487 (Gallerie dell'Accademia, Venice), falls later in his career. In the eighteenth century, Zanetti reported that the artist's *Pietà*

in Venice's Palazzo Ducale carried an inscription of the date 1472, but this is no longer evident on the heavily damaged work (Zanetti 1771/1972, 48–49; Goffen and Nepi Scirè 2000, 153; Poldi and Villa 2008, 66–101).

111 Datings of *St. Francis* include c. 1475–80 (Robertson 1968, 76; Gentili 2004b, 65; Lavin 2007, 231; Bätschmann 2008, 110); c. 1478 (Heinemann 1962, 65); c. 1480 (Dussler 1949, 89; Bottari 1963, vol. 1, 39; Humfrey 2008, 73; Villa 2008b, 131); c. 1480–85 (Pignatti 1969, 97); c. 1481 (Berenson 1916, 100–102); c. 1475–85 (Wohl 1999, 193); c. 1487 (Rearick 2003, 183).

112 Lucco and Villa 2008, 192. Fahy 1964 argues for a later date; the full execution of the altarpiece may have spanned a number of years, as suggested by a document of 1476 recording a bequest toward the costs of the work (Valazzi 1988a, 35). See also Wilson 1977, 306–16, 490–92; Wilson 1989; Valazzi et al. 2009; Poldi and Villa 2011. For the medium of the altarpiece, see Laurenzi Tabasso 1988, 143.

113 *St. Francis* measures 124.6 x 142 cm; the Berlin *Resurrection* 147.5 x 128.8 cm, similar to *St. Francis* but rotated 90 degrees (Lucco and Villa 2008, 208); the Naples *Transfiguration* about 115 x 154 cm (Dalhoff 1996, 28, 188 n. 81). See also Huse 1972, 38; Christiansen 2013. The artist may have purchased panel supports from a carpenter in batches of stock size (Fletcher and Skipsey 1991, 5).

114 For the medium of the *Resurrection*, see Sansovino 1581/2002, 86r.; Lucco and Villa 2008, 208; Poldi 2009, 202. The predominant oil medium of the *Transfiguration* is evident from its handling, particularly passages of wet-in-wet manipulation of paint, and from extensive areas of glazing; see Dalhoff 1996, 28, and Villa 2008a, 51 n. 25.

115 The underdrawings of the *Transfiguration* and the *Resurrection* were observed by the authors with a Nikon Coolpix 995 camera adapted to infrared use, with an 830 nm band-pass filter. See also Villa 2003–4, 75–76, 81; Poldi and Villa 2006, 362–68; Villa 2008a, 40, 49; Villa 2009, 66–69.

116 Mills and White 1977, 58; Dunkerton 2004, 196–98.

117 For the Copenhagen *Man of Sorrows*, see Martineau et al. 1992, 243; Fletcher 1993, 19; Agosti and Thiébaut 2008, 232–35.

118 Martineau et al. 1992, 189–90; Fletcher 1993, 21, 23.

119 Hills forthcoming.

120 Christiansen 1992, 71–73; Galassi 1998, 49–52, 61–62, 117–20.

121 This sequence of the three pictures has been

proposed by Longhi 1949, 281–82; Pallucchini 1959, 65–70; Robertson 1968, 75–76, 91–92; Pignatti 1969, 96–97; Humfrey, Lucco, and Villa forthcoming. Meiss argues that the Frick *St. Francis* is the most Mantegnesque of the three paintings and was executed first, followed by the *Resurrection* and then the *Transfiguration* (Meiss 1964, 18–19). Lucco dates *St. Francis* before the *Resurrection* (Lucco 1990, 446–48), as does David Alan Brown (verbal communication, 2011). Berenson argues for dating both the *Resurrection* and *Transfiguration* before *St. Francis* (Berenson 1916, 100–102).

122 Ludwig and Bode 1903 (for corrections, see Goffen 1989, 310–11 n. 37–38); Meneghin 1962, 301–2, 302 n. 14. Humfrey argues that the documentary evidence does not confirm the altarpiece's installation by 1479, but he agrees with a date of c. 1476–79 on stylistic grounds (Humfrey 1993a, 220, 346). See also Lucco and Villa 2008, 208–10. Bellini's workshop was also responsible for a second altarpiece for San Michele (Fletcher and Mueller 2005).

123 Most scholars propose a wider window between 1475 and 1479 (Pignatti 1969, 96; Tempestini 1992a, 112; Fletcher 1993, 21; Poldi and Villa 2006, 364; Lucco and Villa 2008, 208; Agosti 2009, 135).

124 Arslan 1956, 28; Arslan 1962, 47–48; Dal Pozzolo 2003–4, 15–19.

125 Dalhoff 1996, 35–36, 191–93 n. 100–101; Wilson 2008, 127. See also Tempestini 1992a, 147–48; Pallucchini 1949, 136.

126 See "'The Footprints of Our Lord': Giovanni Bellini and the Franciscan Tradition" in this volume. For the dating of the altarpiece, see Goffen 1986a, 65; Fletcher 1991, 778; Tempestini 1992a, 150–52; Humfrey 1993a, 347; Schmidt Arcangeli 1998; Finocchi Ghersi 2003–4, 11–77; Villa 2008b, 120.

127 Volpin and Lazzarini 1994; Volpin and Stevanato 1994; Dunkerton 2004, 210–13.

128 Lorenzi 1868, 88–89, doc. 192; Huse 1972, 56–71; Wolters 1983, 161–206; Agosti 1986.

129 Dunkerton 2004, 213–15.

130 Gibbons 1965; Skipsey 1990, 36–39; Gentili 1991; Golden 2004; Tempestini 2004.

131 For the "strada lunga" of Bellini's development, see Longhi 1946, 12–13.

St. Francis in the Desert **and the Art of Linear Perspective** (pp. 132–53)

1 St. Bonaventure of Bagnoregio, *Itinerarium Mentis in Deum/Journey of the Mind into God*, translated by Simon Wickham-Smith in 2005 from the

Quaracchi edition of the *Opera Omnia S. Bonaventurae*, vol. 5, 1891, 295: Faculty.uml.edu/rinnis/45.304%20God%20and%20Philosophy/ITINERARIUM.pdf. See also documentacatholicaomnia.eu/04z/z_1221-1274__Bonaventura__Itinerarium_Mentis_in_Deum__LT_EN.pdf.html.

2 Fleming 1982, 31.

3 For the interpretations of the painting's subject, see "'The Footprints of Our Lord': Giovanni Bellini and the Franciscan Tradition" in this volume.

4 Christiansen 2004a, 59; Christiansen 2004b, 47–51; Gentili 2004a.

5 Alberti and Sinisgalli 1435–36/2011 was consulted for this essay. See also Alberti and Sinisgalli 2006.

6 Alberti and Sinisgalli 1435–36/2011, book 1, paras. 19–20, 39–42.

7 For explanations of the Albertian centric-point method, see Edgerton 2009, 117–25; Edgerton 1975, 42–47; Field 1997, 25–29.

8 Alberti and Sinisgalli 1435–36/2011, book 1, paras. 19, 39.

9 Fletcher 2004, 37; Agosti 2009, 17; Savettieri 1998, 17.

10 Agosti 2009, 26; Eisler 1989, 448.

11 Agosti 2009, 26–27.

12 Eisler 1989, 446–47; Clagett 1976, 5–10, 22, n. 66, 23–24.

13 Eisler 1989, 448–49; Fletcher 2004, 35, 37–38; Agosti 2009, 17, 26–28.

14 Blass-Simmen forthcoming; Israel 2007, 280–89; Zorach 2011, 114–18, 121.

15 Finocchi Ghersi, Gentili, and Corsato 2007, 28.

16 For Leonardo, see, most recently, Fiorani and Nova 2013. For Piero, see Field 2005. Both publications provide thorough bibliographies on the literature dedicated to Renaissance optics and linear perspective.

17 Fletcher 1998.

18 Dunkerton 2004.

19 Eisler 1989, 444; Christiansen 2004b, 39–41; Lucco 2004, 83–85.

20 The infrared examination of *St. Francis in the Desert* revealed no evidence of a centric-point or a perspective structure in the underdrawing. See Appendix A in this volume.

21 For the interpretive character of perspectival reconstruction diagrams and for the potential for error in drafting them based on photographs, see Raynaud 2006, 411–30.

22 Godla developed and drafted the perspective reconstructions for this essay. The text was written by Allen in collaboration with Godla to explain the proposed reconstructions. The authors would like to thank Rocco Sinisgalli for

reviewing the diagrams and for his generosity and enthusiasm. Any errors in fact or interpretation are the authors' own.

23 Eisler 1989, 77–104; Degenhart and Schmitt (1990, vol. 5, 103–5) place the Paris album first (c. 1430–60), to be overlapped and followed by the London album (c. 1455–70). See P. F. Brown 1996, 118.

24 Edgerton 1966, 375–77; Edgerton 1975, 50–55; Degenhart and Schmitt 1990, vol. 5, 34–94; Godla forthcoming.

25 Christiansen 2004a, 52.

26 Alberti and Sinisgalli 2006, 67–71.

27 Eisler 1989, 448; Alberti and Sinisgalli 2006, 29–35.

28 Eisler 1989, 443, 444–50; also essential for Jacopo Bellini and perspective, Degenhart and Schmitt 1990, vol. 5, 49–53, 59–94.

29 Field 1997, 25–26; Alberti and Sinisgalli 1435–36/2011, book 1, paras. 19, 39.

30 Eisler 1989, 444; Degenhart and Schmitt 1990, vol. 5, 49–53.

31 For explanations of the distance-point or bifocal method on which discussion of this diagram is based, see Field 1997, 29–32; Edgerton 2009, 61–65; Edgerton 1975, 47–49.

32 Field 1997, 35.

33 Edgerton 1966, 374. Degenhart and Schmitt (1990, vol. 6, 514–15) indicate that the preceding drawing in the British Museum album (1855,0811.75 v.)—facing the Crucifixion at left and illustrating a landscape with a tower, shepherd, and tree—is a continuation of the Crucifixion scene (1855,0811.76r.). However, if these drawings were to be placed side by side, the horizon lines would not align, and they would have two distinctly different perspective schemes with disparate vanishing points. The lightly rendered mountains on the right edge of f. 75v. provide the only possible link to the Crucifixion.

34 Edgerton 1966, 375; Eisler 1989, 445.

35 Edgerton 1966, 375, fig. 5. For a different interpretation of Jacopo's understanding of Albertian perspective, see Degenhart and Schmitt 1990, vol. 5, 59–68, 84–93.

36 See n. 7 above.

37 See Alberti and Sinisgalli 1435–36/2011, book 1, paras. 19, 39–40.

38 Edgerton 2009, 25–29.

39 Alberti and Sinisgalli 1435–36/2011, book 1, paras. 6, 30; Edgerton 1975, 84–87.

40 Alberti and Sinisgalli 1435–36/2011, book 1, paras. 19, 39; Edgerton 2009, 119.

41 Alberti and Sinisgalli 1435–36/2011, book 1, paras.

20, 41; Edgerton 1975, 44–46; Edgerton 2009, 120–21; Massey 2007, 44–45.

42 *Coronation of the Virgin*, the main panel of the Pesaro altarpiece, has a conceptual viewing distance of approximately 5.2 m. This distance, which is far greater than the measure from the painting's centerline to its edge—the conventional limitation of the bifocal method—suggests that the Albertian method was employed. The long viewing distance combined with a low horizon line creates a very gradual recession into depth. Observed from a 5.2 m distance, the painting fills a sliver of the viewer's visual field, only 23 of the 90 degrees that viewers are capable of seeing, providing an intimacy to the depicted scene despite its grand size.

43 Edgerton 1966, 371–72; Edgerton 1975, 45.

44 The orthogonal lines descending from the vanishing point to the units of measurement on the bottom edge of the drawing have not been illustrated.

45 As illustrated in the diagram, the viewing distance is three units of measurement from either side of the vanishing point and thus falls within the drawing. See also Degenhart and Schmitt 1990, vol. 6, 302–3. For Leonardo da Vinci's dissatisfaction with the distortions caused by choosing a short viewing distance using the centric-point method and for his proposed solutions to this problem, see Ackerman 1978/1991, 98–102; Veltman 1986, 161–65; Massey 2007, 44, 49.

46 Christiansen 2004b, 39. The following discussion is indebted to Christiansen 2004a, 58–59.

47 Christiansen 2004b, 39.

48 No evidence of a centric-point or perspectival structure was detected in the infrared. The authors would like to thank Rachel Billinge.

49 *Christ Nailed to the Cross*, with its distance points within the drawing, and *Agony in the Garden*, with its distance points at the painting's edge, might well have been laid out using the bifocal system. Giovanni combined aspects of the bifocal and Albertian methods so seamlessly that differentiating between the two is sometimes impossible. Giovanni must have known that moving the distance point in a bifocal construction has the same effects as moving the intersection of the picture plane (viewing distance) in an Albertian structure.

50 Pélerin (Viator) 1505. For a similar overlay of Pélerin's diagram, see Brion-Guerry 1962, 195, fig. 65; Zorach 2011, 117. For the connections between Pélerin and Jacopo Bellini, see Eisler 1989, 448.

51 Edgerton (1966, 372–75; 1975, 46–49; 2009,

120–23) and Field (1997, 37–40) suggest Alberti's recommendation of this rule-of-thumb test indicates that the artisanal bifocal technique may have informed the development of his centric-point method.

52 Field 1997, 149–50. "Not until the publication of Jacopo Barozzi da Vignola's *Le Due Regole* by Egnatio Danti in 1583 was there an illustrated explanation of the ostensible difference, as well as correlation between Alberti's centric-point system and the distance-point method" (Massey 2007, 51). For Massey's complete discussion, see 44–54.

53 See Appendix A in this volume.

54 See "*St. Francis in the Desert*: Technique and Meaning" in this volume.

55 The 2.4 cm differential between the current height of the panel (124.6 cm) and the proposed reconstruction (127 cm) is the combination of the amount that was cut from the top edge and shrinkage spread across the entire height of the panel. Charlotte Hale suggests the panel shrank as much as 2.5 cm in height (see n. 5 in Appendix A in this volume), leaving the possibility that little more than the unpainted edge was cut away. For the derivation of the original height of the panel as 127 cm, see n. 60 below.

56 See "*St. Francis in the Desert*: Technique and Meaning" in this volume.

57 The following discussion is indebted to Puttfarken 2000, 29–30; 89–96. See also Land 1998, 18–24.

58 See "*St. Francis in the Desert*: Technique and Meaning" in this volume.

59 For the painting's possible original location, which would also have informed Giovanni's planning of its perspective structure, see "The Desert and the City: Marcantonio Michiel and the Early History of *St. Francis*" in this volume.

60 The 127 cm height of the panel inscribed in the circle was arrived at through some reverse engineering and simple plane geometry. The radius of the circle is based on the measure from the left distance point to the centerline of the panel (95.2 cm). The side edges of the panel are original, and, since wood is dimensionally stable in that direction, we assume the panel's width is unchanged. A rectangle 142 cm wide was placed with its lowest corners intersecting the circle and was extended upward until its top corners did as well. The resulting height was 127 cm.

61 The castles and other buildings are located beyond the point where the transversals are useful as indicators of spatial depth; however, the receding planes of the architecture have vertices on or near the left vanishing point.

62 As explained in "*St. Francis in the Desert*: Technique and Meaning" in this volume, the gray heron depicted in profile was "composed later in the painting process" and was not underdrawn. Giovanni may have added this prominently placed creature to slow the composition's spatial recession.

63 See, for example, Daly Davis 1980, 183–200.

64 For Pietro Bembo's famous characterization of Bellini's inventive process, see Keith Christiansen's Foreword in this volume and Christiansen 2004b, 47, 56 n. 49.

The Formative Stimulus for Bellini's *St. Francis in the Desert*: History and Literature of the Franciscan Movement in Late Medieval Italy (pp. 154–67)

1 The literature on Francis of Assisi is exhaustive. The most recent historically grounded monographic treatments are Manselli 1980/1988 and Vauchez 2009/2012.

2 The classic history of the Order of Friars Minor in English is Moorman 1968/1988. A more recent study is Merlo 2003/2009.

3 Clare of Assisi and her Poor Clares have been less well served in scholarship until recently: see Bartoli 1989/1993; Peterson 1993; Alberzoni 2004.

4 There has yet to be a first-rate synthetic treatment of the development of the Franciscan Third Order or Order of Penitents. For work centered on the relationship of Francis of Assisi and the earliest penitents, see, for example, Rivi 1989/2001.

5 For a survey of this phenomenon, see Pazzelli 1993 and, more recently, Carney, Godet-Calogeras, and Kush 2008.

6 Unfortunately, most of the major monographs on the history of the Friars Minor use the poverty question as the centerpiece for reading the Franciscan story. While acknowledging the centrality of the observance (and non-observance) of poverty in the history of the Order, one must also take account of the larger dynamics of its existence and consider the numerous contributions of the friars to church and society throughout the ages.

7 See Cusato 2005, esp. 343–51.

8 Two recent treatments of the early phases of the poverty controversy (late thirteenth and early fourteenth centuries) are Burr 2001 and Cusato 2002.

9 On the clash between the papacy and the Order over the question of poverty and obedience, see Lambert 1998 and Gál and Flood 1996, 1–61.

10 The standard work in English on the Observant Reform movement is still Nimmo 1987; see also Merlo 2003/2009, 319–408. On Conventualism, see Odoardi 1975 and Cusato 2002, 66–80.

11 The history of the Observant Reform movement is complex. In addition to its development within Italy, there were expressions of a similar spirit, which arose independently of events in Italy, in both northern and central France and Spain. Here I limit my observations to happenings on the Italian mainland.

12 Nimmo 1987, 520–31, 593–96, 604–34.

13 Merlo 2003/2009, 349–87, esp. 368–77; Nimmo 1987, 604–10, 631–34.

14 The following survey represents a distillation and synthesis of materials culled from a variety of sources that sometimes conflict with each other on the details of the historical (or mythical) foundation and development of these Franciscan convents and churches.

15 On the Frari, see Sartori 1947; Ungaro 1968; Marini 1979; Goffen 1986b; Gatti 1992; Augusti Ruggeri and Giacomelli Scalabrin 1994; Howard 2002, 81–85.

16 On San Giobbe, see Finotto-Canossiano 1971; Gallo and Nepi Scirè 1994; Finocchi Ghersi, Gentili, and Corsato 2007; Israel 2007.

17 Da Vicenza 1865; Bianchi and Ferrari 1970; Ferrari 1990; Ferrari 1992.

18 Foscari and Tafuri 1983; Ferrari 1992, 62–67; Howard 2002, 81; Onda 2008; Lavin 2013, 18–22.

19 Howard 1987, 64; Rosand 2001, 47–95; T. Cooper 2005, 96–97; de Maria 2010, 9, 75.

20 Lavin 2013, 24.

21 See "The Desert and the City: Marcantonio Michiel and the Early History of *St. Francis*" in this volume.

22 Fleming 1982, 1–11.

23 Fleming 1982, 11–25, which lays out the principal arguments about Francis's place in history based on the stigmata. This is complemented by his detailed analysis and exposition especially in Chapter 2 ("The Desert, Moses and Elijah," 32–74) and Chapter 5 ("The Angel of the Sixth Seal," 129–57).

24 The standard work on Francis as *alter Christus* and Angel of the Sixth Seal is da Campagnola 1971.

25 Vorreux 1977/1979; Cusato 2006 (reprinted in Cusato 2009 but without the color reproductions of the *chartula*).

26 *Itinerarium Mentis in Deum* I, 3: "Haec est igitur via trium dierum in solitudine." Indeed, this first chapter has as its title "Incipit speculatio pauperis *in deserto*" (Bonaventure of Bagnoregio 1938).

27 The rebirth of Franciscan studies is usually (if slightly inaccurately) attributed to the publication of the famous *Vie de Saint François* by the Protestant pastor Paul Sabatier in 1894. Sabatier's biography opens with an extended essay detailing his methodology, namely, to base his portrait not upon the official biographies (which he believed to be tainted by a clerical, if not papal, reorientation of Francis's vision) but rather upon the testimonies garnered from the companions of Francis (those "who were with him and heard him speak"). This methodology—and the resulting portrait of the Poverello—were immediately countered by the Franciscan Order and the Catholic Church in general. And they set in motion a scramble to rediscover sources from the medieval tradition that would bolster the positions of one side over those of the other—hence, the renaissance of Franciscan studies and the emergence of the "Franciscan Question" of the relative historical veracity of the various medieval sources.

28 The *Legenda Maior* was commissioned from the Minister General at the General Chapter of Narbonne in 1260 and accepted by the General Chapter of Pisa in 1263. The official status of the *Legenda* was decreed at the next chapter, in Paris, in 1266. Scant evidence for its proceedings exist; but for the official text, see Cenci 2003, 311, ∫ 12.

29 Bartholomew of Pisa 1906–12.

30 The text of the *Fioretti* still used as the edition of reference is Bughetti 1925 (for the *Considerazioni sulle Stimmate di San Francesco*, see Bughetti 1925, 190–250). The standard English translation is R. Brown 1958, 171–216 (reprinted in the classic *Omnibus of Sources*: Habig 1973, 1429–74, 1525–29).

31 It is important not to overemphasize the contrast between the alleged "historicity" of Bonaventure's account and that of the much later *Considerazioni* since the latter text is based upon the highly symbolic account presented in the *Vita Prima* of Thomas of Celano (1229) and since both Thomas *and* Bonaventure give us theologized presentations of the events on La Verna. There is, in short, no purely historical account of the stigmatization of Francis.

32 The Italian word *considerazioni* is probably best translated as "reflections." For all citations from the work, I will first give the pagination in the Italian Bughetti edition, followed by that in the English translation reprinted in Habig's *Omnibus*.

33 Bughetti 1925, 190–99; Habig 1973, 1429–36.

34 Bughetti 1925, 199–210; Habig 1973, 1436–44. The reference here is not only to the same idea in 1 Celano 37 but also to the text of the *Sacrum Commercium* (possibly composed c. 1238–39 by one of the companions of Francis, Caesar of Speyer), in which Francis and a few of his faithful companions ascend a mountain in search of Lady Poverty. See Cusato 2000, 42–53; Cusato 2004.

35 The narrative placement in the *Considerazioni* of Francis's composition of a blessing for Leo is at variance with Leo's own testimony of the event, recorded in red ink on the back of the famous *chartula*, in which he explicitly states that the writing occurred shortly after the experience of the stigmatization. Here, however, it occurs prior to the event. Again, it is important to recall that we are dealing less with an historical rendering of the events on La Verna than with a theologized reading of them for instructional and meditative purposes. On the *chartula*, see Fleming 1981 and Cusato 2006, 53–68.

36 This phrase seems to be a conscious echoing of the phrase of Paul's Letter to Titus (2:11): "For the grace of God our Savior has appeared to all." This is the epistle from the New Testament that is read every Christmas Eve, announcing, as it were, the coming of Christ into the world. Its use by the author of the *Considerazioni* as an allusion to Francis (minus the unique salvific importance of the Savior) would seem to continue the paralleling of Francis as an *alter Christus* having eschatological significance for the culmination of human history, prevalent in Franciscan circles even in the fifteenth century.

37 It is interesting to note that in the *Instrumentum de Stigmatibus Beati Francisci*, written in 1282, Philip of Perugia describes the mountain of La Verna during this time as being suffused with a "golden light" (perhaps not unlike what Bellini has depicted in the top left portion of his composition). See Philip of Perugia 1897, 642.

38 Bughetti 1925, 210–21; Habig 1973, 1444–53. Indeed, remarkably brief, given the elaborate, descriptive constructions given to us first by Thomas of Celano (1 Cel 94–95) and even more so in the heavily theologized reworking by Bonaventure in his *Legenda Maior*, XIII (Bonaventure of Bagnoregio 1926–41).

39 Bartholomew of Pisa 1906–12. An English translation of the *Book of the Conformity* is currently being prepared for publication.

40 Boriosi 1997, 409–16; Umiker 2007–11.

41 On this transposition, see Boriosi 2008, 362–63.

42 On the female expression of the Observant Reform movement, see Dalarun and Zinelli 2005; Dalarun and Zinelli 2005–9; Dalarun 2007; Boriosi 2008, 363–64; Bertini Malgarini, Caria, and Vignuzzi 2007–11.

43 By this time, the Third Order friars comprised two different expressions of Franciscan life: confraternities of laity (and occasionally some local priests) known as the Third Order Secular, endeavoring to live the ideals of St. Francis out in the world; and religious communities of women and men, each group sharing their resources in common in support of a local ministry of charity while living as professed religious. Both groups (Secular and Regular) still followed at this time the same Rule of the Third Order, Supra Montem, issued by Pope Nicholas IV in 1289.

44 On this precious manuscript, see the inventory compiled by Fascetti 2010, 42–43, ¶ 34. For the catalogue description of ms. 1295 at the Biblioteca Riccardiana, see Morpurgo 1900, 363–64.

45 Fletcher 1972.

46 "IN Iexus no(mine) . 1518. & di 5 aprill(e) In V(e) nex(ia) / Jo Juan piero di michielli q(uondam) s(er) michele sc(ri)se" (In the name of Jesus. 1518 and day 5 April in Venice / I Juan Piero Michiel son of the late sir Michiele wrote [this]). See also Fascetti 2010, 42. Anne-Marie Eze has inspected the manuscript and has noted that the words "in Venexia" are quite difficult to read due to a large water stain. There are also two words at the end of the inscription that were not recorded by Fascetti. Thanks are due to Maddalena Signorini for assistance in reading the inscription. Eze also attempted to trace a precise connection between the two men, Zuan Giacomo and Zuan Piero, through genealogical and archival research.

47 According to de Besse 1902–3, 143, there was a community of tertiaries—or at least some of the female members of the group—who had petitioned the Franciscan Pope Sixtus IV in 1480 to be transformed into a monastery of Poor Clares (monastery of the Holy Cross), following the Rule of Clare. He claims that they were located near a group of Benedictines, possibly on the Giudecca. The island plague quarantines of Lazzaretto Vecchio and Nuovo constitute further potential sites of Franciscan tertiary activity. Israel 2007 discusses confraternities associated with the Franciscans at San Giobbe.

48 McGinn 1986; Reeves 1969/1993, 262–67.

49 My conclusions join with a similar hypothesis formulated by Lavin 2013, 38–39, who conjectures that "all these men, [Alvise] Lando, [Pietro] Bembo and [Zuan Giacomo] Michiel, were members of an Observant Franciscan lay order or confraternity that used the island from time to time as a devotional retreat." The problem with such a hypothesis is that we have not been able to definitively prove or locate with any specificity the existence of such a confraternity of lay Franciscans or whether they would have belonged to the Observant or Conventual branch.

Appendix A
The Technical Examination of
St. Francis in the Desert (pp. 168–85)

1 Technical examination of the panel was undertaken by George Bisacca, Conservator, and Michael Alan Miller, Assistant Conservator, the Metropolitan Museum of Art. Wood identification was based on visual inspection. Poplar is the support most often used by the Bellini workshop and by Italian Renaissance painters in general. See Monfardini 2000, 168, 170, 172.

2 The width of the boards was measured from the picture surface. For the construction of panels in Bellini's workshop, see Monfardini 2000.

3 The butterflies measure approx. 6 by 2 cm and can be identified from the X-radiograph and from overlying cracks in the paint.

4 Evidence of what could have been additional attachments (applied from the reverse, probably at a later date) at the center top and bottom of the panel is seen in the X-radiograph.

5 The paired nails are located 7.8 cm from the top and 7.3 cm from the bottom on the left side, and 6.5 cm from the top and 5.7 cm from the bottom on the right side. It should be noted that any calculations regarding the height of the panel can only be approximate due to the cumulative shrinkage perpendicular to the grain. A poplar panel of these dimensions could shrink as much as 2.5 cm over five centuries.

6 Conservation files, The Frick Collection. According to the treatment report from 1928, this cradle replaced a previous cradle that was considered to have been poorly executed. As part of the 1928 treatment, a wax coating was applied to the reverse and edges with the intention of minimizing the moisture transfer from the unpainted surfaces of the panel. The opacity of this wax coating impedes the thorough examination of the reverse and edges of the panel.

7 Gypsum (calcium sulfate in the dihydrate form) has been found in the grounds of other paintings from Bellini's workshop (Mancuso and Gallone 2004, 131–32) and was typical in Venice and the Veneto. For cross-section analysis, microscopic

paint samples were mounted in a synthetic resin and ground down to reveal the layer structure when viewed under high magnification. All pigment analysis was carried out by Silvia A. Centeno and Mark T. Wypyski, Research Scientists, Department of Scientific Research, the Metropolitan Museum of Art, using Raman spectroscopy and scanning electron microscopy–energy-dispersive X-ray spectrometry: "Summary of the Examination and Analysis" (Department of Scientific Research Report, 18 October 2010, Conservation Files, The Frick Collection).

8 The line on the far left appears to have been made using a straightedge while that on the far right wavers and appears to have been drawn by hand.

9 Pino 1548/1946, 106; Goffen and Nepi Scirè 2000, 187.

10 For a summary of the development and functions of Bellini's underdrawings, see Dunkerton 2004, 201–6; Poldi and Villa 2006.

11 Infrared reflectography was undertaken using an Indigo Systems Merlin Near Infrared camera (indium gallium arsenide [InGaAs], wavelength range: 900–1700 nm) with a StingRay Optics macro lens optimized for this range, in conjunction with a National Instruments IMAQ PCI-1422 frame grabber card and IRvista 2.51 software. Additional infrared photograph details were captured with a Sony XC-77 CCD camera with infrared cut-off filter removed and replaced with a Kodak Wratten 87C filter, used courtesy of Elizabeth Walmsley and John Delaney, National Gallery of Art, Washington, D.C. The painting was first examined using infrared reflectography by Maryan Ainsworth, the Metropolitan Museum of Art, at the Frick in 1986, using a Hamamatsu vidicon (lead oxide-lead sulphide [PbO-PbS], wavelength range: 500–2200 nm) with a C2741 controller, and a Nikon Micro-Nikkor 55 mm lens fitted with a Kodak Wratten 87A filter.

12 Particles of the carbon-based black paint used for the underdrawings can be seen in one of the cross-sections, between the gesso and imprimitura. In the San Giobbe altarpiece (Gallerie dell'Accademia, Venice), cross-sections similarly show a thin lead white imprimitura applied over the underdrawing, as described in Dunkerton 2004, 211.

13 Incised lines were observed by Susannah Rutherglen and the author in architectural features of St. Terentius at the base of the right pilaster of the Pesaro altarpiece (Pinacoteca, Musei Civici, Pesaro), the Transfiguration (Museo

di Capodimonte, Naples), the Prato Crucifixion (Collezione Banca Popolare di Vicenza), and the Sacred Allegory (Galleria degli Uffizi, Florence).

14 Similarly, a narrow rectangular doorway within the arched doorway of the large tower, a window within the arched doorway over the bridge, and a balcony on the shadowed side of the large tower were drawn but not painted. A turret-like chimney drawn on the roof of the largest tower was later covered with the foliage of the tree, which was enlarged during the painting process. Additionally, the small spired tower was drawn more narrowly than it was painted, and the tower with four turrets was drawn with a squared-off spire, but was painted with a pointed spire.

15 See the section on town and landscape in "St. Francis in the Desert: Technique and Meaning" in this volume.

16 See the section on shelter and study in "St. Francis in the Desert: Technique and Meaning" in this volume.

17 Stylus points were noted by the author in the architecture of the St. Terentius at the base of the right pilaster of the Pesaro altarpiece and in the dais in the Sacred Allegory.

18 The use of fine vertical hatching below the eye is also seen in the Portrait of a Young Man (c. 1490; National Gallery of Art, Washington, D.C.). The intersecting parallel hatching recalls the pen-and-ink Study of a Bull (c. 1500; Gabinetto Disegni e Stampe degli Uffizi). See Rearick 1976, 15–16; Goldner 2004, 245–46.

19 For discussion of underdrawings of the Naples and Berlin pictures, see Villa 2003–4, 75–76, 81; Poldi and Villa 2006, 362–68; Villa 2008a, 40, 49; Villa 2009, 66–69.

20 The characterization of the medium of the imprimitura as a drying oil was based on visual inspection of the picture surface, notably the characteristic texture deriving from the application and manipulation of this layer.

21 The imprimitura is visible in a number of paint cross-sections, and in one of these samples particles of carbon-based underdrawing can be seen between the gesso and imprimitura.

22 "[Before painting in oil] . . . first there must be made a composition of pigments which possesses seccative [sic] qualities as white lead, dryers, and earth such as is used for bells, all thoroughly mixed together and of one tint, and when the size is dry this must be plastered over the panel and then beaten with the palm of the hand, so that it becomes evenly united and spread all over, and this may be called the 'imprimatura' (priming)."

Vasari 1568/1906, vol. 1, 186; trans. by Maclehose in Vasari 1568/1907, 230–31.

23 Traces of a barbe are seen at the top left at the edge of the sky, the bottom of the grass to the left of the laurel tree trunk, and the right edge, to the right of the bottom of the lectern.

24 A similar feature is described in the predella of the Coronation of the Virgin (Pinacoteca, Musei Civici, Pesaro). See Poldi and Villa 2011, 29. If this is the case in the present work, some brushstrokes that continue a little way onto the unpainted border (as at the top left) may have occurred in places where the supportive edging was more loosely attached.

25 Medium analysis of paint scrapings was undertaken by Julie Arslanoglu, Associate Research Scientist, Department of Scientific Research, the Metropolitan Museum of Art, using Fourier transform infrared spectroscopy (FTIR), gas chromatography/mass spectrometry (GC/MS), and pyrolysis-GC/MS. Due to limited sampling sites, it was not possible to investigate extensively the binding media of the lower layers with GC/MS. Low binder concentration and pigment interference also prohibited satisfactory results from Fourier transform infrared spectroscopy-attenuated total reflectance (FTIR-ATR) investigations of cross-sections made at selected sites.

26 Analysis of the varnish coating showed the presence of pine resin with some wax. Traces of wax found in the analyzed paint scrapings are attributed to residual varnish. The fatty acid ratios used for oil characterization can be skewed due to the fatty acids found in wax, thus complicating the interpretation of the ratios and, in some cases, hindering definitive identification of the type of oil present.

27 Pine resin was identified in the discolored copper-based green glaze, but as pine resin was also identified as a component of the current varnish coating(s) this could be from contamination and would require further investigation.

28 St. Francis is dated c. 1476–78: see the section on dating in "St. Francis in the Desert: Technique and Meaning" in this volume. The medium of three samples from the Pesaro altarpiece that were analyzed was identified as a drying oil; the type of oil was not characterized. Laurenzi Tabasso 1988, 143; Dunkerton 2004, 207–10.

29 Localized medium defects are seen in several of Bellini's paintings, including the Resurrection (Gemäldegalerie, Berlin) and the Madonna Greca (Pinacoteca di Brera, Milan). See Dunkerton 2004, 207.

30 The younger vanguard of Venetian painters—artists such as Titian, who worked in the more forgiving medium of oil from the beginning of their careers—used reserves much less and executed more of their composing on the panel or canvas, often making significant revisions as they worked. As a result, X-radiographs of these paintings can appear cacophonous compared to X-radiographs of pictures made using reserves. The X-radiograph of Titian's *Noli Me Tangere* (The National Gallery, London), for example, shows extensive changes in the figure of Christ and in the landscape. See Dunkerton et al. 1999, 280–81.

31 For the frieze-like effect seen in X-radiographs of works painted in reserve technique, see the X-ray images of *The Feast of the Gods* (National Gallery of Art, Washington, D.C.) and *The Assassination of St. Peter Martyr* (The National Gallery, London) in Plesters 1993a, 377–78. Another exceptional view of Bellini's initial paint layers was recorded during the transfer of the *Madonna of the Meadow* (The National Gallery, London). See Dunkerton 2004, 219. The Virgin and Child group, hill town, and the tree at right were all rendered with their shadows, including the shadow cast by the Virgin on the meadow. Evidently, the artist considered it crucial to convey at this early stage the fall of light on the main features of the composition.

32 Similarly, in the Prato *Crucifixion* (Collezione Banca Popolare di Vicenza), *Transfiguration* (Museo di Capodimonte, Naples), and the predella panels of the Pesaro altarpiece, even tiny saplings were held in reserve.

33 Surprisingly, the binding medium for the pebbles was identified by FTIR as oil, not egg tempera, which would have been a great deal easier to flick. On pebbles painted with spatter technique, see Dunkerton 2004, 197–98.

34 Any fine details applied on top of the robust, lead-white-rich paint of the flesh of the foot would have been particularly prone to abrasion.

35 The opaque red and particles of purplish translucent red seen on the wounds of the hands were not observed on the foot—here the red is brownish in hue and more amorphous.

36 Lorenzo da Pavia wrote to Isabella d'Este on 16 July 1504: "in invention no one compares with Messer Andrea Mantegna . . . but Giovanni Bellini is excellent in coloring." Fletcher 1971, 710; Brown and Lorenzoni 1982, 84.

37 Matthew 2002, 680–86; Berrie and Matthew 2006, 302–9.

38 This is not necessarily the full palette of the painting; only a limited number of samples were taken for analysis.

39 In *The Feast of the Gods* (National Gallery of Art, Washington, D.C.), the "brown" tree trunks were found to be painted with a mixture of carbon black, lead white, and vermilion, with a final vermilion scumble. Plesters 1993a, 382. Cima similarly used a range of pigments in his browns. See Dunkerton and Roy 1986, 19.

40 In *St. Jerome Reading* (The National Gallery, London), the pebbles are multi-hued: red, yellow, and blue. I am grateful to Luke Syson, then Curator and Head of Research, and Rachel Billinge, Rausing Research Associate, the National Gallery, for facilitating the examination of this painting.

41 The greens are much better preserved in Bellini's Prato *Crucifixion* (see fig. 87).

42 Dunkerton and Roy 1986, 15–16. See also Berrie and Matthew 2006, 303.

43 Though guided by a straightedge, these incised lines waver over the uneven surface of the *imprimitura* and "spattered" pebbles.

44 The X-radiograph of the background of the *Transfiguration* (Museo di Capodimonte, Naples) shows one of a small pair of figures reserved while the other was added later. Naples 1960, 55–57.

45 The green (now browned) glaze of the foliage around the heron was painted after the heron was in place.

46 The stone above and to the right of the rabbit had a rounded profile when first painted (as seen in the X-radiograph); it was later squared up and divided in two. This small change is further evidence of the attention paid by the artist to every detail of this intricate painting.

47 Conservation file, The Frick Collection.

48 Khandekar and Schilling 2001; Scott et al. 2001.

49 Following the procedure described in Arslanoglu et al. 2013.

Appendix B
Detail at the Waist of the Saint's Habit
(pp. 186–87)

1 For the identification of the object as the *chartula*, see Fleming 1982, 100–28; Gentili 2004b, 68. Meiss identifies the article as a "small sheet of paper" alluding to the *Canticle of the Creatures* (Meiss 1964, 21); Lavin suggests "a folded sheet with writing" (Lavin 2007, 231). The object is identified as a fabric patch by Fletcher 1972, 211, and Smart 1973, 475.

2 A diagonal, ruled underdrawn line appears within the rectangle; if this line continued, it would reach the palm of the proper left hand. The purpose of this line is unclear.

3 Spots of later retouching on the rectangle also give it a patchy appearance.

4 Latin inscriptions appear in the *Pietà* (c. 1470–1475; Pinacoteca di Brera, Milan), the San Giobbe altarpiece (c. 1478–80), and the Frari triptych of 1488. Hebrew inscriptions appear in the *Transfiguration* of c. 1479 (Museo di Capodimonte, Naples; see Dalhoff 1996, 35–36, 191–93 n. 100–101) and the Prato *Crucifixion* of c. 1490–1505 (Collezione Banca Popolare di Vicenza).

5 Pincus 2008.

6 A Latin couplet based on an elegy by Propertius is inscribed in the *Pietà* (Pinacoteca di Brera, Milan; see Christiansen 2004b, 36–37, and Belting 1985). In the Frari triptych (1488; Santa Maria Gloriosa dei Frari, Venice), St. Benedict holds his Bible open to the book of Ecclesiasticus, whose title is inscribed on the left page.

7 Gentili 2004a, 167.

8 Fleming argues that Francis is in the process of composing the *chartula* and that only the inward-facing side contains writing. However, his claim that "a few dark marks can be seen through the back of the folded parchment" (Fleming 1982, 105) is not substantiated by technical examination.

9 Armstrong, Hellmann, and Short 1999–2002, vol. 1, 65.

10 Tempestini 1992b and Pincus 2004, 122.

11 See "'The Footprints of Our Lord': Giovanni Bellini and the Franciscan Tradition" in this volume.

12 Rocca 2000, 97. The purse, or *borsa*, was an element of Franciscan habits in the saint's own time: see Rossetti 1989, 16.

13 For Bernardino's eyeglasses, see Israel 2007, 167. Examples include a painting of Bernardino attributed to the Venetian school (c. 1450–75; Rijksmuseum Kröller-Müller, Otterlo; see van Os et al. 1978, 141–45); Antonio Vivarini's triptych of *Sts. Jerome, Bernardino da Siena, and Louis of Toulouse* (c. 1451–56; San Francesco della Vigna, Venice; see Lucco 1990, 403); Cima da Conegliano's *Lamentation* (c. 1495–97; Galleria Estense, Modena; see Humfrey 1993a, 225).

14 For the image from Jacopo's Louvre album (f. 67r.), see Degenhart and Schmitt 1990, vol. 6, 402–5, and vol. 7, pl. 85.

BIBLIOGRAPHY

Ackerman 1978/1991

Ackerman, James S. "Leonardo's Eye." In *Distance Points: Essays in Theory and Renaissance Art and Architecture*, 97–150. London and Cambridge, MA: MIT Press, 1991. From *Journal of the Warburg and Courtauld Institutes* 41 (1978): 108–46.

Agosti 1986

Agosti, Giovanni. "Sui Teleri Perduti del Maggior Consiglio nel Palazzo Ducale di Venezia." *Ricerche di Storia dell'Arte* 30 (1986): 61–87.

———. **2009**

Agosti, Giovanni. *Un Amore di Giovanni Bellini.* Milan: Officina Libraria, 2009.

Agosti and Thiébaut 2008

Agosti, Giovanni, and Dominique Thiébaut. *Mantegna, 1431–1506.* Exh. cat. Paris: Musée du Louvre, 2008.

Aikema 1994

Aikema, Bernard. "Avampiano e Sfondo nell'Opera di Cima da Conegliano: La Pala d'Altare e lo Spettatore tra la Fine del Quattrocento e l'Inizio del Cinquecento." *Venezia Cinquecento* 4, no. 8 (1994): 93–112.

Aikema and Brown 1999

Aikema, Bernard, and Beverly Louise Brown (eds.). *Renaissance Venice and the North: Crosscurrents in the Time of Bellini, Dürer, and Titian.* Exh. cat. Venice: Palazzo Grassi, 1999.

Alberti and Sinisgalli 1435–36/2011

Alberti, Leon Battista. *"On Painting": A New Translation and Critical Edition.* Edited and translated by Rocco Sinisgalli. Cambridge: Cambridge University Press, 2011.

———. **2006**

Sinisgalli, Rocco. *Il Nuovo "De Pictura" di Leon Battista Alberti / The New "De Pictura" of Leon Battista Alberti.* Rome: Kappa, 2006.

Alberzoni 2004

Alberzoni, Maria Pia. *Clare of Assisi and the Poor Sisters in the Thirteenth Century.* St. Bonaventure, NY: Franciscan Institute Publications, 2004.

Aldrovandi et al. 2007

Aldrovandi, Alfredo, et al. "Leggibilità e Conservazione: Il Caso della Crocifissione di Giovanni Bellini della Cariprato." *OPD Restauro: Rivista dell'Opificio delle Pietre Dure e Laboratori di Restauro di Firenze* 19 (2007): 219–32.

Alexander-Skipnes 2003

Alexander-Skipnes, Ingrid. "St. Jerome in the Wilderness: Paintings in Venice by Piero della Francesca, Giovanni Bellini and Hieronymus Bosch." In *Jérôme Bosch et son Entourage et autres Études*, edited by Hélène Verougstraete and Roger van Schoute, 286–97. Paris and Leuven, Belgium: Uitgeverij Peeters, 2003.

Allen 1999

Allen, Denise. "Some Observations on Ercole de' Roberti as Painter-Draughtsman." In Allen and Syson 1999, xv–xxiv.

Allen and Syson 1999

Allen, Denise, and Luke Syson with Jennifer Helvey and David Jaffé. "Ercole de' Roberti: The Renaissance in Ferrara." *The Burlington Magazine* 141, no. 1153 (April 1999): i–xl.

Anderson 1997

Anderson, Jaynie. *Giorgione: The Painter of "Poetic Brevity."* Paris and New York: Flammarion, 1997.

———. **2000**

Anderson, Jaynie. "Molteni in Corrispondenza con Giovanni Morelli: Il Restauro della Pittura Rinascimentale a Milano nell'Ottocento." In *Giuseppe Molteni (1800–1867) e il Ritratto nella Milano Romantica: Pittura, Collezionismo, Restauro, Tutela*, edited by Fernando Mazzocca et al., 47–57. Exh. cat. Milan: Skira, 2000.

Andrisani 1960

Andrisani, Gaetano. "Motivi Francescani nelle Opere del Giambellino." *L'Italia Francescana*, n.s., 35 (Sept.–Oct. 1960): 342–46.

Armstrong 1976

Armstrong, Lilian. *The Paintings and Drawings of Marco Zoppo.* New York and London: Garland Publishing, 1976.

Armstrong, Hellmann, and Short 1999–2002

Armstrong, Regis, J. A. Wayne Hellmann, and William J. Short (eds.). *Francis of Assisi: Early Documents.* 3 vols. and index. New York, London, and Manila: New City Press, 1999–2002.

Arslan 1956

Arslan, Edoardo. *Catalogo delle Cose d'Arte e di Antichità d'Italia: Vicenza.* Vol. 1, *Le Chiese.* Rome: De Luca, 1956.

———. **1962**

Arslan, Edoardo. "Studi Belliniani." *Bollettino d'Arte*, ser. 4, vol. 47, no. 1 (Jan.–March 1962): 40–58.

Arslanoglu et al. 2013

Arslanoglu, J., S. A. Centeno, S. Digney-Peer, and I. Duvernois. "Picasso in the Metropolitan Museum of Art: An Investigation of Materials and Techniques." *Journal of the American Institute for Conservation* 52, no. 3 (2013): 150–55.

van Asperen de Boer et al. 1997

van Asperen de Boer, J. R. J., et al. *Jan van Eyck: Two Paintings of "Saint Francis Receiving the Stigmata."* Philadelphia: Philadelphia Museum of Art, 1997.

Auerbach 1945

Auerbach, Erich. "St. Francis of Assisi in Dante's *Commedia*." *Italica* 22, no. 4 (Dec. 1945): 166–79.

Augusti Ruggeri and Giacomelli Scalabrin 1994

Augusti Ruggeri, Adriana, and Sara Giacomelli Scalabrin (eds.). *Basilica dei Frari: Arte e Devozione.* Venezia dal Museo alla Città 6. Venice: Marsilio, 1994.

Avagnina and Villa 2007

Avagnina, Maria Elisa, and Giovanni C. F. Villa (eds.). *Bellini a Vicenza: Il "Battesimo di Cristo" in Santa Corona.* Exh. cat. Vicenza: Musei Civici, 2007.

Bagarotto 2000

Bagarotto, Rosella, et al. "La Tecnica Pittorica di Giovanni Bellini." In Goffen and Nepi Scirè 2000, 184–202.

Ballarini 2000

Ballarini, Marco. "La Bufera Napoleonica." In *Storia dell'Ambrosiana.* Vol. 2, *Il Settecento*, edited by Ada Annoni and Marco Ballarini, 329–71. Milan: Cariplo, 2000.

Bambach 1999

Bambach, Carmen. *Drawing and Painting in the Italian Renaissance Workshop: Theory and Practice, 1300–1600.* Cambridge: Cambridge University Press, 1999.

Banker 2009

Banker, James. "The Conventual and Observant Franciscans and Sassetta's Altarpiece in San Francesco in Borgo San Sepolcro." In Israëls 2009b, vol. 1, 140–46.

Barausse 2008

Barausse, Manuela (ed.). "Giovanni Bellini: I Documenti." In Lucco and Villa 2008, 327–59.

Barocchi 1971–77

Barocchi, Paola. *Scritti d'Arte del Cinquecento.* 3 vols. Milan and Naples: Riccardo Ricciardi, 1971–77.

Barolsky 1996

Barolsky, Paul. "The History of Italian Renaissance Art Re-envisioned." *Word & Image* 12, no. 3 (July–Sept. 1996): 243–50.

———. **1997**

Barolsky, Paul. "Naturalism and the Visionary Art of the Early Renaissance." *Gazette des Beaux-Arts,* ser. 6, vol. 129 (Feb. 1997): 57–64. Reprinted in Ladis 1998, 317–24.

Barringer 2009

Barringer, Tim. Review of *A Victorian Entrepreneur's Extraordinary Collecting Project. Fine Art Connoisseur* (March–April 2009).

Bartholomew of Pisa 1906–12

Bartholomew of Pisa. "Liber de Conformitate Vitae Beati Francisci ad Vitam Domini Iesu." In *Analecta Franciscana,* IV–V. Quaracchi, Italy: Typographia Collegii S. Bonaventurae, 1906–12.

Bartoli 1989/1993

Bartoli, Marco. *Clare of Assisi.* Translated by Sr. Frances Teresa. Rome: Istituto Storico dei Cappuccini, 1989; Quincy, IL: Franciscan Press, 1993.

Bass 2010

Bass, Marisa Anne. "The Hydraulics of Imagination: Fantastical Fountains in the Drawing Books of Jacopo Bellini." In *Imagination und Repräsentation: Zwei Bildsphären der Frühen Neuzeit,* edited by Horst Bredekamp, Christiane Kruse, and Pablo Schneider, 149–60. Munich: Wilhelm Fink, 2010.

Bätschmann 2007

Bätschmann, Oskar. *Giovanni Bellini: Meister der Venezianischen Malerei.* Munich: C. H. Beck, 2007.

———. **2008**

Bätschmann, Oskar. *Giovanni Bellini.* Translated by Ian Pepper. London: Reaktion, 2008.

Battilotti and Franco 1978

Battilotti, Donata, and Maria Teresa Franco. "Regesti di Committenti e dei Primi Collezionisti di Giorgione." *Antichità Viva* 17, nos. 4–5 (1978): 58–86.

———. **1994**

Battilotti, Donata, and Maria Teresa Franco. "La Committenza e il Collezionismo Privato." In *I Tempi di Giorgione,* edited by Ruggero Maschio, 204–29. Rome: Gangemi, 1994.

Battisti 1991

Battisti, Eugenio. "Le Origini Religiose del Paesaggio Veneto." *Venezia Cinquecento* 1, no. 2 (1991): 9–25.

Baxandall 1965

Baxandall, Michael. "Guarino, Pisanello, and Manuel Chrysoloras." *Journal of the Warburg and Courtauld Institutes* 28 (1965): 183–204.

———. **1988**

Baxandall, Michael. *Painting and Experience in Fifteenth-Century Italy: A Primer in the Social History of Pictorial Style.* 2nd ed. Oxford and New York: Oxford University Press, 1988.

Bellavitis 2001

Bellavitis, Anna. *Identité, Mariage, Mobilité Sociale: Citoyennes et Citoyens à Venise au XVIe Siècle.* Rome: École Française de Rome, 2001.

Bellosi 2008

Bellosi, Luciano. "Giovanni Bellini et Andrea Mantegna." In Agosti and Thiébaut 2008, 103–9.

Belting 1977

Belting, Hans. *Die Oberkirche von San Francesco in Assisi: Ihre Dekoration als Aufgabe und die Genese einer neuen Wandmalerei.* Berlin: Gebr. Mann Verlag, 1977.

———. **1980–81**

Belting, Hans. "An Image and Its Function in the Liturgy: The Man of Sorrows in Byzantium." *Dumbarton Oaks Papers* 34/35 (1980–81): 1–16.

———. **1985**

Belting, Hans. *Giovanni Bellini Pietà: Ikone und Bilderzählung in der Venezianischen Malerei.* Frankfurt: Fischer Taschenbuch, 1985.

———. **1994**

Belting, Hans. *Likeness and Presence: A History of the Image before the Era of Art.* Translated by Edmund Jephcott. Chicago and London: University of Chicago Press, 1994.

———. **2010**

Belting, Hans. "Saint Francis and the Body as Image: An Anthropological Approach." In Hourihane 2010, 3–14.

Bennett 1926

Bennett, M. R. "The Legend of the Green Tree and the Dry." *Archaeological Journal,* ser. 2, vol. 83 (1926): 21–32.

Berenson 1916

Berenson, Bernard. *Venetian Painting in America: The Fifteenth Century.* New York: Frederic Fairchild Sherman, 1916.

———. **1932**

Berenson, Bernard. *Italian Pictures of the Renaissance: A List of the Principal Artists and Their Works with an Index of Places.* Oxford: Clarendon Press, 1932.

———. **1957**

Berenson, Bernard. *Italian Pictures of the Renaissance: Venetian School.* 2 vols. London: Phaidon, 1957.

Bernardi 1990

Bernardi, Donatella. "Interni di Case Veneziane nella Seconda Metà del XVIII Secolo." *Studi Veneziani,* n.s., 20 (1990): 163–249.

Berrie and Matthew 2006

Berrie, Barbara H., and Louisa C. Matthew. "Venetian 'Colore': Artists at the Intersection of Technology and History." In Brown and Ferino-Pagden 2006, 301–9.

———. **2011**

Berrie, Barbara, and Louisa Matthew. "Lead White from Venice: A Whiter Shade of Pale?" In *Studying Old Master Paintings: Technology and Practice: The National Gallery Technical Bulletin 30th Anniversary Conference Postprints,* edited by Marika Spring et al., 295–301. London: Archetype Publications, 2011.

Bertini Malgarini, Caria, and Vignuzzi 2007–11

Bertini Malgarini, Patrizia, Marzia Caria, and Ugo Vignuzzi. "Clarisse dell'Osservanza e Scritture 'di Pietà' in Volgare tra Foligno e Monteluce." *Amicitiae Sensibus: Studi in Onore di Don Mario Sensi. Bollettino Storico della Città di Foligno* 31–34 (2007–11): 297–335.

Bertorello and Martellotti 1988

Bertorello, Carla, and Giovanna Martellotti. "Per una Lettura Critica dei Dati Tecnici: Lo Stato di Conservazione in Rapporto alle Vicende Storiche." In Valazzi 1988b, 85–109.

de Besse 1902–3

de Besse, Ludovic. *Le Bienheureux Bernardin de Feltre et son Oeuvre.* 2 vols. Tours and Paris: A. Mame et Fils–Oeuvre de St-François-d'Assise, 1902–3.

Bianchi and Ferrari 1970

Bianchi, Camillo, and Francesco Ferrari. *L'Isola di San Francesco del Deserto: Ricerca Storica e Intervento di Restauro.* Padua: Istituto di Architettura dell'Università di Padova, 1970.

Billinge 2009a

Billinge, Rachel. "Sassetta's Painting Technique: The Example of the Seven Panels of the National Gallery in London." In Israëls 2009b, vol. 1, 370–81.

———. **2009b**

Billinge, Rachel. "'Some Panels from Sassetta's Sansepolcro Altarpiece' Revisited." *National Gallery Technical Bulletin* 30 (2009): 8–25.

Bisogni 1985

Bisogni, Fabio. "Iconografia dei Predicatori dell'Osservanza nella Pittura dell'Italia del Nord fino agli Inizi del Cinquecento." In *Il Rinnovamento del Francescanesimo: L'Osservanza. Atti dell'XI Convegno Internazionale, Assisi, 20–22 Ottobre 1983,* 229–55. Perugia: Università di Perugia, Centro di Studi Francescani, 1985.

Blass-Simmen forthcoming

Blass-Simmen, Brigit. "'Qualche Lontani': Distance

and Transcendence in the Art of Giovanni Bellini." In Wilson forthcoming.

Boase 1891

Boase, G. C. "Holloway, Thomas (1800–1883)." In *Dictionary of National Biography*. Vol. 27, *Hindmarsh–Hovenden*, edited by Sir Sidney Lee, 181–82. New York: Macmillan and Co.; London: Smith, Elder & Co, 1891.

Bomford 2002

Bomford, David (ed.). *Art in the Making: Underdrawings in Renaissance Paintings*. London: The National Gallery, 2002.

Bona Castellotti and Pulini 2012

Bona Castellotti, Marco, and Massimo Pulini (eds.). *Gli Angeli della Pietà: Intorno a Giovanni Bellini*. Exh. cat. Rimini: Museo della Città, 2012.

Bonaventure of Bagnoregio 1898

Bonaventure of Bagnoregio. *Opera Omnia*. Vol. 8, *Opuscula Varia ad Theologiam Mysticam et Res Ordinis Fratrum Minorum Spectantia*. Quaracchi, Italy: Typographia Collegii S. Bonaventurae, 1898.

———. **1926–41**

Bonaventure of Bagnoregio. "Legenda Maior." In *Analecta Franciscana*, X, 555–626. Quaracchi, Italy: Typographia Collegii S. Bonaventurae, 1926–41.

———. **1938**

Bonaventure of Bagnoregio. "Itinerarium Mentis in Deum." In *Tria Opuscula: Seraphici Doctoris S. Bonaventurae, Breviloquium, Itinerarium Mentis in Deum et de Reductione Artium ad Theologiam*. 5th ed., 289–361. Quaracchi, Italy: Typographia Collegii S. Bonaventurae, 1938.

Borean and Mason 2007

Borean, Linda, and Stefania Mason (eds.). *Il Collezionismo d'Arte a Venezia: Il Seicento*. Venice: Marsilio, 2007.

———. **2009**

Borean, Linda, and Stefania Mason (eds.). *Il Collezionismo d'Arte a Venezia: Il Settecento*. Venice: Marsilio, 2009.

Boriosi 1997

Boriosi, Marc. "Traduire le Franciscanisme: Introduction aux Premières Vulgarisations des Légendes de Saint François d'Assise (France-Italie, XIIIe–XVe Siècles)." *Collectanea Franciscana* 67 (1997): 409–16.

———. **2008**

Boriosi, Marc. "Ré-inventer Saint François: Les Réécritures en Langue Vulgaire des Légendes de Saint François dans les Milieux Franciscains Réformateurs Italiens (fin XIVe–fin XVe Siècles)." *In Le Passé à l'Épreuve du Présent: Appropriations et Usages du Passé du Moyen Âge à la Renaissance*, edited by Pierre Chastang, 359–73. Paris: Presses de l'Université Paris-Sorbonne, 2008.

Bortolami 1988

Bortolami, Sante (ed.). *Città Murate del Veneto*. Milan: Silvana/Amilcare Pizzi, 1988.

Boschini 1660/1966

Boschini, Marco. *La Carta del Navegar Pitoresco: Edizione Critica con la "Breve Istruzione" Premessa alle "Ricche Minere della Pittura Veneziana."* Edited by Anna Pallucchini. Venice and Rome: Istituto per la Collaborazione Culturale, 1966.

Boskovits and Brown 2003

Boskovits, Miklós, David Alan Brown et al. *Italian Paintings of the Fifteenth Century*. The Collections of the National Gallery of Art: Systematic Catalogue. New York and Oxford: Oxford University Press, 2003.

Bottari 1963

Bottari, Stefano. *Tutta la Pittura di Giovanni Bellini*. 2 vols. Milan: Rizzoli, 1963.

Bourdua 2002

Bourdua, Louise. "The 13th- and 14th-Century Italian Mendicant Orders and Art." In *Economia e Arte Secc. XIII–XVIII: Atti della "Trentatreesima Settimana di Studi," 30 Aprile–4 Maggio 2000*, edited by Simonetta Cavaciocchi, 473–88. Prato, Italy: Istituto Internazionale di Storia Economica "F. Datini"; Florence: Le Monnier, 2002.

———. **2004**

Bourdua, Louise. *The Franciscans and Art Patronage in Late Medieval Italy*. Cambridge: Cambridge University Press, 2004.

Braham et al. 1978

Braham, Allan, Martin Wyld, and Joyce Plesters. "Bellini's *The Blood of the Redeemer.*" *National Gallery Technical Bulletin* 2 (1978): 11–24.

Brigstocke 1981

Brigstocke, Hugh. "William Buchanan, His Friends and Rivals: The Importation of Old Master Paintings into Great Britain during the First Half of the Nineteenth Century." *Apollo* 114 (1981): 76–84.

———. **1982**

Brigstocke, Hugh. *William Buchanan and the Nineteenth-Century Art Trade: 100 Letters to His Agents in London and Italy*. London: Paul Mellon Centre for Studies in British Art, 1982.

Brion-Guerry 1962

Brion-Guerry, L. *Jean Pélerin Viator: Sa Place dans l'Histoire de la Perspective*. Paris: Les Belles Lettres, 1962.

Brooke 1975

Brooke, Rosalind. *The Coming of the Friars*. London: George Allen & Unwin; New York: Barnes & Noble, 1975.

———. **2006**

Brooke, Rosalind. *The Image of St. Francis: Responses to Sainthood in the Thirteenth Century*. Cambridge: Cambridge University Press, 2006.

B. Brown 2008

Brown, Beverly Louise. "Picturing the Perfect Marriage: The Equilibrium of Sense and Sensibility in Titian's *Sacred and Profane Love.*" In *Art and Love in Renaissance Italy*, edited by Andrea Bayer, 238–45. Exh. cat. New York: The Metropolitan Museum of Art; Fort Worth: Kimbell Art Museum, 2008.

C. Brown 1969

Brown, Clifford. "'Una Testa de Platone Antica con la Punta dil Naso di Cera': Unpublished Negotiations between Isabella d'Este and Niccolò and Giovanni Bellini." *The Art Bulletin* 51, no. 4 (Dec. 1969): 372–77.

———. **1972**

Brown, Clifford, with Anna Maria Lorenzoni. "An Art Auction in Venice in 1506." *L'Arte* 18–19/20 (1972): 121–36.

P. Brown 1982

Brown, Peter. "The Rise and Function of the Holy Man in Late Antiquity." In *Society and the Holy in Late Antiquity*, 103–52. Berkeley, Los Angeles, and London: University of California Press, 1982.

P. F. Brown 1988

Brown, Patricia Fortini. *Venetian Narrative Painting in the Age of Carpaccio*. New Haven and London: Yale University Press, 1988.

———. **1992**

Brown, Patricia Fortini. "The Antiquarianism of Jacopo Bellini." *Artibus et Historiae* 13, no. 26 (1992): 65–84.

———. **1996**

Brown, Patricia Fortini. *Venice and Antiquity: The Venetian Sense of the Past*. New Haven and London: Yale University Press, 1996.

———. **1999**

Brown, Patricia Fortini. "Carpaccio's *St. Augustine in His Study*: A Portrait within a Portrait." In *Augustine in Iconography: History and Legend*, edited by Joseph C. Schnaubelt and Frederick Van Fleteren, 507–47. New York: Peter Lang, 1999.

R. Brown 1958

Brown, Raphael (ed. and trans.). "The Considerations on the Holy Stigmata." In *The Little Flowers of St. Francis . . . A Modern English Translation from the Latin and the Italian with Introduction, Notes and Biographical Sketches*, 171–216. Garden City, NY: Hanover House, 1958. Reprinted in Habig 1973, 1429–74, 1525–29.

Brown and Ferino-Pagden 2006

Brown, David Alan, Sylvia Ferino-Pagden et al. *Bellini, Giorgione, Titian and the Renaissance of Venetian Painting*. Exh. cat. Washington, D.C.: National Gallery of Art; Vienna: Kunsthistorisches Museum, 2006.

Brown and Fletcher 1972

Brown, Clifford, and J. M. Fletcher. "Giovanni Bellini and Art Collecting." *The Burlington Magazine* 114, no. 831 (June 1972): 404–5.

Brown and Lorenzoni 1982

Brown, Clifford, and Anna Maria Lorenzoni. *Isabella d'Este and Lorenzo da Pavia: Documents for the History of*

Art and Culture in Renaissance Mantua. Geneva: Librairie Droz, 1982.

Brown and Pizzati 2014

Brown, David Alan, and Anna Pizzati. "'Meum amantissimum nepotem': A New Document Concerning Giovanni Bellini." *The Burlington Magazine* 156, no. 1332 (March 2014): 148–52.

Bughetti 1925

Bughetti, Benvenuto (ed.). *I Fioretti di San Francesco.* Florence: Salani, 1925.

Bull 1991

Bull, David. "*Christ Crowned with Thorns* by Giovanni Bellini." *Nationalmuseum Bulletin* 15, no. 2 (1991): 112–24.

Bull and Plesters 1990

Bull, David, and Joyce Plesters. "*The Feast of the Gods*: Conservation, Examination, and Interpretation." *Studies in the History of Art* 40. Washington, D.C.: National Gallery of Art, 1990.

Burr 2001

Burr, David. *The Spiritual Franciscans: From Protest to Persecution in the Century after Saint Francis.* University Park: Pennsylvania State University Press, 2001.

Caimi 1866–67

Caimi, Antonio. "Commemorazione del Cav. Giuseppe Molteni Conservatore delle RR. Gallerie Letta nell'Adunanza Finale del Consiglio Accademico dell'Anno MDCCCLXVII dal Professore Segretario Antonio Caimi." *Atti della R. Accademia di Belle Arti di Milano* (1866–67): 5–22.

Callegari 1997

Callegari, Raimondo. "Su Due Polittici di Giorgio Schiavone." *Arte Veneta* 50 (1997): 24–37.

da Campagnola 1971

da Campagnola, Stanislao. *L'Angelo del Sesto Sigillo e l'Alter Christus: Genesi e Sviluppo di Due Temi Francescani nei Secoli XIII–XIV.* Rome: Edizioni Laurentianum–Edizioni Antonianum, 1971.

Campbell 1981

Campbell, Lorne. "Notes on Netherlandish Pictures in the Veneto in the Fifteenth and Sixteenth Centuries." *The Burlington Magazine* 123, no. 941 (Aug. 1981): 467–73.

Campbell and Chong 2005

Campbell, Caroline, and Alan Chong. *Bellini and the East.* Exh. cat. London: The National Gallery; Boston: Isabella Stewart Gardner Museum, 2005.

Campbell and Cole 2012

Campbell, Stephen, and Michael Cole. *Italian Renaissance Art.* New York: Thames & Hudson, 2012.

Campori 1874

Campori, Giuseppe. "Tiziano e gli Estensi." *Nuova Antologia di Scienze, Lettere ed Arti* 27 (1874): 581–620.

Cannon 1999

Cannon, Joanna. "The Stoclet *Man of Sorrows*: A Thirteenth-Century Italian Diptych Reunited." *The Burlington Magazine* 141, no. 1151 (Feb. 1999): 107–12.

———. 2004

Cannon, Joanna. "Giotto and Art for the Friars: Revolutions Spiritual and Artistic." In *The Cambridge Companion to Giotto*, edited by Anne Derbes and Mark Sandona, 103–34. Cambridge: Cambridge University Press, 2004.

Carney, Godet-Calogeras, and Kush 2008

Carney, Margaret, Jean François Godet-Calogeras, and Suzanne M. Kush (eds.). *History of the Third Order Regular Rule: A Source Book.* St. Bonaventure, NY: Franciscan Institute Publications, 2008.

Casini 1991

Casini, Matteo. "Realtà e Simboli del Cancellier Grande Veneziano in Età Moderna (Secc. XVI–XVII)." *Studi Veneziani*, n.s., 22 (1991): 195–251.

———. 1992

Casini, Matteo. "La Cittadinanza Originaria a Venezia tra i Secoli XV e XVI: Una Linea Interpretativa." In *Studi Veneti Offerti a Gaetano Cozzi*, 133–50. Vicenza: Il Cardo, 1992.

Castelfranchi Vegas 1983

Castelfranchi Vegas, Liana. *Italia e Fiandra nella Pittura del Quattrocento.* Milan: Jaca Book, 1983.

Cecchetti 1887

Cecchetti, Bartolomeo. "Il 'Pennello' della Scuola di S. Marco, Dipinto da Alvise Vivarini, e Data della Morte di Questo Pittore." *Archivio Veneto*, n.s., 17, vol. 34 (1887): 247–48.

Cecchini 2009

Cecchini, Isabella. "Attorno al Mercato, 1700–1815." In Borean and Mason 2009, 151–71.

Cenci 2003

Cenci, Cesare. "Le Definizioni del Capitolo Generale di Parigi del 1266." *Frate Francesco*, n.s., 69 (2003): 307–11.

Cennini 1960

Cennini, Cennino d'Andrea. *The Craftsman's Handbook: The Italian "Il Libro dell'Arte."* Translated by Daniel V. Thompson, Jr. New York: Dover, 1960.

———. 2003

Cennini, Cennino d'Andrea. *Il Libro dell'Arte.* Edited by Fabio Frezzato. Vicenza: Neri Pozza, 2003.

Ceriana 1992–93

Ceriana, Matteo. "Due Esercizi di Lettura: La Cappella Moro in San Giobbe e le Fabbriche dei Gussoni a Venezia." *Annali di Architettura* 4–5 (1992–93): 22–41.

———. 2008

Ceriana, Matteo. "Bellini e le Arti Plastiche." In Lucco and Villa 2008, 90–103.

Chambers and Pullan 2001

Chambers, David, and Brian Pullan, with Jennifer Fletcher. *Venice: A Documentary History, 1450–1630.* Oxford and Cambridge: Blackwell, 1992; Toronto: University of Toronto Press, 2001.

Chatterjee 2012

Chatterjee, Paroma. "Francis's Secret Stigmata." *Art History* 35, no. 1 (Feb. 2012): 38–61.

Chavasse 2003

Chavasse, Ruth. "The *Studia Humanitatis* and the Making of a Humanist Career: Marcantonio Sabellico's Exploitation of Humanist Literary Genres." *Renaissance Studies* 17, no. 1 (March 2003): 27–38.

Christiansen 1992

Christiansen, Keith. "Some Observations on Mantegna's Painting Technique." In Martineau et al. 1992, 68–78.

———. 2001

Christiansen, Keith. "A Contribution to Bellini Underdrawings." In *Per l'Arte: Da Venezia all'Europa: Studi in Onore di Giuseppe Maria Pilo*, edited by Mario Piantoni and Laura De Rossi, 113–16. Vol. 1. Venice: Edizioni della Laguna, 2001.

———. 2004a

Christiansen, Keith. "Bellini and Mantegna." In Humfrey 2004, 48–74.

———. 2004b

Christiansen, Keith. "Giovanni Bellini and the Practice of Devotional Painting." In Kasl 2004a, 6–57. See also "Giovanni Bellini e la Maniera Divota." In *Da Bellini a Veronese: Temi di Arte Veneta*, edited by Gennaro Toscano and Francesco Valcanover, 123–53. Venice: Istituto Veneto di Scienze, Lettere ed Arti, 2004.

———. 2006

Christiansen, Keith. "The Art of Gentile da Fabriano." In *Gentile da Fabriano and the Other Renaissance*, edited by Laura Laureati and Lorenza Mochi Onori, 19–51. Exh. cat. Fabriano, Italy: Spedale di Santa Maria del Buon Gesù, 2006.

———. 2009

Christiansen, Keith. "Facts and Love: The Tender Power of Giovanni Bellini." *The New Republic* (15 April 2009): 25–29.

———. 2013

Christiansen, Keith. "Bellini and the Meditational *Poesia*." *Artibus et Historiae* 34, no. 67 (2013): 9–20.

Christiansen and Weppelmann 2011

Christiansen, Keith, and Stefan Weppelmann (eds.). *The Renaissance Portrait from Donatello to Bellini.* Exh. cat. New York: The Metropolitan Museum of Art; Berlin: Bode-Museum, 2011.

Cicogna 1860–61

Cicogna, Emmanuele Antonio. *La Chiesa di Santo Giobbe in Venezia Illustrata nei suoi Monumenti.* Venice: Andreola, 1860–61.

―――. 1969–70

Cicogna, Emmanuele Antonio. *Delle Inscrizioni Veneziane*. Facsimile ed., 6 vols. in 7. Venice: 1824–53; Bologna: Forni Editore, 1969–70.

Clagett 1976

Clagett, M. "The Life and Works of Giovanni Fontana." *Annali dell'Istituto e Museo di Storia della Scienza di Firenze*, Anno 1 (1976): 5–28.

Clark 1949

Clark, Kenneth. *Landscape into Art*. London: John Murray, 1949.

Cobianchi 2006

Cobianchi, Roberto. "The Practice of Confession and Franciscan Observant Churches: New Architectural Arrangements in Early Renaissance Italy." *Zeitschrift für Kunstgeschichte* 69, no. 3 (2006): 289–304.

―――. 2009a

Cobianchi, Roberto. "Fashioning the Imagery of a Franciscan Observant Preacher: Early Renaissance Portraiture of Bernardino da Siena in Northern Italy." *I Tatti Studies: Essays in the Renaissance* 12 (2009): 55–83.

―――. 2009b

Cobianchi, Roberto. "Franciscan Legislation, Patronage Practice, and New Iconography in Sassetta's Commission at Borgo San Sepolcro." In Israëls 2009b, vol. 1, 106–19.

Coltellacci and Lattanzi 1981

Coltellacci, Stefano, and Marco Lattanzi. "Studi Belliniani: Proposte Iconologiche per la *Sacra Allegoria* degli Uffizi." In *Giorgione e la Cultura Veneta tra '400 e '500: Mito, Allegoria, Analisi Iconologica*, 59–79. Rome: De Luca, 1981.

Conn and Rosand 2011

Conn, Melissa, and David Rosand (eds.). *Save Venice Inc.: Four Decades of Restoration in Venice*. New York and Venice: Save Venice Inc., 2011.

Conti 1994

Conti, Alessandro. "Giovanni Bellini nella Bottega di Jacopo Bellini." In *Hommage à Michel Laclotte: Études sur la Peinture du Moyen Âge et de la Renaissance*, edited by Pierre Rosenberg et al., 260–71. Milan: Electa, 1994.

―――. 2007

Conti, Alessandro. *History of the Restoration and Conservation of Works of Art*. Translated by Helen Glanville. Oxford: Elsevier, 2007.

Cook 1996

Cook, William. "La Rappresentazione delle Stimmate di San Francesco nella Pittura Veneziana del Trecento." *Saggi e Memorie di Storia dell'Arte* 20 (1996): 7–34.

―――. 1999

Cook, William. *Images of St Francis of Assisi in Painting, Stone and Glass from the Earliest Images to ca. 1320 in Italy: A Catalogue*. Florence: Leo S. Olschki; Perth: Department of Italian, University of W. Australia, 1999.

―――. 2004

Cook, William. "Giotto and the Figure of St. Francis." In *The Cambridge Companion to Giotto*, edited by Anne Derbes and Mark Sandona, 135–56. Cambridge: Cambridge University Press, 2004.

D. Cooper 2005

Cooper, Donal. "'In Loco Tutissimo et Firmissimo': The Tomb of St. Francis in History, Legend and Art." In *The Art of the Franciscan Order in Italy*, edited by William R. Cook, 1–37. Leiden and Boston: Brill, 2005.

―――. 2013

Cooper, Donal. "Redefining the Altarpiece in Early Renaissance Italy: Giotto's *Stigmatization of Saint Francis* and Its Pisan Context." *Art History* 36, no. 4 (Sept. 2013): 686–713.

Cooper and Robson 2013

Cooper, Donal, and Janet Robson. *The Making of Assisi: The Pope, the Franciscans and the Painting of the Basilica*. New Haven and London: Yale University Press, 2013.

T. Cooper 2005

Cooper, Tracy. *Palladio's Venice: Architecture and Society in a Renaissance Republic*. New Haven and London: Yale University Press, 2005.

―――. 2007

Cooper, Tracy. "Patricians and Citizens." In *Artistic Centers of the Italian Renaissance: Venice and the Veneto*, edited by Peter Humfrey, 151–203. Cambridge and New York: Cambridge University Press, 2007.

Cottrell 2012

Cottrell, Philip. "Art Treasures of the United Kingdom and the United States: The George Scharf Papers." *The Art Bulletin* 94, no. 4 (Dec. 2012): 618–40.

Crouzet-Pavan 1992

Crouzet-Pavan, Élisabeth. *"Sopra le Acque Salse": Espaces, Pouvoir et Société à Venise à la Fin du Moyen Âge*. 2 vols. Rome: École Française de Rome, 1992.

Crowe and Cavalcaselle 1871

Crowe, J. A., and G. B. Cavalcaselle. *A History of Painting in North Italy: Venice, Padua, Vicenza, Verona, Ferrara, Milan, Friuli, Brescia, from the Fourteenth to the Sixteenth Century . . .* 2 vols. London: John Murray, 1871.

―――. 1871/1912

Crowe, J. A., and G. B. Cavalcaselle. *A History of Painting in North Italy: Venice, Padua, Vicenza, Verona, Ferrara, Milan, Friuli, Brescia, from the Fourteenth to the Sixteenth Century*. Edited by Tancred Borenius. 3 vols. London: John Murray, 1871/1912.

Cunningham 2004

Cunningham, Lawrence. *Francis of Assisi: Performing the Gospel Life*. Cambridge and Grand Rapids, MI: William B. Eerdmans, 2004.

Cusato 2000

Cusato, Michael F. "Talking about Ourselves: The Shift in Writing from Hagiography to History (1235–1247)." *Franciscan Studies* 58 (2000): 37–75.

―――. 2002

Cusato, Michael F. "Whence 'the Community'?" *Franciscan Studies* 60 (2002): 39–92.

―――. 2004

Cusato, Michael F. "*Commercium*: From the Profane to the Sacred." In *Francis of Assisi: History, Hagiography and Hermeneutics in the Early Documents*, edited by Jay M. Hammond, 179–209. Hyde Park, NY: New City Press, 2004.

―――. 2005

Cusato, Michael F. "*Esse ergo mitem et humilem corde, hoc est esse vere Fratrem minorem*: Bonaventure of Bagnoregio and the Reformulation of the Franciscan Charism." In *Charisma und Religiöse Gemeinschaften im Mittelalter*, edited by Giancarlo Andenna, Mirko Breitenstein, and Gert Melville, 343–82. Vita Regularis. *Abhandlungen* 26. Münster: LIT, 2005.

―――. 2006

Cusato, Michael F. "Of Snakes and Angels: The Mystical Experience behind the Stigmatization Narrative of 1 Celano." In *The Stigmata of Francis of Assisi: New Studies, New Perspectives*, 29–74. St. Bonaventure, NY: Franciscan Institute Publications, 2006.

―――. 2009

Cusato, Michael F. *The Early Franciscan Movement (1205–1239): History, Sources, and Hermeneutics*. Spoleto: Fondazione Centro Italiano di Studi sull'Alto Medioevo, 2009.

Daily Telegraph 1911

The Daily Telegraph, 30 Dec. 1911.

Dal Pozzolo 2003–4

Dal Pozzolo, Enrico Maria. "Giovanni Bellini a Vicenza." In Rigon and Dal Pozzolo 2003–4, 13–29.

Dalarun 2007

Dalarun, Jacques. "Le Monastère Santa Lucia de Foligno: Foyer Intellectuel." *Frate Francesco*, n.s., 73 (2007): 419–48.

Dalarun and Zinelli 2005

Dalarun, Jacques, and Fabio Zinelli. "Santa Lucia de Foligno: Histoire, Littérature et Théologie dans un Monastère de Clarisses Observantes." In *Identités Franciscaines à l'Âge des Réformes*, edited by Frédéric Meyer and Ludovic Viallet, 363–84. Clermont-Ferrand: Presses Universitaires Blaise-Pascal, 2005.

―――. 2005–9

Dalarun, Jacques, and Fabio Zinelli. "Le Manuscrit des Soeurs de Santa Lucia de Foligno." *Studi Medievali*, ser. 6, vol. 46 (2005): 117–67; vol. 50 (2009): 751–814.

Daly Davis 1980

Daly Davis, Margaret. "Carpaccio and the Perspective of Regular Bodies." In *La Prospettiva Rinascimentale: Codificazioni e Trasgressioni*, 183–200. Vol. 1. Edited by Marisa Dalai Emiliani. Florence: Centro Di, 1980.

Dalhoff 1996
Dalhoff, Meinolf. *Giovanni Bellini: Die Verklärung Christi: Rhetorik, Erinnerung, Historie*. Kunstgeschichte 56. Münster: LIT Verlag, 1996.

Davidson 1998
Davidson, Arnold. "Miracles of Bodily Transformation; or, How St. Francis Received the Stigmata." In *Picturing Science, Producing Art*, edited by Caroline A. Jones and Peter Galison, with Amy Slaton, 101–24. New York and London: Routledge, 1998. Reprinted in *Critical Inquiry* 35, no. 3 (Spring 2009): 451–80.

De Benedictis 2000
De Benedictis, Cristina. *Marco Antonio Michiel: Notizia d'Opere del Disegno*. Edited by Theodor Frimmel. Vienna: 1896; Florence: Edifir, 2000.

Degenhart and Schmitt 1990
Degenhart, Bernhard, and Annegrit Schmitt. *Corpus der Italienischen Zeichnungen 1300–1450*. Part II, vols. 5–8. Berlin: Gebr. Mann Verlag, 1990.

D'Elia 2006
D'Elia, Una Roman. "Niccolò Liburnio on the Boundaries of Portraiture in the Early Cinquecento." *Sixteenth Century Journal* 37, no. 2 (Summer 2006): 323–50.

De Marchi 2006
De Marchi, Andrea. "Per Speculum in Aenigmate." In *L'Immagine di Cristo dall'Acheropita alla Mano d'Artista dal Tardo Medioevo all'Età Barocca*, edited by Christoph L. Frommel and Gerhard Wolf, 117–42. Vatican City: Biblioteca Apostolica Vaticana, 2006.

De Marchi, Di Lorenzo, and Galli Michero 2012
De Marchi, Andrea, Andrea Di Lorenzo, and Lavinia Galli Michero. *Giovanni Bellini: Dall'Icona alla Storia*. Exh. cat. Milan: Museo Poldi Pezzoli, 2012.

Demus 1988
Demus, Otto. *The Mosaic Decoration of San Marco, Venice*. Edited by Herbert L. Kessler. Chicago and London: University of Chicago Press; Washington, D.C.: Dumbarton Oaks, 1988.

Derbes 1996
Derbes, Anne. *Picturing the Passion in Late Medieval Italy: Narrative Painting, Franciscan Ideologies, and the Levant*. Cambridge and New York: Cambridge University Press, 1996.

Dittmar 1984
Dittmar, Peter. "Die Dekorative Skulptur der Venezianischen Frührenaissance." *Zeitschrift für Kunstgeschichte* 47, no. 2 (1984): 158–85.

Di Vito forthcoming

Di Vito, Mauro. "'Per lo Quale Ennallumini la Nocte': Il Verbasco Fiorito del *San Francesco che Riceve le Stimmate* di Giovanni Bellini alla Frick Collection ed Altri Appunti di Storia Naturale." In Wilson forthcoming.

Dorigato 1993
Dorigato, Attilia (ed.). *Carpaccio, Bellini, Tura, Antonello e altri Restauri Quattrocenteschi della Pinacoteca del Museo Correr*. Exh. cat. Venice: Museo Correr, 1993.

Douglas-Scott 1996
Douglas-Scott, Michael. "Giovanni Bellini's *Madonna and Child with Two Saints and a Donor* at Birmingham: A Proposal." *Venezia Cinquecento* 6, no. 11 (1996): 5–21.

Dunkerton 1994
Dunkerton, Jill. "Developments in Colour and Texture in Venetian Painting of the Early 16th Century." In *New Interpretations of Venetian Renaissance Painting*, edited by Francis Ames-Lewis, 63–73. London: Birkbeck College, University of London, Department of History of Art, 1994.

——. **1999**
Dunkerton, Jill. "North and South: Painting Techniques in Venice." In Aikema and Brown 1999, 93–103.

——. **2003**
Dunkerton, Jill. "Titian's Painting Technique." In Jaffé 2003, 44–59.

——. **2004**
Dunkerton, Jill. "Bellini's Technique." In Humfrey 2004, 195–225.

——. **2010**
Dunkerton, Jill. "La Tecnica Pittorica di Cima." In Villa 2010, 70–77.

Dunkerton and Roy 1986
Dunkerton, Jill, and Ashok Roy. "The Technique and Restoration of Cima's *The Incredulity of S. Thomas*." *National Gallery Technical Bulletin* 10 (1986): 4–27.

Dunkerton et al. 1991
Dunkerton, Jill, Susan Foister, Dillian Gordon, and Nicholas Penny. *Giotto to Dürer: Early Renaissance Painting in The National Gallery*. New Haven and London: Yale University Press, 1991.

——. **1999**
Dunkerton, Jill, Susan Foister, and Nicholas Penny. *Dürer to Veronese: Sixteenth-Century Painting in The National Gallery*. New Haven and London: Yale University Press, 1999.

Dunlop 2007
Dunlop, Anne. "Introduction: The Augustinians, the Mendicant Orders, and Early-Renaissance Art." In *Art and the Augustinian Order in Early Renaissance Italy*, edited by Louise Bourdua and Anne Dunlop, 1–15. Aldershot, UK: Ashgate, 2007.

Dürer/Fry 1995

Dürer, Albrecht. *Dürer's Record of Journeys to Venice and the Low Countries*. Edited by Roger Fry. New York: Dover, 1995.

Dussler 1935
Dussler, Luitpold. *Giovanni Bellini*. Frankfurt: Prestel, 1935.

——. **1949**
Dussler, Luitpold. *Giovanni Bellini*. Vienna: Anton Schroll, 1949.

Echols 1994
Echols, Robert. "Cima and the Theme of Saint Jerome in the Wilderness." *Venezia Cinquecento* 4, no. 8 (1994): 47–69.

Edgerton 1966
Edgerton, Samuel Y. "Alberti's Perspective: A New Discovery and a New Evaluation." *The Art Bulletin* 48, nos. 3/4 (Sept.–Dec. 1966): 367–78.

——. **1975**
Edgerton, Samuel Y. *The Renaissance Rediscovery of Linear Perspective*. New York: Basic Books, 1975.

——. **2009**
Edgerton, Samuel Y. *The Mirror, the Window, and the Telescope: How Renaissance Linear Perspective Changed Our Vision of the Universe*. Ithaca, NY, and London: Cornell University Press, 2009.

Eisler 1969
Eisler, Colin. "The Golden Christ of Cortona and the Man of Sorrows in Italy." *The Art Bulletin* 51, no. 2 (June 1969): 107–18; no. 3 (Sept. 1969): 233–46.

——. **1979**
Eisler, Colin. "In Detail: Bellini's *Saint Francis*." *Portfolio* 1, no. 1 (April–May 1979): 18–23.

——. **1989**
Eisler, Colin. *The Genius of Jacopo Bellini: The Complete Paintings and Drawings*. New York: Harry N. Abrams, 1989.

Elkins 2001
Elkins, James. *Pictures & Tears: A History of People Who Have Cried in Front of Paintings*. New York and London: Routledge, 2001.

Elliott 1996
Elliott, John. *Palaces, Patronage & Pills: Thomas Holloway, His Sanatorium, College & Picture Gallery*. Egham, UK: Royal Holloway, University of London, 1996.

Englebert 1979
Englebert, Omer. *Saint Francis of Assisi: A Biography*. 2nd English ed. Translated by Eve Marie Cooper. Edited by Ignatius Brady and Raphael Brown. Cincinnati: Servant Books, St. Anthony Messenger Press, 1979.

Eze 2009
Eze, Anne-Marie. "Abbé Celotti and the Provenance of Antonello da Messina's *The Condottiere* and

Antonio de Solario's *Virgin and Child with St John*." *The Burlington Magazine* 151, no. 1279 (2009): 673–77.

———. 2010

Eze, Anne-Marie. "Abbé Luigi Celotti (1759–1843): Connoisseur, Dealer, and Collector of Illuminated Miniatures." Ph.D. diss., Courtauld Institute of Art, London, 2010.

Fahy 1964

Fahy, Everett Jr. "New Evidence for Dating Giovanni Bellini's *Coronation of the Virgin*." *The Art Bulletin* 46, no. 2 (June 1964): 216–18.

Fascetti 2010

Fascetti, Federico. "La Tradizione Manoscritta Tre-Quattrocentesca dei *Fioretti di San Francesco (Fine)*." *Archivum Franciscanum Historicum* 103 (2010): 41–94.

Ferino-Pagden and Deiters 2004

Ferino-Pagden, Sylvia, Wencke Deiters et al. "On the Collection History of Giorgione's Viennese Paintings." In *Giorgione: Myth and Enigma*, edited by Sylvia Ferino-Pagden and Giovanna Nepi Scirè, 277–87. Exh. cat. Vienna: Kunsthistorisches Museum, 2004.

Ferrari 1990

Ferrari, Francesco. *Il Francescanesimo nel Veneto dalle Origini ai Reperti di S. Francesco del Deserto: Appunti per una Storia della Provincia Veneta dei Frati Minori*. Bologna: Documentazione Scientifica Editrice, 1990.

———. 1992

Ferrari, Francesco. *S. Francesco del Deserto*. Bologna: Documentazione Scientifica Editrice, 1992.

Fiammazzo 1904

Fiammazzo, Antonio. *Nuovo Contributo alla Biografia di Lorenzo Mascheroni*. Bergamo: Istituto Italiano d'Arti Grafiche, 1904.

Field 1997

Field, J. V. *The Invention of Infinity: Mathematics and Art in the Renaissance*. Oxford and New York: Oxford University Press, 1997.

———. 2005

Field, J. V. *Piero della Francesca: A Mathematician's Art*. New Haven and London: Yale University Press, 2005.

Finocchi Ghersi 2003–4

Finocchi Ghersi, Lorenzo. *Il Rinascimento Veneziano di Giovanni Bellini*. Venice: Marsilio, 2003–4.

Finocchi Ghersi, Gentili, and Corsato 2007

Finocchi Ghersi, Lorenzo, Augusto Gentili, and Carlo Corsato. *The Church of San Giobbe*. Venice: Chorus–Marsilio, 2007.

Finotto-Canossiano 1971

Finotto-Canossiano, Ferdinando (ed.). *San Giobbe: La Chiesa dei Santi Giobbe e Bernardino in Venezia*. Venice: Edizioni Parrocchia San Giobbe, 1971.

Fiorani and Nova 2013

Fiorani, Francesca, and Alessandro Nova (eds.). *Leonardo da Vinci and Optics: Theory and Visual Practice*. Kunsthistorisches Institut in Florenz, Max-Planck-Institut, Studi e Ricerche 10. Venice: Marsilio, 2013.

Fleming 1981

Fleming, John. "The Iconographic Unity of the Blessing for Brother Leo." *Franziskanische Studien* 63 (1981): 203–20.

———. 1982

Fleming, John. *From Bonaventure to Bellini: An Essay in Franciscan Exegesis*. Princeton: Princeton University Press, 1982.

Fletcher 1971

Fletcher, J. M. "Isabella d'Este and Giovanni Bellini's *Presepio*." *The Burlington Magazine* 113, no. 825 (Dec. 1971): 703–13.

———. 1972

Fletcher, Jennifer. "The Provenance of Bellini's Frick *St. Francis*." *The Burlington Magazine* 114, no. 829 (April 1972): 206–15.

———. 1973

Fletcher, Jennifer. "Marcantonio Michiel's Collection." *Journal of the Warburg and Courtauld Institutes* 36 (1973): 382–85.

———. 1981a

Fletcher, Jennifer. "Marcantonio Michiel: His Friends and Collection." *The Burlington Magazine* 123, no. 941 (Aug. 1981): 452–67.

———. 1981b

Fletcher, Jennifer. "Marcantonio Michiel, 'Che Ha Veduto Assai.'" *The Burlington Magazine* 123, no. 943 (Oct. 1981): 602–9.

———. 1990

Fletcher, Jennifer. "Harpies, Venus and Giovanni Bellini's Classical Mirror: Some Fifteenth Century Venetian Painters' Responses to the Antique." In *Congresso Internazionale: Venezia e l'Archeologia*, edited by Gustavo Traversari, 170–76. *Rivista di Archeologia*, Supp. 7. Rome: Giorgio Bretschneider, 1990.

———. 1990–91

Fletcher, Jennifer. "'Fatto al Specchio': Venetian Renaissance Attitudes to Self-Portraiture." *Fenway Court* (1990–91): 45–60.

———. 1991

Fletcher, Jennifer. Review of Rona Goffen, *Giovanni Bellini*. *The Burlington Magazine* 133, no. 1064 (Nov. 1991): 777–80.

———. 1993

Fletcher, Jennifer. "Mantegna and Venice." In *Mantegna and 15th-Century Court Culture*, edited by Francis Ames-Lewis and Anka Bednarek, 17–25. London: University of London, Birkbeck College, 1993.

———. 1998

Fletcher, Jennifer. "I Bellini." In *La Bottega dell'Artista tra Medioevo e Rinascimento*, edited by Roberto

Cassanelli, 131–53. Milan: Jaca Book, 1998. See also "Les Bellini." In *Ateliers de la Renaissance*, edited by Roberto Cassanelli, 131–53. Paris: Desclée de Brouwer, 1998.

———. 2004

Fletcher, Jennifer. "Bellini's Social World." In Humfrey 2004, 13–47.

Fletcher and Mueller 2005

Fletcher, Jennifer, and Reinhold C. Mueller. "Bellini and the Bankers: The Priuli Altarpiece for S. Michele in Isola, Venice." *The Burlington Magazine* 147, no. 1222 (Jan. 2005): 5–15.

Fletcher and Skipsey 1991

Fletcher, Jennifer, and David Skipsey. "Death in Venice: Giovanni Bellini and the *Assassination of St Peter Martyr*." *Apollo* 133, no. 347 (Jan. 1991): 4–9.

Flora 2006

Flora, Holly. *Cimabue and Early Italian Devotional Painting*. Exh. cat. New York: The Frick Collection, 2006.

———. 2009

Flora, Holly. *The Devout Belief of the Imagination: The Paris "Meditationes Vitae Christi" and Female Franciscan Spirituality in Trecento Italy*. Disciplina Monastica 6. Turnhout, Belgium: Brepols, 2009.

Fordyce 1885

Fordyce, Alexander Dingwall. *Family Record of the Name of Dingwall Fordyce in Aberdeenshire Showing Descent from the First Known Progenitor of Either Name—Both Direct and Collateral: With Appendix Containing Notices of Individuals and Families Incidentally Referred*. Fergus, Ontario, 1885.

Foscari and Tafuri 1983

Foscari, Antonio, and Manfredo Tafuri. *L'Armonia e i Conflitti: La Chiesa di San Francesco della Vigna nella Venezia del '500*. Turin: Einaudi, 1983.

Fowles 1976

Fowles, Edward. *Memories of Duveen Brothers*. London: Times Books, 1976.

Freedberg 1989

Freedberg, David. *The Power of Images: Studies in the History and Theory of Response*. Chicago: University of Chicago Press, 1989.

Frick 1949

The Frick Collection: Paintings. New York: The Frick Collection, 1949.

———. 1968

The Frick Collection: An Illustrated Catalogue. Vol. 2, *Paintings: French, Italian and Spanish*. New York: The Frick Collection, 1968.

Friedmann 1947

Friedmann, Herbert. "Cornaro's Gazelle and Bellini's *Orpheus*." *Gazette des Beaux-Arts*, ser. 6, vol. 32 (1947): 15–22.

———. 1980

Friedmann, Herbert. *A Bestiary for Saint Jerome: Animal Symbolism in European Religious Art*. Washington, D.C.: Smithsonian Institution Press, 1980.

Frimmel 1888

Frimmel, Theodor. "Der Anonimo Morelliano (Marcanton Michiel's *Notizia d'Opere del Disegno*)." In *Quellenschriften für Kunstgeschichte und Kunsttechnik des Mittelalters und der Neuzeit* I. Vienna: C. Graeser, 1888.

———. **1896**

Frimmel, Theodor. *Der Anonimo Morelliano (Marcanton Michiel's "Notizia d'Opere del Disegno")*. 2nd ed. Vienna: Carl Graeser, 1896.

———. **1907**

Frimmel, Theodor. "Bemerkungen zu Marc-Anton Michiels *Notizia d'Opere di Disegno*." *Blätter für Gemäldekunde* 3 (1907): Beilage, 37–78.

Frizzoni 1884

Frizzoni, Gustavo (ed.). *"Notizia d'Opere di Disegno" Pubblicata e Illustrata da D. Jacopo Morelli*. 2nd ed. Bologna: Nicola Zanichelli, 1884.

Frugoni 1988

Frugoni, Chiara. *Francesco: Un'Altra Storia*. Genoa: Marietti, 1988.

———. **1993**

Frugoni, Chiara. *Francesco e l'Invenzione delle Stimmate: Una Storia per Parole e Immagini fino a Bonaventura e Giotto*. Turin: Giulio Einaudi, 1993.

Gál and Flood 1996

Gál, Gedeon, and David Flood (eds.). *Nicolaus Minorita: Chronica: Documentation on Pope John XXII, Michael of Cesena and the Poverty of Christ with Summaries in English: A Source Book*. St. Bonaventure, NY: Franciscan Institute Publications, 1996.

Galassi 1998

Galassi, Maria Clelia. *Il Disegno Svelato: Progetto e Immagine nella Pittura Italiana del Primo Rinascimento*. Nuoro, Italy: Ilisso, 1998.

———. **2000**

Galassi, Maria Clelia. "Aspects of the Underdrawing in the Florentine and Venetian Painting during the 15th Century." In *Conservation-Restauration et Techniques d'Exécution des Biens Mobiliers: Enseigne-ments Théoriques*, edited by Catheline Périer-D'Ieteren and Nicole Gesché-Koning, 49–64. Brussels: Université Libre de Bruxelles, 2000.

Gallicciolli 1795

Galicciolli, Giambattista. *Delle Memorie Venete Antiche Profane ed Ecclesiastiche*. Vol. 3. Venice: Domenico Fracasso, 1795.

Gallo and Nepi Scirè 1994

Gallo, Andrea, and Giovanna Nepi Scirè (eds.). *Chiesa di San Giobbe: Arte e Devozione*. Venice: Marsilio, 1994.

Gamba 1937

Gamba, Carlo. *Giovanni Bellini*. Milan: Hoepli, 1937.

Gardner 1982

Gardner, Julian. "The Louvre Stigmatization and the Problem of the Narrative Altarpiece." *Zeitschrift für Kunstgeschichte* 45, no. 3 (1982): 217–47.

Gardner 1998–2011

Gardner, Elizabeth E. *A Bibliographical Repertory of Italian Private Collections*. Edited by Chiara Ceschi with Katharine Baetjer, Daniele D'Anza, and Matteo Gardonio. 4 vols. Vicenza: Neri Pozza; Verona: Cierre/Scripta; Venice: Fondazione Giorgio Cini, 1998–2011.

Gatti 1992

Gatti, Isidoro. *S. Maria Gloriosa dei Frari: Storia di una Presenza Francescana a Venezia*. Venice: Edizioni delle Grafiche Veneziane, 1992.

Gentili 1991

Gentili, Augusto. "Giovanni Bellini, la Bottega, i Quadri di Devozione." *Venezia Cinquecento* 1, no. 2 (1991): 27–60.

———. **2004a**

Gentili, Augusto. "Bellini and Landscape." In Humfrey 2004, 167–81.

———. **2004b**

Gentili, Augusto. "Cosa Racconta Giovanni Bellini in quel 'San Francesco' che è uno dei suoi Capolavori." *VeneziAltrove* 3 (2004): 65–77.

———. **2006**

Gentili, Augusto. "Paesaggio della Meditazione e Paesaggio dell'Emozione nella Pittura Veneziana fra Quattrocento e Cinquecento." In *Archivi dello Sguardo: Origini e Momenti della Pittura di Paesaggio in Italia: Atti del Convegno*, edited by Francesca Cappelletti, 17–39. Florence: Le Lettere, 2006.

Gentili et al. 1985

Gentili, Augusto, with Marco Lattanzi and Flavia Polignano. *I Giardini di Contemplazione: Lorenzo Lotto, 1503/1512*. Rome: Bulzoni, 1985.

Gibbons 1963

Gibbons, Felton. "New Evidence for the Birth Dates of Gentile and Giovanni Bellini." *The Art Bulletin* 45, no. 1 (March 1963): 54–58.

———. **1965**

Gibbons, Felton. "Practices in Giovanni Bellini's Workshop." *Pantheon* 23 (1965): 146–55.

———. **1977**

Gibbons, Felton. "Giovanni Bellini's Topographical Landscapes." In *Studies in Late Medieval and Renaissance Painting in Honor of Millard Meiss*, edited by Irving Lavin and John Plummer, vol. 1, 174–84, vol. 2, 64–66. New York: New York University Press, 1977.

Gieben 1996

Gieben, Servus. "Per la Storia dell'Abito Francescano." *Collectanea Franciscana* 66 (1996): 431–78.

Gilbert 1952

Gilbert, Creighton. "On Subject and Not-Subject in Italian Renaissance Pictures." *The Art Bulletin* 34, no. 3 (Sept. 1952): 202–16.

———. **1992**

Gilbert, Creighton. *Italian Art, 1400–1500: Sources and Documents*. Evanston, IL: Northwestern University Press, 1992.

Giulini 2003–4

Giulini, Patrizio. "Il Paesaggio Vegetale del *Crocifisso*." In Rigon and Dal Pozzolo 2003–4, 65–67.

Godla forthcoming

Godla, Joseph. "Jacopo Bellini Drawing as a Precursor to Piero della Francesca's *Quadrata Degradata*." Forthcoming.

Goffen 1975

Goffen, Rona. "Icon and Vision: Giovanni Bellini's Half-Length Madonnas." *The Art Bulletin* 57, no. 4 (Dec. 1975): 487–518.

———. **1986a**

Goffen, Rona. "Bellini, S. Giobbe and Altar Egos." *Artibus et Historiae* 7, no. 14 (1986): 57–70.

———. **1986b**

Goffen, Rona. *Piety and Patronage in Renaissance Venice: Bellini, Titian, and the Franciscans*. New Haven and London: Yale University Press, 1986.

———. **1988**

Goffen, Rona. *Spirituality in Conflict: Saint Francis and Giotto's Bardi Chapel*. University Park and London: Pennsylvania State University Press, 1988.

———. **1989**

Goffen, Rona. *Giovanni Bellini*. New Haven and London: Yale University Press, 1989.

———. **1993a**

Goffen, Rona. "Bellini Disegnatore e la sua Attività Giovanile." In Dorigato 1993, 16–24.

———. **1993b**

Goffen, Rona. "Titian's *Sacred and Profane Love*: Individuality and Sexuality in a Renaissance Marriage Picture." In *Titian 500*, edited by Joseph Manca, 120–44. Studies in the History of Art 45. Washington, D.C.: Center for Advanced Study in the Visual Arts, 1993.

Goffen and Nepi Scirè 2000

Goffen, Rona, and Giovanna Nepi Scirè (eds.). *Il Colore Ritrovato: Bellini a Venezia*. Exh. cat. Venice: Gallerie dell'Accademia, 2000.

Golden 2004

Golden, Andrea. "Creating and Re-creating: The Practice of Replication in the Workshop of Giovanni Bellini." In Kasl 2004a, 90–127.

Goldner 2004

Goldner, George. "Bellini's Drawings." In Humfrey 2004, 226–55.

Gombrich 1976

Gombrich, E. H. "Light, Form and Texture in Fifteenth-Century Painting North and South of the Alps." In *The Heritage of Apelles: Studies in the Art of the Renaissance*, 19–35. Oxford: Phaidon, 1976.

Grave 1998

Grave, Johannes. "Ein Neuer Blick auf Giovanni Bellinis Darstellung des Heiligen Franziskus." *Bruckmanns Pantheon* 56 (1998): 35–43.

———. 2004

Grave, Johannes. *Landschaften der Meditation: Giovanni Bellinis Assoziationsräume*. Freiburg: Rombach, 2004.

de Groër 1987

de Groër, Georgette. "Notes de Voyage d'un Pèlerin Flamand en Italie au XVe Siècle." In *Art, Objets d'Art, Collections: Hommage à Hubert Landais: Études sur l'Art du Moyen Âge et de la Renaissance, sur l'Histoire du Goût et des Collections*, 75–83. Paris: Blanchard, 1987.

Gronau 1930

Gronau, Georg. *Giovanni Bellini: Des Meisters Gemälde*. Stuttgart and Berlin: Deutsche Verlags-Anstalt, 1930.

Grubb 2000

Grubb, James. "Elite Citizens." In *Venice Reconsidered: The History and Civilization of an Italian City-State, 1297–1797*, edited by John Martin and Dennis Romano, 339–64. Baltimore and London: The Johns Hopkins University Press, 2000.

Gullino 2002

Gullino, Giuseppe. "Giustinian, Giovanni." In *Dizionario Biografico degli Italiani*. Vol. 57. Rome: Istituto della Enciclopedia Italiana, 1960–. Accessed online: http://www.treccani.it/biografie/

Habig 1973

Habig, Marion (ed.). *St. Francis of Assisi: Writings and Early Biographies: English Omnibus of the Sources for the Life of St. Francis*. 3rd ed. Chicago: Franciscan Herald Press, 1973.

Hadley 1987

Hadley, Rollin van (ed.) *The Letters of Bernard Berenson and Isabella Stewart Gardner, 1887–1924, with Correspondence by Mary Berenson*. Boston: Northeastern University Press, 1987.

Hall 1992

Hall, Marcia. *Color and Meaning: Practice and Theory in Renaissance Painting*. Cambridge and New York: Cambridge University Press, 1992.

Hammond 2002

Hammond, Norman. "Bellini's Ass: A Note on the Frick *St. Francis*." *The Burlington Magazine* 144, no. 1186 (Jan. 2002): 24–26.

———. 2007

Hammond, Norman. "Bellini's Birds: Avifauna in the Frick *St. Francis*." *The Burlington Magazine* 149, no. 1246 (Jan. 2007): 36–38.

Harbison 1992

Harbison, Craig. "Meaning in Venetian Renaissance Art: The Issues of Artistic Ingenuity and Oral Tradition." *Art History* 15, no. 1 (March 1992): 19–37.

Harrison-Barbet 1994

Harrison-Barbet, Anthony. *Thomas Holloway: Victorian Philanthropist: A Biographical Essay*. Rev. ed. Egham, UK: Royal Holloway, University of London, 1994.

Hartt 1940

Hartt, Frederick. "Carpaccio's *Meditation on the Passion*." *The Art Bulletin* 22, no. 1 (March 1940): 25–35.

Hartt and Wilkins 2003

Hartt, Frederick, and David G. Wilkins. *History of Italian Renaissance Art*. 5th ed. New York: Harry N. Abrams, 2003.

Haskell 2000

Haskell, Francis. *The Ephemeral Museum: Old Master Paintings and the Rise of the Art Exhibition*. New Haven and London: Yale University Press, 2000.

Heers and de Groër 1978

Heers, Jacques, and Georgette de Groër. *Itinéraire d'Anselme Adorno en Terre Sainte (1470–1471)*. Paris: Éditions du Centre National de la Recherche Scientifique, 1978.

Heinemann 1962

Heinemann, Fritz. *Giovanni Bellini e i Belliniani*. Vol. 1. Venice: Neri Pozza, 1962.

Hendy and Goldscheider 1945

Hendy, Philip, and Ludwig Goldscheider. *Giovanni Bellini*. Oxford and London: Phaidon; New York: Oxford University Press, 1945.

Hills 1987

Hills, Paul. *The Light of Early Italian Painting*. New Haven and London: Yale University Press, 1987.

———. 1990

Hills, Paul. "The Renaissance Altarpiece: A Valid Category?" In *The Altarpiece in the Renaissance*, edited by Peter Humfrey and Martin Kemp, 34–48. Cambridge and New York: Cambridge University Press, 1990.

———. 1999

Hills, Paul. *Venetian Colour: Marble, Mosaic, Painting and Glass, 1250–1550*. New Haven and London: Yale University Press, 1999.

———. 2004

Hills, Paul. "Bellini's Colour." In Humfrey 2004, 182–94.

Hills forthcoming

Hills, Paul. "Vesting the Body of Christ." In Wilson forthcoming.

Hirdt 1997

Hirdt, Willi. *Il San Francesco di Giovanni Bellini: Un Tentativo di Interpretazione del Dipinto della Frick Collection*. Florence: Edizioni Polistampa, 1997. Reprinted as "Giovanni Bellinis Heiliger Franziskus (Frick Collection, New York)." In *Lesen und Sehen: Aufsätze zu Literatur und Malerei in Italien und Frankreich: Festschrift zum 60. Geburtstag Willi Hirdt*, edited by Birgit Tappert and Willi Jung, 29–74. Tübingen: Stauffenburg, 1998.

Hochmann 2008a

Hochmann, Michel. "Le Collezioni Veneziane nel Rinascimento: Storia e Storiografia." In Hochmann et al. 2008, 2–39.

———. 2008b

Hochmann, Michel. "Le Dessin dans la Peinture Vénitienne: Nouvelles Recherches." *Revue de l'Art* 160, no. 2 (2008): 11–22.

Hochmann et al. 2008

Hochmann, Michel, Rosella Lauber, and Stefania Mason (eds.). *Il Collezionismo d'Arte a Venezia: Dalle Origini al Cinquecento*. Venice: Marsilio, 2008.

Hourihane 2010

Hourihane, Colum (ed.). *Looking Beyond: Visions, Dreams, and Insights in Medieval Art and History*. Princeton: Index of Christian Art; University Park: Pennsylvania State University Press, 2010.

Howard 1987

Howard, Deborah. *Jacopo Sansovino: Architecture and Patronage in Renaissance Venice*. 2nd ed. New Haven and London: Yale University Press, 1987.

———. 1989

Howard, Deborah. "The Church of the Miracoli in Venice and Pittoni's St. Jerome Altar-Piece." *The Burlington Magazine* 131, no. 1039 (Oct. 1989): 684–92.

———. 2002

Howard, Deborah. *The Architectural History of Venice*. Rev. ed. New Haven and London: Yale University Press, 2002.

———. 2004

Howard, Deborah. "Bellini and Architecture." In Humfrey 2004, 143–66.

———. 2013

Howard, Deborah. "Contextualising Titian's *Sacred and Profane Love*: The Cultural World of the Venetian Chancery in the Early Sixteenth Century." *Artibus et Historiae* 34, no. 67 (2013): 185–99.

Humfrey 1985

Humfrey, Peter. "The 'Life of St. Jerome' Cycle from the Scuola di San Gerolamo in Cannaregio." *Arte Veneta* 39 (1985): 41–46.

———. 1991

Humfrey, Peter. "Two Lost *St. Jerome* Altarpieces by Giovanni Bellini." *Venezia Cinquecento* 1, no. 2 (1991): 109–17.

———. 1993a

Humfrey, Peter. *The Altarpiece in Renaissance Venice*. New Haven and London: Yale University Press, 1993.

———. 1993b
Humfrey, Peter. "Marco Zoppo: La Pala di Pesaro." In *Marco Zoppo e il suo Tempo*, edited by Berenice Giovannucci Vigi, 71–78. Bologna: Nuova Alfa, 1993.

———. 2004
Humfrey, Peter (ed.). *The Cambridge Companion to Giovanni Bellini*. Cambridge and New York: Cambridge University Press, 2004.

———. 2008
Humfrey, Peter. "Giovanni Bellini e i suoi Committenti." In Lucco and Villa 2008, 67–75.

———. forthcoming
Humfrey, Peter. "The Reception of Giovanni Bellini in Britain, Up to c. 1900." In Wilson forthcoming.

Humfrey, Lucco, and Villa forthcoming
Humfrey, Peter, Mauro Lucco, and Giovanni C. F. Villa. *Giovanni Bellini: Catalogo Completo*. Forthcoming.

Huse 1972
Huse, Norbert. *Studien zu Giovanni Bellini*. Berlin and New York: Walter de Gruyter, 1972.

Huse and Wolters 1990
Huse, Norbert, and Wolfgang Wolters. *The Art of Renaissance Venice: Architecture, Sculpture, and Painting, 1460–1590*. Translated by Edmund Jephcott. Chicago and London: University of Chicago Press, 1990.

Ilchman et al. 2009
Ilchman, Frederick, et al. *Titian, Tintoretto, Veronese: Rivals in Renaissance Venice*. Exh. cat. Boston: Museum of Fine Arts, 2009.

Israel 2007
Israel, Janna. "The Picture of Poverty: Cristoforo Moro and Patronage of San Giobbe, Venice." Ph.D. diss., Massachusetts Institute of Technology, Cambridge, 2007.

Israëls 2007
Israëls, Machtelt. "Absence and Resemblance: Early Images of Bernardino da Siena and the Issue of Portraiture (With a New Proposal for Sassetta)." *I Tatti Studies: Essays in the Renaissance* 11 (2007): 77–114.

———. 2009a
Israëls, Machtelt. "Painting for a Preacher: Sassetta and Bernardino da Siena." In Israëls 2009b, vol. 1, 120–39.

———. 2009b
Israëls, Machtelt (ed.). *Sassetta: The Borgo San Sepolcro Altarpiece*. 2 vols. Florence: Villa I Tatti, The Harvard University Center for Italian Renaissance Studies; Leiden: Primavera Press, 2009.

Jaffé 2003

David Jaffé (ed.). *Titian*. Exh. cat. London: The National Gallery, 2003.

Janson 1994
Janson, Anthony. "The Meaning of the Landscape in Bellini's *St. Francis in Ecstasy*." *Artibus et Historiae* 15, no. 30 (1994): 41–54.

Jung 2010
Jung, Jacqueline. "The Tactile and the Visionary: Notes on the Place of Sculpture in the Medieval Religious Imagination." In Hourihane 2010, 202–40.

Kasl 2004a
Kasl, Ronda (ed.). *Giovanni Bellini and the Art of Devotion*. Exh. cat. Indianapolis: Indianapolis Museum of Art, 2004.

———. 2004b
Kasl, Ronda. "Holy Households: Art and Devotion in Renaissance Venice." In Kasl 2004a, 58–89.

Khandekar and Schilling 2001
Khandekar, N., and M. R. Schilling. "A Technical Examination of a Seventeenth-Century Polychrome Sculpture of St. Gines de la Jara by Luisa Roldan." *Studies in Conservation* 46 (2001): 23–34.

Köster 2008
Köster, Gabriele. *Künstler und ihre Brüder: Maler, Bildhauer und Architekten in den Venezianischen Scuole Grandi (bis ca. 1600)*. Berlin: Gebr. Mann Verlag, 2008.

Krellig 2009
Krellig, Heiner. "Francesco and Bonomo Algarotti." In Borean and Mason 2009, 239–41.

Krischel 2002
Krischel, Roland. "Zur Geschichte des Venezianischen Pigmenthandels: Das Sortiment des *Jacobus de Benedictis à Coloribus*." *Wallraf-Richartz-Jahrbuch* 63 (2002): 93–158.

Krüger 1992
Krüger, Klaus. *Der Frühe Bildkult des Franziskus in Italien: Gestalt- und Funktionswandel des Tafelbildes im 13. und 14. Jahrhundert*. Berlin: Gebr. Mann Verlag, 1992.

Ladis 1998
Ladis, Andrew (ed.). *Franciscanism, the Papacy, and Art in the Age of Giotto: Assisi and Rome*. New York and London: Garland Publishing, 1998.

Lambert 1998
Lambert, Malcolm D. *Franciscan Poverty: The Doctrine of the Absolute Poverty of Christ and the Apostles in the Franciscan Order, 1210–1323*. Rev. ed. St. Bonaventure, NY: Franciscan Institute Publications, 1998.

Land 1974
Land, Norman E. "Michele Giambono: A Catalogue Raisonné." Ph.D. diss., University of Virginia,

Charlottesville, 1974.

———. 1980
Land, Norman. "Two Panels by Michele Giambono and Some Observations on St. Francis and the Man of Sorrows in Fifteenth-Century Venetian Painting." *Studies in Iconography* 6 (1980): 29–51.

———. 1989
Land, Norman. "A Note on Giovanni Bellini's *St. Francis* in the Frick Collection." *Southeastern College Art Conference Review* 11, no. 4 (1989): 300–304.

———. 1994
Land, Norman. *The Viewer as Poet: The Renaissance Response to Art*. University Park: Pennsylvania State University Press, 1994.

———. 1998
Land, Norman. "Carlo Crivelli, Giovanni Bellini, and the Fictional Viewer." *Source* 18, no. 1 (Fall 1998): 18–24.

Lanzi 1793–94/1988
Lanzi, Luigi. *Viaggio nel Veneto*. Edited by Donata Levi. Florence: Studio per Edizioni Scelte, 1988.

———. 1795–96/1968–74
Lanzi, Luigi. *Storia Pittorica della Italia dal Risorgimento delle Belle Arti fin presso al Fine del XVIII. Secolo*. Edited by Martino Capucci. 3 vols. Florence: Sansoni, 1968–74.

———. 1815–16
Lanzi, Luigi. *Storia Pittorica della Italia dal Risorgimento delle Belle Arti fin presso al Fine del XVIII. Secolo*. 4th ed. 6 vols. Pisa: Niccolò Capurro, 1815–16.

Lattanzi and Mercalli 1983
Lattanzi, Marco, and Marica Mercalli. "Il Tema del *San Girolamo nell'Eremo* nella Cultura Veneta tra Quattro e Cinquecento." In *Il S. Girolamo di Lorenzo Lotto a Castel S. Angelo*, edited by Bruno Contardi and Augusto Gentili, 71–106. Exh. cat. Rome: Museo Nazionale di Castel Sant'Angelo, 1983.

Lauber 2001
Lauber, Rosella. "Per l'Edizione Critica della *Notizia d'Opere di Disegno* di Marcantonio Michiel." Ph.D. diss., University of Udine, Udine, 2001.

———. 2002a
Lauber, Rosella. "'Et è il Nudo che Ho Io in Pittura de l'istesso Zorzi': Per Giorgione e Marcantonio Michiel." *Arte Veneta* 59 (2002): 98–115.

———. 2002b
Lauber, Rosella. "Per un Ritratto di Gabriele Vendramin: Nuovi Contributi." In *Figure di Collezionisti a Venezia tra Cinque e Seicento*, edited by Linda Borean and Stefania Mason, 25–71. Udine: Forum, 2002.

———. 2004
Lauber, Rosella. "Da Venezia a New York, L'Epopea del San Francesco di Bellini: Dal 1525, Quando lo Vide Michiel, Ricostruite Tutte le Tappe (o quasi) della Preziosa Tavola." *VeneziAltrove* 3 (2004): 79–89.

———. 2005

Lauber, Rosella. "'Opera Perfettissima': Marcantonio Michiel e la *Notizia d'Opere di Disegno*." In *Il Collezionismo a Venezia e nel Veneto ai Tempi della Serenissima*, edited by Bernard Aikema, Rosella Lauber, and Max Seidel, 77–116. Venice: Marsilio, 2005.

———. 2007a
Lauber, Rosella. "'Et Maxime in li Occhî': Per la Descrizione delle Opere d'Arte in Marcantonio Michiel." In *Testi, Immagini e Filologia nel XVI Secolo*, edited by Eliana Carrara and Silvia Ginzburg, 1–36. Pisa: Edizioni della Normale, 2007.

———. 2007b
Lauber, Rosella. "Giulio Giustinian." In Borean and Mason 2007, 276–77.

———. 2008
Lauber, Rosella. "Taddeo Contarini." In Hochmann et al. 2008, 263–64.

———. 2009
Lauber, Rosella. "Cornaro 'della Ca' Granda,' Collezione." In Borean and Mason 2009, 260–62.

———. 2009–10
Lauber, Rosella. "Una Lucente Linea d'Ombra: Note per Giorgione nel Collezionismo Veneziano." In *Giorgione*, edited by Enrico Maria Dal Pozzolo and Lionello Puppi, 189–206. Exh. cat. Castelfranco Veneto: Museo Casa Giorgione, 2009–10.

———. forthcoming
Lauber, Rosella. "'Finito et Ricercato Mirabilmente': Per Nuovi Contributi sul *San Francesco nel Deserto* di Giovanni Bellini, ora nella Frick Collection di New York." In Wilson forthcoming.

Laurenzi Tabasso 1988
Laurenzi Tabasso, Marisa (ed.). "Le Indagini Scientifiche." In Valazzi 1988b, 127–43.

Lavin 1990
Lavin, Marilyn A. *The Place of Narrative: Mural Decoration in Italian Churches, 431–1600*. Chicago and London: University of Chicago Press, 1990.

———. 2002
Lavin, Marilyn A. *Piero della Francesca*. London and New York: Phaidon, 2002.

———. 2007
Lavin, Marilyn A. "The Joy of St. Francis: Bellini's Panel in the Frick Collection." *Artibus et Historiae* 28, no. 56 (2007): 231–56.

———. 2009
Lavin, Marilyn A. *Artists' Art in the Renaissance*. London: Pindar Press, 2009.

———. 2013
Lavin, Marilyn A. "The Joy of St. Francis: Bellini's Panel in the Frick Collection." Rev. ed. In *Beyond the Text: Franciscan Art and the Construction of Religion*, edited by Xavier Seubert and Oleg Bychkov, 14–39. St. Bonaventure, NY: Franciscan Institute Publications, 2013.

Lawrence 1994
Lawrence, C. H. *The Friars: The Impact of the Early Mendicant Movement on Western Society*. London and New York: Longman, 1994.

Lazzarini 1983
Lazzarini, Lorenzo. "Il Colore nei Pittori Veneziani tra il 1480 e il 1580." *Bollettino d'Arte*, supp. 5, *Studi Veneziani: Ricerche di Archivio e di Laboratorio* (1983): 135–44.

Le Goff 1988
Le Goff, Jacques. "The Wilderness in the Medieval West." In *The Medieval Imagination*. Translated by Arthur Goldhammer, 47–59. Chicago and London: University of Chicago Press, 1988.

———. 1999
Le Goff, Jacques. *Saint François d'Assise*. Paris: Éditions Gallimard, 1999.

———. 2004
Le Goff, Jacques. *Saint Francis of Assisi*. Translated by Christine Rhone. London and New York: Routledge, 2004.

Levi 1988
Levi, Donata. *Cavalcaselle: Il Pioniere della Conservazione dell'Arte Italiana*. Turin: Einaudi, 1988.

Levi d'Ancona 1977
Levi d'Ancona, Mirella. *The Garden of the Renaissance: Botanical Symbolism in Italian Painting*. Florence: Leo S. Olschki, 1977.

———. 2001
Levi d'Ancona, Mirella. *Lo Zoo del Rinascimento: Il Significato degli Animali nella Pittura Italiana dal XIV al XVI Secolo*. Lucca: M. Pacini Fazzi, 2001.

Lieberman 1982
Lieberman, Ralph. *Renaissance Architecture in Venice, 1450–1540*. New York: Abbeville Press; London: John Calmann and Cooper, 1982.

Little 1978
Little, Lester. *Religious Poverty and the Profit Economy in Medieval Europe*. Ithaca, NY: Cornell University Press, 1978.

London Gazette 1863
The London Gazette, 2 Jan. 1863.

———. 1865a
The London Gazette, 4 July 1865.

———. 1865b
The London Gazette, 7 July 1865.

———. 1896
The London Gazette, 17 Jan. 1896.

Longhi 1914
Longhi, Roberto. "Piero dei Franceschi e lo Sviluppo della Pittura Veneziana." *L'Arte* 17 (1914): 198–221, 241–56.

———. 1946
Longhi, Roberto. *Viatico per Cinque Secoli di Pittura Veneziana*. Florence: Sansoni, 1946.

———. 1949
Longhi, Roberto. "The Giovanni Bellini Exhibition." *The Burlington Magazine* 91, no. 559 (Oct. 1949): 274–83.

Lorenzi 1868
Lorenzi, Giambattista. *Monumenti per Servire alla Storia del Palazzo Ducale di Venezia: Parte I: Dal 1253 al 1600*. Venice: Marco Visentini, 1868.

Lucas and Plesters 1978
Lucas, Arthur, and Joyce Plesters. "Titian's *Bacchus and Ariadne*." *National Gallery Technical Bulletin* 2 (1978): 25–47.

Lucco 1990
Lucco, Mauro. "Venezia." In *La Pittura nel Veneto: Il Quattrocento*. Vol. 2. Milan: Electa, 1990, 395–480.

———. 2004
Lucco, Mauro. "Bellini and Flemish Painting." In Humfrey 2004, 75–94.

———. 2006
Lucco, Mauro (ed.). *Antonello da Messina: L'Opera Completa*. Exh. cat. Rome: Scuderie del Quirinale, 2006.

———. 2008a
Lucco, Mauro. "La Primavera del Mondo Tuto, in Ato de Pitura." In Lucco and Villa 2008, 18–37.

———. 2008b
Lucco, Mauro. "'Uscito dalla Scuola del Bellino': Qualche Nota Tecnica sugli Inizi di Giorgione." In *Giorgione Entmythisiert*, edited by Sylvia Ferino-Pagden, 117–41. Turnhout, Belgium: Brepols, 2008.

Lucco and Villa 2008
Lucco, Mauro, and Giovanni C. F. Villa (eds.). *Giovanni Bellini*. Exh. cat. Rome: Scuderie del Quirinale, 2008.

Luchs 1995
Luchs, Alison. *Tullio Lombardo and Ideal Portrait Sculpture in Renaissance Venice, 1490–1530*. Cambridge and New York: Cambridge University Press, 1995.

Ludwig 1905
Ludwig, Gustav. "Archivalische Beiträge zur Geschichte der Venezianischen Malerei." *Jahrbuch der Königlich Preuszischen Kunstsammlungen* 26 (1905): Beiheft, 1–159.

Ludwig and Bode 1903
Ludwig, Gustav, and Wilhelm Bode. "Die Altarbilder der Kirche S. Michele di Murano und das Auferstehungsbild des Giovanni Bellini in der Berliner Galerie." *Jahrbuch der Königlich Preussischen Kunstsammlungen* 24, no. 2 (1903): 131–46.

Lugli 2009
Lugli, Emanuele. "Between Form and Representation: The Frick *St. Francis*." *Art History* 32, no. 1 (Feb. 2009): 21–51.

Lynn-Davis 1998
Lynn-Davis, Barbara. "Landscapes of the Imagination in Renaissance Venice." Ph.D. diss., Princeton

University, 1998.

Magrini 2009
Magrini, Marina. "Anton Maria Zanetti il Vecchio." In Borean and Mason 2009, 317–19.

Manchester 1857
Catalogue of the Art Treasures of the United Kingdom: Collected at Manchester in 1857. 2nd ed. Exh. cat. London: Bradbury and Evans, 1857.

Mancuso and Gallone 2004
Mancuso, Cinzia Maria, and Antonietta Gallone. "Giovanni Bellini and His Workshop: A Technical Study of Materials and Working Methods." In Kasl 2004a, 128–51.

Manoli and Zanolini 2012
Manoli, Federica, and Paola Zanolini. "Note sul Restauro e sulla Tecnica Pittorica dell'*Imago Pietatis* del Museo Poldi Pezzoli." In De Marchi, Di Lorenzo, and Galli Michero 2012, 84–90.

Manselli 1980/1988
Manselli, Raoul. *Saint Francis of Assisi.* Translated by Paul Duggan. Rome: Bulzoni, 1980; Chicago: Franciscan Herald Press, 1988.

de Maria 2010
de Maria, Blake. *Becoming Venetian: Immigrants and the Arts in Early Modern Venice.* New Haven and London: Yale University Press, 2010.

Marini 1979
Marini, Luciano. *La Basilica dei Frari.* Venice: ARDO–Edizioni d'Arte, 1979.

van Marle 1935
van Marle, Raimond. *The Development of the Italian Schools of Painting.* Vol. 17. The Hague: Martinus Nijhoff, 1935.

Martineau et al. 1992
Martineau, Jane, et al. *Andrea Mantegna.* Exh. cat. London: Royal Academy of Arts; New York: The Metropolitan Museum of Art, 1992.

Massey 2007
Massey, Lyle. *Picturing Space, Displacing Bodies: Anamorphosis in Early Modern Theories of Perspective.* University Park: The Pennsylvania State University Press, 2007.

Mather 1936
Mather, Frank Jewett Jr. *Venetian Painters.* New York: Henry Holt & Co., 1936.

———. **1938**
Mather, Frank Jewett Jr. *A History of Italian Painting.* New York: Henry Holt & Co., 1938.

Matthew 1998
Matthew, Louisa. "The Painter's Presence: Signatures in Venetian Renaissance Pictures." *The Art Bulletin* 80, no. 4 (Dec. 1998): 616–48.

———. **2002**
Matthew, Louisa. "'Vendecolori a Venezia': The Reconstruction of a Profession." *The Burlington Magazine* 144, no. 1196 (Nov. 2002): 680–86.

Maze 2013
Maze, Daniel Wallace. "Giovanni Bellini: Birth, Parentage, and Independence." *Renaissance Quarterly* 66, no. 3 (Fall 2013): 783–823.

Mazzotta 2012
Mazzotta, Antonio. *Giovanni Bellini's Dudley Madonna.* London: Paul Holberton Publishing, 2012.

McAndrew 1980
McAndrew, John. *Venetian Architecture of the Early Renaissance.* Cambridge and London: MIT Press, 1980.

McGinn 1986
McGinn, Bernard. "Circoli Gioachimiti Veneziani (1450–1530)." *Cristianesimo nella Storia* 7 (1986): 19–39.

McHam 2008
McHam, Sarah Blake. "Reflections of Pliny in Giovanni Bellini's *Woman with a Mirror.*" *Artibus et Historiae* 29, no. 58 (2008): 157–71.

———. **2013**
McHam, Sarah Blake. *Pliny and the Artistic Culture of the Italian Renaissance: The Legacy of the "Natural History."* New Haven and London: Yale University Press, 2013.

Meiss 1945
Meiss, Millard. "Light as Form and Symbol in Some Fifteenth-Century Paintings." *The Art Bulletin* 27, no. 3 (Sept. 1945): 175–81.

———. **1963**
Meiss, Millard. "Giovanni Bellini's *St. Francis.*" *Saggi e Memorie di Storia dell'Arte* 3 (1963): 9–30, 111–45.

———. **1964**
Meiss, Millard. *Giovanni Bellini's "St. Francis" in the Frick Collection.* Princeton: Princeton University Press, 1964.

———. **1966**
Meiss, Millard. "Giovanni Bellini's *St. Francis.*" *The Burlington Magazine* 108, no. 754 (Jan. 1966): 27.

———. **1974**
Meiss, Millard. "Scholarship and Penitence in the Early Renaissance: The Image of St. Jerome." *Pantheon* 32, no. 2 (April–June 1974): 134–40.

Meiss and Jones 1966
Meiss, Millard, and Theodore G. Jones. "Once Again Piero della Francesca's Montefeltro Altarpiece." *The Art Bulletin* 48, no. 2 (June 1966): 203–6.

Meneghin 1962
Meneghin, P. Vittorino. *S. Michele in Isola di Venezia.* Vol. 1. Venice: Stamperia di Venezia, 1962.

Merlo 1989
Merlo, Grado G. "Dal Deserto alla Folla: Persistenti Tensioni del Francescanesimo." *Le Venezie Francescane,* n.s., 6 (Jan.–June 1989): 60–77.

———. **2003/2009**
Merlo, Grado G. *In the Name of Saint Francis: History of the Friars Minor and Franciscanism until the Early Sixteenth Century.* Translated by Raphael Bonanno. Padua: Editrici Francescane, 2003; St. Bonaventure, NY: Franciscan Institute Publications, 2009.

Meyer zur Capellen 1985
Meyer zur Capellen, Jürg. *Gentile Bellini.* Stuttgart and Wiesbaden: Franz Steiner, 1985.

da Milano 1945
da Milano, Ilarino. "San Bernardino da Siena e l'Osservanza Minoritica." In *S. Bernardino da Siena: Saggi e Ricerche Pubblicati nel Quinto Centenario della Morte (1444–1944),* 379–406. Milan: Società Editrice, 1945.

Miller 2004
Miller, David. "The Conservation of a *Madonna and Child* by Giovanni Bellini and His Workshop." In Kasl 2004a, 152–59.

Mills and White 1977
Mills, John, and Raymond White. "Analyses of Paint Media." *National Gallery Technical Bulletin* 1 (Sept. 1977): 57–59.

Monfardini 2000
Monfardini, Pierpaolo. "Supporti Lignei e Sistemi di Struttura: Tecniche di Costruzione e Interventi di Restauro." In Goffen and Nepi Scirè 2000, 168–74.

Moorman 1968/1988
Moorman, John. *A History of the Franciscan Order from its Origins to the Year 1517.* London: Oxford University Press, 1968; Chicago: Franciscan Herald Press, 1988.

Morelli 1800
Morelli, D. Jacopo. *Notizia d'Opere di Disegno nella Prima Metà del Secolo XVI . . .* Bassano, 1800.

Morelli/Frizzoni 1893
Morelli, Giovanni. *Kunstkritische Studien über Italienische Malerei: Die Galerie zu Berlin.* Edited by Gustavo Frizzoni. Leipzig: F. A. Brockhaus, 1893.

***Morning Post* 1911**
The Morning Post, 16 Dec. 1911.

Morpurgo 1900
Morpurgo, Salomone (ed.). *I Manoscritti della R. Biblioteca Riccardiana di Firenze: Manoscritti Italiani.* Vol. 1. Rome: Presso i Principali Librai, 1900.

Morse 2006
Morse, Margaret. "The Arts of Domestic Devotion in Renaissance Italy: The Case of Venice." Ph.D. diss., University of Maryland, College Park, 2006.

———. **2007**
Morse, Margaret. "Creating Sacred Space: The Religious Visual Culture of the Renaissance Venetian *Casa.*" *Renaissance Studies* 21, no. 2 (April 2007): 151–84.

——. 2013

Morse, Margaret. "From *Chiesa* to *Casa* and Back: The Exchange of Public and Private in Domestic Devotional Art." In *Reflections on Renaissance Venice: A Celebration of Patricia Fortini Brown*, edited by Blake de Maria and Mary E. Frank, 142–53. Milan: 5 Continents, 2013.

Moschini 1943

Moschini, Vittorio. *Giambellino*. Bergamo, Milan, and Rome: Istituto Italiano d'Arti Grafiche, 1943.

Moschini Marconi 1955–70

Moschini Marconi, Sandra. *Gallerie dell'Accademia di Venezia*. 3 vols. Rome: Istituto Poligrafico dello Stato, 1955–70.

Muir 1989

Muir, Edward. "The Virgin on the Street Corner: The Place of the Sacred in Italian Cities." In *Religion and Culture in the Renaissance and Reformation*, edited by Steven Ozment, 25–40. Sixteenth-Century Essays & Studies XI. Kirksville, MD: Sixteenth-Century Journal Publishers, 1989.

Mundy 1977

Mundy, E. James. "Franciscus Alter Christus: The Intercessory Function of a Late Quattrocento Panel." *Record of the Art Museum, Princeton University* 36, no. 2 (1977): 4–15.

Mussi 1903

Mussi, Paolo (trans.). *The Anonimo: Notes on Pictures and Works of Art in Italy Made by an Anonymous Writer in the Sixteenth Century*. Edited by George C. Williamson. London: George Bell and Sons, 1903.

Nagel and Pericolo 2010

Nagel, Alexander, and Lorenzo Pericolo (eds.). *Subject as Aporia in Early Modern Art*. Farnham, UK: Ashgate, 2010.

Naples 1960

IV Mostra di Restauri. Exh. cat. Naples: Palazzo Reale, 1960.

Neff 1981

Neff, Mary. "A Citizen in the Service of the Patrician State: The Career of Zaccaria de' Freschi." *Studi Veneziani*, n.s., 5 (1981): 33–61.

——. 1985

Neff, Mary Frances. "Chancellery Secretaries in Venetian Politics and Society, 1480–1533." Ph.D. diss., University of California, Los Angeles, 1985.

Nepi Scirè 1991

Nepi Scirè, Giovanna. *Treasures of Venetian Painting: The Gallerie dell'Accademia*. Venice: Arsenale Editrice, 1991.

——. 1994

Nepi Scirè, Giovanna. "I Restauri della Pala di San Giobbe di Giovanni Bellini." *Contributi, Problemi di Conservazione e Restauri: Quaderni della Soprintendenza per i Beni Artistici e Storici di Venezia* 19 (1994): 21–25.

New York Times 1915

"H. C. Frick's *St. Francis*, by Giovanni Bellini." *The New York Times*, 10 Oct. 1915.

Nimmo 1987

Nimmo, Duncan. *Reform and Division in the Medieval Franciscan Order: From Saint Francis to the Foundation of the Capuchins*. Rome: Capuchin Historical Institute, 1987.

Norton 1857

Charles Eliot Norton. "The Manchester Exhibition." *Atlantic Monthly* 1 (Nov. 1857): 33–46.

Nova 1998

Nova, Alessandro. "Giorgione's *Inferno with Aeneas and Anchises* for Taddeo Contarini." In *Dosso's Fate: Painting and Court Culture in Renaissance Italy*, edited by Luisa Ciammitti, Steven F. Ostrow, and Salvatore Settis, 41–62. Los Angeles: Getty Research Institute, 1998.

Nuttall 2000

Nuttall, Paula. "Jan van Eyck's Paintings in Italy." In *Investigating Jan van Eyck*, edited by Susan Foister, Sue Jones, and Delphine Cool, 169–82. Turnhout, Belgium: Brepols, 2000.

Oberthaler 2004

Oberthaler, Elke. "On Technique, Condition and Interpretation of Five Paintings by Giorgione and His Circle." In *Giorgione: Myth and Enigma*, edited by Sylvia Ferino-Pagden and Giovanna Nepi Scirè, 267–76. Vienna: Kunsthistorisches Museum, 2004.

Oberthaler and Walmsley 2006

Oberthaler, Elke, and Elizabeth Walmsley. "Technical Studies of Painting Methods." In Brown and Ferino-Pagden 2006, 285–300.

Odoardi 1975

Odoardi, Giuseppe. "Conventualismo." In *Dizionario degli Istituti di Perfezione*. Vol. 2. Rome: Edizioni Paoline, 1975, cols. 1711–26.

O'Malley 2005

O'Malley, Michelle. *The Business of Art: Contracts and the Commissioning Process in Renaissance Italy*. New Haven and London: Yale University Press, 2005.

Onda 2008

Onda, Silvano. *La Chiesa di San Francesco della Vigna e il Convento dei Frati Minori: Storia, Arte, Architettura*. Venice: Litostampa, 2008.

Origo 1962

Origo, Iris. *The World of San Bernardino*. New York: Harcourt, Brace & World, 1962.

van Os 1974

van Os, H. W. "St. Francis of Assisi as a Second Christ in Early Italian Painting." *Simiolus* 7, no. 3 (1974): 115–32.

van Os et al. 1978

van Os, H. W., J. R. J. van Asperen de Boer, C. E. de Jong-Jansen, and C. Wiethoff. *The Early Venetian Paintings in Holland*. Translated by Michael Hoyle. Maarssen, The Netherlands: Gary Schwartz, 1978.

Pächt 2002

Pächt, Otto. *Venezianische Malerei des 15. Jahrhunderts: Die Bellinis und Mantegna*. Edited by Margareta Vyoral-Tschapka and Michael Pächt. Munich: Prestel, 2002.

Packard 1970–71

Packard, Elisabeth C. G. "A Bellini Painting from the Procuratia di Ultra, Venice: An Exploration of Its History and Technique." *Journal of the Walters Art Gallery* 33/34 (1970–71): 64–84.

Pall Mall Gazette 1912

Pall Mall Gazette, 2 Jan. 1912.

Pallucchini 1949

Pallucchini, Rodolfo. *Giovanni Bellini: Catalogo Illustrato della Mostra*. Exh. cat. Venice: Palazzo Ducale, 1949.

——. 1959

Pallucchini, Rodolfo. *Giovanni Bellini*. Milan: Aldo Martello, 1959.

——. 1962

Pallucchini, Rodolfo. *Giovanni Bellini*. Translated by R. H. Boothroyd. London: William Heinemann, 1962.

Panofsky 1927

Panofsky, Erwin. "'Imago Pietatis': Ein Beitrag zur Typengeschichte des 'Schmerzensmanns' und der 'Maria Mediatrix.'" In *Festschrift für Max J. Friedländer zum 60. Geburtstage*, 261–308. Leipzig: E. A. Seemann, 1927.

Paoletti 1893–97

Paoletti, Pietro. *L'Architettura e la Scultura del Rinascimento in Venezia: Ricerche Storico-Artistiche*. Venice: Ongania-Naya, 1893–97.

——. 1894–95

Paoletti, Pietro. *Raccolta di Documenti Inediti per Servire alla Storia della Pittura Veneziana nei Secoli XV e XVI*. 2 vols. Padua: R. Stabilimento, P. Prosperini, 1894–95.

Paoletti and Ludwig 1899

Paoletti, Pietro, and Gustav Ludwig. "Neue Archivalische Beiträge zur Geschichte der Venezianischen Malerei." *Repertorium für Kunstwissenschaft* 22 (1899): 87–93, 255–78, 427–57.

Paolucci et al. 2005–6

Paolucci, Antonio, Luciana Prati, and Stefano Tumidei (eds.). *Marco Palmezzano: Il Rinascimento nelle Romagne*. Exh. cat. Forlì, Italy: Complesso Monumentale di San Domenico, 2005–6.

Pasolini 2003

Pasolini, Pier Paolo. *Tutte le Poesie*. Edited by Walter Siti. 2 vols. Milan: Mondadori, 2003.

Pazzelli 1993

Pazzelli, Raffaele. *The Franciscan Sisters: Outlines of History and Spirituality*. Steubenville, OH: Franciscan University Press, 1993.

Pélerin (Viator) 1505

Pélerin, Jean (Viator). *De Artificiali Perspectiva*. Toulouse: Pierre Jacques, 1505.

Pergam 2011

Pergam, Elizabeth A. *The Manchester Art Treasures Exhibition of 1857: Entrepreneurs, Connoisseurs and the Public*. Farnham, UK: Ashgate, 2011.

Peterson 1993

Peterson, Ingrid J. *Clare of Assisi: A Biographical Study*. Quincy, IL: Franciscan Press, 1993.

Philip of Perugia 1897

Philip of Perugia. "Instrumentum de Stigmatibus Beati Francisci." In *Analecta Franciscana*, III, 641–45. Quaracchi, Italy: Typographia Collegii S. Bonaventurae, 1897.

Pignatti 1969

Pignatti, Terisio. *L'Opera Completa di Giovanni Bellini*. Milan: Rizzoli, 1969.

Pignatti and Bonnefoy 1969/1975

Pignatti, Terisio, and Yves Bonnefoy. *Tout l'Oeuvre Peint de Giovanni Bellini*. Translated by Simone Darses. Milan: Rizzoli, 1969; Paris: Flammarion, 1975.

Pignatti and Pedrocco 1999

Pignatti, Terisio, and Filippo Pedrocco. *Giorgione*. Translated by Marguerite Shore. Milan: RCS Libri; New York: Rizzoli, 1999.

Pillepich 2001

Pillepich, Alain. *Milan, Capitale Napoléonienne, 1800–1814*. Paris: A. Pillepich; Lettrage Distribution, 2001.

Pincus 2004

Pincus, Debra. "Bellini and Sculpture." In Humfrey 2004, 122–42.

———. **2008**

Pincus, Debra. "Giovanni Bellini's Humanist Signature: Pietro Bembo, Aldus Manutius and Humanism in Early Sixteenth-Century Venice." *Artibus et Historiae* 29, no. 58 (2008): 89–119.

Pino 1548/1946

Pino, Paolo. *Dialogo di Pittura*. Edited by Rodolfo and Anna Pallucchini. Venice: 1st ed. 1548; Milan: Edizioni Daria Guarnati, 1946.

Plesters 1993a

Plesters, Joyce. "Examination of Giovanni Bellini's *Feast of the Gods*: A Summary and Interpretation of the Results." In *Titian 500*, edited by Joseph Manca, 375–91. Studies in the History of Art 45. Washington, D.C.: Center for Advanced Study in the Visual Arts, 1993.

———. **1993b**

Plesters, Joyce. "Ultramarine Blue, Natural and Artificial." In *Artists' Pigments: A Handbook of their* History and Characteristics, edited by Ashok Roy, 37–65. Vol. 2. Washington, D.C.: National Gallery of Art, 1993.

Pliny/Rackham 1952

Pliny the Elder. *Natural History, Books 33–35*. Translated by H. Rackham. Cambridge and London: Harvard University Press, 1952.

Pochat 1973

Pochat, Götz. *Figur und Landschaft: Eine Historische Interpretation der Landschaftsmalerei von der Antike bis zur Renaissance*. Berlin and New York: Walter de Gruyter, 1973.

Poldi 2009

Poldi, Gianluca. "Note quasi Sparse sul Colore e la Tecnica di Giambellino: Nuovi Studi Analitici." In *Indagando Bellini*, edited by Gianluca Poldi and Giovanni C. F. Villa, 160–217. Milan: Skira, 2009.

———. **2009–10**

Poldi, Gianluca. "Dalle Opere in Mostra alla Tecnica di Giorgione: Nuove Analisi e Confronti." In *Giorgione*, edited by Enrico Maria Dal Pozzolo and Lionello Puppi, 225–42. Exh. cat. Castelfranco Veneto: Museo Casa Giorgione, 2009–10.

Poldi and Villa 2006

Poldi, Gianluca, and Giovanni C. F. Villa. "Giovanni Bellini e Dintorni ovvero Appunti Veneziani." In *Dalla Conservazione alla Storia dell'Arte: Riflettografia e Analisi non Invasive per lo Studio dei Dipinti*, edited by Gianluca Poldi and Giovanni C. F. Villa, 321–412. Pisa: Edizioni della Normale, 2006.

———. **2008**

Poldi, Gianluca, and Giovanni C. F. Villa (eds.). *Bellini a Venezia: Sette Opere Indagate nel loro Contesto*. Milan: Silvana, 2008.

———. **2011**

Poldi, Gianluca, and Giovanni C. F. Villa. "A New Examination of Giovanni Bellini's *Pesaro Altarpiece*: Recent Findings and Comparisons with other Works by Bellini." In *Studying Old Master Paintings: Technology and Practice: The National Gallery Technical Bulletin 30th Anniversary Conference Postprints*, edited by Marika Spring et al., 28–36. London: Archetype Publications, 2011.

Poldi et al. 2006

Poldi, Gianluca, Giovanni C. F. Villa, Simone Caglio, and Letizia Bonizzoni. "Le Analisi dei Pigmenti della Pala di San Cassiano." In *Antonello da Messina: Analisi Scientifiche, Restauri e Prevenzione sulle Opere di Antonello da Messina in Occasione della Mostra alle Scuderie del Quirinale*, edited by Gianluca Poldi and Giovanni C. F. Villa, 244–55. Milan: Silvana, 2006.

Pollard 2007

Pollard, John Graham. *Renaissance Medals*. The Collections of the National Gallery of Art: Systematic Catalogue. 2 vols. New York and Oxford: Oxford University Press, 2007.

Posse 1931

Posse, Hans. "Die Briefe des Grafen Francesco Algarotti an den Sächsischen Hof und seine Bilderkäufe für die Dresdner Gemäldegalerie, 1743–1747." *Jahrbuch der Preuszischen Kunstsammlungen* 52, Beiheft (1931): 1–73.

Pratesi and Sabatelli 1982

Pratesi, R., and G. Sabatelli (eds.). *I Fioretti di San Francesco*. Florence: Libreria Editrice Fiorentina, 1982.

Puglisi and Barcham 2006

Puglisi, Catherine, and William Barcham. "Gli Esordi del *Cristo Passo* nell'Arte Veneziana e la *Pala Feriale* di Paolo Veneziano." In *"Cose Nuove e Cose Antiche": Scritti per Monsignor Antonio Niero e Don Bruno Bertoli*, edited by Francesca Cavazzana Romanelli, Maria Leonardi, and Stefania Rossi Minutelli, 403–29. Collana di Studi 7. Venice: Biblioteca Nazionale Marciana, 2006.

———. **2008**

Puglisi, Catherine, and William Barcham. "Bernardino da Feltre, the Monte di Pietà and the *Man of Sorrows*: Activist, Microcredit and Logo." *Artibus et Historiae* 29, no. 58 (2008): 35–63.

———. **2011**

Puglisi, Catherine, and William Barcham (eds.). *Passion in Venice: Crivelli to Tintoretto and Veronese: The Man of Sorrows in Venetian Art*. Exh. cat. New York: Museum of Biblical Art, 2011.

Pullan 1971

Pullan, Brian. *Rich and Poor in Renaissance Venice: The Social Institutions of a Catholic State, to 1620*. Cambridge: Harvard University Press; Oxford: Basil Blackwell, 1971.

Puttfarken 2000

Puttfarken, Thomas. *The Discovery of Pictorial Composition: Theories of Visual Order in Painting 1400–1800*. New Haven and London: Yale University Press, 2000.

Ravà 1920

Ravà, Aldo. "Il 'Camerino delle Antigaglie' di Gabriele Vendramin." *Nuovo Archivio Veneto*, n.s., 39 (1920): 155–81.

Rawlings 2009

Rawlings, Kandice. "Liminal Messages: The *Cartellino* in Italian Renaissance Painting." Ph.D. diss., Rutgers, The State University of New Jersey, New Brunswick, 2009.

Raynaud 2006

Raynaud, Dominique. "La Théorie des Erreurs et son Application à la Reconstruction des Tracés Perspectifs." In *L'Artiste et L'Oeuvre à L'Épreuve de la Perspective*, edited by Marianne Cojannot-le Blanc et al., 411–30. Rome: Collection de L'École Française de Rome, 2006.

Rearick 1976

Rearick, W. R. *Tiziano e il Disegno Veneziano del suo Tempo*. Exh. cat. Florence: Gabinetto Disegni e Stampe degli Uffizi, 1976.

———. 2003

Rearick, William. "La Dispersione dei Dipinti già a Santa Maria dei Miracoli." In *Santa Maria dei Miracoli a Venezia: La Storia, la Fabbrica, i Restauri*, edited by Mario Piana and Wolfgang Wolters, 179–92. Venice: Istituto Veneto di Scienze, Lettere ed Arti, 2003.

Reeves 1969/1993

Reeves, Marjorie. *The Influence of Prophecy in the Later Middle Ages: A Study in Joachimism*. Oxford: Clarendon Press, 1969; Notre Dame: University of Notre Dame Press, 1993.

Ridolfi 1648/1965

Ridolfi, Carlo. *Le Maraviglie dell'Arte*. Edited by Detlev Freiherr von Hadeln. 2 vols. Venice: Gio. Battista Sgaua, 1648; Rome: Società Multigrafica Editrice SOMU, 1965.

Rigon 2003–4

Rigon, Fernando. "L'Architettura di Vicenza e Giovanni Bellini." In Rigon and Dal Pozzolo 2003–4, 31–37.

Rigon and Dal Pozzolo 2003–4

Rigon, Fernando, and Enrico Maria Dal Pozzolo. *Bellini e Vicenza*. Exh. cat. Vicenza: Palazzo Thiene; Venice: Gallerie dell'Accademia, 2003–4.

Rivi 1989/2001

Rivi, Prospero. *Francis of Assisi and the Laity of His Time*. Translated by Heather Tolfree. Padua: Edizioni Messaggero, 1989; St. Bonaventure, NY: Franciscan Institute, Greyfriars Review, 2001.

Robertson 1968

Robertson, Giles. *Giovanni Bellini*. Oxford: Clarendon Press, 1968.

Robson 2006

Robson, Michael. *The Franciscans in the Middle Ages*. Woodbridge, UK: Boydell Press, 2006.

Rocca 2000

Rocca, Giancarlo (ed.). *La Sostanza dell'Effimero: Gli Abiti degli Ordini Religiosi in Occidente*. Exh. cat. Rome: Museo Nazionale di Castel Sant'Angelo, 2000.

Romanelli 1993

Romanelli, Giandomenico. *Ca' Corner della Ca' Granda: Architettura e Committenza nella Venezia del Cinquecento*. Venice: Albrizzi, 1993.

Rosand 1981

Rosand, David. "Titian and the Eloquence of the Brush." *Artibus et Historiae* 2, no. 3 (1981): 85–96.

———. 2001

Rosand, David. *Myths of Venice: The Figuration of a State*. Chapel Hill and London: University of North Carolina Press, 2001.

Rossetti 1989

Rossetti, Felice. *L'Abito Francescano*. Frigento, Italy: Casa Mariana, 1989.

Rossi 1895

Rossi, Vittorio. "Il Canzoniere Inedito di Andrea Michieli detto Squarzòla o Strazzòla." *Giornale Storico della Letteratura Italiana* 26 (1895): 1–91.

Royal Academy of Arts 1912

Exhibition of the Works of the Old Masters and Deceased Masters of the British School, including a Collection of Pictures and Drawings by Edwin Austen Abbey, R. A. Winter Exhibition. Forty-Third Year. Exh. cat. London: Royal Academy of Arts, 1912.

Rupprich 1956

Rupprich, Hans (ed.). *Dürer: Schriftlicher Nachlass*. Vol. 1. Berlin: Deutscher Verein für Kunstwissenschaft, 1956.

Rutherglen 2011

Rutherglen, Susannah. "In a New Light: Bellini's *St. Francis in the Desert*." *The Frick Collection Members' Magazine* (Spring/Summer 2011): 2–7.

Sabellico 1502/1985

Sabellico, Marc'Antonio. *Del Sito di Venezia Città (1502)*. Edited by G. Meneghetti. Venice: Filippi, 1985.

Saltzman 2008

Saltzman, Cynthia. *Old Masters, New World: America's Raid on Europe's Great Pictures, 1880–World War I*. New York: Viking, 2008.

———. 2010

Saltzman, Cynthia. "'The Finest Things': Colnaghi, Knoedler and Henry Clay Frick." In *Colnaghi: The History*, edited by Jeremy Howard, 32–36. London: Colnaghi, 2010.

Sansovino 1581/2002

Sansovino, Francesco. *Venetia Città Nobilissima et Singolare, Descritta in XIIII Libri . . .* Venice: Domenico Farri, 1581; Bergamo: Leading Edizioni, 2002.

Sansovino and Martinioni 1663/1998

Sansovino, Francesco, and Giustiniano Martinioni. *Venetia Città Nobilissima et Singolare, Descritta in XIIII Libri . . .* Venice: Steffano Curti, 1663; Venice: Filippi, 1998.

Sanudo 1493–1530/2011

Sanudo, Marin. *De Origine, Situ et Magistratibus Urbis Venetae; ovvero, La Città di Venetia (1493–1530)*. 2nd ed. Edited by Angela Caracciolo Aricò. Venice: Centro di Studi Medievali e Rinascimentali "E.A. Cicogna," 2011.

———. 1879–1903

Sanudo, Marin. *I Diarii di Marino Sanuto*. Edited by Rinaldo Fulin et al. 58 vols. Venice: Fratelli Visentini, 1879–1903.

Sartori 1947

Sartori, Antonio. *Guida Storico-Artistica della Basilica di S. M. Gloriosa dei Frari in Venezia*. Padua: Il Messaggero di S. Antonio, Basilica del Santo, 1947.

Savettieri 1998

Savettieri, Chiara. "La *Laus Perspectivae* di Matteo Colacio e la Fortuna Critica della Tarsia in Area Veneta." *Ricerche di Storia dell'Arte* 64 (1998): 5–22.

Scarpa 1994

Scarpa, Pietro. "Le Ante d'Organo di San Marco di Gentile Bellini." *Arte Documento* 8 (1994): 51–58.

Scharf 1857

George Scharf, Jr. *A Handbook to the Paintings by Ancient Masters in the Art Treasures Exhibition. Being a Reprint of the Critical Notices Published in "The Manchester Guardian."* Manchester: Bradbury and Evans, 1857.

Scher 1994

Scher, Stephen. *The Currency of Fame: Portrait Medals of the Renaissance*. Exh. cat. New York: The Frick Collection; Washington, D.C.: National Gallery of Art, 1994.

Schiller 1972

Schiller, Gertrud. "The Man of Sorrows – 'Imago Pietatis.'" In *Iconography of Christian Art*, translated by Janet Seligman, 197–228. Vol. 2. Greenwich, CT: New York Graphic Society, 1972.

Schmidt Arcangeli 1998

Schmidt Arcangeli, Catarina. "La Sapienza nel Silenzio: Riconsiderando la Pala di San Giobbe." *Saggi e Memorie di Storia dell'Arte* 22 (1998): 9–54.

Schmitter 1997

Schmitter, Monika. "The Display of Distinction: Art Collecting and Social Status in Early Sixteenth-Century Venice." Ph.D. diss., University of Michigan, Ann Arbor, 1997.

———. 2003

Schmitter, Monika. "The Dating of Marcantonio Michiel's *Notizia* on Works of Art in Padua." *The Burlington Magazine* 145, no. 1205 (Aug. 2003): 564–71.

———. 2004

Schmitter, Monika. "'Virtuous Riches': The Bricolage of *Cittadini* Identities in Early-Sixteenth-Century Venice." *Renaissance Quarterly* 57, no. 3 (Autumn 2004): 908–69.

———. 2011

Schmitter, Monika. "The *Quadro da Portego* in Sixteenth-Century Venetian Art." *Renaissance Quarterly* 64, no. 3 (Fall 2011): 693–751.

Schulz 2010–12

Schulz, Anne Markham. "New Light on Pietro, Antonio, and Tullio Lombardo." *Mitteilungen des Kunsthistorischen Institutes in Florenz* 54, no. 2 (2010–12): 231–56.

Schulze Altcappenberg 1995

Schulze Altcappenberg, Heinrich-Thomas. *Die Italienischen Zeichnungen des 14. und 15. Jahrhunderts im*

Berliner Kupferstichkabinett: Kritischer Katalog. Berlin: Staatliche Museen, 1995.

Sciolla 1993
Sciolla, Gianni Carlo. "Due Epigrammi Inediti di Girolamo Bologni da Treviso per Giovanni Bellini." *Arte Veneta* 44 (1993): 62–64.

Scott et al. 2001
Scott, D. A., N. Khandekar, M. R. Schilling, N. Turner, Y. Taniguchi, and H. Khanjian. "Technical Examination of a Fifteenth-Century German Illuminated Manuscript on Paper: A Case Study in the Identification of Materials." *Studies in Conservation* 46 (2001): 93–108.

Settis 1978
Settis, Salvatore. *La "Tempesta" Interpretata: Giorgione, i Committenti, il Soggetto*. Turin: Einaudi, 1978.

———. **1978/1990**
Settis, Salvatore. *Giorgione's "Tempest": Interpreting the Hidden Subject*. Translated by Ellen Bianchini. Turin: Einaudi, 1978; Cambridge: Polity Press; Chicago: University of Chicago Press, 1990.

Seubert 2011
Seubert, Xavier John. "Isaiah's Servant, Christianity's Man of Sorrows, and Saint Francis of Assisi." In Puglisi and Barcham 2011, 28–32.

Shapley 1945
Shapley, Fern Rusk. "Giovanni Bellini and Cornaro's Gazelle." *Gazette des Beaux-Arts*, ser. 6, vol. 28 (1945): 27–30.

Signorini 2006
Signorini, Mariarita. "Al Visibile e all'Infrarosso, il Gioco delle Differenze." In *La Terrazza del Mistero* 2: *L'Allegoria Sacra di Giovanni Bellini: Analisi Storica e Interpretazione Psicoanalitica con una Rilettura dopo il Restauro*, edited by Graziella Magherini et al., 81–92. Florence: NICOMP, 2006.

Skipsey 1990
Skipsey, David. "The Giovanni Bellini Workshop: Organisation, Methods and Techniques." Unpublished thesis, Courtauld Institute of Art, London, 1990.

Smart 1973
Smart, Alastair. "The *Speculum Perfectionis* and Bellini's Frick *St. Francis*." *Apollo*, n.s., 97, no. 135 (May 1973): 470–76.

Smith 1972
Smith, Alistair. "Dürer and Bellini, Apelles and Protogenes." *The Burlington Magazine* 114, no. 830 (May 1972): 326–29.

Snyder 1997
Snyder, James. "Observations on the Iconography of Jan van Eyck's *Saint Francis Receiving the Stigmata*." In van Asperen de Boer et al. 1997, 75–87.

Sohm 1991
Sohm, Philip. *Pittoresco: Marco Boschini, His Critics, and Their Critiques of Painterly Brushwork in Seventeenth- and Eighteenth-Century Italy*. Cambridge and New York: Cambridge University Press, 1991.

Spezzani 1994
Spezzani, Paolo. "Breve Nota sulle Riflettoscopie in Infrarosso della Pala di San Giobbe di Giovanni Bellini." *Contributi, Problemi di Conservazione e Restauri: Quaderni della Soprintendenza per i Beni Artistici e Storici di Venezia* 19 (1994): 27–28.

Spimpolo 1933–39
Spimpolo, Timoteo. *Storia dei Frati Minori della Provincia Veneta di S. Francesco*. 2 vols. Vicenza: Il Terz'Ordine Francescano/Convento S. Lucia, 1933–39.

Steer 1965
Steer, John. Review of *Saggi e Memorie di Storia dell'Arte* 3 (1963), and Fritz Heinemann, *Giovanni Bellini e i Belliniani* (1962). *The Burlington Magazine* 107, no. 751 (Oct. 1965): 533–34.

———. **1982**
Steer, John. *Alvise Vivarini: His Art and Influence*. Cambridge and London: Cambridge University Press, 1982.

Stubblebine 1985
Stubblebine, James. *Assisi and the Rise of Vernacular Art*. New York: Harper and Row, 1985.

Tassini 1888
Tassini, Giuseppe. "Cittadini Veneziani, Famiglie Veneziane Originarie." Biblioteca del Museo Correr, Venice, Provenienze Diverse, ms. P.D. c 4. 5 vols.

———. **1988**
Tassini, Giuseppe. *Curiosità Veneziane; ovvero, Origini delle Denominazioni Stradali di Venezia*. Edited by Lino Moretti. Venice: Filippi, 1988.

Tempestini 1992a
Tempestini, Anchise. *Giovanni Bellini: Catalogo Completo dei Dipinti*. Florence: Cantini, 1992.

———. **1992b**
Tempestini, Anchise. "Giovanni Bellini e l'Oreficeria: I Pastorali dei Vescovi e degli Abati nei suoi Dipinti." In *Ori e Tesori d'Europa: Atti del Convegno di Studio*, edited by Giuseppe Bergamini and Paolo Goi, 269–78. Udine: Arti Grafiche Friulane, 1992.

———. **2000**
Tempestini, Anchise. *Giovanni Bellini*. Milan: Electa, 2000.

———. **2004**
Tempestini, Anchise. "Bellini and His Collaborators." In Humfrey 2004, 256–71.

———. **2008**
Tempestini, Anchise. "Temi Profani e Pittura Narrativa in Giovanni Bellini." In Lucco and Villa 2008, 52–65.

Thode 1885/1998
Thode, Henry. *Franz von Assisi und die Anfänge der Kunst der Renaissance in Italien*. Berlin: Grote, 1885; Essen: Emil Vollmer Verlag, 1998.

Thode/Bellosi 1993
Thode, Henry. *Francesco d'Assisi e le Origini dell'Arte del Rinascimento in Italia*. Edited by Luciano Bellosi. Translated by Rossella Zeni. Rome: Donzelli, 1993.

Tietze and Tietze-Conrat 1944
Tietze, Hans, and E. Tietze-Conrat. *The Drawings of the Venetian Painters in the 15th and 16th Centuries*. New York: J. J. Augustin, 1944.

Tietze-Conrat 1946
Tietze-Conrat, E. "Again: Giovanni Bellini and Cornaro's Gazelle." *Gazette des Beaux-Arts*, ser. 6, vol. 29 (1946): 187–90; vol. 30 (1946): 185.

Tintori and Meiss 1967
Tintori, Leonetto, and Millard Meiss. *The Painting of the Life of St. Francis in Assisi*. New York: W. W. Norton, 1967.

Toyama 2009
Toyama, Koichi. "Light and Shadow in Sassetta: *The Stigmatization of Saint Francis* and the Sermons of Bernardino da Siena." In Israëls 2009b, vol. 1, 304–15.

Turner 1966
Turner, A. Richard. *The Vision of Landscape in Renaissance Italy*. Princeton: Princeton University Press, 1966.

Umiker 2007–11
Umiker, Monica Benedetta. "Introduzione alla *Vita del Glorioso Seraphico Sancto Francesco* nel ms. 1102 della Biblioteca Comunale Augusta di Perugia." *Amicitiae Sensibus: Studi in Onore di Don Mario Sensi. Bollettino Storico della Città di Foligno* 31–34 (2007–11): 391–412.

Ungaro 1968
Ungaro, Giuseppe. *The Basilica of the Frari, Venice*. Venice: Basilica of the Frari, 1968.

Urban 1848
Urban, Sylvanus. *The Gentleman's Magazine*, n.s., 30, no. 185 (Jul.–Dec. 1848).

Valazzi 1988a
Valazzi, Maria Rosaria. "La Pala di Pesaro nei Documenti d'Archivio e nella Letteratura Critica dal Secolo XV al XIX." In Valazzi 1988b, 35–39.

———. **1988b**
Valazzi, Maria Rosaria (ed.). *La Pala Ricostituita: L'Incoronazione della Vergine e la Cimasa Vaticana di Giovanni Bellini: Indagini e Restauri*. Exh. cat. Pesaro: Musei Civici, 1988.

Valazzi et al. 2009
Valazzi, Maria Rosaria, et al. "La *Pala di Pesaro* di Giovanni Bellini." *Kermes: La Rivista del Restauro* 22 (April–June 2009): 23–51.

Vasari 1568/1906

Vasari, Giorgio. *Le Vite de' Più Eccellenti Pittori Scultori ed Architettori*. Edited by Gaetano Milanesi. 9 vols. Florence: G. C. Sansoni, 1906.

———. **1568/1907**

Vasari, Giorgio. *Vasari on Technique, Being the Introduction to the Three Arts of Design, Architecture, Sculpture and Painting . . .* Translated by Louisa S. Maclehose. Edited by G. Baldwin Brown. London: J. M. Dent, 1907.

Vauchez 2009/2012

Vauchez, André. *Francis of Assisi: The Life and Afterlife of a Medieval Saint*. Translated by Michael F. Cusato. Paris: Librairie Arthème Fayard, 2009; New Haven: Yale University Press, 2012.

Veltman 1986

Veltman, Kim H., with Kenneth D. Keele. *Studies on Leonardo da Vinci I: Linear Perspective and the Visual Dimensions of Science and Art*. Munich: Deutscher Kunstverlag, 1986.

Venturi 1915

Venturi, Adolfo. *Storia dell'Arte Italiana*. Part VII, *La Pittura del Quattrocento*, vol. 4. Milan: Hoepli, 1915.

Vescovo 1999

Vescovo, Piermario. "Preliminari Giorgioneschi I: Gabriele Vendramin e la *Tempesta*." *Wolfenbütteler Renaissance-Mitteilungen* 23, no. 3 (Dec. 1999): 103–18.

———. **2000**

Vescovo, Piermario. "Preliminari Giorgioneschi II: Taddeo Contarini e i *Tre Filosofi*." *Wolfenbütteler Renaissance-Mitteilungen* 24, no. 2 (2000): 109–24.

da Vicenza 1865

da Vicenza, Antonio Maria. *Memorie Storiche del Convento e della Chiesa di San Francesco del Deserto nelle Lagune di Venezia, Pubblicate nell'Occasione che la Religiosa Famiglia dei Minori Riformati vi Rientra ad Abitare*. Venice: Tipografia G. Merlo, 1865.

Villa 2003–4

Villa, Giovanni C. F. "Un Bellini in Chiaroscuro: Indagini Infrarosse e Problemi Cronologici." In Rigon and Dal Pozzolo 2003–4, 73–85.

———. **2008a**

Villa, Giovanni C. F. "L'Arte della Ricerca, il Primato del Disegno: 'L'Altra Luce' di Giovanni Bellini." In Lucco and Villa 2008, 38–51.

———. **2008b**

Villa, Giovanni C. F. *Giovanni Bellini*. Milan: Silvana, 2008.

———. **2009**

Villa, Giovanni C. F. "Indagando Bellini: Quattro Ancone in un Itinerario." In *Indagando Bellini*, edited by Gianluca Poldi and Giovanni C. F. Villa, 13–127. Milan: Skira, 2009.

———. **2010**

Villa, Giovanni C. F. (ed.). *Cima da Conegliano: Poeta del Paesaggio*. Exh. cat. Conegliano: Palazzo Sarcinelli, 2010.

Volpin and Lazzarini 1994

Volpin, Stefano, and Lorenzo Lazzarini. "Il Colore e la Tecnica Pittorica della Pala di San Giobbe di Giovanni Bellini." *Contributi, Problemi di Conservazione e Restauri: Quaderni della Soprintendenza per i Beni Artistici e Storici di Venezia* 19 (1994): 29–37.

Volpin and Stevanato 1994

Volpin, Stefano, and Roberto Stevanato. "Studio dei Leganti Pittorici della Pala di San Giobbe di Giovanni Bellini." *Contributi, Problemi di Conservazione e Restauri: Quaderni della Soprintendenza per i Beni Artistici e Storici di Venezia* 19 (1994): 39–43.

de Voragine 1993

de Voragine, Jacobus. *The Golden Legend: Readings on the Saints*. Translated by William Granger Ryan. 2 vols. Princeton: Princeton University Press, 1993.

Vorreux 1977/1979

Vorreux, Damien. *A Franciscan Symbol, the Tau: History, Theology, and Iconography*. Translated by Marilyn Archer and Paul Lachance. Paris: Éditions Franciscaines, 1977; Chicago: Franciscan Herald Press, 1979.

Waagen 1854

Waagen, Gustav Friedrich. *Treasures of Art in Great Britain: Being an Account of the Chief Collections of Paintings, Drawings, Sculptures, Illuminated Mss., &c. &c.* 3 vols. London: John Murray, 1854.

———. **1857**

Waagen, Gustav Friedrich. *Galleries and Cabinets of Art in Great Britain: Being an Account of More than Forty Collections of Paintings, Drawings, Sculptures, Mss., &c. &c. Visited in 1854 and 1856, and Now for the First Time Described . . .* London: John Murray, 1857.

Wallert and van Oosterhout 1998

Wallert, Arie, and Carlo van Oosterhout. *From Tempera to Oil Paint: Changes in Venetian Painting, 1460–1560*. Exh. cat. Amsterdam: Rijksmuseum, 1998.

Whistler and Dunkerton 2009

Whistler, Catherine, and Jill Dunkerton. "Titian's *Triumph of Love*." *The Burlington Magazine* 151, no. 1277 (Aug. 2009): 536–42.

Wilde 1974

Wilde, Johannes. *Venetian Art from Bellini to Titian*. Oxford: Clarendon Press, 1974, reprinted 1981.

Wills 2001

Wills, Garry. *Venice: Lion City: The Religion of Empire*. New York and London: Simon & Schuster, 2001.

Wilson 1977

Wilson, Carolyn. "Bellini's Pesaro Altarpiece: A Study in Context and Meaning." Ph.D. diss., Institute of Fine Arts, New York University, New York, 1977.

———. **1989**

Wilson, Carolyn. "Early Citations of Giovanni Bellini's Pesaro Altar-Piece." *The Burlington Magazine* 131, no. 1041 (Dec. 1989): 847–49.

———. **2004**

Wilson, Carolyn. "Giovanni Bellini and the 'Modern Manner.'" In Humfrey 2004, 95–121.

———. **2008**

Wilson, Carolyn. "Giovanni Bellini e il Dipinto d'Altare: Solennità dell'Intento, 'Pietà' Necessaria e Devozione Assoluta: La Natività e la Trasfigurazione." In Lucco and Villa 2008, 117–29.

———. **forthcoming**

Wilson, Carolyn (ed.). *Examining Giovanni Bellini: An Art "More Human and More Divine."* Turnhout, Belgium: Brepols, forthcoming.

Wohl 1999

Wohl, Hellmut. "The Subject of Giovanni Bellini's St. Francis in the Frick Collection." In *Mosaics of Friendship: Studies in Art and History for Eve Borsook*, edited by Ornella Francisci Osti, 187–98. Florence: Centro Di, 1999.

Wolters 1983

Wolters, Wolfgang. *Der Bilderschmuck des Dogenpalastes: Untersuchungen zur Selbstdarstellung der Republik Venedig im 16. Jahrhundert*. Wiesbaden: Franz Steiner, 1983.

Zanardi 1996

Zanardi, Bruno, with Federico Zeri and Chiara Frugoni. *Il Cantiere di Giotto: Le Storie di San Francesco ad Assisi*. Milan: Skira, 1996.

Zanetti 1771/1972

Zanetti, A. M. *Della Pittura Veneziana e delle Opere Pubbliche de' Veneziani Maestri*. Venice: Giambattista Albrizzi, 1771; Venice: Filippi, 1972.

Zannini 1993

Zannini, Andrea. *Burocrazia e Burocrati a Venezia in Età Moderna: I Cittadini Originari (sec. XVI–XVIII)*. Venice: Istituto Veneto di Scienze, Lettere ed Arti, 1993.

Ziliotto 1950

Ziliotto, Baccio (ed.). *Raffaele Zovenzoni: La Vita, I Carmi*. Celebrazioni degli Istriani Illustri 3. Trieste: Smolars, 1950.

Zorach 2011

Zorach, Rebecca. *The Passionate Triangle*. Chicago and London: University of Chicago Press, 2011.

Zorzi 1972

Zorzi, Alvise. *Venezia Scomparsa*. 2 vols. Milan: Electa, 1972.

PHOTOGRAPH CREDITS

Unless otherwise stated, all photographs were supplied by the owners indicated in the captions and are reproduced with permission. The following credits apply to images for which additional acknowledgment is due.

Figs. 1, 8, 14, 16, 20, 44, 46, 49, 77, 91: Scala / Art Resource, NY

Figs. 3, 62, 65, 100, 101: © The National Gallery, London / Art Resource, NY

Fig. 4: Fondazione Giorgio Cini, Venice

Fig. 5: Fondazione Musei Civici di Venezia

Figs. 7, 30: © Trustees of The British Museum

Figs. 9, 18, 86: Cameraphoto Arte, Venice / Art Resource, NY

Fig. 11: © RMN-Grand Palais / Art Resource, NY, photograph Gérard Blot

Fig. 12: Procuratoria della Basilica di San Marco, Venice; photograph Dino Chinellato, courtesy Melissa Conn and Save Venice Inc.

Figs. 13, 15: Alinari / Art Resource, NY

Fig. 17: © The Metropolitan Museum of Art / Art Resource, NY

Fig. 19: Marquand Library of Art and Archaeology, Princeton University, Samuel H. Kress Foundation Fund; Photographs John Blazejewski

Figs. 21, 22, 37, 38: Ministero dei Beni e delle Attività Culturali e del Turismo—Biblioteca Nazionale Marciana

Fig. 23: Erich Lessing / Art Resource, NY

Fig. 25: Ralph Lieberman

Figs. 26, 68: Scala / Ministero per i Beni e le Attività Culturali / Art Resource, NY

Fig. 27: Sotheby's London, with special thanks to Jaynie Anderson

Fig. 28: bpk, Berlin / Gemäldegalerie Alte Meister / Hans-Peter Klut / Art Resource, NY

Fig. 29: Nimatallah / Art Resource, NY

Figs. 31, 32, 33: Descendant of the Boucher-Desforges family

Figs. 35, 36: © National Portrait Gallery, London

Fig. 39: Royal Holloway, University of London

Figs. 41–43, 48, 50, 51, 54, 55, 57, 60, 63, 67, 69, 71–73, 80, 88, 93, 94, 99, 111–15, 117–20: Department of Paintings Conservation, The Metropolitan Museum of Art

Figs. 45, 96: bpk, Berlin / Kupferstichkabinett / Joerg P. Anders / Art Resource, NY

Figs. 61, 116: Department of Scientific Research, The Metropolitan Museum of Art

Fig. 76: Federazione Italiana dei Parchi e delle Riserve Naturali; photograph Giordano Giacomini

Fig. 87: Banca Popolare di Vicenza / Opificio delle Pietre Dure, Florence

Fig. 97: Gianni Dagli Orti / The Art Archive at Art Resource, NY

Fig. 98: Angela Cerasuolo and Marina Santucci / Soprintendenza Speciale per il Patrimonio Storico, Artistico ed Etnoantropologico e per il Polo Museale della Città di Napoli. Infrared photograph Charlotte Hale

Figs. 102, 103, 106, 107: Overdrawing Joseph Godla

Figs. 104, 105, 108: Drawing Joseph Godla

Fig. 109: Diagram Joseph Godla

Fig. 122: Fondazione Giorgio Cini, Venice

Page 58: Michael Bodycomb

INDEX